Animals in Ancient Art from the Leo Mildenberg Collection

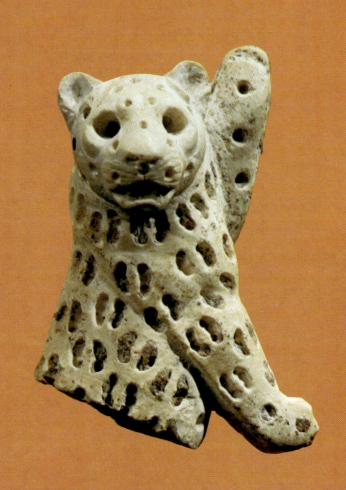

Animals in Ancient Art

FROM THE LEO MILDENBERG COLLECTION

Edited by Arielle P. Kozloff

PUBLISHED BY THE CLEVELAND MUSEUM OF ART
IN COOPERATION WITH INDIANA UNIVERSITY PRESS

Front Cover
7 Bull from a Devotional Standard

Back Cover
98 Monkey Aryballos
46 Swimming Hippopotamus

Frontispiece
2 Rampant Leopard

All rights reserved by The Cleveland Museum of Art · 1981
11150 East Boulevard, Cleveland, Ohio 44106 U. S. A.

Printed in West Germany
Designed by Merald E. Wrolstad
Typesetting by Creative Composition, Inc., Ashland, Ohio 44805
Printing by Verlag Philipp von Zabern, Mainz, West Germany

Distributed by Indiana University Press, Bloomington, Indiana 47401

Library of Congress Cataloging in Publication Data
Main entry under title:
Animals in ancient art from the Leo
 Mildenberg collection.

 1. Art, Ancient—Exhibitions. 2. Animals
in art—Exhibitions. 3. Mildenberg, Leo—
Art collections—Exhibitions. I. Kozloff,
Arielle P. II. Mitten, David Gordon.
III. Cleveland Museum of Art.
N5335.C6C62 730'.093'074013 81–7653
ISBN 0–910386–65–X AACR2

iv

Contents

Colorplates

Contributors

RDD Richard D. DePuma

KPE K. Patricia Erhart

SMG Sidney M. Goldstein

BAK Barbara A. Kathman

APK Arielle P. Kozloff

DGM David Gordon Mitten

JN Jenifer Neils

SJP Sara Jane Pearman

PV Philippe Verdier

Preface

For those of us who have known Leo Mildenberg for some years, one of the highlights of any trip to Europe has been visiting him and meeting the new and reacquainting ourselves with the old members of his menagerie of ancient animals. Animals are everywhere—on tables, on desks, on bookshelves, and on walls. It's like sitting in the middle of a Lilliputian zoo without cages. And Leo bounces around from one to the next, like an African bush baby, focusing the visitor's attention first on a bronze lion then on a terracotta bird then across the room to a stone turtle until all of the animals seemed to fly, swim, and prance before the visitor's eyes. The experience is at once a great delight and a great frustration, for there is never enough time to spend with any one of the animals to be able to study it well.

This exhibition is born of that mixture of delight and frustration which have been shared for years by Sherman E. Lee, Director of The Cleveland Museum of Art, and by many of the contributors to this catalog, most especially David Gordon Mitten. Dr. Lee and the Trustees of the Museum enthusiastically supported the idea of exhibiting the collection, and Dr. Mildenberg generously agreed to part with his animals for the years involved in preparing a catalog and mounting a traveling exhibition. Thomas T. Solley, Director, Indiana University Art Museum; Roger Mandle, Director of the Toledo Museum of Art, and Kurt Luckner, Curator of Ancient Art of that museum; Jiri Frel, Curator of Antiquities of the J. Paul Getty Museum, Malibu; and David Ross, Chief Curator, University Art Museum, University of California, Berkeley, represent the museums who will exhibit the collection. All of these individuals have been highly supportive and helpful.

The contributors to the catalog had the luxury of studying the actual objects rather than working solely from photographs. This gave us the opportunity to write minutely detailed descriptions which we hope will be useful to specialists. David Gordon Mitten, James Loeb Professor of Classical Art and Archaeology, Harvard University, and Curator of Ancient Art, Fogg Art Museum, wrote the largest number of entries concentrating on his area of expertise, classical bronzes, with a few forays into terracotta and impasto and one Near Eastern entry. Richard D. DePuma, Associate Professor, School of Art and Art History, University of Iowa, concentrated on Greek and Etruscan jewelry, carved gems, and vases. K. Patricia Erhart, Assistant Professor, Department of Art and Archaeology, Princeton University, researched vessel handles and panther and ram figures. Etrusco-Corinthian plastic vases were the province of Barbara A. Kathman, Instructor in Cleveland's Department of Art History and Education. Jenifer Neils, Assistant Curator of Ancient Art at Cleveland, and Assistant Professor, Department of Art, Case Western Reserve University, was responsible for a variety of objects in the classical area. The glass objects in all fields except for [186] were the province of Sidney M. Goldstein, Curator of Ancient Glass, the Corning Museum of Glass. Philippe Verdier, former consultant to the Department of Early Western Art, Cleveland, and consultant for ancient Near Eastern Art to the DeMenil Foundation, Houston, studied the Hittite, Urartian, Achaemenian, "Animal Style," and late Roman-Byzantine objects, except for [197]

which was prepared by Sara Jane Pearman, Slide Librarian, at the Cleveland Museum. The Egyptian section and some Near Eastern and Classical entries were prepared by Arielle P. Kozloff, Associate Curator in Charge of Ancient Art, The Cleveland Museum of Art. Dorothy G. Shepherd, Chief Curator of Textiles and Islamic Art, and Anne W. Wardwell, Associate Curator of Textiles, also at Cleveland, assisted with the lion textile panel entry.

A few words should be said about the organization of the catalog. It is divided into three general areas—Near East, Egypt, and Classical—and generally the animals are arranged in those areas by their subject matter. The Egyptian section includes two animals which were probably not made in Egypt [62, 63] but which have very clear iconographical ties with Egypt. The Near Eastern section encompasses animals that were produced anywhere from the Levantine Coast to the Steppes to the Indus Valley. The Islamic material is included at the end of that section. The Classical section includes, besides those objects made in Greece and in the Roman Empire, objects from Cyprus and Crete, and one object probably from southeastern Europe which seems related to early Greek bronze work [69]. Here, and in the essays and entries, the numbers appearing in brackets refer to the catalog numbers of objects in this book. In general, the comparative literature includes only the most recent citation for that subject plus references not cited elsewhere.

The lengthy detail in the catalog descriptions in no way reflects on the quality of the photographs masterfully and sensitively produced by Nicholas C. Hlobeczy, Head of Photographic Department at the Cleveland Museum. David M. Heald, Assistant Photographer, photographed [2, 38, 42, 68, 85, 114, 116, 142, 154, 155, 163, 168, 179, 192, and 193]. Mr. Heald and Lydia Dull printed all the photographs, and Nancy Schroeder carefully and patiently kept all photographic records and material in order.

The two individuals who spent more time with the animals than anyone outside the major contributors are Frederick Hollendonner, Conservator of Objects, and Bruce Christman, Assistant Objects Conservator. They brought invaluable knowledge and expertise to our study of these objects. They answered everyone's questions with precision and patience, pointed out details of material and construction, and painstakingly carried out necessary projects of conservation. Other conservators and physical scientists consulted for specific problems were Lambertus van Zelst, Director, Research Laboratory, Museum of Fine Arts, Boston; Arthur Beale, Head Conservator, Clifford Craine, Associate Conservator of Objects, and Eugene Farrell, Senior Conservation Scientist, all at the Center for Conservation and Technical Studies of the Fogg Art Museum, Harvard University; and Leonard Gorelick and A. John Gwinnett, of the University of New York at Stony Brook.

Frances M. Saha, former Assistant in the Department of Ancient Art in Cleveland, was involved in all stages of the preliminary organization of the exhibition and in the preparation of the catalog. She also typed almost all of the entries and essays by Cleveland contributors, and proofread part of the catalog. She carefully checked and re-checked bibliographical references and aided in the organization of the list of abbreviations. Leona Miller assisted in typing as did Marlene Dee who also took part in the final organization.

Dr. Neils did far more than write entries. She also carefully read all of the Classical entries, as well as many of the Egyptian and Near Eastern ones, and made helpful and pertinent suggestions for their improvement. She prepared information for the maps of the Classical

World and assisted in proofreading most of the catalog. Her support, good humor, and willingness to deal with any task have been invaluable. Dr. Pearman also assisted in various areas of research and in proofreading.

Jo Zuppan, Associate Editor of Publications, gracefully, patiently, and tactfully carried all of the burdens involved in the copy editing of the catalog. She met every problem no matter how large or small with equal élan, and like the master of any art, she made difficult tasks look easy. Merald E. Wrolstad, Chief Editor of Publications, beautifully designed the catalog and coordinated its publication. Joseph L. Finizia, Assistant Designer, designed and prepared the maps, and the end papers.

Delbert R. Gutridge, Registrar, and Carol T. Thum, Assistant Registrar, arranged details of shipping, receiving and insurance with great efficiency and careful attention.

The Cleveland contributors appropriated far more than their fair share of the Cleveland Museum's library space for many months. This invasion was tolerated with his usual kindness and dry humor by Jack Perry Brown, Librarian. He and all of his staff were exceptionally helpful with all sorts of bibliographical details. We wish to thank especially Georgina Gy. Toth, Associate Librarian for Reference; Judith G. Frost, Associate Librarian; Bonnie Postlethwaite, Serials Librarian; Jane Farver, Photograph Librarian; and Al Habenstein and Gerald Butler.

Because of the small size and in some cases fragmentary nature of the objects in this collection, problems of installation were especially complex. No one is more capable at turning any such problem into an advantage and creating an effective installation in which each piece is allowed to speak clearly for itself than William E. Ward, Designer at the Cleveland Museum. Mr. Finizia also assisted in this area. John Yencho, Plant Operations Manager, and Ezekial Williams, Utility Foreman, provided materials and oversaw and co-ordinated gallery work. Larry Schmidt, Installation Technician, made many of the mounts for the objects.

A number of other individuals were helpful in a variety of ways: Edmund Meltzer translated two inscriptions in entries [58] and [61]; D. A. Rickards and Wallace Wendt helped to identify animal species and generally tried to keep us from making any zoological blunders; Sylvia Hurter and Thomas Solley, helped to transport objects; Norbert Schimmel arranged for the scientific analysis of the objects in entry [1]. Most of all, I wish to personally thank my husband, Jerald S. Brodkey, for pitching in whenever asked to read drafts, proofread galleys, and organize photographs, and for his unflagging support throughout the project.

A very generous grant from Bank Leu, Zurich, made through the offices of Hans Knopfli, Executive Vice President, Bank Leu Ltd. provided most of the funds for the production of the catalog. Without this support, a publication of this magnitude would not have been possible. The Cleveland showing of the exhibition was assisted by a grant from the Ohio Arts Council.

Arielle P. Kozloff

Introduction

Ask now the beasts and they shall teach thee
and the fowls of the air, and they shall tell thee. Job. 12, 7

The immediate appeal of the objects in the Leo Mildenberg collection is that they are almost entirely figures of living animals, not imaginary ones. A pacific man, a gentle man, Leo Mildenberg chose for his private pleasure ancient figures of animals in action or in repose, but no monsters, no animals attacking other animals, and no animals being put to death by man. As with every general rule, there are exceptions in the collection, but emerging from Dr. Mildenberg's ebullient optimism are the most endearing rationalizations for these exceptions. After all, the dolphin [192] might not be eating the octopus, he might be disgorging it after having found it distasteful. A little Attic cup [100] displays a boar hunt scene, but the boar is still very much alive and unharmed and may well escape.

The nearly 250 objects presented here, grouped in 199 catalog entries, were collected by a man who is both a numismatic scholar and a romantic, both gregarious and private, both generous and quite modest. Like the Biblical Job quoted above, Leo Mildenberg has lived through great adversity in his life; he has also enjoyed many of its sweeter moments. All of these facets are apparent in his animal collection from the comic quacking duck lamp [165] to the somber and introverted "Tragic Ape" [122].

It is no accident that there is a disproportionate number of lion figures in this collection. Originally it began with a few lions bought as namesakes. As every collector knows, new additions are irresistible. First the few lions became a pride; then the rest of the jungle joined them in a most natural and enchanting way.

Scholar that he is, Leo Mildenberg placed his collection before us for study so that it might teach us. There are new art forms presented here that have never been published before, as well as fine new additions to well-established types. These objects have allowed and inspired the presentation of new information that the authors hope will be of scientific, art historical, and iconographic interest and value.

Romantic that Dr. Mildenberg is, he has made his "animals" available so that we might share his pleasure in viewing them. As he often says when showing one, "Here, take it in your hands. Look at it! It speaks to you!" True, they are inanimate objects; true, even if they were living animals they could not speak to us in words. Yet when we look closely at these small works of art, they seem magically to stare right back and even to talk to us.

Magic is a very important part of what these animals convey. The most ancient ones come from a time when certain animals were thought to have magical characteristics and many types of animals were worshipped for their own special traits. The bull, for example, was admired in antiquity as the most virile and sexually potent of creatures. Sculptors and artisans made objects in the shape of bulls for ritual use. Inured in the special magical value placed on an animal by his own culture, the ancient artist naturally emphasized those traits considered

most important. In almost every art form from almost every culture the male genitalia were prominently displayed. But in Hittite art the bull's horns, which supported the heavens, were exaggerated; in Roman art, the bull's physique, like that of the classical athlete, was developed to the point that he resembled a bovine body builder. Each culture developed its own individual way of seeing the animal's natural characteristics and its "personality." And the magic that each culture felt inherent in its ritual objects is conveyed as well in the animal figures that had a more decorative or practical use. That magic is part of what speaks to us today.

Even the more "modern" animals in this collection—the Roman, Byzantine, and Islamic ones—are inheritors of visual and literary traditions rich in animal symbolism. The Islamic glass lion [44] with its open jaws and curvilinear tail bespeaking angry swishes is not the ferocious, dangerous beast of more ancient times. His forms are stylized and static. He speaks to us not of his own awesome power, but of the power and magic of lions past, of his ancestors many centuries ago.

It should be no surprise to us that the animal figures which seem the most magical are the most finely crafted ones. They may not be the most complex or ornate figures; they may be the simplest. These are the ones that were crafted by artists who had the keenest powers of observation and who translated what they saw with the greatest sensitivity. A stone weight might be rendered with only the barest surface articulation. Yet two stone ridges and four shallow drill holes are enough, when masterfully achieved, to transform this modest weight into an extraordinarily fine rendition of a sleeping duck [12 *bis*].

A tiny gold dog [155], no larger than a piece of lint, was probably a mere jewelry element. Yet, this miraculous figure shows the tremendous care that was given even the tiniest, most superficially ornamental of objects. Under magnification one can see that no detail of the face was missed, the hide was delicately hatchmarked, and rib marks were set carefully along the flanks. The result is not just one of mechanical but lifeless perfection. Because of a keen awareness and appreciation of living animals, the artist imbued this little figure with a spirit, almost a life of its own.

Much larger than the gold dog, one of the largest objects in the Mildenberg collection is a limestone lion [51], which in its own way is no less a miniature. The Egyptian recumbent lion on a flat plinth is one of many figures which seem to have been copied from a large contemporary work famous in its day. The aesthetic heritage of this limestone lion, however transcends more centuries and cultures than any other.

Nearly a thousand years before this limestone lion was made, King Amenhotep III had his sculptors carve huge guardian lions with turned heads for his temple at Soleb. His near descendant Tutankhamen had this form followed for a lion figure on top of an alabaster vessel from his tomb. The turned head continued to be popular in the Late Period, but its greatest revival was in the monumental pink granite lions of Nectanebo I. Our limestone lion appears to be a miniature of those impressive sculptures. Perhaps it was a model for the large limestone copies (now in the Louvre) produced under the reign of Nectanebo II. Another limestone model, perhaps of Nectanebo II's lions, is in the Metropolitan Museum. The influence of Amenhotep III's Soleb lions was restricted neither to Egypt nor to antiquity. A large basalt lion

(now in the Louvre) close in sculptural style to the pink granite lions but with Assyro-Persian musculature markings was found at Byblos. And the Nectanebo I lions themselves were among the booty that the Roman emperors took home with them. In Rome the lions were placed on public view. From a variety of vantage points in ancient, medieval, and Renaissance Rome, these great lions (now in the Vatican Museum) have inspired artists for centuries.

The small Mildenberg lion is but a twig on the family tree of great monumental sculptures. Yet its small size is to our advantage. We can hold it in our hands, study it closely, and contemplate it. And in its own quiet way it can teach us and it can speak to us.

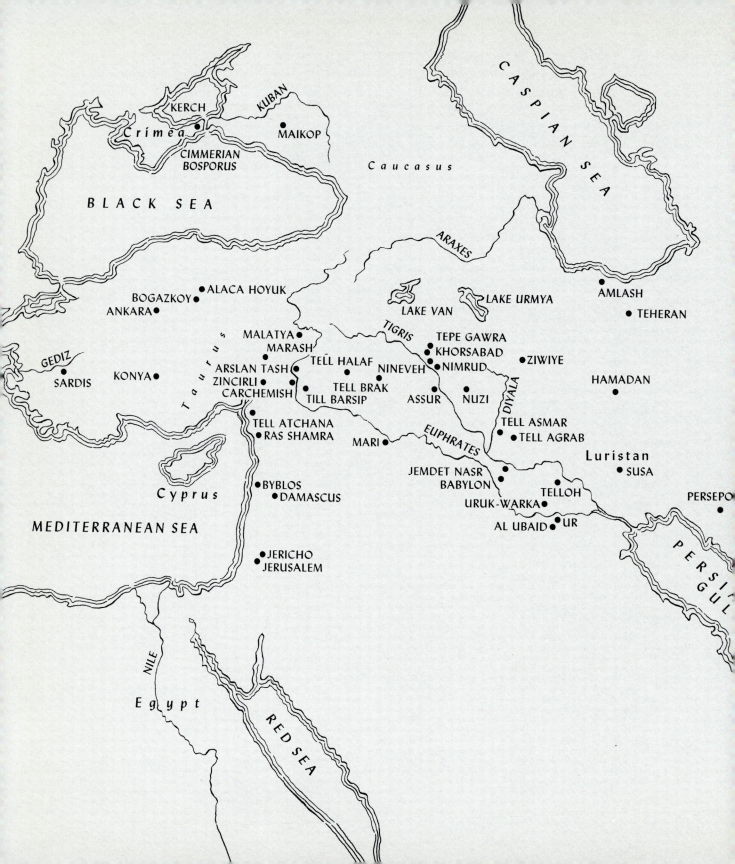

Animals from the Ancient Near East

Leo Mildenberg chose the animals for his collection on the basis of quality and on the basis of his personal response to them rather than on a desire for encyclopedic representation. This is especially true in the ancient Near Eastern section, which is outside Dr. Mildenberg's scholarly bailiwick. Compared to the Classical World, the many great ancient Near Eastern civilizations are represented by a few fine objects, objects which in some cases are unparalleled in other known representations.

The earliest group of objects [1] is of a type never before published. They are so difficult to identify that dates have been suggested for them ranging from the fourth to the first millennium BC. As far as I can judge, the latter date is based only on their supposed provenance, a location which has produced Urartian material. I feel the strongest evidence supports a very early dating. However, there is next to nothing known about the precursors of Urartu, and it will probably be many more years until careful excavations reveal anything substantial about Urartu's heritage and these stone sculptures.

These animals and the inlaid leopard from Warka [2] represent the earliest stages of stone sculpture in the round in the Near East. The Jemdet Nasr Period at the end of the fourth and beginning of the third millennium, to which this latter object dates, is named for the excavation site near Kish between the Tigris and the Euphrates rivers. The Sumerians built a sophisticated civilization there with materials imported from abroad, and complex architectural structures.

In these earliest times many Near Eastern gods were represented in animal form. By the early second millennium BC, however, in the various cultures shown here, most of the major gods were portrayed as human beings and the animals which had once represented them became their attributes and companions. Throughout the extent and history of the Near East, the lion and the bull were the two most widely used animal symbols in mythology and, therefore, in art.

In earliest Mesopotamia, religion was a source not only of salvation, but of terror. Nature could be bountiful but also had frightening, even devastating aspects which had to be appeased. The lion and the bull, powerful of both limb and lung, thus became the roarers and bellowers of thunderstorms. Inanna, the goddess of thunderstorms and rain, was sometimes represented as a lion and usually rode in a huge rumbling chariot drawn by seven roaring lions. What more terrifying representation of a thunderstorm could be drawn? As if that were not enough, the other thunder animal, the bull, was sometimes lent to Inanna.

The bull was ordinarily a symbol of An, the "father of all gods," the "Fecund Breed-Bull." His involvement in spring thunderstorms was not simply that of noisemaker. Here his fertility was graphically symbolized in the rain which engendered vegetation. Thus the bull was associated not only with thunder, but with the clouds as well and when in spring the clouds disappeared, according to one myth, the bull died.

With both bulls and lions storming through the skies, there was bound to be a clash. Indeed the combat between these two animals became a central theme in Near Eastern art. Even though this motif does not appear in the Mildenberg collection, it is a very important one, the struggle between lion and bull being a conflict between divine forces. In Mesopotamian mythology and art (particularly cylinder seals) sometimes the lion dominated, while at other times the bull triumphed.

The victory of man over beast and man's subsequent elevation in divine hierarchy is graphically illustrated by the story of the goddess Ishtar, spurned by the object of her desires, the hero Gilgamesh. At best an impetuous lady, Ishtar had previously brought great pain and suffering, if not death, to all of the men and animals she loved. When she fell in love with Gilgamesh, she promised incredible wealth to him if he would marry her. Gilgamesh, well aware of her reputation, not only refused the offer, but even insulted her. Infuriated, the goddess pried the terrible Bull of Heaven from her father, Anu. She sent the beast after Gilgamesh, and as it charged it decimated wide areas of land and hundreds of people with only its first two snorts. But Gilgamesh and his henchman Enkidu were adept at handling cattle. Like a well-experienced cowhand, Enkidu grabbed the bull's tail and twisted it, stopping the animal short while Gilgamesh slayed it with his sword.

In the mountains of Anatolia, too, the gods of third millennium BC Hatti were zoomorphic, but by the second millennium and the period of Hittite dominance, animals had become the gods' attributes or, quite literally, their vehicles, for gods were shown riding standing up on the backs of animals. During the Hittite Empire Period (1400–1200 BC), this mountain people had developed such strength and such a high degree of civilization that it challenged and even overcame Egypt's domination over much of the Near East. Hittite influence was so strong that some of its language entered Egyptian vocabulary. At that time, two of the most important sculptural symbols, both holdovers from Hattian art, were the stag and the bull (see [7, 8, 9, 10]), the one wild, the other tame. And the two man-animal relationships— the one interdependent, the other independent—are probably of no little consequence in determining the gradual selection of the stag and the bull as co-gods. Perhaps the combination of both the tamed and the untamed gave the Anatolians a more secure grasp on the world as a whole.

The importance of aesthetics in the choice of animals for representation should not be neglected. Even to modern eyes the elaborate shapes of the bull's horns and the stag's antlers have a fascination. And certainly this was the case in antiquity as well. In Hattian and in Hittite art, their bodies and legs were simplified to angular rods, mere braces for elaborately exaggerated head gear (see especially [7]). The shapes of these horns and antlers had cosmic connotations and were related both aesthetically and symbolically to the openwork cosmic disks, which like the stags, were pole-top fixtures. According to a Turkish fairy tale, the world rests on the horns of an ox and every time he shakes his head, the earth trembles—a possible reference to the frequency of earthquakes in Anatolia. This fairy tale may be reflected in the Hittite belief that the universe rested on the tips of bull's horns.

The panther and the lion were also symbols of various deities, and the lion represented the king as well. The lion's association with royalty was reinforced by the shape of his tail

which was sometimes depicted as a spiralled *kalmush,* the Hittite kings' symbol of sovereignty. In Hittite literature, the king was literally "lionized" as in the case of King Hattusilas, who "like a lion with his paw struck the city of Hassh[wa]."

The lion was the only non-monster used in Anatolia and North Syria as a portal guardian. The rather long names given by the Assyrian governor of Till Barsip (770–760 BC) to two gate lions at his palace, illustrate not only the Near Eastern reverence for this animal's power, but also its ancestry as an ancient Mesopotamian storm deity. One was called "the impetuous storm, irresistible in attack, crushing rebels, procuring that which satisfies the heart," undoubtedly a reference to the lion's terrifying aspect as the thundering beast of Inanna. The other guardian lion was named, "He who pounces on rebellion, scours the enemy, drives out evil, and lets enter good." This last phrase defines "apotropaism" which is at the heart of most animal sculptures, whether used as amulets or as decorations for vessels, weapons, and so on.

The early first-millennium Luristan tribes of the Iranian mountains are best known for their bronzes (see [13, 14]). Both their life style and their talent for metalwork are paralleled later in the first millennium by the Thracians and the Scythians who roamed from Bulgaria to northern Iran, to the Caucasus, to the Steppes. The Luristan artists represented a culture that lived close to and with its animals. Its art abstracted the animal form into decorative devices that laid the foundations for the later "animal style" art of the Thracians and Scythians (see [36, 37, 38]).

The stag and the ibex were two of the major Luristan heraldic symbols. Perhaps it was the elusiveness of these creatures that appealed to these tribal folk. Repeated attempts to breed deer and antelopes in captivity both in Mesopotamia and Egypt had failed. Yet these animals proliferated in the wild. Undoubtedly, this quality was attractive to the freedom-loving people not only for their own sake but also for the sake of the herds of horses which were their livelihood. Many of the bronzes made in Luristan were horse trappings with stag, ibex, or mouflon motives for practical or votive use. Certainly, the forms of the wild animals were intended to act magically on behalf of the domesticated horses to ensure their own proliferation as if in the wild.

The Urartian kingdom of the ninth through seventh centuries BC through its location north of Lake Van echoes Hittite styles bringing new taut contours and highly stylized details of musculature borrowed from Assyria to the more naturalistic art of the Hittite Empire Period. The tiny four-lion team [20], probably the bead from a necklace, is a liaison between the art of Assyria and the Hittite Empire through Urartu. And like so many of the objects in the Mildenberg collection, the "bead" is also a liaison in miniature to the monumental architectural sculptures of its era, cousins to the Till Barsip pair.

Although Urartian objects (see [17–21]) have been filtering into museum and private collections for years, this mountain kingdom is only imperfectly understood. On the other hand, its successor to the east and south, the Achaemenian Empire is perhaps the best known of all the ancient Near Eastern civilizations.

The royal palace complexes at Persepolis and Pasargadae, among the greatest ancient structures of their kind extant, give us some idea in their detailed relief sculpture of the wealth of the Achaemenian Empire (559–338 BC). At least two of the items of jewelry repre-

sented on the stone walls at Persepolis exist in their actual form in the Mildenberg collection, i.e., the striding lion bracteate [31] and the silver bracelets [29]. The chalcedony recumbent bull [28] itself recalls the massive bull protome column capitals from the same site. And another semiprecious stone piece—the springing leopard finial [32], a classical motif in Persian form—reveals the contact between East and West. Whereas in the previous centuries Near Eastern art had influenced the sculpture and drawing of Egypt and the Mediterranean world, in this small leopard we begin to see a reversal of influence culminating in Alexander the Great's conquest of the Persian Empire.

The later glass objects included in this section reflect their ancient Near Eastern heritage. The Islamic glass roaring lion [44] especially recalls its ancient ancestors on the bronze Urartian belt [19] and the gold Achaemenian bracteates [30, 31]. Certainly the Islamic glassmaker knew neither of these objects yet the traditions were so deeply engrained that when he wished to create an imposing guardian figure for the contents of the glass vessel, he chose none other than the roaring, open-mouthed lion with its serpentine tail held high like a royal scepter. APK

1 *Group of Animal Sculptures with Intaglios*

Dickite stone. Anatolia or Iran, said to have been
found north of Lake Van, Neolithic Period, late 4th
millennium BC.

(a) H. 5.5 cm.; W. 2.5 cm.; L. 9.8 cm.
(b) H. 5.1 cm.; W. 2.3 cm.; L. 8.5 cm.
(c) H. 5.6 cm.; W. 4.1 cm.; L. 8.5 cm.
(d) H. 5.1 cm.; W. 3.7 cm.; L. 8.1 cm.
(e) H. 8.6 cm.; W. 3.2 cm.; L. 12.2 cm.
(f) H. 6.1 cm.; W. 3.3 cm.; L. 10.6 cm.
(g) H. 3.2 cm.; W. 4.3 cm.; L. 5.3 cm.
(h) H. 1.8 cm.; W. 2.2 cm.; L. 3.4 cm.
(i) H. 2.5 cm.; W. 2.2 cm.; L. 4.8 cm.
(j) H. 12.5 cm.; W. 5.6 cm.; L. 22 cm.
(k) H. 6.2 cm.; W. 4 cm.; L. 12.5 cm.
(l) H. 7 cm.; W. 2.9 cm.; L. 4.8 cm.
(m) H. 2.8 cm.; W. 1.2 cm.; L. 5.2 cm.
(n) H. 3.2 cm.; Diam. 1.8 cm.
(o) H. 5.1 cm.; Diam. 2 cm.

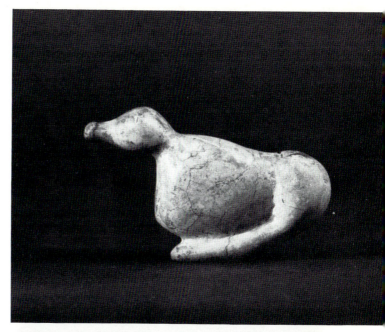

A group of simply shaped animal forms with deeply
carved intaglios on their sides and undersides. The
stone, a clay mineral called dickite, has a Mohs hardness
between 2 and 3, and is native to the Caspian Sea area.
The surfaces of all pieces show spalling or superficial
cracking due to long burial.

The intaglios in both human and animal form
are carved in varying depths. Heads, shoulders, and
haunches are generally deeper; legs and paws, shallower.
Heads, paws, shoulders, and haunches have been cut by
hand drilling. Drilled areas have been connected by
grooving. This grooving has caused the intaglios to be
undercut in some spots as if they were meant to hold
inlays. The intaglios have an average depth of 3.5 mm.
compared to 2 mm. of Jemdet Nasr seals. The direction
that the intaglio symbol faces is indicated by an arrow.

1a with impression

(a) Galloping dog or wolf; intaglio under foot—bird in
flight (?) (←). Long-nosed dog with hind legs formed as
one mass as they reach forward in airborne phase of
gallop. The small ears are barely articulated; eyes and
nostrils are shallow drill holes. The stone is reddish
throughout the torso and legs, gray to black on the head,
rump, and feet.

Condition: Deep crack runs from side to side through
foot.

9

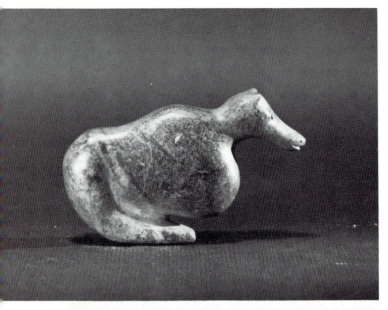

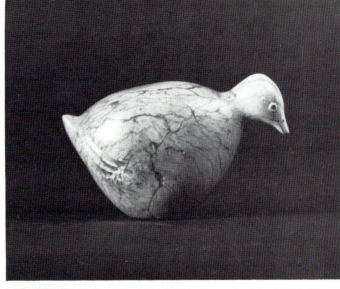

1b with impression

1c with impression

(b) Galloping fox; intaglio under foot—flying duck (←). Similar to (a) above. Ears stand higher, drilling of eyes and nostrils is deeper. Mouth is a deep horizontal cut. The eyes are drilled into a barely articulated ridge which gives them a hooded appearance. A deep groove divides the hind legs at the hocks. The stone is mottled gray on the right side and patchy blood red on the left.

Condition: A deep crack runs through the left third of the head down the spine around the left haunch and through the left side. Three losses in the left shoulder.

(c) Nesting quail; intaglio underneath—bent human figure (→). A lemon-shaped body in pearl gray stone striated with dark gray. The quail's eyes are deeply drilled and encircled by a high ridge. The nostrils are shallow drillings, the mouth a shallow scratch along the beak. Three broad grooves suggest the primary feathers of folded wings on either side of the upturned tail. The bottom of the bird's breast has been flattened to serve as the field for the intaglio.

Condition: A circular patch has been glued onto the back left side of the neck. A loss occurred on the left side. A deep crack runs through the width of the intaglio.

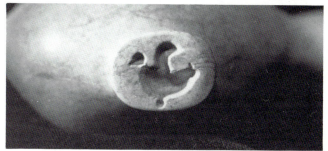

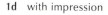
1d with impression

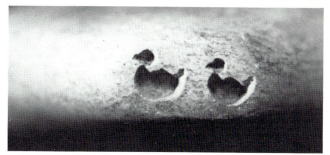
1e with impression

(d) Nesting quail; intaglio under foot—flying quail (←). Similar to (c) except that the side grooves extend along the tail. A truncated cone shape extends from the breast and serves as the field for the seal. The mouth is not a single continuous scratch, but one on either side of the beak. The stone ranges from mostly pearl gray on the right side to rust on the left.

Condition: Two deep cracks run through the right tail section.

(e) Nesting quail; intaglio underneath—two swimming ducks (←). The body is a flattened mace head shape. The head has the same relative proportions and handling of details as (c) above, but here the entire eye structure is in sunk relief. There is no articulation of feathers. The stone is light gray splotched with rust and dark gray.

Condition: Superficial crack on right side.

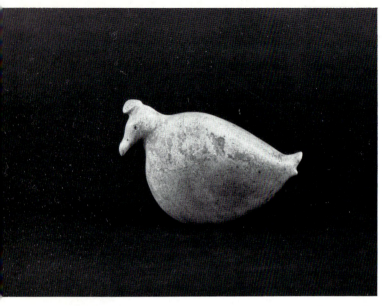

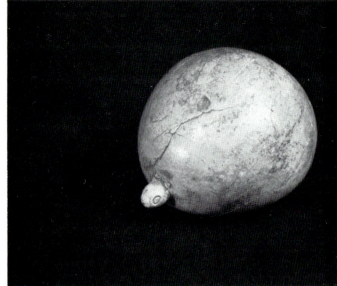

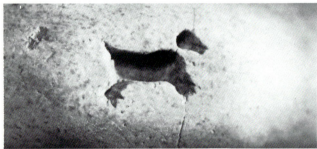

1f with impression

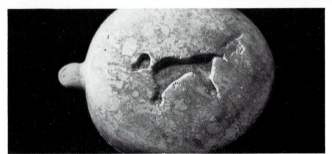

1g with impression

(f) Nesting guinea fowl; intaglio underneath—bear, or short-tailed, heavily clawed canid (→). Shape is a squatter version of (e). The head is smaller in proportion to its body than (c), (d), or (e), and the beak more pronounced and crooked. A mushroom-shaped comb crowns the head. The tail is forked. The eyes are deeply drilled with an incision partially encircling each drill hole. As in (c) and (e), the breast is flattened to receive the intaglio. The stone is a fairly even light rust color.

Condition: Hole on upper left side. Vertical crack behind center of body.

(g) Large turtle; intaglio on bottom similar to (f) (←). Hemisphere with projecting neck and tiny head. The eyes are scratched ovals; the mouth is a scratched curve. The stone is a muddy gray color.

Condition: Crack through right side and over top.

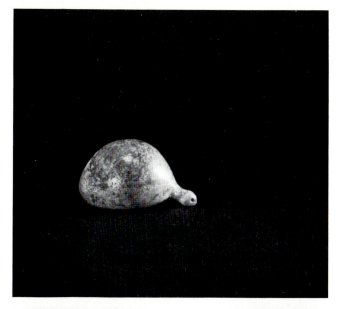

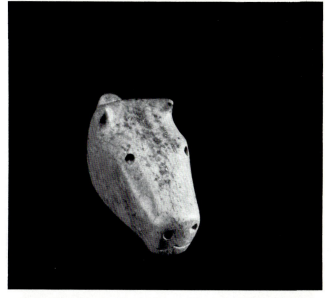

1h with impression

1i with impression

(h) Small turtle; intaglio underneath—leaping stag (←). Similar to (g), but head and neck stretch at a downward angle from the body. The pearl gray stone has deep rust veining. Eyes drilled; mouth, one short horizontal scratch.

Condition: Deep crack at right rear.

(i) Head of a bear; intaglio underneath—bent human figure (→). Flat-sided head with pierced tang for suspension projecting from back of head. Ears and nostrils are deeply drilled. The mouth peaks in the front indicating the split upper lip of a dog or bear rather than a hooved animal. (Note, however, that the lip of (b) and (l) are not split.) The ears are short and pointed. Pearl gray stone has red veining as a blaze on the forehead and nose.

Condition: Intact.

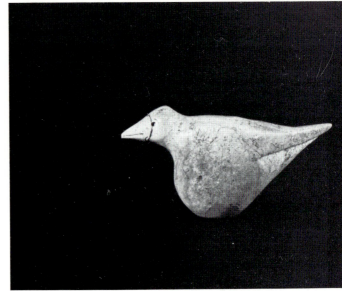

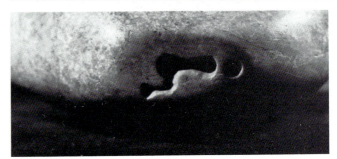

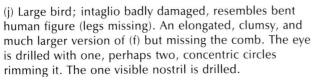

1j with impression

1k with impression

(j) Large bird; intaglio badly damaged, resembles bent human figure (legs missing). An elongated, clumsy, and much larger version of (f) but missing the comb. The eye is drilled with one, perhaps two, concentric circles rimming it. The one visible nostril is drilled.

Condition: Very poor. Right side in worse condition than left—either very badly weathered or damaged in fire. Cracks on right side, middle of back, beak, and left neck reglued.

(k) Sparrow (?); intaglio underneath—bent human figure (→). The body is somewhat mace head shaped like (e), though the back is broader in proportion. Primary feathers are long and the tail pointed. The head terminates in a conical beak. The nostrils and eyes are drilled. A linear crescent is scratched above each eye. The stone is pinkish-gray spotted with blood red.

Condition: Tip of beak crumbling. Major crack around beak and another through right side of head. Deep crack near base of tail and over back on right side.

(l) Head of a canid, equid, or bovid on a truncated base; intaglio underneath—crowned human figure with three circles (→); intaglio on proper right—bouquet tree; intaglio on proper left—recumbent stag with notched tail (→). The head is close to an elongated version of a bear head, but without the split upper lip. The eyes are drilled into mounds similar to (b). The head sits on top of and is part of a structure resembling a horse's neck. However, the structure emerges from the animal's cheeks rather than from the back of the head as in nature. The stone is pearl gray to light rust.

Condition: Loss at proper left rear corner of base.

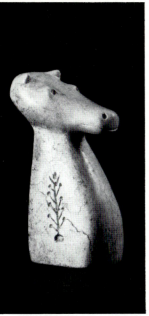
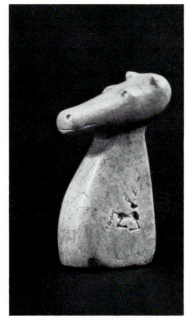
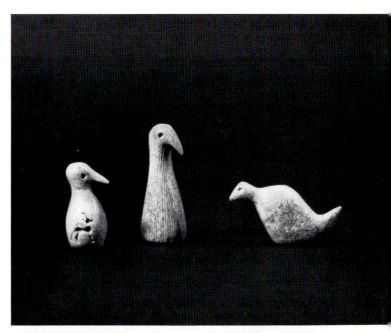

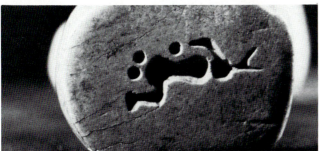
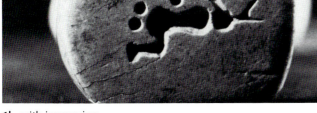
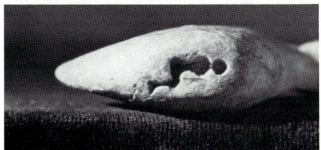

1l with impression

(m) Snail or worm (?); intaglio underneath—bent human figure (→). The head with a pointed snout emerges from an upper corner of the nearly rectangular body. The short tail curls up from the diagonal corner. The eyes are drilled; the mouth is a scratch. The stone is gray with red at the tip of the tail.

Condition: Snout worn and crumbling.

(n) Bird protome; intaglio on bottom—bent human figure (→); intaglio on proper right side—antelope (white oryx?) (→). The body is shaped like a squat bowling pin. The eyes are drilled. The beak is long and pointed with a scratched mouth and no nostrils. The stone is buff to pink on the right; gray on the left.

Condition: Circular crack on left side.

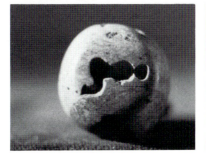
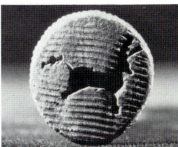

Above: **1n 1o 1m**
Below: Impressions for **1m**

1n 1o

15

(o) Bird protome; intaglio on bottom—long-eared quadruped with notched tail (→). Similar to (m) above, but the body is more elongated. The beak is curved. The body and the bottom of the piece are patterned with long, narrow, contiguous grooves running nearly the length of the object. The stone is gray with a patch of rust color on the back.

Condition: Intact. Surface worn.

This is an extraordinary group of objects probably deriving from a culture that is not yet known. The fact that these small stone animals are difficult to identify and, indeed, make up part of a unique find has caused some scholars to doubt their authenticity.

The approach to the sculptures suggests a Neolithic aesthetic. Each piece is so simply sculptured that the original rock or large pebble retains much of its integrity as a natural form. In fact, the shape of each animal and even the type of animal represented seem to have been determined by the original shape and coloration of the natural stone. Very little detail has been added and that by hand and rotary drilling and grooving with a stone tool. This lack of surface ornamentation is also indicative of Neolithic work. Some general comparisons can be made along these lines with earliest Elamite sculptures.

The sculptural style of the Mildenberg birds (c, d, e, f) is most similar to a 10.2 cm. tall jade bird in the Nelson Gallery-Atkins Museum in Kansas City. Bought on the open art market, this piece is dated Chinese Neolithic Period. The bird forms are also reminiscent of predynastic Egyptian stone vessels such as two in the British Museum (35,306 and 36,355) and one in the Louvre (E27201).

The bear head (i) and another, broader one on loan to The Cleveland Museum of Art are reminiscent of a Shang or Choú Period jade bear in the Fogg Art Museum, Cambridge, Massachusetts. Sherman Lee describes the work on the Fogg sculpture as a recollection of Neolithic techniques. The head is blocky, the eyes drilled, and the front of the snout flat, with the mouth a single slash like those of the galloping canids (a, b).

Perhaps the closest parallels in early Near Eastern sculpture come from the British excavations at Tell Brak. A large number of amulets and small sculptures with the same, very compact forms as the Mildenberg animals were found in the late fourth-millennium Eye-Temple. Often the eyes are drilled in the same manner as well. Mallowan

has interpreted these figures as magical token offerings. Similar compact sculptures were found in the early layers at Susa, and a number of those are pierced for suspension. The torso of a bull with a pierced lug instead of a head extending from its neck would seem to be a corollary to the bear heads discussed here. An Ubaid animal head pendant with lug attachment was found at Tepe Gawra.

The galloping canids' gait is depicted in a mode which precedes the "flying gallop" of the second millennium and onwards. Figures of dog-like creatures with their hind legs reaching forward exist on painted pottery from the early levels at Susa. Susian cylinder seals contain antelope protomes, the bodies of which seem to be grooved like the bird protomes (n) and (o).

The canine-equine-bovine protome (l) is problematic in that it most closely resembles the horse—which did not enter the Near East in large numbers until the beginning of the second millennium BC, although it was known somewhat in the third millennium. However, all of the forms presented here are so schematic that one has to allow room for a number of possible identifications for this piece from canid to bear to calf.

The intaglio designs are also very simple in conception. All but one is a single image. The recumbent stag with legs oddly spaced at a distance from the torso and antelopes with long, notched tails appear at Susa as does the bouquet tree. A similar plant with alternating branches occurs on a cylinder seal from Warka. In the second millennium the bouquet tree has symmetrical branches. The bent human figure symbol, which appears frequently in the group studied, resembles the burial position of the late fourth–early third millennia BC. This symbol exists in a slightly more complex form in sign no. 25 of the Urartian hieroglyphic alphabet compiled by Barnett. This latter symbol has an arm which the Mildenberg examples lack. Two of the intaglio images on similar unpublished objects in the Norbert Schimmel collection are also related to Barnett's list. One is an animal head similar to Barnett's nos. 32 and 39; the other is a winged quadruped similar to but simpler than Barnett's no. 37. Although the only winged quadrupeds yet known from the fourth millennium BC are lions, it is possible that the "wing" here is really a sheaf of grain as in early seals of bulls and antelopes with grain above their backs. The flying duck symbol (b) and quail symbol (d) find parallels in the archaic seal impressions from Ur.

Barnett suggests that the Urartian language was written boustrophedon, always reading inwards, towards the signs representing human or animal faces. The symbols under discussion are almost equally divided between those oriented left and those oriented right. Even if the "bent

human figure" is misinterpreted, clearly the symbol's orientation varies. Thus, if these symbols are a rudimentary written language, they could be read from either direction. Barnett feels that the earliest date for the Urartian alphabet could be pushed back to the fourteenth century BC. He suggests several possibilities for the origin of the language, one of them being the revival of an archaic script. Perhaps the signs represented here are that script.

All of the stone figures shown here are comfortable to hold in the hand and use as stamps; they do not, however, show signs of wear around the sharp edges of the intaglio figures. Two of the animals in this group (l) and (n) have intaglios on their sides, an inconvenient placement for use as stamp seals. Both bear heads known to me are equipped for suspension. Another object, obviously of the same group, now on the art market is similarly equipped for suspension, but is unique among the pieces studied in that it does not bear an intaglio. The implication seems to be that these objects are amuletic and were not intended for use as seals.

Several objects of this group from both the Mildenberg collection and the Norbert Schimmel collection were studied by A. John Gwinnett and Leonard Gorelick (University of New York at Stony Brook), with the consultation of Don Lindsley (Geochemist and Professor in the Department of Earth and Space Sciences at Stony Brook), and George Harlow (Curator of Mineralogy at the American Museum of Natural History). The following is extracted from a letter of Gwinnett and Gorelick to Norbert Schimmel on 29 December 1980:

In the case of your stone artifacts, we limited our functional analysis of drilling to the eyes of several of the artifacts We found that the pattern produced in the drilling of the eyes could not have been done by the two most likely drills, namely a contemporary steel bur or a green stone such as used by contemporary craftsmen and dentists. On the other hand, they could have been made, as we showed experimentally, by flint drills. This, of course, is strongly suggestive that it was made in ancient times, providing one leaves an open mind to the possibility that a contemporary forger had the knowledge and skill to fashion, haft, and use flint drills. This is possible albeit unlikely, particularly when considered with the additional evidence that became manifest during our investigation. This evidence was:

1. All of the pieces had signs of varying degrees of weathering, ranging from cracking, to spalling to erosion. All of the pieces had polishing lines which were clearly done by hand, as was evident under microscopy. The SEM [scanning electron microphotos] showed, without any question, that the cracking took place after the hand polishing . . . [According to Lindsley's report, "The cracks definitely offset many of the polishing lines and scratches . . ."].

2. Since it is possible that weathering can be hastened artificially by a forger, an additional and unanticipated part of our investigation included our own experiments in such stressing. We were able to do this because Professor Lindsley had identified the stone as the clay mineral "dickite" by means of x-ray diffraction and refractive index. We were able to further identify the stone by x-ray energy dispersive analysis and scanning electron microscopy. We also confirmed that a sample of dickite provided for us by Professor George Harlow at the American Museum of Natural History, was also dickite by running similar tests on it. Using this sample, we then stressed the piece by soaking it in [sea] water for thirty days, then freezing it, thawing it, and heating it [up to 400°]. No cracking or other weather signs appeared. This confirmed Professor Lindsley's opinion that dickite, a clay mineral, would be very difficult to weather artificially by a contemporary forger.

3. A third area of information was provided by Professor Lindsley. A computerized search of the literature revealed that the clay mineral dickite is known to come from the area, both east and west, of the Caspian Sea.

In conclusion, the great bulk of stylistic evidence points to a Neolithic or late fourth-millennium BC date. These small sculptures show the same characteristics of style that one sees in Neolithic cultures from Egypt to the Near East to the Orient. The style of the intaglios including such details as the long, notched tails of two animals and the asymmetrical branches of the bouquet tree are consistent with fourth-millennium style. It is conceivable that these signs are examples of a very early pictorial script. All evidence of the techniques of manufacture so far obtained are consistent with very early techniques. The present physical condition is consistent with a long period of burial. APK

Bibliography: Unpublished.

Comparative literature: Leonard Gorelick and A. John Gwinnett, "Ancient Seals and Modern Science," *Expedition* XXI, no. 3 (Winter 1978) 38–47; Leonard Gorelick and A. John Gwinnett, "Ancient Lapidary," *Expedition* XXII no. 2 (Fall 1979) 17–32; Pierre Amiet, *Elam* (Auvers-sur-Oise: Centre National de la Recherche Scientifique, 1966) pp. 110-127, figs. 65–90; Sherman E. Lee, *A History of Far Eastern Art* (New York: Harry N. Abrams, 1973) figs. 10, 19; Max E. Mallowan, "Excavations at Brak and Chagar Bazar," *Iraq* IX (1957) 40–42 pls. VII–XVI; Louis Le Breton, "The Early Periods at Susa, Mesopotamian Relations," *Iraq* XIX (1957) 116, figs. 31–32, 35; S. R. K. Glanville, "Egyptian Theriomorphic Vessels in the British Museum," *JEA* XII (1926) 52 ff., pl. XII; Christiane Desroches-Noblecourt, "Quatre objets protodynastiques provenant d'un 'trésor' funéraire," *La Revue du Louvre* II (1979) 108–110, figs. 1, 5;

Ping-ti Ho, *The Cradle of the East* (Hong Kong: Chinese University Publications Office, 1975) p. 149; Beatrice Laura Goff, *Symbols of Prehistoric Mesopotamia* (New Haven: Yale University Press, 1963) figs. 230, 254–256, 274; Pierre Amiet, *Glyptique susienne*, 2 vols., Mémoires de la délégation archéologique en Iran, XLIII (Paris: Paul Geuthner, 1972) II, pl. 103, no. 953, pl. 111, no. 1032, pl. 175, no. 2014; Richard D. Barnett, "The Hieroglyphic Writing of Urartu," in K. Bittel et al., eds., *Anatolian Studies Presented to Hans Gustav Güterbock on the Occasion of His 65th Birthday* (Istanbul: Nederlands Historisch-Archaeologisch Instituut in Het Nabije Oosten, 1974) pp. 43–55, pls. XI–XIII; L. Legrain, *Ur Excavations, III, Archaic Seal Impressions*, Publications of the Joint Expedition of the British Museum and of the University Museum, University of Pennsylvania, Philadelphia, to Mesopotamia (Oxford: Oxford University Press, 1936) pl. 36.

2 Rampant Leopard

Limestone inlaid with Egyptian blue. Warka,
Proto-Literate Period c–d, end of 4th millennium BC.
H. 5.8 cm.; W. 3.5 cm.; L. 4.1 cm.

A leopard preserved to mid-section in heraldic rampant pose, head turned to right. The effect of partially open jaws is attained by a single deep drilling between the two sets of canine teeth and a shallower drilling at each corner of the mouth. The eyes are drilled 0.5 cm. deep. The leopard's spots are formed by two configurations of drill holes. On the head and narrow leg portions the spots are symmetrically arranged single drill holes. Over the rest of the surface the spots are shaped like pairs of facing crescents arranged in vertical rows. Each crescent is formed by three (rarely two or four) contiguous shallow drillings.

Only one inlay, which looks like a beauty mark on the right cheek, remains intact. This inlay was analyzed with energy dispersive x-ray fluorescence by Dr. Lambertus van Zelst (Director, Research Laboratory, Museum of Fine Arts, Boston) and found to be the frit material, Egyptian blue. Blue inlays on objects of similar date have characteristically been called lapis lazuli, often without benefit of analytical testing. If this leopard is of the date suggested, the earliest location and occurrence of Egyptian blue must be recognized as fourth-millennium BC Mesopotamia.

Two of four other drillings are illustrated. Because of their grooved contours and the wear around their edges, they appear to be ancient. They are of two diameters, 0.5 cm. and 0.2 cm. The wider drilling pierces the back below the withers at a 90° angle to the surface and to a depth of 1.1 cm. Slightly above and to the right a drill of the smaller diameter passed at a 30° angle to the surface through the first drilling to a depth of 1.6 cm. The two holes form an X

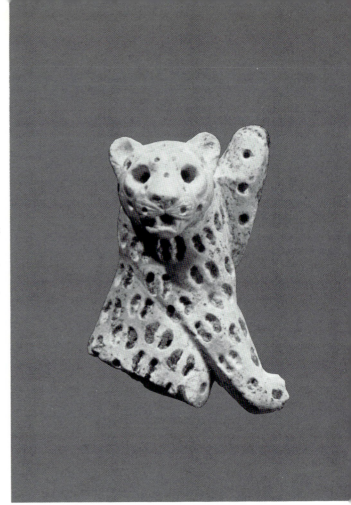

2 See also frontispiece

2 underside

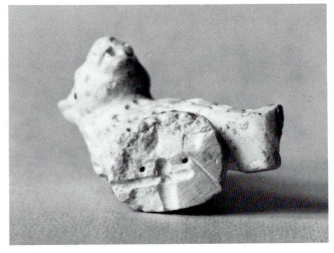

on the interior of the piece. The break at the leopard's mid-section occurred along the axes of the other two drillings. The 0.5 cm. drill enters from the left side of the leopard and ends at the break; the 0.2 cm. drill enters from the animal's back crossing the first drilling and continuing to a depth of 2.2 cm.

The animal represented may be the Sinai leopard which still roams the Levant. The closest parallel is a recumbent leopard found at Uruk-Warka in Iraq and dated to Proto-literate "c" or "d." This piece, now in the Iraq Museum, Baghdad, has been identified as the handle or knob for a cylinder seal. The function of the Mildenberg leopard is less easily surmised.

The break at the bottom of the piece appears to have been an accidental one along the axes of the ancient drill holes. Most of the bull and ram figures of this type and date were suspended as amulets and the drillings in this leopard suggest a similar use. Nevertheless, with his legs extended, the leopard does not have the usual compact shape of an amulet. One cannot help but compare the pose with the much later lion vessels of Leontopolis, Egypt.

Condition: As noted throughout essay above. APK

Bibliography: Unpublished.

Comparative literature: Bill Clark, "Animals of the Bible," *Biblical Archaeology Review* VII (January/February 1981) 26; Manfred Robert Behm-Blancke, *Das Tierbild in der altmesopotamischen Rundplastik*, Deutsches Archäologishes Institut, Abteilung Baghdad: Baghdader Forschungen, I (Mainz: Philipp von Zabern, 1979) esp. pp. 9–10, pl. 73, no. 30, pl. 7, no. 28; E. Douglas van Buren, *The Fauna of Ancient Mesopotamia as Represented in Art*, Analecta Orientalia XVIII (Rome: Pontificium Institutum Biblicum, 1939) pp. 10–12, pl. 1, fig. 5; John D. Cooney, "The Lions of Leontopolis," *Brooklyn Museum Bulletin* XV, no. 2 (Winter 1954) 17–30.

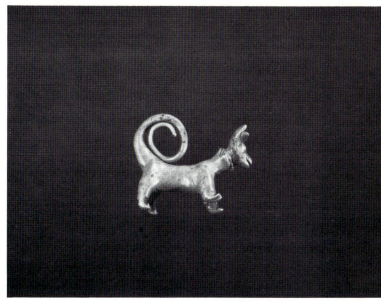

3 See also colorplate XVII

3 *Long-Tailed Dog Amulet*

Silver, solid, hand-worked. Probably Elamite, end of 4th millennium BC but possibly later. H. 2.4 cm.; W. 1 cm.; L. 3.1 cm.

A canine with bat ears wears a collar and holds his tail coiled like a hunting horn. The collar is deeply gashed perhaps indicating twisted rope. The tail, very thick at the base, is plastically the continuation of the muscular haunch. Details of the face are scantily chased, enough to impart a ferocious expression to the animal. The mouth is an open slit. The legs are rather short with barely indicated paws. A tubular hole runs through the length of the body, indicating that the piece was probably worn as an amulet.

The combination of collar and coiled tail is reminiscent of a Persian bronze dog in the Adam collection and of a similar late Hittite one from Malatya in central Anatolia. But the same voluminous curling tail as well as a similar collar appear very early in a gold dog pendant (1.3 × 1.4 cm.) excavated in the southern acropolis of Susa and dating to the end of the fourth millennium. The Susian dog is made by rolling up and pinching a gold sheet ("coquille" technique). The tail of the Mildenberg dog shows some evidence of having been formed the same way.

Condition: Intact. Some surface wear. A diagonal cut on the face. PV

Bibliography: Unpublished.

Comparative literature: Moorey, *Adam Collection*, p. 172, no. 165; Helmuth Th. Bossert, *Altanatolien* (Berlin: Ernst Wasmuth, 1942) p. 187, nos. 783-785; Pierre Amiet, *Elam* (Auvers-sur-Oise: Centre National de la Recherche Scientifique, 1966) p. 69, fig. 30, cf. fig. 89, p. 127.

4 *Frog Bead for a Collar*

Hematite. Mesopotamia, 3rd millennium BC.
H. 1.7 cm.; W. 2.1 cm.; L. 2.9 cm.

This hematite frog is almost almond shaped, and a median line runs along the middle of its back. The thighs and hind legs are gathered up like tongs. The forelegs are pierced to form two loops; the frog must have been threaded along with beads to form a collar. Frog representations on Jemdet Nasr "brocade style" seals have similar compact outlines and median lines. Frog figures on cylinder seals from excavations at Ur have splayed legs.

In Mesopotamia as in Egypt the frog was a symbol of fertility and was used extensively as an amulet. When made of hematite, it supposedly endowed its bearer with the ability to destroy his enemies. Hematite frogs were also used as weights in the first half of the third millennium BC; examples are in the British Museum.

The frog played a part in divination and occasionally was a substitute victim in sacrifices. Associated with Ea, the goddess of the underworld waters, it is found in tombs around the neck of the dead or, when of a larger scale as at Kish, supporting a drinking cup. In both instances it was supposed to help the soul after death in crossing a voracious, all-devouring river at the entrance of the underworld.

Condition: Intact excepting a few minor scratches and chips on the hematite. PV

Bibliography: Unpublished.

Comparative literature: M. Weber, "Frosch," *Reallexikon für Antike und Christentum* VIII (Stuttgart: Anton Hiersemann, 1972) cols. 524, 529, 530; L. Legrain, *Ur Excavations*, vol. III: *Archaic Seal-Impressions*, Publications of the Joint Expedition of the British Museum and of the University Museum, University of Pennsylvania, Philadelphia, to Mesopotamia (Oxford: Oxford University Press, 1936) pl. 15, nos. 282-283; H. R. Hall, "Babylonian and Egyptian Accessions," *BMQ* III (1928 – 1929) 12-13, pl. IV; L. Ch. Watelin and S. Langdon, *Excavations at Kish* (Paris: Paul Geuthner, 1934) pl. XXI; Denise Schmandt-Besserat and S. M. Alexander, *The First Civilization: The Legacy of Sumer*, exhib. cat. (Austin: The University Art Museum, The University of Texas, 1975) p. 44, no. 70.

4

5

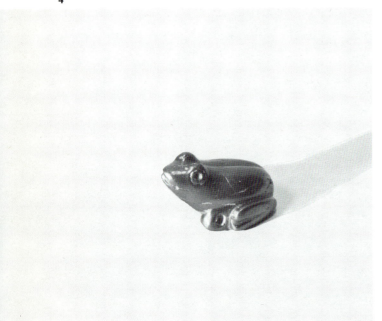

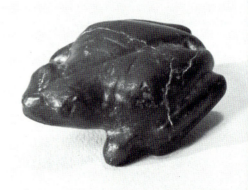

5 Frog

Steatite. Mesopotamia, 3rd millennium BC. H. 2 cm.; W. 3.8 cm.; L. 5.4 cm.

This steatite frog belongs to the same category of prophylactic objects as the hematite frog bead [4], although it is bigger and some of its details are more clearly indicated. A few oblique, incised lines branch off from the lengthwise median line. The protruding forelegs are pierced for suspension. A third hole passes through the base of the spine. The hind legs are tucked under the sides of the belly like prongs. Seen from above the frog resembles the head of a snake.

Condition: Some pitting of surface. Three cracks on the frog's back, one across the face. PV

Bibliography: Unpublished.

Comparative literature: See [4].

6 Fledgling Ostrich (?)

Buff terracotta. Indus Valley or Western Asia, 3rd millennium BC. H. 4.8 cm.; W. 2.8 cm.; L. 4.9 cm.

The large, high-backed body and the long neck and legs are those of an ostrich, but the tiny incipient wings and large head suggest the young of that species. The modeling is so simple, however, that it could be argued to be the fledgling of many types of bird. The legs are formed as a single column flared at the base. The underside of the foot is slightly concave. The eyes are simple deep punctures.

By far the largest number of similar terracotta birds come from Harappa and Mohenjo-daro, in the Indus Valley, although examples are known from Iran, Iraq, and Crete as well. The most common type has been identified by Mackay as the dove sacred to the great Sumerian goddess Ninkharsag. In both the Indus Valley and Crete terracotta doves have been found in context with mother-goddess figures. The eyes of the Indus Valley examples are generally pellets, sometimes punctured. The simple punctate eyes of the Mildenberg ostrich are seen in the late fourth – third millennium BC terracottas from Tepe Gawra but also occur less frequently on Mohenjo-daro animals.

Condition: Break through neck repaired. Tip of beak worn. APK

Bibliography: Unpublished.

Comparative literature: Madho Sarup Vats, *Excavations at Harappa* (Delhi: Manager of Publications, 1940) pl. LXXVIII, nos. 1-15; E. J. H. Mackay, *Further Excavations at Mohenjo-daro* (Delhi: Manager of Publications, 1938) I, 295-296, II, pl. LXXVII, nos. 4-12; Rai Govind Chandra, *Studies of Indus Valley Terracottas* (Sonarpura, Varanasi: Shri V. S. Singh, 1973) pp. 39-43, figs. 92, 93, 96, 101, 106; André Parrot, *Le Temple d'Ishtar. Mission archéologique de Mari* I (Paris: Paul Geuthner, 1956) 206, pl. LXIX, no. 1111; E. A. Speiser, *Excavations at Tepe Gawra* I (Philadelphia: University of Pennsylvania Press, 1935) pl. LXXVII, nos. 3, 7, 8; Sir John Marshall, ed., *Mohenjo-daro and the Indus Civilization* (London: Arthur Probsthain, 1931) III, pl. XCVI, nos. 2, 11, 12, 17.

6

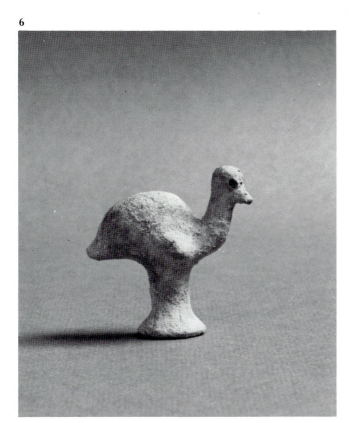

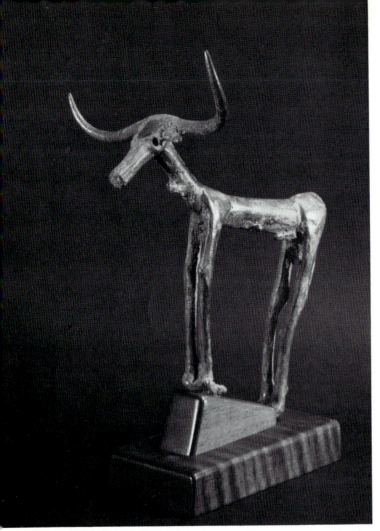

7 See also front cover

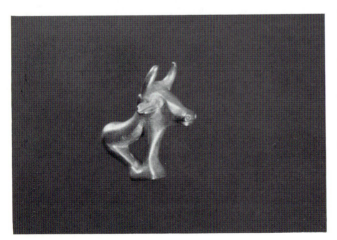

7 Bull from a Devotional Standard

Bronze, solid cast, inlaid with electrum. Hattian, last quarter of 3rd millennium BC. H. 13.5 cm.; L. 14.5 cm.; W. of horns 12 cm.

The Mildenberg bull is a masterful balance of naturalistic art and geometrized form. To modern eyes it conjures up the approach to animals of the sculptor Gonzalez and of the painter Dubuffet. The wide horns turned upward are lyre-shaped. The muzzle is characteristically long and tubular as is the neck, with its tuft of hair underneath, and the belly, with its sharply delineated phallus. Inset on the forehead is a triangular piece of electrum. The rump is raised.

The bull was held on a standard by a tenon cast with the animal of which a 1 cm. long ledge remains attached behind the forefeet and some traces in front of the hind feet. The attachment was *tau* shaped, ending in a point to be inserted in a canopy support or other piece of ritual furniture. The two pairs of legs, bent at the knees and hocks, converge on their support, giving the impression that this long-legged bull with shaking knees is emulating his co-god — the stag — in readiness to jump. With the platform aslant, as in the few intact examples extant, the animal would have appeared poised as at the brink of a ski jump.

Ritual standards topped by bulls and stags were probably used to decorate cult furniture or shrines. The bull was the attribute of the later Hittite Weather God and must have had a similar identification in Hattian times. In Hittite mythology the bull supported the universe on the tips of his horns.

The eyes are more deeply hollow than in other examples of bulls on standards. On similar bronze bulls excavated in the tombs of Alaca-Höyük, east of Ankara, electrum was used as inlays of dots or stripes on the body.

Condition: Bull figure intact excepting asymmetrically bent right horn. Supporting ledge broken and mostly lost. Superb dark green patina. PV

Bibliography: Unpublished.

Comparative literature: Ekrem Akurgal, *The Art of the Hittites* (London: Thames and Hudson, 1962) pp. 307-308, pls. 1-6; H. Z. Koşay, *Türk Tarih Kurumu tarafindan yaplin Alaca Höyük kuzisi* (Ankara: Türk Tarih Kurumu Basimevi, 1951) pp. 161, 167, pls. CL, CLXII, CXXII, CXXX; H. Z. Koşay, *Alacahöyuk* (Ankara: Turkish press, broadcasting and tourist dept. 194-?) pls. 11, 26.

8 See also colorplate III

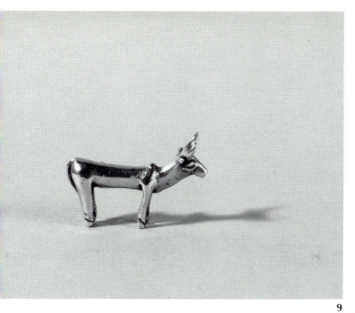

Bibliography: Unpublished.

Comparative literature: Jessica Rawson, ed., Animals in Art (London: British Museum Publications, 1977) p. 4, fig. 5; Antike Bronzen, Liste 14, commercial exhib. cat. (Zurich: Arete Galerie für antike Kunst, n.d.) no. 20.

9 Standing Bull Pendant

Electrum. Hattian or Proto-Hittite, end of 3rd millennium BC. H. 2.6 cm.; W. 1.3 cm.; L. 3.9 cm.

The bull was cast solid with two loops on the proper left side of the body for attachment to a piece of jewelry or fabric. The forelegs are vertical and the hind legs oblique inwards as on some Hattian bull standards (see [7] and [8]). Here the body is longer leaving more space between the front and back legs. This also makes the legs appear shorter in proportion to the body than is the Hattian norm. There is a small pointed hump at the withers. The hanging tail rests against the inside of the right leg. The sex is only implied by a slight swelling.

Condition: Intact with some minor pitting of the surface. PV

Bibliography: Unpublished.
Comparative literature: See [7] and [8].

9

8 Bull Jewel

Gold, solid cast. Hattian or Proto-Hittite, end of 3rd millennium BC. H. 2.4 cm.; W. 1.2 cm.; L. 2.3 cm.

Forelegs and hind legs join on a narrow square support with rounded corners. They form a triangle with the slanting body and protruding rump. The naturalistic rendering is focused on the head which is bigger than the body. The horns curve upward and inward, the fleshy ears stick out horizontally, the mouth is slightly open, and the nostrils dilated. The bone structure of the muzzle is masterly rendered by a delicate faceting. Two ridges starting from the base of the horns delineate the eye socket and sweep on to the end of the muzzle.

The tiny gold bull, perhaps used on a priest's garment, is a descendant in jewelry of the Hattian bull standards in bronze (see [7]). In contrast to the bronzes are the gold bull's top-heavy proportions and the convergence of his four hooves. In the Hattian bronze prototypes and in a silver bull with gold inlays on a copper stand — probably from Alaca Höyük and now in the British Museum (135851) — the legs do not touch each other and the void between them is shaped like a trapezoid, not a triangle. However, there is an exception in bronze closer to Mildenberg's bull published by the Arete Gallery.

Condition: Nearly "mint." PV

10 Bull Head Fragment from a Rhyton

Terracotta. Hittite, 15th century BC. L. 14 cm.; Thickness of wall 1.2 cm.

The left half of a bull's head with entire muzzle intact. The left horn and ear and back of left mandible are broken off.

The coarse, gray clay body is colored with two slips, one a reddish brown, the other a creamy beige, both highly burnished. The eyeball, colored with the creamy beige slip, bulges like a volcanic crater. The iris is missing. A thick, oval, diagonally hatched rim circles the eye and another the base of the horn. The eyelid is marked by three rows of diagonal hatchings forming a herringbone design. The nostrils are pierced through to the hollow interior. Four broad, curving incisions ripple the muzzle beside and above the nostrils. The bull's nose ring, in beige low relief, arcs over the fleshy muzzle. A beige halter striped with reddish brown is attached at either side and curves along the jaw then under and behind the ear. The traditional triangle on the bull's forehead is painted in beige slip over a rectangular field of lightly hatched herringbone patterns and below this a semicircle of deeper oval hatchmarks.

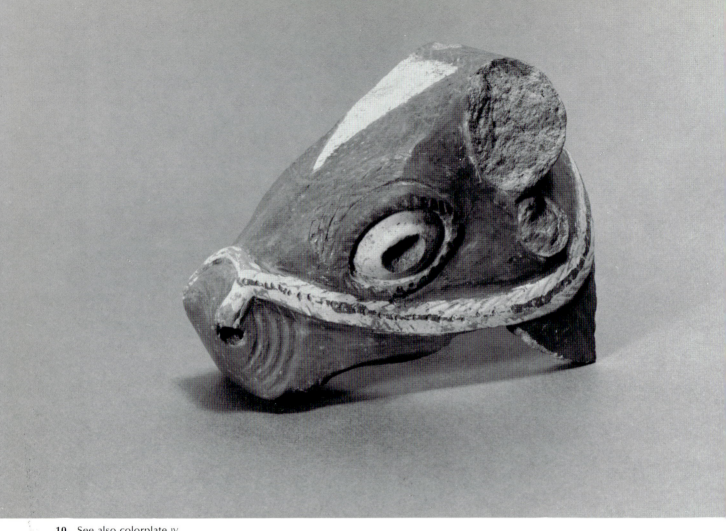

10 See also colorplate IV

The head was originally formed in halves, as if in molds, and then joined. On the inside of the remaining fragment the coil of clay used to reinforce the join remains visible between the nostrils. On the underside of the bridge of the nose are tracks made by the three fingers that smoothed the join between the two halves.

Hittite pottery reached its zenith in naturalistic zoomorphic vessels (referred to in Hittite texts as *bibru* jars). Lion, duck, and bull forms are known. Two bull rhyta reconstructed from fragments found at Boğazköy-Büyükkale in northeastern Anatolia IVb are now in the Archaeological Museum, Ankara. Another facial fragment from Boğazköy retains a dark clay inlay in its eye. The reconstructed bulls were found as a pair and are thought to represent the Hurrian bulls, Serris and Hurris ("Day" and "Night"), who were adopted by the Hittite Weather God to pull his chariot. These bulls were special to pious humans for they interceded with the gods for individuals at prayer.

Condition: Shallow loss at left corner of muzzle. Other breaks as described above. Surface excellent. APK

Bibliography: Unpublished.

Comparative literature: U. Bahadir Alkim, *Anatolia* I (Cleveland: World Publishing, 1968) 217, 270, no. 114, fig. 114; Kurt Bittel, *Hattusha* (New York: Oxford University Press, 1970) pp. 72-73, pls. 15-16; Franz Fischer, *Die hethitische Keramik von Boğazköy*, Boğazköy-Hattuša IV, ed. Kurt Bittel (Berlin: Deutsche Orient-Gesellschaft, 1963) p. 157, no. 1279.

11 Bull with Incised Decoration

Bronze. Anatolian, end of 2nd millennium BC.
H. 4 cm.; W. 3.2 cm.; L. 6.2 cm.

The simplified, but young and sprightly, standing bull recalls Anatolian bronze animals in the Walters Art Gallery (Baltimore), one example reproduced by Bossert, and two in The Cleveland Museum of Art. What distinguishes the Mildenberg bull is the incised decoration around the eyes, on the forehead, and on the back of the neck. It consists of meandering lines, locks, a fern leaf pattern, and strings of beads. The rounded tail is cleft in two with each of the halves decorated with a fern leaf pattern and punched beads. The ornamentation was not added merely for art's sake but was primarily intended to designate the animal as divine.

On the Mildenberg bull's forehead, a floral motif surrounds the "fertility triangle," represented by a triangular piece of electrum on the forehead of the Hattian bronze bull [7]. Besides being a fertility symbol, this triangle points to the divine element in the atmosphere.

The fern leaf design remains very close to that on the terracotta bull head rhyton fragment (see [10]). It compares also to that of another slightly later terracotta bull head in the Ankara Archaeological Museum. Analagous fern leaf patterns around the eyes and underscoring other anatomical details are found on another bronze in The Cleveland Museum of Art (69.122)—a monster with one body and two heads, one of a lion, the other of a bull—that is said to have been found in northwestern Iran. Both the fern leaf pattern and the strings of beads are found on bull heads from an Urartian cauldron in the British Museum. The Mildenberg bull can thus be considered a forerunner of the trend of neo-Hittite revival which in Urartian art rivalled the imitation of Assyrian models.

Condition: Intact. Even olive green patina. PV

Bibliography: Unpublished.

Comparative literature: Jeanny Vorys Canby, *The Ancient Near East in the Walters Art Gallery* (Baltimore: The Walters Art Gallery, 1974) no. 30; Helmuth Th. Bossert, *Altanatolien* (Berlin: Ernst Wasmuth, 1942) no. 161; John D. Cooney, "A Medley of Bulls," *The Bulletin of The Cleveland Museum of* Art LVIII (January 1971) 11-19, figs. 4-9; Kurt Bittel, *Les Hittites* (Paris: Gallimard, 1976) pp. 151-152, figs. 156-157.

12 Cylinder Seal with Ibexes

Glassy faience. Mitannian, ca. late 14th – early 13th century BC. H. 2 cm.; Diam. 1 cm.

The upper third of the cylinder is decorated with dotted guilloches between lines. The bottom border is also a line. The main part of the impression shows two ibexes with their heads turned back standing on each side of a pillar of

11

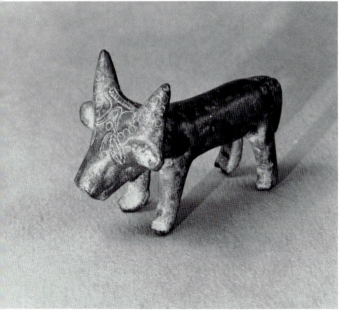

12

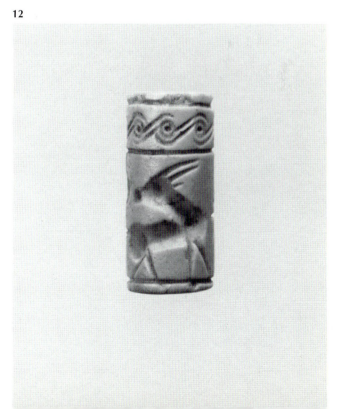

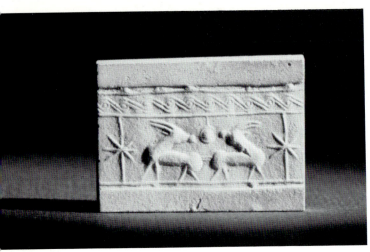

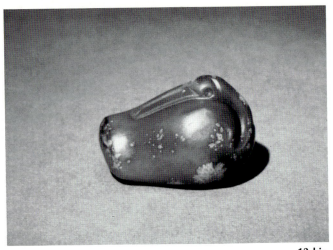

12 impression

12 bis

heaven or a Tree of Life. The pillar (or tree) is conventionally represented as a stem transfixed by a six-pointed star. On the opposite part of the cylinder there is a cosmic sign—a dotted circle. The turquoise-colored seal belongs to the so-called "popular" or "common" style of Mitannian seals which dominated Mesopotamian glyptic art from ca. 1500 to 1350 BC and which is also represented in level II of Tell Atchana (Alalakh) in northern Syria.

Condition: Intact except for minor chipping around edges. PV

Bibliography: Unpublished.

Comparative literature: H. Frankfort, *Cylinder Seals* (London: Macmillan, 1939) p. 276, fig. 90, pp. 278-283, pl. XLII, o; Edith Porada, *Corpus of Ancient Near Eastern Seals in North American Collections*, vol. I: *The Collection of the Pierpont Morgan Library*, The Bollingen Series XIV (Washington, DC: Pantheon Books, 1948) 139-140, nos. 1008-1009, pl. CLIII, and p. 145, no. 1046E, pl. CLIX; Briggs Buchanan, *Catalogue of Ancient Near Eastern Seals in the Ashmolean Museum*, vol. I: *Cylinder Seals* (Oxford: The Clarendon Press, 1966) 184-185, nos. 939-943, 949, pl. 58, Sir Leonard Woolley, *Alalakh: An Account of the Excavations at Tell Atchana in the Hatay, 1937-1949* (Oxford: Oxford University Press, 1955) pp. 258ff, pls. LX, 10, LXI, 24, LXIII, 61, LXV, 98-99.

12 bis *Duck Weight*

Agate, lentil green with brown patches. Assyro-Chaldean, ca. 1500 BC. H. 2.3 cm.; W. 2.4 cm.; L. 3.4 cm.; Wt. 18.1 gm.

The duck curves his neck over the top of voluminous shoulders to rest his head and long bill on his back. His drilled eyes are open, not yet asleep; his nostrils are also lightly drilled. A V-shape ridge distinguishes his head from his neck. His extremely long bill is ridged along the midline. One drilled hole for suspension enters lengthwise at the base of the neck; another enters at the tail, right of center. The two holes join at their sides near the center. The brown patches of the stone are used to great advantage, coloring the edge of the duck's tail, the top of his head, and his shoulder area where wingbar feathers would be.

One of the most common shapes for Near Eastern weights was the "sleeping duck." The earliest examples are from third-millennium BC Sumerian sites, but the Mildenberg duck with its long, ridged bill compares more closely with second-millennium BC duck weights from Susa and Nineveh. It is an extremely fine example of its kind.

The weight, 18.1 grams, is the same as the one-shekel weight of Nineveh which was twice that of the Babylonian shekel.

Condition: Intact except for some pitting of surface. APK

Bibliography: Unpublished.

Comparative literature: M.-C. Soutzo et al., *Délégation en Perse. Mémoires XII* (Paris: Ernest Leroux, 1911) pp. 1-8, 14, 25-32; Pierre Amiet, *Elam* (Auvers-sur-Oise: Centre National de la Recherche Scientifique, 1966) fig. 346B, p. 453.

13 Alert Stag

Bronze, solid cast. Iran, early 1st millennium BC.
H. 5.3 cm.; W. 2.1 cm.; L. 2.9 cm.

The stag with his head turned left (perpendicular to his body), his forelegs and hind legs planted firmly, stands unsteadily because his right foreleg is slightly too short. The long slanting and squinting eyes give an attractive expression to the face. The imperfect adjustment of the forepart of the body to the hind part suggests that the wax model was made in two halves.

The same molding process and the characteristic slanting eyes are observed in an Iranian bronze young donkey auctioned in Paris. Both bronzes seem to precede the production associated with the Elburz ranges in northern Persia as of 900 BC.

Condition: Intact except for minor pitting of surface. Black patina. PV

Bibliography: Unpublished.

Comparative literature: Bronzes du Louristan et d'Amlash, sale cat. (Paris: Hotel Drouot, May 1980) no. 336.

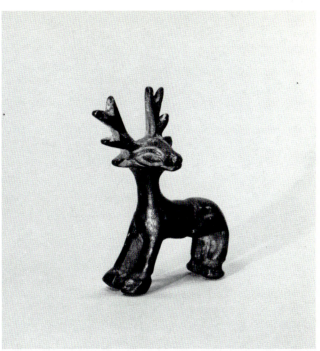

13

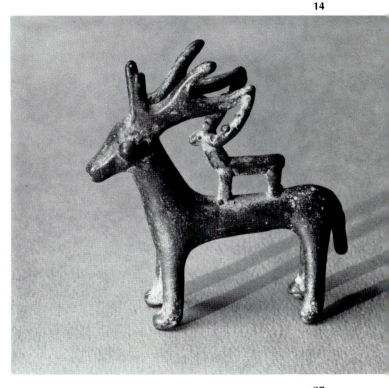

14

14 Fawn Riding a Stag

Bronze, solid cast (body of stag hollow). Iran, Luristan, 8th–7th centuries BC. H. 8.2 cm.; W. 3 cm,; L. 8.2 cm.

The motif is a charming one and so far the only one published. The tips of the antler tines are joined together. The bodies are simplified into a completely smooth texture. The round bulging eyes which lack sockets are characteristic of Luristan bronzes.

Similar schematized bodies and plastic eyes are observed on two bronzes of undetermined origin in the Museum für Vor-und Frühgeschichte, Berlin, and numerous others. The closest comparison with the theme of the Mildenberg bronze is a Luristan bronze rhyton in the shape of an ibex holding its fawn on its antlers in the former Barbier collection. A whetstone handle in Tehran is in the form of two does, one riding piggyback. A whetstone handle in Brussels is in the form of a dog on the back of an ibex, and in Seattle an ibex whetstone handle has a fawn sprouting from his chest. There is an example of the remains of a stag and fawn deposited together in an Amlash tomb.

Condition: Small hole in right side. Uneven dark green and dark brown surface. PV

27

Bibliography: Unpublished.

Comparative literature: Wolfram Nagel, *Altorientalisches Kunsthandwerk, Berliner Beiträge zur Vor-und Frühgeschichte,* V (Berlin: Walter de Gruyter, 1963) pls. LVIII, no. 140, LIX, no. 142; Edith Porada and Richard Ettinghausen, exhib. cat. *7000 Years of Iranian Art,* (Washington, D. C.: The Smithsonian Institution Traveling Exhibition Service, 1964-65) pp. 135-136, nos. 190, 366, p. 140, no. 157; *Bronzes antiques de la Perse: Collection Jean Paul Barbier, Genève,* sale cat. (Paris: Hotel Drouot, 27 May 1970) pp.15, 72, no. 62; Jean-Louis Huot, *Persia: From Its Origins to the Achaemenids,* I, trans. H. S. B. Harrison (London: Frederick A. Praeger Limited, 1965) no.80; Roman Ghirshman, *Persia from the Origins to Alexander the Great,* trans. Stuart Gilbert and James Emmons (London: Thames and Hudson, 1964) p. 67, nos. 84, 86.

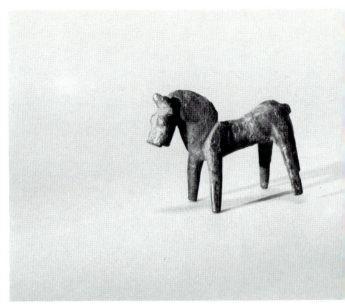

15

15 *Horse Pendant*

Bronze, the body hollow, the legs, neck, and head solid. Gilan (Amlash), early 1st millennium BC. H. 3.3 cm.; W. 2.2 cm.; L. 4.6 cm.

The horse stands on four legs set wide apart, shaped like nails and running straight into the shoulders and rump which are in high relief. The line of the hind legs is not straight; a notch marks the hocks. A groove sharply cuts the chest from the body and the neck from the head. The lower jaw is heavy and the muzzle, very wide. The broad slit mouth implies a bare line of teeth. The eyes are bulging, and the pointed ears comparatively small. The head looks downward, and the curved, high mane ends in a razor sharp ridge. The tail is a mere stump of bronze set into a hole in the rump. A tubular hole runs through the brisket to the withers. The bronze was delicately tooled to impart sheen and nervosity to the texture of the animal's skin.

Like the Amlash stags, the pendant horses were hung in a string from the belt. In the Adam collection are two similar horses of which the date and origin, early first millennium BC at Gilan in the Elburz ranges, are approximated by comparison with a cosmetic stick with a horse terminal found in tomb 5 at Ghalekuti II in Dailaman. A number of Luristan pins also end in horse protomes. An exceptional one with two addorsed horses as terminals was auctioned recently.

Condition: Intact. Dark green patina with areas of cuprite. PV

16

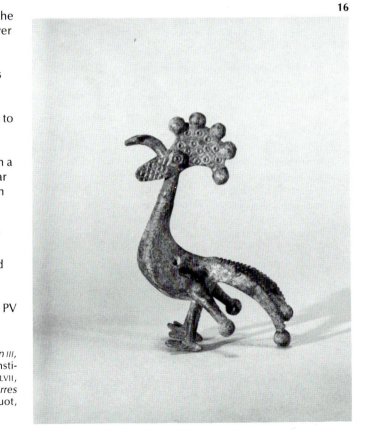

Bibliography: Unpublished.

Comparative literature: Toshihiko Sono and Shinji Fukai, *Dailaman III, The Excavations at Hassani Mahale and Ghalekuti* (Tokyo: The Institute of Oriental Culture, University of Tokyo, 1968) pp. 45-46, pl. XLVII, 4a, 4b; Moorey, *Adam Collection,* nos. 160-161; *Bronzes et terres cuites du Louristan et la Caspienne,* sale cat. (Paris: Nouveau Drouot, 26 September 1980) no. 36.

16 Rooster Amulet

Bronze, solid cast. Iranian, early 1st millennium BC.
H. 6.5 cm.; W. 3.1 cm.; L. 4.7 cm.

The cock has five knobs on his crest and four on his fanned wings. The cascade of tail may indicate that he is a game cock. The two inner wings have an indented edge. The crest is also punctured with ten or twelve dotted circles. The crescent-shaped bill is crooked. The eyes, cast in low relief, have incised pupils. The two wattles hanging from the neck are crosshatched. Two holes run from either side of the ridge on his back to either side of the ridge on his breast indicating that the bird was worn as a pendant from a belt. Three similar birds are in the Adam collection. Two birds with the same characteristic knobs formerly in the Barbier collection are even closer to the Mildenberg one, although Moorey raised the question of whether the Adam birds should not be cataloged as Islamic rather than Persian. They are correctly labeled Iranian in the auction catalog.

Decorative knobs were utilized by Celtic bronze casters of the Hallstatt Period. The practice is well documented in Iran, where various objects with similar knobs have been excavated. This decorative motif may derive from an earlier Iranian pattern of pomegranate terminals symbolic of the Tree of Life. Nevertheless, the combination of dotted circles and knobs on the Mildenberg rooster suggests rather a connotation of the dome of heaven and cosmic immortality, a symbolism transmitted from Persia to the Celtic world which also made use of knobs for decoration and symbolism.

Condition: Intact. Feet are bent and splayed though perhaps this was the original intention. Mostly matte green surface. PV

Bibliography: Unpublished.

Comparative literature: Moorey, *Adam Collection,* p. 174, no. 170; *Bronzes antiques de la Perse: Collection Jean Paul Barbier, Genève,* sale cat. (Paris: Hotel Drouot, 27 May 1970) pp. 28, 127, nos. 175, 176.

17 Three Bull Protomes

Bronze, solid cast. Neo-Hittite or Urartian, ca. 1000 BC or later. H. 5.7 cm.; W. 2.7 cm.; L. 6.4 cm.

The legs of each of the three bull protomes rest on narrow rectangular bases. A tang ending in a pierced disk juts out from the back of each bull's withers. The bulls lower their horns, not aggressively but rather submissively, as befits their position of support. The horns, curved inside, point upward. The eyes are shallow, almond-shaped incisions nearly hidden by the large, drooping ears. It may be pointed out that the bulls' forelocks end squarely, as they

17

do on the bull head attachments of Urartian cauldrons. The slightly upward sloping tangs supported a basin used in purification rites. However, no Urartian basin directly supported by bull protomes has been excavated and recorded scientifically and the authentic Urartian tripods always end in bull hooves.

A basin with concave walls supported by three bull protomes standing on their forelegs like the Mildenberg protomes was auctioned recently. In the Pomerance collection there is a small tripod made of three bull protomes standing on their forelegs with heads reversed in the Achaemenian fashion of animal handles. Only 5.8 cm. high, it has a hole in the center suggesting that it may have supported a sort of standard. A bronze cauldron with convex walls coming from Semirech'e, in the Alma-Ata Museum, western Turkestan, Soviet Union, is supported on three legs made of the foreparts of wild sheep. It is considered a product of Sakian art coming from north of Sogdia, southeast of the Aral Sea, but is perhaps an import from a western region of the Near East.

The expression and attitude of the Mildenberg bulls compares with that of a bull carved on an eleventh-century BC stele in the Aleppo Museum. It comes from Til Barsip (Tell Akhmar) in the upper valley of the Euphrates (today northern Syria) and represents the Weather God standing on the divine bull, a motif familiar in Syria and Anatolia. There is also a pottery bowl from Aleppo which is supported by three horse protomes according to a formula analogous to that of the Mildenberg bulls. The association of the bull with a sacred vessel harks back to the Jemdet Nasr Period of Sumer (see a recumbent bull supporting a jar in the collection of Mr. and Mrs. Joseph Ternbach, Forest Hills, New York). At the opposite end of the spectrum are two medieval candlesticks of tripod animal form. The supreme expression of this type of vessel was the *Brazen Sea*, a huge bronze basin which stood near the altar of burnt offerings in the inner court of the temple at Jerusalem and rested on the backs of twelve oxen in four groups of three (I Kings 7:23, 25.)

Condition: All intact except for surface corrosion. The matte patina is pale blue-green in color with some rust colored staining. PV

Bibliography: Unpublished.

Comparative literature: *Bronzes et terres cuites Louristan-Amlash*, sale cat. (Paris: Nouveau Drouot, 26 September 1980) no. 129; E. L. B. Terrace, B. V. Bothmer, J. L. Keith, et al., *The Pomerance Collection of Ancient Art*, exhib. cat. (New York: The Brooklyn Museum, 1966) p. 49, no. 56; Karl Jettmar, *Art of the Steppes*, trans. Ann E. Keep (New York: Crown Publishers, 1967), pp. 172-173, fig. 119; Horst Klengel, *The Art of Ancient Syria*, trans. Joan Becker (South Brunswick and New York: A.S. Barnes, 1972) p. 40; Kurt Bittel, *Les Hittites* (Paris: Gallimard, 1976) p. 285, no. 326; Denise Schmandt-Besserat and S.M. Alexander, *The First Civilization: The Legacy of Sumer*, exhib. cat. (Austin: The University Art Museum, The University of Texas, 1975) no. 189, p. 79; Anne Roes, "Two Medieval Candlesticks of Unusual Type," *Artibus Asiae* xx (1957) 66-71, cf. fig. 3, p. 68.

18 *A Winged Bull Head Cauldron Attachment*

Bronze, hollow cast. Urartu, last third of 7th century BC. H. 6 cm.; W. 6.2 cm.; L. 9.9 cm.

The attachment is shaped like a bull's head, the neck of which is joined at a right angle to a convex plate evoking the wings and tail of a displayed bird of prey. Three rivets through the wings and the tail fitted it to a cauldron. It is likely the bull head was prepared in sectional molds of clay and that wax copies were afterwards assembled for the final casting. The head and neck were joined to the bird-form plate; the horns and the horizontal ears were added. The seam at the base of the horn is rendered inconspicuous by the decorative device of a notched ring.

The horns curve forward, outward, and upward, their tips re-curving inward. The center of the forehead is covered by two levels of undulating hair each ending in spiral curls. The rectangular forelock flares over the top of the skull and behind it. From that point the mane is parted by a median strip left bare between two rows of engraved horizontal, wavy lines that end in spiral curls. The protruding eyebrows are bean-shaped, the eyes staring. The eyelids, and particularly the canthi, are sharply incised. The length of the nose is delineated by two gently curving grooves starting from the inner corner of the eyebrows. In the middle, two short grooves branch downward imitating veins swelling under the skin. Three grooves curve above the muzzle and the nostrils are marked by two depressions. A deep groove separates the upper and lower jaws. Around the mouth the sagging and, as it were, humid lips are delicately rendered. A ruff of spiral curls hangs from ear to ear around the neck. The feathers of the bird attachment are rendered with a naturalistic care. The removal of the casting core has left an opening through the back of the feather plate and the neck to the forehead, at the entrance of

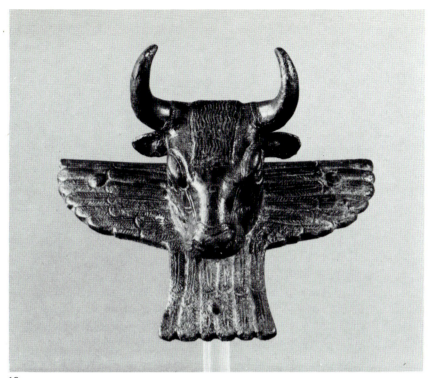

18

which remains a trace of the separate casting of the head and neck unit.

All the features described above characterize only the bull head attachments excavated in Urartu as distinct from those found in Phrygia, North Iran, Greece, and even South Italy, whether they were exports or local artifacts fashioned after Urartian models. The purely Urartian bull heads without exception look to the outside of the cauldron and never have a ring on their backs.

It is not difficult to narrow down the chronological limits within which the Mildenberg bull head was cast. Its style represents a course of evolution midway between the early style, hallmarked by the highly stylized treatment of parts, and the later, flowing, more naturalistic manner that became less interested in pointing up decorative details in order to imitate more closely the real animal. To the first stage belong the four attachments of a cauldron discovered at Toprak Kale: two are in the British Museum, one in the Walters Art Gallery, Baltimore (54.791), and a fourth in a private collection, Paris.

The mature naturalistic style in which the bull head was treated as a synthetic blend in which decorative features like the ruff of spiral curls around the neck are omit-

ted, is represented by four attachments from Gushchi, on the western bank of Lake Urmia, in Armenia. They are shared between the Louvre (AC 17–207), the Fogg Museum at Harvard, the Cincinnati Museum of Art, and The Cleveland Museum of Art (42.204). A fifth head found at Alishar, on the Aras River between Russia and Armenia, probably dates slightly earlier, to the reign of the Urartian King Argishti II (713–685 BC). In between the Toprak Kale and Gushchi groups falls the cauldron found at Altin Tepe, near Erzincan in the Euphrates upper valley reaches, today in the Archaeological Museum at Ankara. It is complete with its tripod support and its four bull head attachments. The tomb from which it was excavated is dated by an inscription on a vase found there to the reign of Urikki, king of Cilicia (ca. 740–732 BC). The inscription gives perhaps only the "terminus post quem," and it remains possible that the cauldron is later than 732 BC. Its attachments are shaped like the abstract form of a bird of prey, without any rendering of the feathers. On the other hand, the feathers on the Toprak Kale bull head in the British Museum were treated as a purely geometrical pattern. Their presence indicates a retardataire development of an already modified attachment form and would place the head towards the

time after Rusa I ascended the throne of Urartu (735 BC). Since the Mildenberg bull head clearly belongs to the type represented by the Altin Tepe cauldron, it should date to ca. 730–710 BC or in the very beginning of Argishti II's reign.

The Mildenberg protome would have been attached to a cauldron probably used for mixing water and wine. The vessel's circumference can be calculated from the curve of the bird's wings as 42 cm. The width of the Altin Tepe cauldron is 72 cm. for a capacity of 100 liters. Smaller cauldrons were called *kiuri* and stood on tripod bases with feet ending in bulls' hooves. A relief of Sargon II's (722–705 BC) palace showing the temple of Haldi, which the Assyrian king destroyed at Ardini-Musasir in 714 BC, illustrates how such cauldrons were set on their tripods before the temples. See also [17].

Condition: The tip of the proper right horn is restored. There is one defect in the cast—a tiny hole between the proper right horn and the eye. The greater part of the neck on its proper right is roughened from corrosion. On the muzzle, more faintly on the forelock, on the front part of the attachment, and more thickly on its back, there is a layer of emerald green patina. Some bare spots of bronze are visible. PV

Bibliography: Unpublished.

Comparative literature: R. D. Barnett, "The Excavations of the British Museum at Toprak Kale near Van," *Iraq* XII (1950) 1–43, cf. p. 19, pls. XVI, XXII, 1–3, fig. 11; George M. A. Hanfmann, "Four Urartian Bulls' Heads," *AnatSt* VI (1956) 205–213; R. D. Barnett and N. Gökce, "The Find of Urartian Bronzes at Altin Tepe, Near Erzincan," *AnatSt* III (1953) 121–129; Pierre Amandry, "Chaudrons à protomes de taureau," in Paul S. Weinberg, ed., *The Aegean and the Near East* (Locust Valley, NY: J. J. Augustin, 1956) pp. 239–261; B. B. Piotrovsky, *Urartu: The Kingdom of Van and Its Art*, trans. Peter S. Gelling (New York: Frederick A. Praeger, 1967) pp. 37–41 (The caption for fig. 24 is erroneous. Instead of Harvard University Museum, read "Louvre."); Guitty Azarpay, *Urartian Art and Artifacts: A Chronological Study* (Berkeley and Los Angeles: University of California Press, 1968) pp. 52–55, fig. 15, pls. 30–34; Oscar White Muscarella, "Winged Bull Cauldron Attachments from Iran," *Metropolitan Museum Journal* I (1968) 7–18.

19 Belt with Lions and Bulls

Bronze repoussé and chased. Urartian, middle 7th century BC. H. 13.1 cm.; W. 11.7 cm.; Thickness 0.1 cm.

A thin, fragmentary sheet of bronze with five rows of alternating lions and bulls striding to the left. The direction indicates that the fragment belongs to the left half of a belt, the right half of which would have been decorated with the same animals striding to the right. Before the right-most column of animals, the metal is bent from the belt's having been folded around the dead warrier or from having been deposited in a funeral cauldron in the tomb. On the upper and lower edges are single rows of tiny rivet holes by which the bronze belt was attached to a backing, perhaps of leather.

The pattern of alternating striding lions and bulls—although met on fragmentary belts that have appeared on the art market in recent years—is characteristic of shields commissioned for the national temples by the Urartian kings. No less than fourteen of them were found at Karmir Blur, near Yerevan in Armenian Russia. They were dedicated to Haldi—the main god of the still little-known Urartian pantheon—by Argishti I (787–764) and Sarduri II (764–ca. 755–735). On those shields the lions and bulls were punched and engraved with a sophisticated set of puncheons and chisels.

Striding lions and bulls like Mildenberg's also appear on a shield dedicated by King Rusa III (654–640 BC) excavated at Toprak Kale, near Lake Van in Iran.

Although the curling locks of hair on the bulls made with a pointed puncheon are reminiscent of the eighth-century court style, the technique of engraving is less plastic than that on the Karmir Blur shields, suggesting a somewhat later date, perhaps in the reign of King Rusa III.

The system of decorating shields with processions of striding lions and bulls could be adapted easily to the ornamentation of belts. The shields are divided into four quadrants. The directions of the animals in each quadrant are reversed so that they stand facing the same bisecting diameter of the shield. When the shield was hung with this diameter vertical, none of the animals was seen upside down. The direction of friezes of animals is also reversed on belts. Generally, the division of the direction is asymmetrical.

On the belts the animals usually do not parade as on the Mildenberg belt but rather play roles in royal or mythological hunts. The hot pursuit forces them to gallop, and the bulls have to lift their tails, as on the bronze strips from Gushchi (shared between the Ashmolean Museum in Ox-

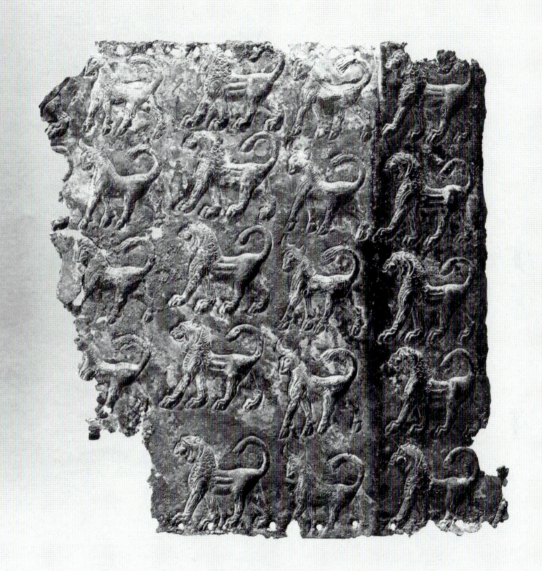

ford and the Metropolitan Museum), the belt piece in the Adana Regional Museum, and the belt in the Norbert Schimmel collection. In this last example, the lions either turn their heads back toward the hunters or they majestically stride with their right forelegs lifted up in what seems to be a goosestep march, one of the hieratic conventions of the court style. On two horse blinkers in the Bröckelschen collection, the bulls facing the lions lift up their tails. Two lions walking with their tails hanging and two bulls striding with their tails curled up decorate, together with two winged and fish-tailed genii, a silver pectoral — a moon-shaped breast ornament — in the Ankara Museum. Four striding lions with their tails erect appear on a bronze pectoral of the same shape in the Adana Museum.

The Mildenberg fragment reflects the processional pattern seen on shields of the court style, but it was not executed in the same masterly technique. Like the strip from Altin Tepe, which is dated to the reign of Argishti II (713–679), it shows an angular style of engraving and the use of dots made with a point and not with a ring-puncheon. Though one still observes the bulge on the lions' foreheads, they have lost the saddle motif usual in court style. Their manes were punched with moon crescent accents which did not obtain the flaming effect so brilliant on the shields. True to the Assyrian "animal style" which the Urartian artists emulated, the lions exhibit muscular emphasis, a snarling front, and a gaping maw, but their tongues are no longer lolling and their lower jaws have lost their S-shaped contour. The coat of the bulls is summarily rendered as a hatched area all along the spine, with appended lines of dots. The tassels of long hair hanging on the shoulder and haunch are now conventionalized and scribed in shorthand. The graphic rendering of the bulls' coats is very close to that of the Gushchi belt which, like an Urartian belt in the Boston Museum (1972.398), dates in the middle decades of the seventh century BC.

It is likely that on the Mildenberg belt, as on the royal shields, the lion symbolizes Haldi, the national warrior god, and the bull, the storm god, Teisheba, an avatar of the Mesopotamian god Teshub. On the Karmir Blur belt in the Historical Museum of Soviet Armenia, the two gods parade standing on the backs of their emblematic animals. On the Boston belt, Haldi hunts riding a lion, and Shiuini, the sun god, rides a horse.

Condition: Bent as described above. A few detached small pieces were soldered back on. The piece was never gilt, the brassy sheen in places is deceptive and results from the high tin content of the alloy. There are minor losses especially in the left third of the belt, in the lower right corner, and right upper edge. PV

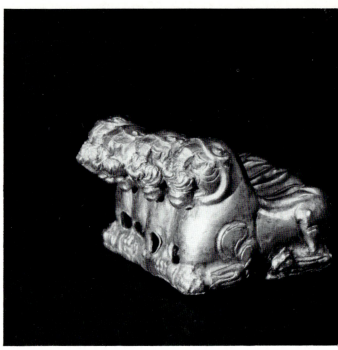

20 See also colorplate x

Bibliography: Unpublished.

Comparative literature: B. B. Piotrovsky, *The Kingdom of Van (Urartu)* (in Russian) (Moscow: Publishing House of Eastern Literature, 1959) p. 167, pls. XXXVII, XXXIX; B. B. Piotrovsky, *The Art of Urartu VIII–VI Century BC* (in Russian) (Leningrad: Hermitage, 1962) pp. 66–69, figs. 38–40, p. 74, fig. 42, pls. XXII, XXV; Guitty Azarpay, *Urartian Art and Artifacts: A Chronological Study* (Berkeley and Los Angeles: University of California Press, 1968) pp. 21–37, fig. 8, pls. 7, 18–20, pp. 67–68, pls. 56–58; Peter Calmeyer, *Altiranische Bronzen der Sammlung Bröckelschen* (Berlin: Staatliche Museen, 1964) pl. 26, nos. 59–60; Maurits Nanning van Loon, *Urartian Art: Its Distinctive Traits in the Light of New Excavations* (Istanbul: Nederlands Historisch-Archaeologisch Instituut, 1966) pp. 116–118, fig. 13, pls. XXV, XXVI; Ekrem Akurgal, *Urartäische und altiranische Kunstzentren* (Türk Tarih Kurumu Basimevi, 1968) pp. 64–79; *Schimmel Catalog* (1974) no. 133; Herbert Hoffmann, "An Urartian Decorated Bronze Strip from Diyarbakir," in *Studies Presented to George M. A. Hanfmann* ed. D. G. Mitten, J. G. Pedley, and J. A. Scott (Cambridge, MA: Fogg Art Museum, 1971) pp. 69–76 (with bibliography completely up to date); Hans-Jörg Kellner, "Pectorale aus Urartu," *Belleten* XLI, no. 163 (1977) 482–483, pl. 1 (wrongly captioned 3) and pl. 2, pp. 487–488, fig. 1; Orhan Aytuğ Taşyürek, "The Urartian Bronze Hoard from Giyimli," *Expedition* XIX, no. 4 (Summer 1977) 12–20, figs. 13, 15–16; Timothy Kendall, "Urartian Art in Boston; Two Bronze Belts and a Mirror," *BMFA* LXXV (1977) 27–55, figs. 7–8; *Bronzes antiques de la Perse: Collection Jean Paul Barbier, Genève*, sale cat. (Paris: Hotel Drouot, 27 May 1970) p. 49, no. 27.

20 Ornament in the Form of a Team of Four Lions

Heavy gold foil. Neo-Hittite, late 8th century BC.
H. 2 cm.; W. 3.1 cm.; L. 2.9 cm.

Four hollow crouching lions are assembled in a team and soldered to a flat plate. They share the complete profile view of the left lion and the corresponding profile view of the right one. The heads are kept separated; the spines, rumps, and tails are also individualized. Attention to muscles and bone structure was lavished on these two profile views. The heads show a ruff around the neck and furrowed muscles around the eyes and over the jaws. The mouths are ajar. Of the paws only the nails are sharply rendered. Under the chests and rumps of the four lions are pierced four holes for threading the jewel onto a necklace.

The closest comparison is a bead worn by King Warpalawas on the rock relief at Ivriz, near Konya, carved in the second half of the eighth century BC. The jewel calls immediately to mind teamed lions in Neo-Hittite sculpture at Tell Tayinat and particularly those of the Sakçagözü Göllüdag doorways which reveal the influence exerted then by Assyrian sculpture (750–700). The Mildenberg lions are similar in style to an eighth-century bronze lion from Toprak Kale east of Lake Van in Turkey now in the British Museum. However, the Toprak Kale lion doubles his forelegs back under his body rather than reaching forward like the Mildenberg lions. A Neo-Hittite origin for the Milden-berg lions is corroborated by comparison of the linear patterns of muscles on the legs and rumps with those of a recumbent bronze lion from Kayalidere near Varto, northeast of Lake Van, in the Ankara Museum and on a relief from Carchemish. There is only one object in precious metal comparable with the Mildenberg four lions — a Lydian electrum brooch of the sixth century BC, in the Norbert Schimmel collection. The subject is a hollow recumbent lion, set in a sort of low enclosure. See also [21].

Condition: Fairly well preserved. There are two small cracks in the gold, one on the back of the second lion and one between it and the third lion. Contact in the tomb with a bronze object has left a green stain on the left lower part of the base. PV

Bibliography: Unpublished.

Comparative literature: Kurt Bittel, Les Hittites (Paris: Gallimard, 1976) pp. 286–287, figs. 327–328; Helmuth Th. Bossert, Altanatolien (Berlin: Ernst Wasmuth, 1942) p. 222, no. 873; Ekrem Akurgal, The Art of the Hittites (London: Thames and Hudson, 1962) pls. 113; 134–136, 140, cf. XXIV; Schimmel Catalog (1974) no. 134; R. D. Barnett, "The Excavations of the British Museum at Toprak Kale near Van," Iraq XII (1950) pl. XI; M. Chahin, "Some Urartian Bronzes," in Atti del primo simposio internazionale di arte armena (Venice, 1978) p. 75, fig. 18.

21 Nail with Roaring Recumbent Lion

Iron and gold foil with traces of red glass. Urartu, 7th century BC. H. 5.5 cm.; W. 1.3 cm.; L. 2.4 cm.

The broken iron pin is capped by a sort of two-level capital, the lower level incised with leafy ornaments. On top crouches a lion whose barely visible legs are doubled up under him. He roars, baring his fangs. His fiery eyes and snarling face are finely executed and well preserved. Gold foil covers the lion and his support. Decorative granulation is distributed apparently at random in clusters over the lion's body. Lines of granulation form less arbitrary patterns; a half oval of granulation echoes the incised tail which folds around the right stifle and ends in a triangle. A median line of granulation starting from the middle of the skull divides the back of the neck into two halves. It branches off at the level of the ears to end in two circlets and form a tau. A glass jewel was set in a still existing bezel encircled by a row of granules on the animal's chest. Only the left ear made of a short soldered coil remains.

21

22

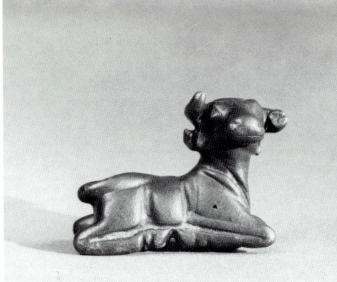

23

An analogous nail in silver is in the Norbert Schimmel collection. Similar pins have been excavated in northeastern Urartu, like a crouching vertical lion on top of a pin from Karmir Blur, near Yerevan in Soviet Armenia, and one with a pair of crouching lions exhibited in Krefeld in 1979. The double muscle lines on the haunch are similar to those on a lion from Toprak Kale in the British Museum. However, the Neo-Hittite double shoulder lines are missing (see [20]). In general the Mildenberg lion also has a softer appearance.

Such nails, having become dress ornaments, continue the aesthetic tradition of Mesopotamian foundation nails and are directly linked with iron pins ending in bronze lions found at Hasanlu in Azerbaijan and now in the University Museum, Philadelphia. See also [20].

Condition: The iron nail is very corroded and the gold foil has been replaced on the lower left side, on the withers, in front of the right haunch, and in minute portions elsewhere. Minute granules of red glass remain in the bezel. PV

Bibliography: Unpublished.

Comparative literature: Schimmel Catalog (1978) no. 150; K. R. Maxwell-Hyslop, Western Asiatic Jewellery, c. 3000–612 BC (London: Methuen and Co., 1971) pl. 158; Edith Porada, The Art of Ancient Iran: Pre-Islamic Cultures (New York: Crown Publishers, 1965) p. 115, pl. 29, p. 116, fig. 67; R. D. Barnett, "The Excavations of the British Museum at Toprak Kale near Van," Iraq XII (1950) pl. XI; Hans-Jörg Kellner, Urartu: Ein wiederentdeckter Rivale Assyriens, exhib. cat. (Krefeld: Museumszentrum Burg Linn, 1979) no. 222, pl. 6.

22 Lion Head Finial or Protome

Bronze, solid cast. East Greek or Anatolian, late 7th – first half of 6th century BC. L. (overall) 4.4 cm.; H. and W. of head 1.4 cm.

This cylindrical object terminates in the square-muzzled head of a lion. The shaft is cylindrical in section; its rear portion tapers to a smaller, blunt-ended tang. The lion head displays massive features with plastic linear forms such as triple ridges outlining the eyes and triple ridges creating wrinkles defining the cheeks between the nose and the corners of the mouth. The gaping mouth, filled with pointed teeth, is outlined by a double groove running completely around it. On both sides of the mouth, the upper teeth are separated by a horizontal groove, traversed by a vertical one to indicate the molars. The ears, laid back along the top of the head, are formed by small oval buttons outlined by grooves.

The purpose of this object, as well as of its counterpart of Roman date [177] are unknown. The presence of the tang suggests that it was intended to be inserted into a socket in some larger object, perhaps as a stopper or plug. The massive, squarish modeling and patterned rectilinear incision suggests ancestry among Neo-Hittite or other Anatolian lions of the late Iron Age or early Archaic Period.

Condition: Intact. Sound, shiny, dark green patina. DGM

Bibliography: Unpublished.

Comparative literature: For recent discussion of Neo-Hittite prototypes for small lions, especially in the Greek world, see H. Gabelmann, Studien zum frühgriechischen Löwenbild (Berlin: Gebr. Mann, 1965) pp. 17-21.

23 Recumbent Bull

Bronze, solid cast. Neo-Elamite, end of 2nd to beginning of 1st millennium BC. H. 3 cm.; W. 2 cm.; L. 4.3 cm.

A recumbent bull with four legs tucked under his body is represented in profile to the right while turning his head to the onlooker. The tail is curved across the top of the right haunch. The left ear is pierced. Very smooth modeling and the rippling dewlap show subtle tactile values. When the animal is turned upside down, one sees that the legs and hooves are articulated. A circular lump of metal remains underneath between the forelegs.

The bull's turned head and the manner in which he tucks all legs beneath his body are reminiscent of ancient Mesopotamian bull sculptures. The handling of volumes also has aspects of Behm-Blancke's Mesopotamian Style Group IV. However, certain features forbid such an early dating. First, the plasticity of this little figure with the strong thrust of the head and knees away from the body contrasts greatly with the rock bound nature of early sculpture. Secondly, the foreleg from the knee down is turned upside down so that the front fetlock rests on the ground in symmetry with the rear fetlock. This aberration from nature was never seen in early Mesopotamian art. It does appear, however, on a Neo-Elamite ceramic bull-god in the Louvre (SB 6652).

Despite the deep gouges used to distinguish anatomical features (the abdomen and shoulder) reminiscent of early Mesopotamian sculpture, this little bull figure has a softness and naturalism that appears in mid-second-millennium sculpture, again in Neo-Elamite art. Small bronze bull weights from fourteenth-century BC Ras Shamra are much more naturalistic than the Mildenberg bull. Three objects in the Louvre, a bull-god (SB 6652), a horse head (SB 2787), and a recumbent gazelle (SB 5642), all exhibit the soft, naturalistic tendencies of early first-millennium Neo-Elamite sculpture. The position of the tail is yet another Neo-Elamite device. And the pierced ear, probably meant to hold a gold earring, is a feature of animal sculptures throughout the Near East in the early first millennium.

Condition: Left horn and right ear are broken. The cast is good with minute flaws; it left five holes underneath and two minuscule ones in the forepart of the body. APK

Bibliography: Unpublished.

Comparative literature: Manfred Robert Behm-Blancke, *Das Tierbild in der altmesopotamischen Rundplastik*, Deutsches Archäologisches Institut, Abteilung Baghdad: Baghdader Forschunger, I (Mainz: Philipp von Zabern, 1979) pl. 9, no. 56, pl. 15, and *passim*, pl. 30; Pierre Amiet, *Elam* (Auvers-sur-Oise: Centre National de la Recherche Scientifique, 1966) p. 491, fig. 368 A–B p. 506, fig. 381, p. 532, fig. 408; John Gray, *The Canaanites* (London: Thames and Hudson, 1964) pl. 53; Arielle P. Kozloff, "A Bronze Menagerie," *The Bulletin of The Cleveland Museum of Art* LXIII (March 1976) 74–76, figs. 1–2.

24 Recumbent Ram Pin Terminal

Silver, hollow. Lydian (?), ca. 8th century BC. H. 1.7 cm.; W. 1 cm.; L. 1.9 cm.

A crouching ram with legs folded under him turns his head at a right angle over his right shoulder. The fur is indicated by stippling. The surface of the head has become roughened obscuring any stippling which may have been there. He rests on a flat oval base encircled with a beaded wire rim also used around what remains of the supporting pin. Body and head were formed separately, each in two halves, and soldered together. A ridge above each eye and wrinkles on the nose are lightly tooled.

Similarly manufactured objects include a Lydian or East Greek lion in the Norbert Schimmel collection and another four from Sardis. The beaded rim also appears on the Sardis lions. The sculptural style, the subtlety of modeling with

24 See also colorplate II

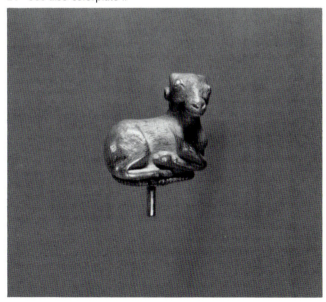

little surface articulation on the body, and the prominent eye are reminiscent of deer on a frieze in the British Museum. The eye ridge and muzzle wrinkles compare with Urartian bull figures (see [18]). The stippled skin appears on first-millennium Egyptian animals (see [50]).

Condition: Tiny hole above right ear; large hole above left eye. Oval base reglued at beaded wire rim. APK

Bibliography: Unpublished

Comparative literature: Schimmel Catalog (1974) no. 134; C. Densmore Curtis, *Sardis XIII: Jewelry and Gold Work, Part 1, 1910–1914* (Rome: American Society for the Excavation of Sardis, 1925) pl. VIII, figs. 7a, b, c; George M. A. Hanfmann and Nancy H. Ramage, *Sculpture from Sardis: The Finds Through 1975* (Cambridge, MA: Harvard University Press, 1978) p. 156, no. 230, fig. 400.

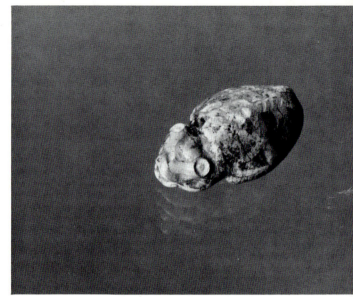

25

25 *Macrocephalic Turtle*

Glass. Achaemenian or earlier, 5th century BC, possibly late 2nd millennium BC. H. 1.3 cm.; W. 2.1 cm.; L. 3.6 cm.

Translucent deep or medium blue (?) glass now completely obscured by a thick buff weathering crust and silvery iridescence; trail decorated with opaque white and opaque yellow glass; formed on a cylindrical core or rod (4 mm. diam.). The shell, triangular in cross section, and the head are flattened on the underside. The roughly triangular head appears to have been formed from a second bit of glass and tooled to form an open mouth, then highlighted with a white trail. A yellow trail was added to outline the top of the head. A similar sequence is employed on the body where a white trail is applied in a single zigzag on the top and underside, which is crossed by a yellow trail, attached between the eyes and wound several times down to the end of the shell. Overlaying these trails are two composite eyes, now lost, and a spirally twisted trail of blue (?) and white (?) open-looped at one end and applied down the back, then bent around the edge of the shell and trailed forward and back to outline the circumference of the shell. All of this elaborate and once colorful decoration is now completely obliterated by the heavy weathering crust.

This bead or horizontally pierced pendant probably represents a variety of the big headed or sea turtle. The attribution of date is problematic since the elaborate trail decoration is reminiscent of the Achaemenian beads and kohl tubes of the fifth and fourth centuries BC. These objects often combine simple and spiral wound trails in their decorative pattern. The series of large beads in The Corning Museum of Glass (72.1.22A-D) offers a striking parallel in their zigzag pattern overlaid with a spiral decorated trail. However, one is also struck by the heavy weathering crust which is more common on objects not of Achaemenian date but from the second millennium BC. Beads and vessel fragments from Nuzi or Tel-al-Rimah are weathered in this manner.

Condition: Thick weathering crust, silvery iridescence over surface; all glass seems to be completely weathered, possibly some devitrification. Surface mostly compact, some cracking and eruptions. Area behind neck on shell has broken away and has been repaired. Some pieces of trail improperly replaced, glue covers most of neck giving the impression the head was broken off and reattached. SMG

Bibliography: Unpublished.

Comparative literature: Richard F. S. Starr, *Nuzi*, 2 vols. (Cambridge, MA: Harvard University Press, 1939) I, 449–453, II, pls. 120–l, 130–l; D. Oates, "The Excavations of Tel-al-Rimah, 1964, Preliminary Report," *BASOR* no. 178 (1965) p. 54, fig. 8; D. Barag, "Rod-formed Kohl-tubes of the Mid-First Millennium B.C.," *JGS* XVII (1975) 23–26; S. M. Goldstein, *Pre-Roman and Early Roman Glass in The Corning Museum of Glass* (Corning, NY: The Corning Museum of Glass, 1979) pp. 47–51, 104–107, 114, nos. 232–235 (illus.).

26 Nesting Bird Pendant

Glass. Mediterranean, Syria (?), 4th–3rd century BC.
H. 2.4 cm.; W. 2.4 cm.; L. 3.1 cm.

Turbid deep gray-blue glass body with an opaque white
trail decoration; formed on a pointed core or tool. The bird
has a small head with pointed beak, long neck, and large
applied gray-blue eyes. The elongated body has applied
white trails, left in relief, over which are added a suspen-
sion loop, D-shaped wings, and a flattened tail with rounded
end. The latter two are highlighted with white trails. The
wings are open and spread forward in a nesting position.
The underside retains a conical hole, suggesting that the
piece was formed on a pointed core or tool; the back
portion was pinched together before the tail and wings
were added.

Such pendants have been found in both the western
and eastern Mediterranean. Woolley excavated them at Al
Mina in Syria in an early fourth-century BC context while
similar forms were found at Ampurias in Spain from fourth-
and third-century BC tombs. Related examples were found
on Rhodes and Sardinia as well as at Carthage. Scholars feel
that many of these pendants and the related core-formed
head beads may have been manufactured at Carthage since
this city has a high concentration of such beads and
pendants. Many of the pendants are quite large and would
have been too heavy for human apparel. Elaborate collars
for animals have been suggested as a possible explanation,
but this bird and the following one [27] are small enough to
have been worn by a man or woman. The pendants were
widely traded throughout the Mediterranean. At one time,
they may have represented individual gods, but their bright
colors and caricature-like quality must have quickly rele-
gated them to the status of a trinket or possibly, in the case
of the beads, an amulet to ward off the evil eye.

Condition: The entire surface is covered with a
thick buff weathering crust, which shows some pitting
and spalling. SMG

Bibliography: Unpublished.

Comparative literature: L. Woolley, "The Excavations at
Al Mina Sueida," *JHS* LVIII (1938) 158, NM 40, pl. XIV; M. Almagro,
La necropolis de Ampurias I (Barcelona: Seix Y Barral, 1953)
pp. 102, 103, figs. 15-17; G. D. Weinberg, "Glass Manufacture
in Hellenistic Rhodes," *Arkaeologikon Deltion* XXIV, no. 1 (1969)
143, pl. 80a; D. B. Harden, "Ancient Glass, I: Pre-Roman" *Arch J*
CXXV (1969) 57, n. 62; M. Seefried, "Glass Core Pendants Found in
the Mediterranean Area," *JGS* XXI (1979) 17-26, figs. 1, 15, 24,
for general discussion of entire group; T. E. Haevernick,
"Gesichtsperlen," *MadrMitt* XVIII (1977) 152-231 for a catalog
of related face beads.

27 Bird Pendant

Glass. Mediterranean, Syria (?), 4th–3rd century BC.
H. 1.86 cm.; W. 0.9 cm.; L. 2.1 cm.

Translucent blue-gray body, bubbled and filled with
stone or particles of unmelted batch, with applied
trails of opaque white and opaque yellow. It was
formed on a pointed core or tool. The bird is similar to the
preceding pendant [26], although somewhat more com-

26

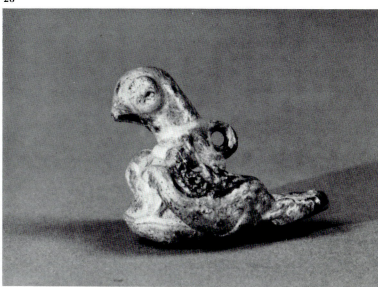

27

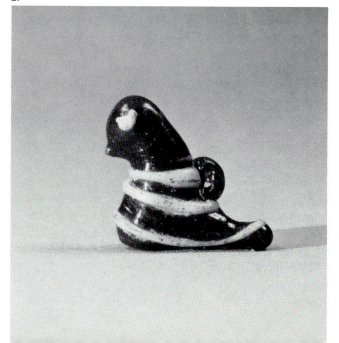

pact and less complicated. The head is heavier and the neck shorter. The eyes are applied in yellow, the body decorated by a horizontal white trail wrapped around three times and left in relief. A blue suspension loop is attached over trails. The tail has been pulled out from the body, the underside pinched to elongate the form.

Condition: The tip of the beak is slightly chipped, otherwise the pendant is unweathered. SMG

Bibliography: Unpublished.

Comparative literature: See [26].

28 Recumbent Bull Amulet

Chalcedony. Early Achaemenian, probably 6th century BC. H. 2.2 cm.; W. 0.8 cm.; L. 2.6 cm.

Bull with neck arched and head bent slightly downward rests with his legs tucked under his body. Vertical or oblique lines separate the legs from the body. A rectangular base with rounded corners is carved in one piece with the bull. The spine is lined with a serrated, zipper-like pattern. Crisscross modeling accents are incised on the shoulders and haunches. The eyes are not delineated. The horns are formed in one mass. The bull is pierced lengthwise near the base, the hole being bored from both ends.

28

The chalcedony bull was probably worn as an amulet rather than as a pendant between beads in a necklace. The attitude of the bull conjures up the massive Achaemenian bull protomes topping columns at Persepolis. An even smaller Achaemenian bull amulet in lapis lazuli is in the Walters Art Gallery, Baltimore (42.221). The musculature on the Walters bull is rendered in a more naturalistic way, the legs being more carefully delineated than the hasty, stylized cuts on the Mildenberg bull, but it has a similar form and the same spinal zipper pattern. The crisscross lines on the chalcedony bull echo the surface decoration of animal figures at Ziwiye. The configuration of the horns and the lack of emphasis on the eyes are also characteristics of much earlier Urartian models (see [17]). Neither the Urartian nor the Achaemenian style is represented here in its purest form. The impression, however, is given of an emerging aesthetic which still owes a great debt to earlier styles.

Condition: Intact except for the missing horn tips. APK

Bibliography: Unpublished.

Comparative literature: Jeanny Vorys Canby, *The Ancient Near East in The Walters Art Gallery* (Baltimore: The Walters Art Gallery, 1974) no. 51; Denise Schmandt-Besserat, *Ancient Persia: The Art of an Empire,* exhib. cat. (Austin: The University of Texas, 1978) p. 73, no. 85.

29 Pair of Bracelets with Calf Heads

Silver, solid cast. Achaemenian, 5th century BC. Diam. 7.8 cm.; W. of rod 0.5 cm.

A pair of bracelets of penannular form. The hoops end in calf heads with flattened ears. The ruff along the jaw line is cold worked. Incised decoration imitating Achaemenian filigree is cold worked behind the calf heads. Two collars circle each neck. First a linear bordered one decorated with a row of punched circles, then one with punched circles, each in the center of a diamond. A thin curving triangle with a punched circle at the tip stretches from the collar along the shank on either side.

Bracelets with confronted animal heads appeared at the end of the Mesopotamian period of Kassite art. They became a favorite with the Luristan bronze casters who produced three loop shapes—tape-like, tubular, and solid— at first with soldered animal terminals and then whole cast. They became most conspicuous in the early first millennium BC at the Assyrian court. Male figures in Neo-Assyrian reliefs are often shown wearing such bracelets on their upper arms.

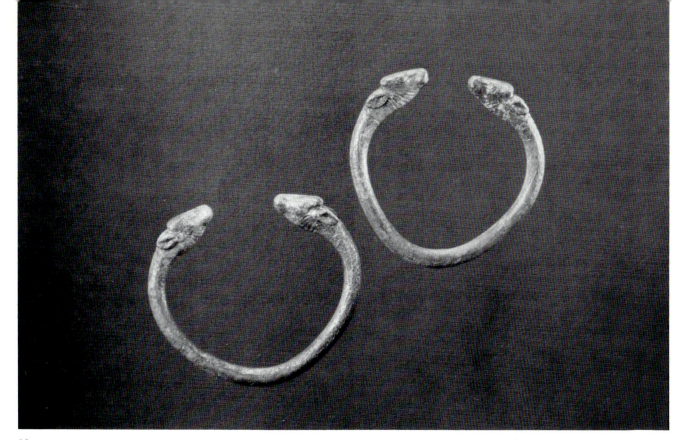

29

Calf heads are the rarest of all bracelet terminals, being far outnumbered by ram or antelope heads during the Achaemenian Period. The circles and crossed lines encompassing circles behind the calf heads occur in the early stage when animal head terminals were cast separately and then soldered to the bracelet. The same ornamental remnant of a previous technical device is observed on a "Luristan" bracelet in the Bröckelschen collection and elsewhere. This ornamental remnant is revived in Achaemenian jewelry. It appears in filigree on bracelets from Pasargadae and here as incised work on the Mildenberg bracelets as well as on Hellenistic gold bracelets.

The fringe around the calves' lower jaws on the Mildenberg bracelets is a feature which occurred in Assyrian jewelry as, for example, on a bracelet in the Louvre and on two bracelets in a Nimrud relief carving (dating in the reign of Ashurnasirpal II, ca. 1060) where they are carried on a tray by an attendant. It is absent from Luristan bracelets but was revived in Achaemenian art in filigree work and in incised decoration imitating filigree. A mold for bracelets ending in a calf head with the characteristic ruff around the lower jaw and very similar in style to the Mildenberg calf heads was excavated at Persepolis. The striations of the ruff do not appear in the mold. The elongation of the head and the manner in which the ruff is worked is in good Achaemenian style comparing well with a solid silver bracelet in Geneva and the calf head on a complex solid silver handle in the Norbert Schimmel collection.

Condition: Unbroken, but heavily corroded. The surfaces of both are blackened. PV and APK

Bibliography: Unpublished.

Comparative literature: Peter Calmeyer, *Altiranische Bronzen der Sammlung Bröckelschen* (Berlin: Staatlichen Museen, 1964) p. 57, no. 130, pl. 64; David Stronach, *Pasargadae: A Report on the Excavations Conducted by the British Institute of Persian Studies from 1961 to 1963* (Oxford: Oxford University Press, 1978) pl. 147; Rodolfo Siviero, *Gli ori e le ambre del Museo Nazionale di Napoli* (Florence: Sansoni, 1954) pls. 156-159, 162; Pierre Amandry, "Orfèvrerie achéménide," *AntK* I (1958) 9ff, cf. 12-14, 17, 18; Erich F. Schmidt, *Persepolis* vol. II: *Contents of the Treasury and Other Discoveries* (Chicago: University of Chicago Press, 1957) p. 79, fig. 16; R. Ghirshman, G. Wiet, et al., *Trésors de l'ancien Iran*, exhib. cat. (Geneva: Musée Rath, 1966) no. 643, pl. 54; *Schimmel Catalog* (1974) no. 158.

30 Bracteate with Janiform Lions' Heads

Gold. Persia, Achaemenian, early 5th century BC.
Diam. 4.2 cm.; Th. 0.3 cm.

Bracteates are cut-out ornaments pressed in a thin gold
sheet and sewn on royal garments. They are depicted on
the carved reliefs of Darius and Xerxes at Persepolis (see
comparative literature [31]). Framed within a toric and
braided circle, the bracteate was stamped with two
addorsed roaring lions' heads. The slanting eyes are set in
vigorously accented sockets. The snarling nose and upper
lip are furiously wrinkled. Muscles in the form of slings
swell the cheeks. The tongues jut out from between
wide-open jaws and bare, sharp fangs. The chins end
in a sort of clog shape. The median line between the
heads—their common mane—is designed like a Tree of Life
made of pairs of palm fronds, each pair flaring outward
from one of a vertical column of fourteen punched dots.
Three loops for attachment were soldered to the back.

This bracteate differs from all other Achaemenian
examples in that it is not executed in openwork. Also lions'
heads on bracteates usually face each other. When the
bodies are represented, they are back to back and the
heads look over their shoulders at each other, thus
re-establishing a synthetic scheme, as in the decoration
on a bracteate in the British Museum (13211). The antithetic
composition of animal heads appeared early on a military
standard carved on a relief from the palace of Sargon II
(722–705). It decorates an Achaemenian gold belt ornament
and dagger pommel in the Metropolitan Museum and a
later Scythian hilt under Iranian influence, from Chertomlyk,
now in the Hermitage. All those examples predate the
Achaemenian gold bracteates. None offers the perfect
janiform pattern of the Mildenberg bracteate. Finally, the
juxtaposition of a Tree of Life and of two winged lions
coalescing into a single frontal head is observed on a gold
plaque for a garment coming from Ziwiye, in Kurdistan, also
in the Metropolian Museum. There was in the Kofler-Truniger
collection a gold plaque from Ziwiye with four lions, back
to back in pairs, left and right of a Tree of Life.

It seems that the Mildenberg bracteate represents an
early stage in the decoration of gold bracteates, affording a
link between the art of Ziwiye and that rooted later in
Hamadan which is illustrated by a series of bracteates. It
could date towards the end of the reign of Darius who died
in 485 BC. See also [31].

Condition: Almost pristine except for a small split in the
rim near 12 o'clock. PV

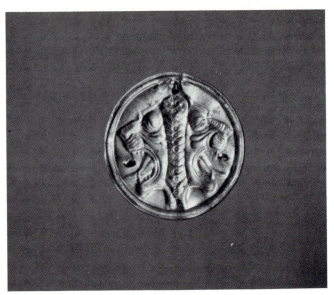

30 See also colorplate VIII

Bibliography: Bloesch et al., *Das Tier*, p. 61, no. 373, pl. 62.

Comparative literature: Helene J. Kantor, ''Achaemenid Jewelry in
the Oriental Institute,'' *JNES* XVI (1957) 1-23, pls. III, VII-IX; R.D.
Barnett, "Ancient Oriental Goldwork," *BMQ* XXII, nos. 1/2
(February 1960) 29-30, pl. VII; R. Ghirshman, *Persia from the Origins
to Alexander the Great*, trans. Stuart Gilbert and James Emmons
(London: Thames and Hudson, 1964) pp. 380, 358, fig. 463; K.R.
Maxwell-Hyslop, *Western Asiatic Jewellery, c. 3000–612 BC*
(London: Methuen and Co., 1971) pp. 210-211, pls. 173-175;
Charles K. Wilkinson, "Assyrian and Persian Art," *BMMA* XIII
(March 1955) 213-224; R. Wehrli, *Sammlung E. und M.
Kofler-Truniger, Luzern*, exhib. cat. (Zürich: Kunsthaus Zürich,
1964) no. 382, pl. 28.

31 Striding Lion Bracteate

Gold. Achaemenian, 5th century BC. H. 1.8 cm.;
W. 0.05 cm.; L. 2.1 cm.

The bracteate represents a lion passant impressed on a
thin leaf of gold (see also [30]). The open mouth shows the
delicately incised interior. Along the spine the fur is
intimated by hatched oblique lines. The mane is rendered
as a grid of striated tufts. The tail is completely curved back
for reinforcement forming a horseshoe shape. The muscular
chest and rump are stamped with isolated designs both
decorative and expressive of the redoubtable vitality of the
animal. The taut sinews in the legs are pregnant with savage
energy. The eye in its crescent-shaped socket and the claws
are marked by tear-drop shapes. On the back are soldered
five tiny loops.

In Sumerian the word *urgula* (in Akkadian *urgulu*) designated lion bracteates appliquéd on representations of garments of the gods. The Achaemenian kings appropriated the divine ornaments.

Two gold lions with loops on their backs were found in the treasury at Persepolis. One of them is modeled in the fashion of lions carved on the reliefs of the palace at Persepolis. Lions passant adorn the hem of the sleeve of the king's cape on a relief of Xerxes' harem there and that of the king's robe in Darius' main hall. The Mildenberg bracteate compares also with the lions carved in low relief on the tomb of Artaxerxes II, above the royal audience scene at the top of the east jamb of the eastern doorway in the northern wall, and those adorning the king's chariot in the great tribute procession. Lions passant found at Hamadan (ancient Ecbatana) have entered various public and private collections. Their bodies are partitioned in order to receive inlays of glass paste, and six loops are soldered in their backs. The lion's mane of a Persian bracteate discovered at Dodona (Greece) is inlaid. Nine bracteates shaped like winged sphinxes excavated in Sardis (Turkey) are provided with eight to ten loops each. Striding animal bracteates were also adopted by the Scythians as attested by examples from Maikop. Numberous other examples exist. A large collection of striding lion bracteates is in the Oriental Institute, Chicago.

Condition: Perfectly preserved. PV

Bibliography: Unpublished.

Comparative literature: Erich F. Schmidt, *Persepolis: vol. I Structures, Reliefs, Inscriptions* (Chicago: The University of Chicago Press, 1953) pls. 142, 195, 198A,B; *Persepolis: vol. II, Contents of the Treasury and Other Discoveries* (1957) pp. 77-78, fig. 14b; Ernst E. Herzfeld, *Iran in the Ancient East* (Oxford: University Press, 1941) pls. LXXII, LXXIV; A. Leo Oppenheim, "The Golden Garments of the Gods," *JNES* VIII, no. 2 (April 1949) 172-193, cf. 177 and 188; Helene J. Kantor, "Achaemenid Jewelry in the Oriental Institute," *JNES* XVI (1957) 1-23, pls. III-V; "Chronique des fouilles et découvertes archéologiques en Grèce en 1955," *BCH* LXXX (1956) 300, fig. 2; C. Densmore Curtis, *Sardis XIII: Jewelry and Gold Work, Part 1, 1910–1914* (Rome: American Society for the Excavation of Sardis, 1925) pl. I, no. 2; Pierre Amandry, "Orfèvrerie achéménide," *AntK* I (1958) 9-23, cf. 9-10, pl. 7, fig. 1; cf. *ILN* 17 July, 1948, pp. 58-59, fig. 7; Farkas, Piotrovsky, et al., *Scythians: Treasures*, pp. 156-157.

32 *Springing Leopard Finial*

Glazed chalcedony and traces of iron. Achaemenian, 4th century BC. H. 2.7 cm.; W. 1.4 cm.; L. 4.5 cm.

The snarling leopard springs from a stylized lotus flower. His teeth and the wrinkles on his muzzle are incised. His ears are flat against the back of his head. He wears a wide collar decorated with a row of dots between two linear borders like a stitched and studded leather collar. The ruff of fur around his lower jaw partially covers the collar in front. Two rib marks are subtly carved, rather than sharply incised. Dots indicating the animal's coloring are very lightly drilled at random over the body. Glaze remains thickly applied to the lotus and in lesser amounts in the interstices and protected areas of the sculpture.

The animal's pose at once recalls the Parthian springing leopard incense burner handles (see [33]), but the tension in this leopard's arched neck, tucked chin, and snarling face is purely Achaemenian. The absence of the usual Achaemenian shoulder musculature and the softness of the rib marks probably indicate Greek influence. The collar may be a miniature of the rosette-studded ones worn by bulls on reliefs at Persepolis.

The leopard was not a popular motif in Achaemenian art, but as Dionysus' mascot (see [174]) was well represented in Greek art. Therefore, not only elements of style, but the subject matter itself is also probably under strong Western influence.

31

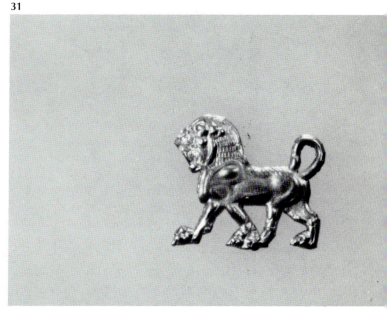

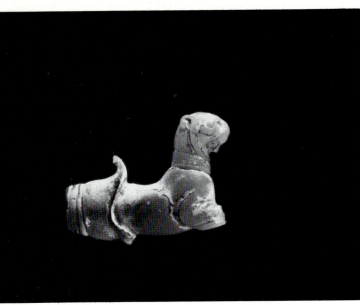

32

As a practical object, it is not unlike the bronze lion portions of an investiture ring in the Borowski collection. The ring is somewhat more Parthian in style, but the lions are similar in size to the Mildenberg leopard and they emerge from lotus flowers as well.

Although the technique used here may seem like a classic case of gilding the lily (or lotus), this stone is not a particularly beautiful example of chalcedony.

Condition: The lotus is split in half. This break continues on a diagonal through the leopard's left shoulder. The forelegs are broken off in front of the cat's chest. Some of the iron pin shaft remains imbedded in the center of the flower and has discolored the chalcedony in that area. APK

Bibliography: Unpublished.

Comparative literature: Erich F. Schmidt, *Persepolis:* vol. i *Structures, Reliefs, Inscriptions* (Chicago: The University of Chicago Press, 1953) pp. 83 n. 98, 225, pls. 135, 153; R. Ghirshman, G. Wiet, et al., *Trésors de l'ancien Iran,* exhib. cat. (Geneva: Musée Rath, 1966) p. 119, no. 664, pl. 67.

33 *Handle of an Incense Burner in the Form of a Leopard*

Bronze, solid cast. Persia, Parthian Period, ca. middle of 1st century AD. H. 3.9 cm.; W. 2.2 cm.; L. 10.2 cm.

The leopard stands on his hind legs and rests his forefeet on a now lost flat dish. It compares closely with a complete incense burner with a similar handle coming from Burūdjird in Luristan, now in The Cleveland Museum of Art (61.32). There is a hole for the rivet used to attach the left paw of the Mildenberg leopard to its dish. The one driven through the right paw was filed off probably at the time the dish was discarded. The casting was left in a rough state with no chasing added for anatomical details. The tail is coiled around the left leg. Some fur is intimated on the top of the head between the ears by three furrowing indentations. There is a sort of ruff beneath the chinline but no collar at the base of the neck, as in the Cleveland bronze handle. The body was punched with ocellations for hollow spots on the leopard's fur. Dotted circles also represented cosmic symbols and therefore had amuletic value.

Two similar incense burners with animal-shaped handles were excavated in Taxila, Pakistan. One, in the form of a rampant lion, also has holes in his forefeet for attachment to the incense pan; the other in the shape of a horned and winged lion is still attached to a three-leg incense pan. His hind legs rest on a small pedestal, which we may also surmise was the case with the Mildenberg leopard. The Taxila incense burners were excavated in strata dating before the Kushan attack on Taxila in AD 60.

A beautiful panther rearing on her hindlegs and raising her left forepaw (the right forepaw formerly lying on a lost censer vessel) could be seen in 1979 at the Habib Anavian Gallery in New York. Another panther with two paws formerly resting on a lost censer vessel was auctioned at Hôtel Drouot in Paris. A different Parthian handle in the form of a springing leopard with a hollow body and only the head and neck cast solid is in the Norbert Schimmel collection, and one shaped like a springing horse was auctioned at Hôtel Drouot. Examples are also known of Parthian censer handles shaped like a doe or winged griffin.

Condition: Intact except for holes mentioned above. The patina has a delicate dark gray-green sheen. PV

Bibliography: Unpublished.

Comparative literature: Mehdi Bahrami, "Courrier d'art de Téhéran, Encensoir de bronze de l'époque parthe," *Artibus Asiae* xi (1948) 288-292, figs. 1, 2; Sir John Marshall, *Taxila: An Illustrated Account of Archaeological Excavations Carried out at Taxila under the Orders of the Government of India between the Years 1913 and*

1934, vol. I: *Structural Remains* (Cambridge: University Press, 1951), 148, 194; vol II: *Minor Antiquities*, 596, no. 322; vol. III: *Plates*, pls. 176, no. 322, 184,l; *Schimmel Catalog* (1974) no. 164; Ayako Imai, *Catalogue of a Selection of the Habib Anavian Collection* (New York: Habib Anavian, 1979) no. 5; *Bronzes et terres cuites du Louristan et la Caspienne*, sale cat. (Paris: Nouveau Drouot, 26 September 1980) no. 144; P.R.S. Moorey, *Ancient Iraq* (Oxford: Ashmolean Museum, 1976) p. 50, pl. XXXVI; *Bronzes du Louristan et d'Amlash*, sale cat. (Paris: Hotel Drouot, 22 May 1980) no. 379.

34 *Oval Medallion with Eagle and Two Swans*

Gold cloisonné inlaid with turquoise stone and blue and red glass. Late Achaemenian, 4th century BC. Diam. 2 cm.; H. 3 cm.

An oval gold medallion pierced lengthwise, one side decorated with a highly stylized cloisonné design. An eagle spreads its wings, the tips curve upward and inward. He grasps in his claws two round objects and hovers above a sleeping bird, perhaps a swan. The bird sleeps with his bill resting on his back. The same motif, repeated above the eagle, is tangential with his skull, beak, and wing tips. A nine-petal rosette fills the space between each of the eagle's wings and the border of the medallion. The gold cloisons are filled mainly with turquoise, but there are also remains of lapis lazuli-colored glass and traces of red glass.

The medallion is made in two layers—cloisons are laid in the top layer, and in the lower layer, a tube passes lengthwise through the hollow space. A cord for attachment would have been threaded through it. A comparable but different system of attaching an oval gold medallion to a necklace is found in an Iranian necklace in a private collection (New York) and in a similar later Parthian necklace in the Rabenou collection. The comparison extends to a gold necklace with an oval medallion suspended lengthwise, which was excavated at Kerch on the Crimean peninsula, and to another one from nearby Jüz Oba on the Cimmerian Bosporus. The possibility should not be discarded, however, that in spite of its size the Mildenberg medallion was set in a ring. Such a mounting is suggested by rings found in the Seven Brothers barrow in the Kuban region north of the Black Sea (one from nearby Great Bliznitsa in the Taman peninsula) and two others from Kerch just across the Cimmerian Bosporus.

33

34 See also colorplate XIV

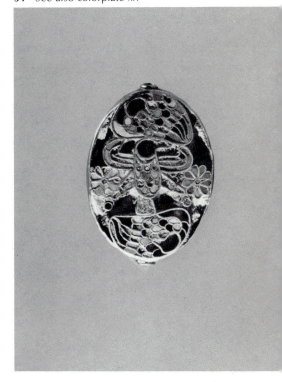

The technique of inlaying gold with gems, mainly turquoise (which would have been imported from Sogdia) or vicariously glass paste, was used in a collar and an armlet excavated in Susa (Iran; now in the Louvre) and two armlets from the Oxus region (now in the British Museum). The method, already ancient in Egyptian jewelry, was adapted on Assyrian ivories found at Nimrud (Iraq) and became a hallmark of Achaemenian jewelry. Two Achaemenian gold earrings inlaid with the symbols of Ahura Mazda on a crescent-shaped moon are shared between the Museum of Fine Arts in Boston and the Norbert Schimmel collection. Muscarella cites several similar examples.

The technique of gold cloisonné with gems and glass pastes spread to the Scythian area near the Black Sea, although enamel was preferred there. A buckle discovered at Kurdzhips in the Maikop district (in Krasnodar, southwest of Stalingrad and north of the Black Sea) is decorated with enameled rosettes following the Persian type. Is it purely coincidental that the odd number of petals of the Mildenberg rosettes is shown also on a gold cloisonné ring filled with nine vitreous pastes, found at Vaphio, now in the National Museum, Athens?

It is not easy to locate the origin of the medallion decoration with precision. The shape of the Mildenberg eagle is close to an aquiliform ornament attached to a gold necklace excavated at Susa and to two bracteates in the British Museum Oxus treasure. An eagle clawing an ibex and an eagle clawing a stag were found in Siberia and are now in the Hermitage. The image is also similar to the Egyptian Horus falcon who is often shown in jewelry displayed and clasping two round *shen* signs in his claws.

A relief of an eagle attacking a bird surmounted by a fantastic winged and horned animal appears on the south façade of the tenth-century Church of the Holy Cross in Aght'amar, on Lake Van. The model was probably transmitted by Sasanian art and may be the Christian copy of a time-honored symbol. The Aght'amar relief is the only instance I noted of an eagle motif bracketed between two birds.

The technical tradition represented by the Mildenberg medallion was supposedly transmitted through a long period of time and possibly it could be a work combining Scythian and Iranian art that originated in the Black Sea region. It is more tempting to look in that direction rather than towards the Caspian Sea. Formally and technically, however, it remains connected with the jewelry of the Oxus River.

Condition: There are many losses in the inlays. But as a whole, the medallion is a better preserved work of cloisonné gold than any Achaemenian jewelry already published. The crumbly white texture in some areas of the background must be decayed glass paste, as is the case with objects from the treasure of Persepolis. Lapis blue glass remains in the field below the proper right flower. Traces of red are in the center of that same flower as well as in the feathers of the bottom bird figure. PV

Bibliography: Unpublished.

Comparative literature: S. Kahn, R. Ghirshman, et al., *Sept Mille ans d'art en Iran*, exhib. cat. (Paris: Petit Palais, 1961–1962) nos. 740–741, pls. LXXV, LXXVI; E. H. Minns, *Scythians and Greeks: A Survey of Ancient History and Archaeology on the North Coast of the Euxine from the Danube to the Caucasus* (Cambridge: University Press, 1913) p. 427, fig. 318; p. 208, fig. 106(8); p. 401, fig. 294(8); p. 411, fig. 298; *Schimmel Catalog* (1974) no. 156; O. M. Dalton, *The Treasure of the Oxus with Other Examples of Early Oriental Metal-work*, 3rd ed. (London: The British Museum, 1964) p. 34, no. 117, fig. 65, pl. XII, no. 33, pl. XXI, no. 34; N. Kondakov, J. Tolstoï, and S. Reinach, *Antiquités de la Russie méridionale* (Paris: Ernest Leroux, 1891) p. 316, fig. 282, p. 381, fig. 334; Marc Rosenberg, *Geschichte der Goldschmiedekunst: IV Zellenschmelz: I Entstehung* (Frankfurt: Joseph Baer, 1921), p. 23, fig. 13, p. 25, fig. 27I; Sirarpie Der Nersessian, *Aght'amar Church of the Holy Cross* (Cambridge, MA: Harvard University Press, 1965) p. 14 and fig. 29.

35 *Migratory Bird in Flight*

Bronze. Iran, Scythian, 7th century BC. H. 1 cm.; W. 3.1 cm.; L. 4.6 cm.

The neck of the bird is outstretched. The eyes are globular. Scythe-like wings curve back to form a crescent. They are decorated, as is the bold, flared tail, with several straight deep incisions. There is on the reverse a small ring suggesting that the bird was a unit in a string of birds threaded together.

The general outline of the object resembles those of seventeen gold birds with flared tails that were excavated in Melgunov's barrow twenty miles from Elisavetgrad in the southern Ukraine. Similarly incised bronze accessories in the shape of sitting ducks were found in a Scythian horse burial in the Seven Brothers barrow in the lower reaches of the Kuban in Krasnodar, southwest of Stalingrad. Their wings, however, are triangular and not crescent-shaped. But scythe-like wings characterize comparable marsh birds, of which there are two examples in the Louvre (21.390-1) and one in the Adam collection. Moorey has hypothesized that these represent a stray vestige of Scythian occupancy in Iranian territory in the second quarter of the first millennium BC.

Condition: Intact. Minute loss from right wing. Black patina on top, dark green below. PV

Bibliography: Unpublished.

Comparative literature: E. H. Minns, *Scythians and Greeks: A Survey of Ancient History and Archaeology on the North Coast of the Euxine from the Danube to the Caucasus* (Cambridge: University Press, 1913) p. 172, fig. 69; M. I. Artamonov, *Treasures of Scythian Kurgans in the Collection of the State Hermitage* (in Russian) (Prague: Artia, 1966) p. 11, fig. 5, p. 36, fig. 66; P. Amiet, "Notes d'archéologie iranienne: A propos de quelques acquisitions récentes du Musée du Louvre," *La Revue du Louvre et des Musées de France* XIX (1969), 330, fig. 11, 332-333; Moorey, *Adam Collection* (London: Faber and Faber, 1974) p. 96, fig. 62

36 *Crouching Boar Bridle Ornament*

Bronze. Iranian, probably 6th century BC. H. 2.6 cm.; W. with prong 2 cm.; without prong 0.9 cm.; L. 4.8 cm.

A crouched boar, represented in strict profile to the left, doubles his left hind leg under his belly and lays his snout on his extended left forepaw. On the spine the bristling crest starts before the left ear and stops at the small of the back. His curled tail hangs flush with his hams. On the back there is a cubic tenon pierced vertically and horizontally with four holes for attachment of leather straps. On each side of the tenon lies an irregular, oval-shaped depression.

The pattern, the dimensions, and the tenon correspond exactly with a pair of bronze Iranian boars in the Teheran Museum studied by Pierre Amandry in 1962. The same system for attachment is found on ivory plaques compared with the bronze ones by D. P. Hansen and published later the same year. A gold-over-bone plaque with the same kind of tenon is in the Metropolitan Museum (1979.352.1) under the caption of "Scythian style." Two highly stylized gold boar bridle ornaments are in the collection of Mr. and Mrs. Douglas J. Bennet, Jr. A third one was in the Brummer collection. According to Amandry the motif of the animal doubling his hind legs under his belly and stretching his forelegs in continuation of the belly line has been indiscriminately attributed to Scythian art for a long time, whether the animal represented was a boar, a stag, a goat, or an ibex. Actually this idea was not born in Scythia, but in Mesopotamia and spread from there to Anatolia and the Mediterranean Near East, including Greece. When it went north of the Caucasus, however, Scythian art gave it wide recognition.

Condition: Intact with a beautiful green patina. PV

Bibliography: Unpublished.

Comparative literature: Pierre Amandry, "Un motif 'Scythe' en Iran et en Grèce," JNES XXIV, no. 3 (July 1965) 149-160, pl. XXIX, nos. 3, 4, 6-8; D. P. Hansen, "An Archaic Bronze Boar from Sardis" *BASOR* no. 168 (December 1962) pp. 27-36; *Notable Acquisitions 1979–1980 Selected by Phillippe de Montebello, Director* (New York: The Metropolitan Museum of Art, 1980) p. 10; E. C. Bunker, C. B. Chatwin, and A. R. Farkas, *"Animal Style" Art from East to West*, exhib. cat. (New York: Asia Society, 1970) pp. 48, 58, no. 35. *Catalogue of the Ernest Brummer Collection of Egyptian and Near Eastern Antiquities and Works of Art*, sale cat. (London: Sotheby and Co., 16, 17 November 1964) pp. 70-71, no. 174.

37 *Strap Ornament in Form of a Rabbit*

Bronze. Black Sea Region, 4th century BC. H. 1.5 cm.; L. 1.1 cm.; W. with prong 1.4 cm.

The rabbit is represented facing right in strict profile with one foreleg and one hind leg doubled up against its belly. The ear, flattened on the neck, makes a continuous curved line with the spine and the tail. The eye socket is exaggerated, but the nostril only slightly indicated.

It is unclear whether the crouching rabbit is frozen out of terror, or if it must be cataloged as another "Scythian" animal motif (see [36]). The ornament is provided with a half loop in the back as on those gold hare appliqués found on the garments of warriors in a grave

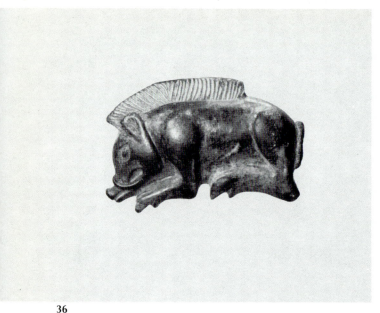

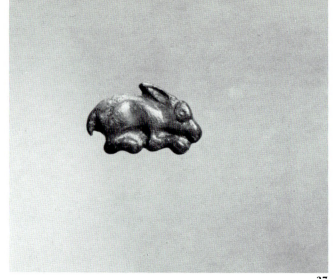

36

37

at Nymphaeum, in Crimea, and in the Romny barrow on the left bank of the Dnieper.

In the vast expanse of lands occupied by the Scythians, the rabbit is rarely met as an ornament although the hare was known to inhabit these areas. Few were found in the frozen tombs of Siberia, and they exhibit the twisted rump characteristic of pure Scythian art. The motif must have been born in the goldsmith's workshops of the Black Sea, where Greek craftsmanship combined with the "animal style" traditional south of the Caucasus, before its migration to the north.

Condition: Intact. The green patina covers the tail, rump, back and shoulders as well as the greater part of the reverse and part of the loop. PV

Bibliography: Unpublished.

Comparative literature: E. A. Gardner, "Ornaments and Armour from Kertch in the New Museum at Oxford," *JHS* V (1884) 62-73, pl. XLVI, 7; E. H. Minns, *Scythians and Greeks: A Survey of Ancient History and Archaeology on the North Coast of the Euxine from the Danube to the Caucasus* (Cambridge: University Press, 1913) p. 101, fig. 83; M. Vickers, *Scythian Treasures in Oxford* (Oxford: Ashmolean Museum Publications, 1979); Sergei I. Rudenko, *Frozen Tombs of Siberia: the Pazyryk Burials of Iron Age Horsemen,* trans. M. W. Thompson (London: J. M. Dent and Sons, 1970) p. 254, pl. 102, I; B. Piotrovsky et al., *Avant les Scythes,* exhib. cat. (Paris: Le Réunion des Musées Nationaux, 1979) p. 59.

38 *Pawing Lion*

Bronze. Thracian (?), 3rd century BC. H. 4.2 cm.; W. 0.6 cm.; L. 4.3 cm.

Relief in strict right profile of a lion passant, lifting his foreleg. The body which flares up to the rounded rump was reworked by hammering and presents four parallel facets along its full length. Only a stump of the tail remains. The hind leg extends down from its joint like a rod ending in a boot. The foreleg is piston-shaped, the shoulder in high relief against the body. The thick long neck was faceted by hammering. The ear was left flat and flush with the neck. The mane was grooved into a ruff. A ridge marks the articulation of the open jaws. Between them the tongue is simply rendered as a bar. The pudgy nose is very small, and there are no indications of nostrils. The piece was probably used as a horse bridle appliqué. The reverse of the head and body are concave.

This little bronze has a feature pointing to Celtic art—incipient deformation through excessive articulation of limbs, as in the silverware and coins of the Celts—but it retains Near Eastern overtones. The combination belongs to an artistic culture where Celtic patterns mechanized the "animal style" of Asia Minor. The blend occurred in Thrace as of and after 400 BC. Curiously enough, the hybrid forms engendered in the Sub-Carpathian regions had a much later revival in a sub-branch of Scythian art—the so-called Martinovka

culture of the Ukraine, revealed by bronze appliqués made to be mounted on saddles. There is no doubt that the Mildenberg lion is much older and is a removed descendant of the voracious animals decorating silver vessels from Hagighioł in the Dobrudja district west of the Danube delta on the Black Sea and the gold helmet of Cọtofeneşti. It harks back even to an animal group on the lid of a brewer's coffer from Gordion ca. 500 BC.

Condition: The tail is missing. The patina is olive green. PV

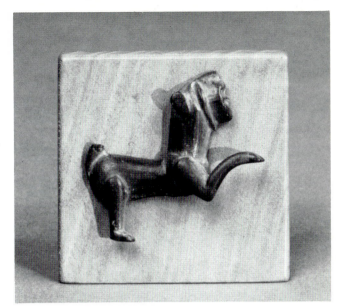

38

Bibliography: Unpublished.

Comparative literature: Paul Jacobsthal, *Early Celtic Art* I (Oxford: Clarendon Press, 1944) pp. 36-39; Farkas, Piotrovsky, et al. *Scythians: Treasures,* p. 127, no. 184, pl. 28; Jessica Rawson, ed., *Animals in Art* (London: British Museum Publications, 1977) pp. 8-9; Karl Schefold, "Die iranische Kunst der Pontusländer (Südrussland und Thrakien)" in *Handbuch der Archäologie,* 2 vols. (Munich: C. H. Beck'sche Verlagsbuchhandlung, 1954) I, 423-454, II, pls. 63-68; T. G. E. Powell, "From Urartu to Gundestrup: The Agency of Thracian Metal-work," in *The European Community in Late Prehistory: Studies in Honour of C. F. C. Hawkes,* ed. John Boardman, M. A. Brown, and T. G. E. Powell (Totawa, NJ: Rowman and Littlefield, 1971) pp. 183-210, fig. 47; D. Berciu, *Contribution à l'étude de l'art Thraco-Gète,* Bibliotheca Historica Romaniae Monograph XIII (Bucarest: Editura Academiei Republicii socialiste România, 1974) pp. 60-67, 85-92.

39 *Stocky Zebu or Buffalo*

Bronze, solid cast. Iran or Caucasus, 9th–7th centuries BC. H. 6.8 cm.; W. 3.1 cm.; L. 7.7 cm.

The head, neck, and dewlap are much too large for the rest of the body and give this bull a comic appearance. The shape of his horns and his heavy forequarters could identify him as a water buffalo. His eyes and nostrils are also exaggerated and are shaped like craters. Widely separated lips add a liveliness to the face. Three rows of very worn snail curls form the forelock. The ears are almost as large as the talon-shaped horns. Well-articulated shoulders and haunches stand in moderately high relief from the body, the haunches wrapping around over top. His hocks and knees are very knobby, and his cloven feet have almost human proportions. The stocky tail hangs down, quietly echoing the large genitalia. The zebu is cast in one piece with a flat plate base.

The well-marked shoulder and wrap-around haunch are characteristics found in Luristan bronzes (see also [15]) and in eighth-century BC Anatolian bulls. A mid-first–millennium bronze in the Norbert Schimmel collection has a large head and ears, crater-form eyes, less knobby knees

39

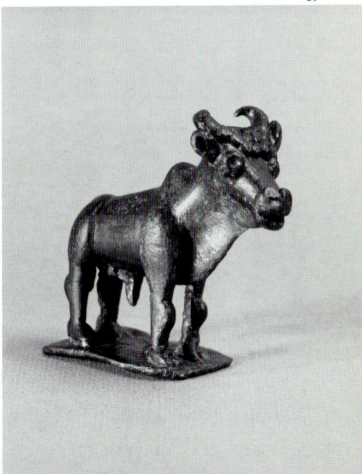

and hocks, and exaggerated hooves. Crater-form eyes and nostrils are usually associated with Scythian and other northern "animal style" works of art. The famous seventh-to sixth-century Scythian gold stag shield plaque has similar features as well as the large head and ears, and long hooves. Perhaps the clearest indication of date is the snail-curl forelock borrowed from ninth- to eighth-century royal Assyrian coiffures. This feature could also be a reworking of the long wavy Urartian forelock in the seventh century BC (see [18]).

Condition: Much surface wear from corrosion. Black patina with patches of cuprite especially on dewlap. Right front corner of base lost. APK

Bibliography: Unpublished.

Comparative literature: R. Ghirshman, G. Wiet, et al. *Trésors de l'ancien Iran,* exhib. cat. (Geneva: Musée Rath, 1966) p. 106, no. 540, pl. 35; Diana M. Buitron, "The Cult of the God at Kourion," *The Walters Art Gallery Bulletin* XXXIII, no. 3 (December 1980) 1-2; *Schimmel Catalog* (1974) no. 152; Farkas, Piotrovsky, et. al., *Scythians: Treasures* p. 100, no. 18 and color pl. 3.

40 *Wide-Eyed Wolf*

Bronze, solid cast. Steppes, second half 1st millennium BC. H. 4.8 cm.; W. 2 cm.; L. 9 cm.

A stocky animal with a long muzzle, short pointed ears, a thick neck, a stiffly hanging tail, and short legs. The eyes are sharply cut disks within punched circular rims. The nostrils are represented by a single hole. The strong jaws are differentiated by a slit. The paws are cursorily but suggestively modeled. After casting, the hair was tooled as thin, barely visible lines.

This bronze and the following one [41] share common traits—simple tubular anatomical masses, over-large heads, blunt snouts, circular punched eyes, deeply punctured nostrils, rigidly straight forelegs, and bent hind legs. The head size and facial features occur on Mongolian bronzes of the Warring States Period (481–221 BC). Usually the haunches of Chinese bronze animals have a rounder and more springy appearance, but the animal's haunches on a second-century bronze plaque from Hsiung-nu have very straight lines. Similar punched eyes, punctured nostrils, and oversized heads appear on late Ordos and Tagar bronzes. Punched eyes are seen throughout the Steppes in Altai, Scythian, and Sarmatian bronzes. The tubular forms and thick tail appear on horse-shaped handles for a first-century BC Sarmatian cauldron. Predatory beasts including the wolf were a favorite subject matter

throughout the Steppes while bull figures as in [41] are rarely seen above the North Caucasus.

Condition: Intact. Minor corrosion on surface, green patina. APK

Bibliography: Unpublished.

Comparative literature: E. C. Bunker, C. B. Chatwin, and A. R. Farkas, "*Animal Style" Art from East to West,* exhib. cat (New York: The Asia Society, 1970) figs. 97, 98, 124; Karl Jettmar, *Art of the Steppes,* trans. Ann E. Keep (New York: Crown Publishers, 1967) pls. 13, 25; Farkas, Piotrovsky, et al., *Scythians: Treasures,* p. 125, no. 165.

41 *Snorting Bull or Zebu*

Bronze, solid cast. Southern Steppes or North Caucasus, second half 1st millennium BC. H. 5.7 cm.; W. 2.6 cm.; L. 7.8 cm.

The eyes are deeply set in their sockets and simply rendered as disks within punched circular rims. The long muzzle and the wide-open blowing nostrils echo a tradition maintained in late Hittite bronzes. The horns are penannular in shape. The bull's hump seems too small to classify him as the zebu well represented in Amlash terracottas and bronzes. It may rather be a reminder of the suspension collar located at the same place on earlier bronze amulets.

The bull curls his tail over his haunch like the much later Roman Apis ([62]). However, on the bull discussed here the tail is attached firmly to his spine producing a loop which looks as though it were made for suspension like some bronzes from Amlash, but this beast does not balance evenly when suspended.

For further discussion and comparative literature see [40].

Condition: Intact. Matte gray-green patina. Harshly cleaned. APK

Bibliography: Unpublished.

Comparative literature: Jean Gabus and Roger-Louis Junod, *Amlash Art* (Bern: Hallwag, 1967) p. 8; Pierre Amiet, *Arts de l'ancien Iran,* exhib. cat. (Marseille: Musée Borély, 1975) nos. 181, 182, 184.

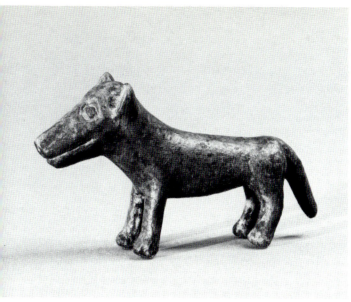

40

41

42 *Belt Buckle with a Recumbent Camel*

Bronze. Sarmatian, ca. 200 BC. H. 4 cm.; L. 7.7 cm.;
Max. Th. 0.6 cm.

A kneeling Bactrian camel turned to the left appears
in open work within a rectangular plaque with which its
silhouette has many points of contact. Its design and
technique align it with the early openwork objects of
Eurasian manufacture before Folkwandering art.

Sarmatian belt buckles are very rare. The Mildenberg
one closely compares with a buckle found in the grave
cemetery of Prokhorovka, a burial ground of Sarmatians
in the region of the Ilek River, north of the eastward bend
of the Ural River above the Caspian Sea. Similar buckles
and plaques are in the British Museum (13.5977, 2-3 and
1921.6.28, 1-2) and further examples in the Metropolitan
Museum and Stoclet collection. A much earlier camel
buckle is in the Foroughi collection, Teheran.

Condition: The piece is eroded and split in the
lower middle part of the framework as well as through
the camel's belly. Dark green patina. PV 42

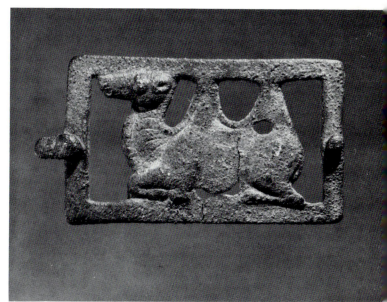

Bibliography: Unpublished.

Comparative literature: T. Sulimirski, *The Sarmatians* (London:
Thames and Hudson, 1970) pp. 86-89, fig. 31 on p. 88; Edith
Porada and Richard Ettinghausen, *7000 Years of Iranian
Art*, exhib. cat. (Washington, DC: The Smithsonian Institution
Traveling Exhibition Service, 1964–1965) p. 83, no. 410, p. 137.

43 *Bowl with Pincered-Decoration of Birds*

Glass. Islamic (probably from Egypt but possibly Near Eastern), AD late 9th–10th centuries. H. 4.5 cm.; Diam. (rim) 11.65 cm.

Translucent light green glass; blown and pincer-decorated. Rim rounded by reheating. Straight-sided wall forms shallow cylindrical vessel with slightly kicked base, thickened at center with pontil mark on bottom. The wall is elaborated with the motif of a standing bird, facing left with a small head and V-shaped tail. The pattern is repeated eleven times.

43 See also colorplate XXI

The outline of the bird was formed in relief on both faces of the pincers, plier-like tools whose jaws contained decorative designs on the inner surfaces. Squeezing the hot glass vessel wall within the jaws would impart the design to the object. Only the eye of the bird stands out in relief, the outline of the bird is pressed into the glass on both inner and outer surfaces. Some play existed in the tool jaws since the two images are not aligned in many of the impressions. This can most easily be seen where the eye on the exterior surface is obliterated by the outline of the beak on the interior surface.

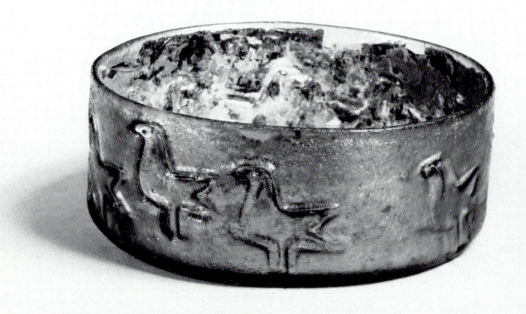

Although not unknown, the bird motif is less common than the rosettes and concentric circles which are usually the hallmark of pincer-decorated wares made in Egypt. Often these motives cover the entire surface with some regularity or symmetrical spacing. It is tempting to suggest that the impressions of this stylized but attentive flock may not have been due to the carelessness of the craftsmen. Perhaps the glassmaker was amused by the sight of a small flock of birds arriving at a newly planted field, eager to dine, but moving cautiously toward their goal, occasionally crowding up on each other. Is it possible that the bowl itself is the object of that feathered flurry? Such a shallow bowl would be difficult for serious human drinking but well-suited as a bird feeder. Smaller footed glass cups and bowls are still used for water and seed in bird cages in the Near East today.

Condition: Thick iridescent weathering crust adheres to interior; exterior surface is slightly pitted where this crust has been removed. SMG

Bibliography: Unpublished.

Comparative literature: C. J. Lamm, *Mittelalterliche Gläser und Steinschnittarbeiten aus dem Nahen Osten*, 2 vols. (Berlin: Verlag Dietrich Reimer, 1929) I, 66-71, II, pls. 16, 18, 19; C. J. Lamm, *Oriental Glass of Medieval Date Found in Sweden and the Early History of Lustre-Painting* (Stockholm: Wahlström and Widstrand, 1941) p. 11, pl. II. 2; A. Lane, "Medieval Finds at Al Mina in North Syria," *Archaeologia* LXXXVII (1938) 70, fig. 12.

44 *Handle with Lion Attachment*

Glass. Islamic, Near East; probably Persia, AD 11th–12th centuries. H. 6.1 cm.; W. (handle) 1.2 cm.

Translucent light green glass; applied and tooled decoration from a blown vessel. Strap handle, bends into a gentle arc, roughly rectangular in cross section, preserving two circular pads which form a thumb rest. An attachment in the form of a lion is applied and tooled from three trails of glass. Immediately in front of the animal, the handle folds where it attached to the vessel rim.

The tail of the lion is joined to the back of the head not only for stability, since the glassmaker has repeated the gentle curve of the handle. The king of beasts is firmly planted on this arc and issues forth an open-mouthed roar. Perhaps he expressed pleasure with the contents of the jug, perhaps impatience at the interval between refills.

Applied trails were a popular decorative motif throughout the history of glass. Islamic glassmakers took particular delight in shaping blobs of applied glass into tiny beasts which guarded the contents of bottles and drinking vessels. None are so prominent or lively as this lion.

Condition: Fragment of a handle from a jug or cup, thin golden iridescent weathering crust adhering to surface, some pitting of surface where this crust has fallen away. SMG

Bibliography: Unpublished.

Comparative literature: P. J. Riis and V. Poulsen, *Hama fouilles et recherches 1931–1938 IV, 2, Les verreries et poteries medievales* (Copenhagen: Fondation Carlsberg, 1957) pp. 57-58, fig. 153; A. v. Saldern, *Glassamlung Hentrich: Antike und Islam* (Düsseldorf: Kunstmuseums Düsseldorf, 1974) pp. 203-204, 250 nos. 304-306, 393 (illus.); "Recent Important Acquisitions," *JGS* VII (1965) 124, no. 17 (illus.).

44 See also colorplate VII

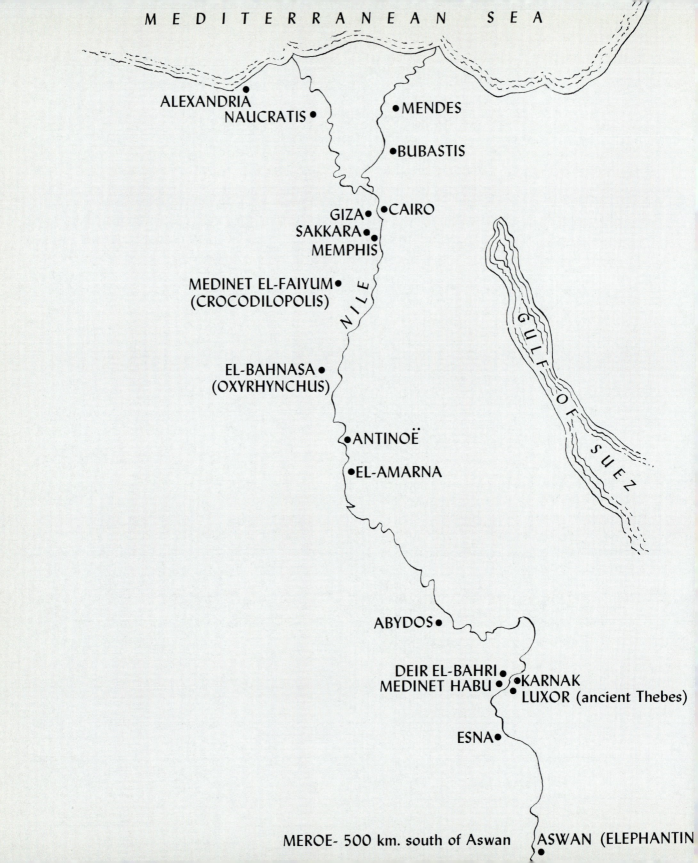

MEDITERRANEAN SEA

ALEXANDRIA
NAUCRATIS ● ● MENDES

● BUBASTIS

GIZA ● ● CAIRO
SAKKARA ●
MEMPHIS

MEDINET EL-FAIYUM ●
(CROCODILOPOLIS)

NILE

EL-BAHNASA ●
(OXYRHYNCHUS)

● ANTINOË

● EL-AMARNA

GULF OF SUEZ

ABYDOS ●

DEIR EL-BAHRI ●
MEDINET HABU ● ● KARNAK
● LUXOR (ancient Thebes)

ESNA ●

MEROE- 500 km. south of Aswan ASWAN (ELEPHANTIN

Animals from Ancient Egypt

The uniformity of Egypt's civilization throughout most of its history contrasts sharply with the rich tapestry of the diverse cultures of the Near East. The eternal fertility of the Nile Valley and the insulation of the bordering mountains and deserts contributed the most to its stability. Egypt's nearly constant climate—changing only with the gradual rise and fall of the Nile waters every year—assured the spread of similar fauna throughout the land, at least in earliest times. Cattle, antelopes, gazelles, hippopotamuses, and crocodiles proliferated there. Various dogs and other canids, hedgehogs, and mongooses thrived. Big cats, especially lions, as in the Near East were plentiful as were the smaller ones. Once domesticated the small cats became great pets of the Egyptians, although if we are to judge from artistic representations they were never popular in the ancient Near East.

In time civilization took its toll on many of these animals, to the extent that today the hippopotamus and the crocodile—the largest and most infamous of the Nile dwellers—roam free only south of the Aswan dam. No less dangerous to the life and limb of Nile sailors than the crocodile, the hippo was associated with Seth, the god of the underworld. As the mythological slayer of King Menes, the unifier of Upper and Lower Egypt, the hippo became the object of ritual royal hunts. The Egyptians tried to move the beast away from the more productive agricultural areas, not just because of his threat to human life. As a nocturnal forager, the animal wrought tremendous damage in the carefully planted and irrigated grain fields.

Sheep and goats which do not seem to have been indigenous to Egypt were imported at the end of the fourth to the beginning of the third millennium BC from western Asia. Giraffes, which had been found within Egypt in earliest times, moved south away from the encroaching agricultural areas, and by Dynasty XVIII they were prized gifts sent from Nubia in the Sudan. Monkeys and apes were brought in from foreign lands, too, as well as elephants and even bears.

Some of these animals—the usual cats and dogs, as well as monkeys and even the occasional gazelle—became beloved pets in wealthy homes. These tame creatures often appear in banqueting scenes on painted tomb walls, sitting beneath their owners' chairs munching on a piece of fruit or a fish. Many of the wild game species such as lions, ostriches, gazelles, and antelopes were kept in royal game preserves for the king to hunt at his leisure.

The Egyptians and the peoples of the ancient Near East shared a wide array of animal types to choose from in developing their art forms, but their approach to depicting these animals differs greatly although a few similarities exist. As ever, the bull symbolizes male might and virility, while the lion represents royal power. But in Egypt the approach to the animal itself was more direct and less tangential. In Egypt, animals were very likely to be major gods, rather than mascots of anthropomorphic gods. There is no more clear manifestation of this statement than the Apis bull—a particular live bull chosen by priests according to very strict physical requirements. The bull was then taken to Memphis where he became a god and was

meticulously cared for until the end of his life. According to Herodotus, his every movement was studied for omens. At his death the Apis was sealed into a colossal stone sarcophagus and buried amidst much lamentation in the huge special underground burial vault at Sakkara called the Serapeum—then replaced with another carefully selected bull.

Animal cults reached the height of their popularity and widespread practice in the Late Period, from about Dynasty XXVI (664–525 BC) onward through the beginning of the Ptolemaic Period (304–30 BC). Workshops turned out bronze votive animal figurines to supply worshippers who offered these sculptures at shrines and temples in return, they hoped, for answers to their prayers. Citizens also did good deeds in the eyes of their gods by paying for the mummification and burial of real animals, such as cats and ibises.

It is easy to oversimplify later Egyptian religion into a series of animal cults. Actually Egyptian religion and the role of animals in it are extremely complex. The success or importance of any deity whether anthropomorphic or theriomorphic depended not on any particular virtue of the animal itself but to a large extent on the political power of the region that was the center of that animal's cult. Bastet, for example, did not become widely popular until her capital Bubastis in the Delta became politically powerful in the Third Intermediate Period (1070–712 BC).

Politics also caused some animals to lose popularity, although others may have lost favor due to their own natural defects. The rise and fall of the turtle as a magical force occurred at such an early date that we can only surmise what the conditions might have been. In the Predynastic Period (ending ca. 3000 BC) the turtle was not only a favorite food but also a popular subject matter for amulets. Only a few hundred years later, however, in the Old Kingdom, the turtle had become an anathema and its name was employed in some very graphic curses. The same sort of reversal at almost the same time occurred in the Near East, not with turtles, but with fish. While fish had been a favorite food millennia earlier, by Assyrian times not just the fish but even the poor fisherman was condemned. The word for "fisherman" was synonymous with a "lawless person." In the case of the Egyptian turtle, perhaps it was the reptile's association with the murky "underworld" that caused his undoing. But one wonders if there might not have been in both cases some very practical reason, such as a communicable disease or parasite dangerous to humans.

Throughout Egypt's history, her approach to animals in both language and art was a very literal one. In a large number of cases, sculptures of animals (for example, in the Mildenberg collection, the seated cat [57], the Ptolemaic recumbent lion [52], the uraeus [48], the frog [47], the falcon [65], and the bull [61]) are all three-dimensional versions of the hieroglyphic signs appearing at the end of the words that signify these animals in the ancient Egyptian language. Many of the spoken words used to identify these animals were taken directly from the animals' own mouths. The word for cat—in ancient Egyptian "miu"—after the sound-signs were written was finished with an idea-sign in the form of an alert, seated cat. Similarly the word for ram, "ba," ended in the figure of a curly horned ram.

This same phenomenon is true of much of Egyptian art. A very large percentage of the motives used in all forms of art—from three-dimensional sculptures of humans and animals to tomb walls to beads in necklaces—are identical with ideograms in the Egyptian written lan-

guage. Some scenes in painted tombs are so full of painted or carved figures in ideographic form that except for the missing syntax observers might feel as though they should literally read the scene. Therefore, it should be no surprise that the standard representation for the Apis bull in Egypt was the striding pose of the ideogram for the word "bull." The twisting, prancing form of the Roman version of Apis held no interest for the Egyptians, for it did not literally signify the idea they sought to express.

This is not to say that every animal was depicted in his "hieroglyphic" form. Certainly there were variations, but the repertoire for each animal was generally not very large and most of the poses for three-dimensional figures avoided any suggestion of movement. Even the "striding Apis" has all four feet rooted in the earth. In addition, the variations for most animals in three-dimensional sculptural figures—not including such decorative arts as furniture mounts, jewelry, and parts of vessels—were simply slight variations of one accepted pose. The Apis could be shown leading either with his right legs or left legs, but he was almost never portrayed recumbent. The lion, on the other hand, was almost always shown lying down, infrequently sitting like a house cat, and just as rarely on foot. The Mildenberg lions illustrate nearly all of the variations of the recumbent pose. The "hieroglyphic" pose occurs both in the inscription [49], of course, and in the later amulet [52]. The first variation [51] of that pose derives from a Dynasty XVIII ancestor, Amenhotep III's guardian lions from his temple at Soleb, and has the alert but casual and unconcerned attitude of a lion who has just eaten well. The second variation is simply a hybrid of the first two [50].

In Egyptian art the lion was always calmly confident, except, of course, when he was the quarry of royal hunting parties. The very presence of the lion as the Egyptians portrayed him was powerful enough to repel any trespasser from the building he guarded. He needed neither to rise to his feet nor to roar threateningly like Hittite or Urartian guardian lions.

The association between the lion and the Egyptian king was also a very literal one. The lion was the king and vice versa. The Meroitic lion [53] is the descendant of a long line of exactly that motif wherein the human figure lies helpless at (or perhaps past) the mercy of the Egyptian king in lion form. Even the word for "prince" or "local ruler" in ancient Egyptian was written with a hieroglyphic ideogram in the form of the forepart of a recumbent and self-composed lion.

If pose or position was very important to the reading of the figure, an important part of that was gesture. This feature is highly important to the full understanding of human figural representation in Egyptian art. And while one does not generally think of a living animal gesturing in the manner of a human being, there are some motions natural to animals. Others that appear in art are translations from human movements. In the bronze cat family [58] the kitten which seems to tease innocently at her mother's chest may actually be raising her paw in the traditional petitioner's gesture. Dogs and cats, both large and small, use this pawing of the air as a natural way of attracting the attention of their superiors, most especially their owners. It is similar to the gesture of human petitioners in Egyptian art who raise one or both hands as they approach the king or divinity. In the animal version, the dog or cat may find it necessary to actually nudge his owner with his paw for the desired result. However, the gesture is very often complete with no physical contact at all. The symbolism of this bronze cat group may be

deeper therefore than is immediately apparent. Perhaps the kitten represents the petitioner or acts as intercessor for him in begging the goddess Bastet's attention to his prayer. We shall see the gesture recur in the Classical World as well.

Human-inspired gestures appear among the Mildenberg animals in very subtle form. The limestone lion [51], a descendant of some of the great animal sculptures of all times, the Soleb lions and the guardian lions of King Nectanebo I, leans on his left elbow like the sated guest at a Roman banquet. His left forepaw is upturned and the paw of the free right foreleg loosely clasps it in a beneficent relaxed gesture of regal composure. In nature, however, the lion, as well as other cats and dogs, lacks the joint necessary for rotating his paw like the hand on a human wrist. The gesture ascribed to the lion here is not bestial but human and is another example of Egypt's personification/humanization of animals in her art.

The spirit which the Egyptians instilled in their animal sculptures is the source of their attraction for Leo Mildenberg. As he says about his magnificent silver *uraeus* [48]—the only one of its kind known—"When I saw it in the dealer's showcase, it glared back at me and pierced me with its eyes. It almost leaped at me. I knew that I had to have it!" The *uraeus* is not the only great object in the Egyptian section. The hippo [46] is a beautifully modeled piece of sculpture with superb surface decoration, and on both accounts it must be ranked among the best Egyptian faience hippos in the world. The same can be said of the striding Apis [61], probably one of the two best of its kind extant.

The turquoise faience recumbent lion [52] has a heritage nearly as impressive as that of the limestone lion [51]. Although the type is well-known in monumental sculpture of the Ptolemaic and Roman periods, fine faience miniatures are extremely rare and this one is probably the finest of all. As a lion he looks old and rather tired, like the 3000-year-old civilization he represents, but some things about him are still the same as they were thousands of years earlier. He is still the "hieroglyphic" lion. In profile view he can be read as nothing but "lion"—the lion, who, from the beginnings of Egypt, represented its king, its power, and its immutability. APK

45 Turtle Amulet

Steatite. Predynastic Period (?), ca. 3200 BC. H. 1.8 cm.;
W. 3.6 cm.; L. 5.8 cm.

From a top or side view this animal resembles the heavily
plated Egyptian land tortoise (*Testudo kleinmanni*), but on
the underside the hind legs and tail are carved in the char-
acteristic "M" shape of the Egyptian water turtle (*Trionyx
triunguis*). The carapace plates are crudely carved, cross-
hatched rows. The plastron is separated from the under
edge of the carapace on each side by a long groove. The
animal lifts his head—which has a pointed nose but not the
long tubular version of the *Trionyx*—like a turtle peering out
of the water.

Turtle figurines are well known from the earliest
periods of Egyptian history, when these animals were
enjoyed for their meat. However, as time went on turtles
came to be considered untrustworthy because they spend
part of their lives underwater which was considered part
of the ancient Egyptian underworld. In much the way later
Egyptians treated the hippopotamus (see [46]), the predy-
nastic Nile dwellers made objects in the turtle's image to
gain him as an ally against the other denizens of the
underworld.

The image presented here is not in the best Egyptian
tradition partly because of the anatomical discrepancies
cited. Crosshatching of the type seen here is also not typical
of Egyptian turtles, although crude, large crosshatched

45

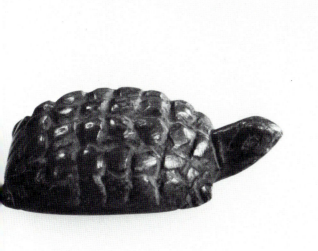

plates do occur. Widely spaced asymmetrical crosshatching
occurs on a faience turtle and on other faience amulets
from the Third Dynasty to Larsa Periods at Ur.

Condition: Intact with minor surface wear. APK

Bibliography: Unpublished.

Comparative literature: Henry G. Fisher, *Ancient Egyptian
Representations of Turtles* (New York: Metropolitan Museum of
Art, 1968) pp. 1-2, 9-11, figs. 17, 19, pls. 1, 2, 17 (no. 69); Sir Leonard
Woolley and Sir Max Mallowan, *Ur Excavations*, Vol. VII: *The Old
Babylonian Period* (London: British Museum Publications, 1976) p.
183, pl. 93.

46 Swimming Hippopotamus

Turquoise-blue faience, Dynasty XI–XII (2040–1783 BC).
H. 6.3 cm.; W. 5.2 cm.; L. 12.8 cm.

The hippo's left legs reach forward, the right legs back,
and the head is held up as if the animal were swimming
beneath the river's surface. His hide is decorated with black
(manganese oxide) drawings of Nilotic flora and fauna.

The drawings on Egyptian faience hippos are fairly stan-
dardized, but certain features of the Mildenberg example
are remarkable. The quality and spiritedness of the drawing
are unexcelled among similar objects. Motifs are placed
with the greatest care and drawn with taut, clean lines. The
field, as is usual, is divided into four quadrants—the top of
the head and neck, each of the two flanks, and the top of
the haunches. The first three quadrants bear open blue
lotus flowers (*Nymphaea caerulia*), buds, and pads. The
fourth is blanketed with the full blossom of the white lotus
(*Nymphaea Lotus*). So situated these motifs enhance the
bulky physiognomy and power of the hippo. Apparently
unique is the combination of two particular animals—a
wide-eyed frog (*Rana mascareniensis*) (see [47]) perched on
the white lotus, his nose in the air as if ready to strike at the
equally wide-eyed butterfly (*Lycaena icarus*?) hovering
above the blue lotus just behind the hippo's withers.

Decorated faience hippopotami have been found only
in tombs of the Middle Kingdom, a time when statuettes of
hippos far outnumbered statuettes of any other animal.
The purpose of these figures is not now known. Since hip-
popotami seemed to spend most of their lives submerged
in the underworld, surfacing only to wreak destruction,
these mammals were considered instruments of the god
Seth, and hippo figures may therefore, have been placed in
the tomb to placate evil spirits or to attract and trap any
which might approach the deceased. Almost all faience
hippos' legs were broken in antiquity, and it is possible
that it was done in order to render the evil spirit harmless.

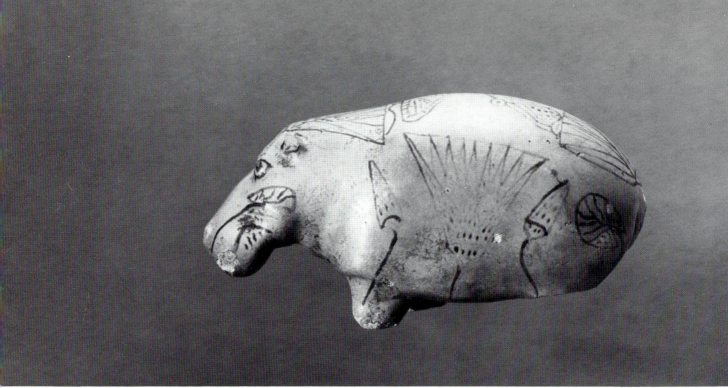

See also back cover

Condition: Small chips are missing from the nostrils, ears, corners of the mouth, tail, and haunches. Legs broken probably in antiquity. Surface has become matte and slightly discolored on the sides. APK

Bibliography: Unpublished.

Comparative literature: L. Keimer, "Remarques sur l'ornementation des hippopotames in faience . . . ," *REgA* II (1929); John D. Cooney, "Egyptian Hippopotami in the Brooklyn Collection," *The Brooklyn Museum Bulletin* XII (Fall 1950) 5-12; Elizabeth Riefstahl, *Ancient Egyptian Glass and Glazes in The Brooklyn Museum* (Brooklyn: The Brooklyn Museum, 1968) pp. 94-95, nos. 11-12, figs. p. 17 and pl. II; William C. Hayes, *The Scepter of Egypt* 2 vols. (New York: Metropolitan Museum of Art, 1953) I, 226-227, fig. 142.

47 *Frog Amulet*

Cornelian. Dynasty XVIII (1550–1307 BC). H. 0.7 cm.; W. 0.9 cm.; L. 1.2 cm.

A *Rana mascareniensis*, a variant of the edible *Rana esculenta*, sits on a smooth base, his nose pointed in the air. The cornelian is bright orange with one black streak over the eyes. The piece is pierced from front and from back, the openings joining close to the tail.

Frog amulets were commonly worn by both the living and the dead in antiquity as a charm that would provide fertility for the former and rejuvenation and long life after death for the latter. Innumerable similar examples exist.

Condition: Intact. APK

Bibliography: Unpublished.

Comparative literature: John D. Cooney, "Intaglios, Cameos, and Related Works," *The Bulletin of the Cleveland Museum of Art* LV (April 1968) 119 and fig. 9; W. M. Flinders Petrie, *Amulets* (London: Constable and Co., 1914), p. 12, pl. II; G. A. Reisner, *Catalogue général des antiquités égyptiennes du Musée du Caire: Amulets* (Cairo: Institut français d'archéologie orientale, 1907) pp. 188-192, pls. XXIII-XXIV, nos. 12452-12482.

46 top

47

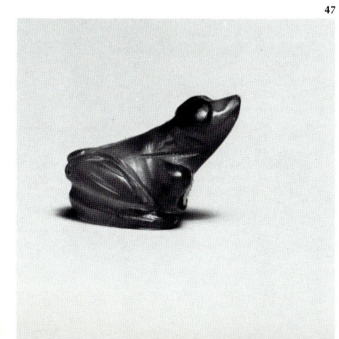

48 *Rearing Cobra (Uraeus)*

Silver-copper alloy, niello, glass, turquoise, cornelian, obsidian, and gold. Late New Kingdom, probably Dynasty XIX (1307–1196 BC). H. of snake 9.7 cm.; H. of prong 6 cm.; W. of snake 4 cm.

The forepart of a rearing cobra with hood expanded. The tail extends backward only 2.7 cm. past the vertical of the body, the end being smoothly finished. A vertical prong, apparently cast with the rest of the body, extends downward from the tail. The prong is covered with a thick layer of bronze corrosion. The composition of the metal is a silver-copper alloy with a heavy preponderance of silver. The eyes are inlaid with glass (possibly red glass now turned green) and inset with obsidian disks for pupils. Tiny fragments of gold leaf remain around the rim of the eye. Patches of niello (now badly abraded) color the canthus of the eye and cover the top of the head and back of the snake. A wide, incised inverted V forms the mouth, and another, more curving, delineates the underside of the jaw. Four short, vertical strokes are incised below each eye, above the upper lip. Small patches of gold leaf appear on the back. The front of the body is zoned into six fields for inlays: two columns of three spaces each, separated by a mid-line of incised horizontal strokes. The mid-line retains traces of gold leaf. The two lowest inlay fields retain large pieces of turquoise inlay. The corners of the middle zones bear minute particles of cornelian. In the two top zones— semicircles with scalloped edges—are patches of a glassy blue film, apparently the residue of a glass inlay imitating lapis lazuli. At the center of the mid-line between the two semicircles is a hole pierced front to back probably for the attachment of the tied bow emblem common to *uraei* before the Late Period and sacred to the goddess Neith.

The cobra was the traditional defender of the Egyptian king and divinities. It sat coiled on top of their heads and spat venom into the eyes of enemies. This is a form of defense used in nature by the spitting cobra (*Naja nigricollis*) and not by the Egyptian cobra (*Naja haje*), although the *uraeus* is usually identified as the latter.

A gold and silver *uraeus* inlaid with semiprecious stones was found in the tomb of Neb-hotep at Dahshur. De Morgan felt that the jewel was certainly inserted in a mask which had not survived. The prong of the Mildenberg *uraeus* is much longer and sturdier than the Dahshur example, which suggests that it was a fitting for something larger than a mask such as a large sculpture. *Uraei* were also used as furniture ornaments, but known examples are of much lighter manufacture and with much shorter prongs.

61

The position of the prong indicates that the *uraeus* was sunk into the top of the head rather than the brow of a large sculpture. Kings and queens wore *uraei* on their brows; gods and goddesses with animal heads wore *uraei* on top usually in front of a sun disk. The abbreviation of the Mildenberg cobra's body would best be explained if it had stood before a disk, behind which the rest of the tail was attached. The lack of any headdress also speaks favorably for its use in conjunction with a disk on the head of a divine figure, since a *uraeus* as a lone sculpture or as an independent decorative device generally wore a crown or disk on its head. The bronze corrosion attached to the prong indicates that the sculpture which it adorned was bronze, possibly overlaid with precious metal.

The cobra's elegance and elongation indicate a late New Kingdom date. The four strokes below the eye may be compared to the two or three on Tutankhamen *uraei*, the three (sometimes four) on two-dimensional representations in the tomb of Horemheb, and the fairly consistent four on painted representations in the tomb of Nofretari. In the Late Period these strokes often appear behind the eye, or not at all. The use of silver, though never common in Egypt, was at a high point in Ramesside times. The combined use of semiprecious stone and glass inlays on the same object was also a Ramesside practice. Silver-copper and even silver-tin alloys are known from Dynasty XVIII on.

This cobra in its original state must have been splendid if not garish; no parallel is known. With its gold front, black head and back, red eyes, and dark blue, red, and turquoise inlays, the snake must have closely resembled painted examples in Nofretari's tomb. Its name *uraeus* is a Hellenized version of the Egyptian word meaning to "rise up" or "rear up." And this it did, probably in front of a gold-leafed sun disk on the head of a spectacular, over life-sized divine figure of late New Kingdom date.

Condition: Metal is intact; inlays lost as noted above. The surface has been slightly abraded in cleaning. Bronze corrosion appears in several small spots on the tail in addition to prong. APK

Bibliography: Unpublished.

Comparative literature: Günther Roeder, *Ägyptische Bronzewerke* (Hamburg: J. J. Augustin, 1937) pp. 59-62, esp. no. 355, p. 60; Roeder, *Bronzefiguren*, pp. 388-394, esp. p. 389, Vienna no. 4271; Alfred Lucas, *Ancient Egyptian Materials and Industries*, 4th ed. rev. by J. R. Harris (London: Edward Arnold, 1962) p. 249; Hans Goedicke, *Nofretari* (Graz: Akademische Drückanstalt, 1971) cf. pls. 1, 2, and *passim*; Hans Gerhard Evers, *Staat aus dem Stein* 2 vols. (Munich: F. Bruckmann, 1929) II, 21-24.

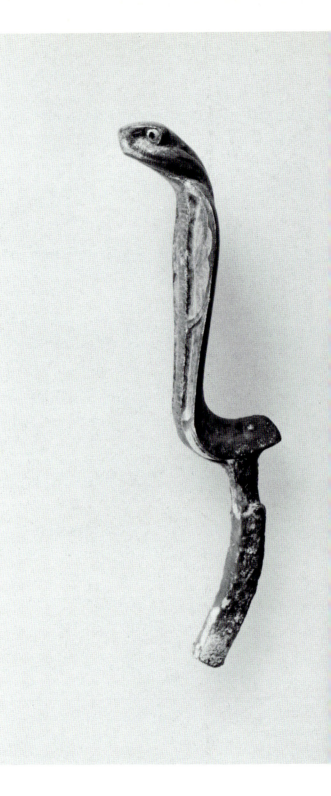

48 See also colorplate XIII

49 Fragment of Relief with Lion Hieroglyph

Beige limestone with red impurities. Second half Dynasty XVIII (1401–1307 BC). H. 7.8 cm.; H. of lion figure 1.8 cm.; L. of lion figure 5.5 cm.

The fragment is spalled from a large block and is irregularly shaped. Below the bolt hieroglyph "s" lies the recumbent lion hieroglyph "r," and below that the sedge plant "šm'."

The even and uncrowded spacing of the lettering, the very elongated form of the lion, and great attention to detail suggest a middle to late Dynasty XVIII date.

Besides being a mere hieroglyph, the lion was a symbol of royal (particularly kingly) power, and during the Late Period (712–332 BC) represented the god Mihos (see [58]).

Condition: One broken edge cuts through the left side of the bolt; another cuts diagonally through the sedge plant. APK

Bibliography: Unpublished.

Comparative literature: None.

50 Small Lion Amulet

Blue and red faience. Egypt, Late New Kingdom–Dynasty XXVI (ca. 1196–525 BC). H. 1.9 cm.; W. 1.1 cm.; L. 3.5 cm.

Male lion rests on thin rectangular base, head turned over left shoulder. The forelegs extend along a longitudinal axis, the right leg slightly advanced. The faience is a muddy, light blue with red faience indicating the eyes and mane. The animal's coat is lightly hatched in rows. What can be seen of the tail curls around the right rear corner of the base and up the right haunch. The base is slightly hollowed underneath.

The combination of two colors in faience suggests a New Kingdom or later date; the muddiness of colors pushes the date after the New Kingdom. The hatching of the fur and lack of muscle delineation are appropriate to the New Kingdom and the first half of the first millennium BC. Later (Ptolemaic Period) lions generally have slacker, less alert features [51, 52] and those with heads turned usually cross their paws [51].

Condition: Intact. APK

Bibliography: Unpublished.

Comparative literature: G. A. Reisner, *Catalogue général des antiquités égyptiennes du Musée du Caire: Amulets* (Cairo: Institut français d'archéologie orientale, 1907) p. 80, nos. 12400–12403, pl. XXII.

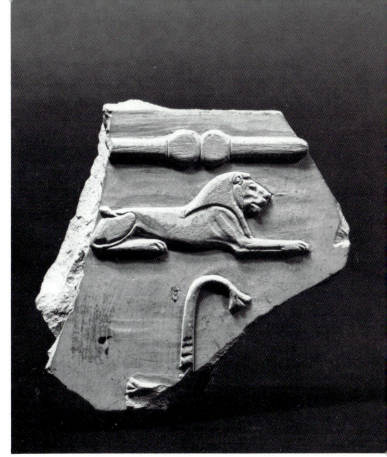

49

50

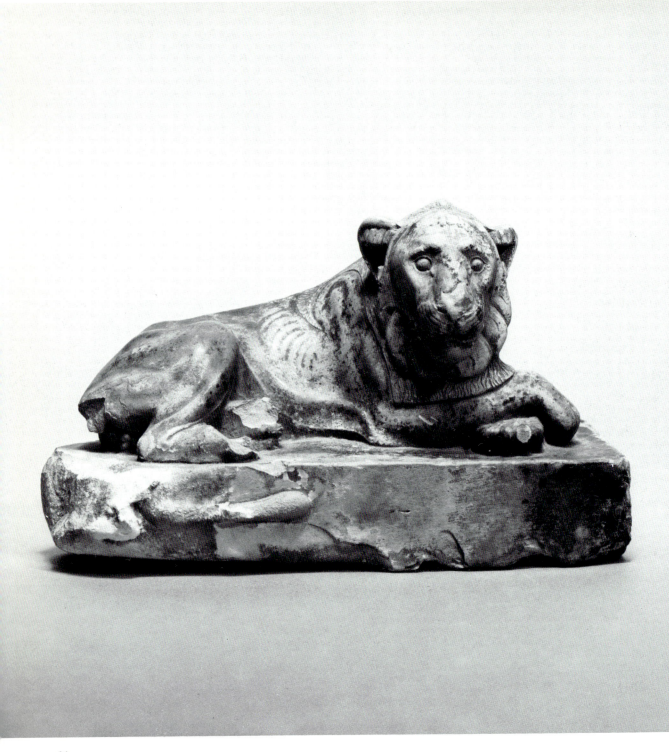

51 Lion Sculptor's Model

Creamy white limestone. Dynasty XXX–Early
Ptolemaic Period (4th–3rd centuries BC). H. 11.6 cm.;
W. 7.5 cm.; L. 19.7 cm.

Lion recumbent on rectangular base with head turned
over right shoulder; right forepaw draped over upturned
left; left hind foot protruding from beneath right haunch.
The remains of a tail trails along side of base. Chin is low
slung giving an appearance of age to the animal. Careful
incisions detail upper eye rim, ear tufts, mane, and
whiskers. Parallel lines are incised at 1.2 cm. intervals on
the front end of the base and along the bottom
lengthwise. Another line runs crosswise centering exactly
on the lion's nose.

The measured lines on the base of this and similar
small limestone sculptures suggest their use as sculptors'
models or trial pieces, although the use as votive figures
has been suggested. The form of these limestone lions
seems to be taken directly from the monumental and
majestic pink granite lions of Nectanebo I (380–362 BC)
now in the Vatican which were copied by Nectanebo II
(360–343 BC) for his lions (now in the Louvre) which
guarded the Serapeum at Sakkara. Very possibly
the Mildenberg lion and similar ones were models
of the granite lions used as "sketches" for creating
the second pair.

A lion similar in size but finer and probably earlier in
date is in the Walters Art Gallery, Baltimore (22.40). The
latter still retains echoes of the "figure-8" delineation of
shoulder musculature inspired by Achaemenian art (see
[30]). It lacks the traditional Egyptian C-hook of mane at
the shoulder, a feature which fell out of use during the
Persian Period. The Mildenberg lion shows a recovery of
the C-hook which reappears in Ptolemaic lions and a
softened version of the "figure-8" which by this time
resembles a hairpin shape. The slight misalignment of this
last detail as well as the carelessly placed rib marks and
the completely elided withers give the impression of a
less than masterful hand at work. An unfinished example
closer to the Walters type is in The Cleveland Museum of
Art (20.200 unpublished).

Condition: The lion's nose, hind paws, and tail, and the
corners of the back end of the base are broken. The skin
of the stone has deteriorated and chipped off at places.

APK

Bibliography: Fine Egyptian, Western Asiatic, and Classical
Antiquities, sale cat. (New York: Sotheby Parke Bernet, 11
December 1976) no. 302 illus.

Comparative literature: Charles Boreux, Guide catalogue
sommaire, 2 vols. (Paris: Musée du Louvre, 1932) I, 169, pl. 21;
Hans Wolfgang Müller, "Löwenskulpturen in der Ägyptischen
Sammlung des Bayerischen Staates," MJb XVI (1965) 25 ff.; G.
Steindorff, Catalogue of the Egyptian Sculpture in the Walters Art
Gallery (Baltimore: The Walters Art Gallery, 1946) p. 93, no. 311,
pl. LIX.

52 Recumbent Lion Amulet

Light blue faience. Middle Ptolemaic to Roman
Period, ca. 2nd century BC–AD 1st century. H. 3.2
cm.; W. 1.8 cm.; L. 6.8 cm.

Recumbent on a thin rectangular base of which the back
end is rounded, the lion faces straight ahead, his paws
stretched out before him. The tail curls around the right
haunch. The mane, which forms a C-hook over the
shoulders, is indicated by diamond-shaped incisions, the
whiskers by vertical hatchmarks. The eyes are rimmed,
and the lower jaw protrudes giving the impression of an
aged lion who has lost his upper fangs. Crude stylized
incisions mark the ribs (five inverted comma shapes), the
shoulder (a bent hairpin shape), and the forelegs. The
forelegs do not stretch out straight, but rather angle in
at the pastern from which the paws fan out again at
the sides.

52 See also colorplate XI

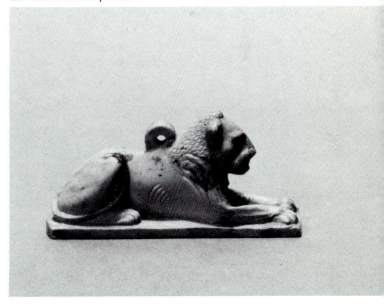

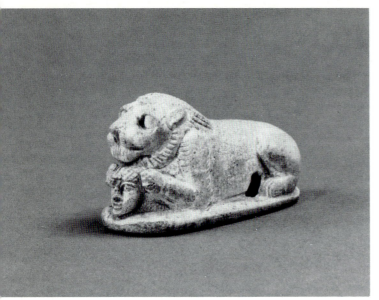

53

The lion is nearly an exact miniature of a monumental granite lion dated to the Ptolemaic Period and now in Copenhagen (AEIN 1498). Minor differences are that the tails are on opposite sides and the cheekbones and ears are handled slightly differently. A similar articulation of the mane and vertical whisker lines is visible on a Ptolemaic lion plaque in the Walters Art Gallery, Baltimore (22.41). The incised "bent-hairpin" shoulder delineation generally appears on sphinxes and lions of mid to late Ptolemaic date. Compare also a broken Dynasty XXVII version in University College, London, which has a less haggard face, lower stifle joint, and better-placed rib marks.

Condition: Intact with scattered brown patches on surface. APK

Bibliography: Bloesch, *Das Tier*, no. 80.

Comparative literature: Otto Koefoed-Petersen, *Catalogue des statues et statuettes egyptiennes* (Copenhagen: Fondation Ny Carlsberg, 1950) p. 71, no. 126, pl. 131; G. Steindorff, *Catalogue of Egyptian Sculpture in The Walters Art Gallery* (Baltimore: The Walters Art Gallery, 1946) p. 97, no. 345A, PL. lxv; Serge Sauneron, "Le nouveau sphinx composite du Brooklyn Museum et le rôle du dieu Toutou-Tithoès," *JNES* XIX (January–October 1960) 269-287, pls. X, XIV; B. V. Bothmer, *Egyptian Sculpture of the Late Period* (Brooklyn: The Brooklyn Museum, 1960) p. 162, no. 125, pl. 116; W. M. Flinders Petrie, *Amulets* (London: Constable and Co., 1914) p. 45, pl. XXXVIII, no. 219h; Hans Wolfgang Müller, "Löwenskulpturen in der Ägyptischen Sammlung des Bayerischen Staate," *MJb* XVI (1965) 25 ff.

53 *Royal Lion Seizing a Foreign Captive*

Steatite with traces of green glaze, Napata-Meroë (Upper Nubia, modern Sudan), ca. 1st century BC. H. 3.5 cm.; W. 3 cm.; L. 6.7 cm.

The lion rests on his belly with the head of his prey clasped tightly between his paws beneath his chin. The captive's body either disappears beneath the lion's or has already been devoured. The lion's tail curves around the right haunch. The base is an oval rim. The entire piece is hollow.

The Egyptian king in lion guise attacking a foreigner is a classic Egyptian theme. However, the style of this example is purely Meroitic. The large, staring disk-shaped eyes and over-stated chin (in any case a late feature, see [52]) recall a first century BC sandstone lion from the Temple of Apedemak, now in Liverpool. The mane is arranged in "corn rows," a Meroitic affectation. The sculptured style of the human physiognomy—large staring eyes, hooked nose, and thick pursed lips—compares well with reliefs of the first century BC to first century AD found at Wad Bam Naqa and Meroë.

Condition: Loss below and hole in front of right hind paw; hole below right forepaw. The true color of the stone as shown at the loss is gray. The surface has weathered to a creamy white. APK

Bibliography: Unpublished.

Comparative literature: Steffen Wenig, *Africa in Antiquity* II (Brooklyn: The Brooklyn Museum, 1978) p. 257, no. 194, p. 202, nos. 123, 124.

54 obverse

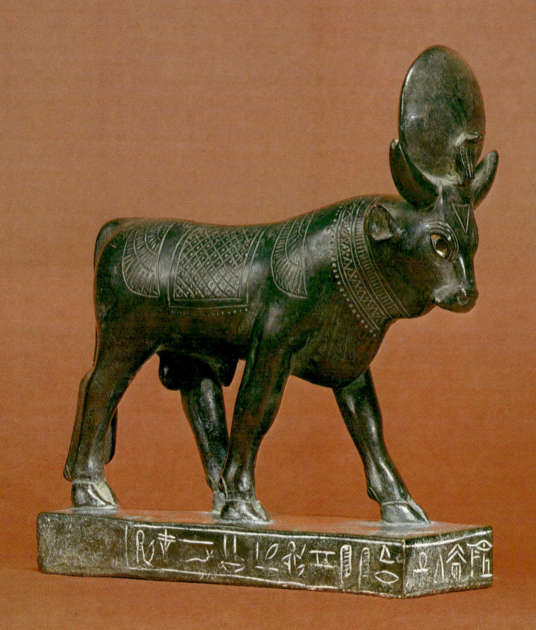

Plate I Striding Apis Bull [61]

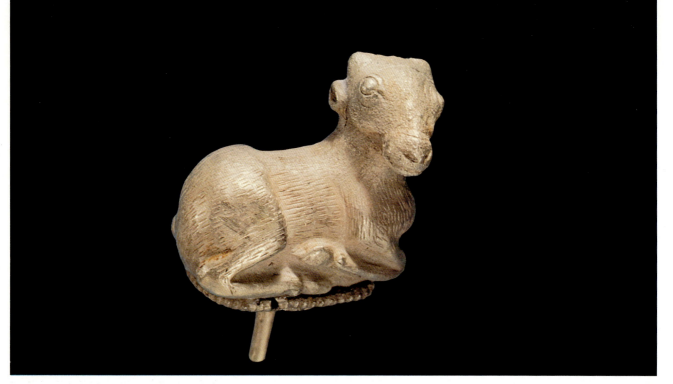

Plate II Recumbent Ram Pin Terminal [24]

Plate III Bull Jewel [8]

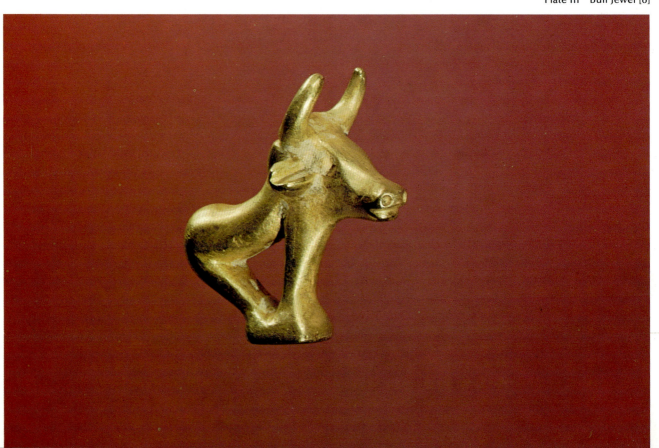

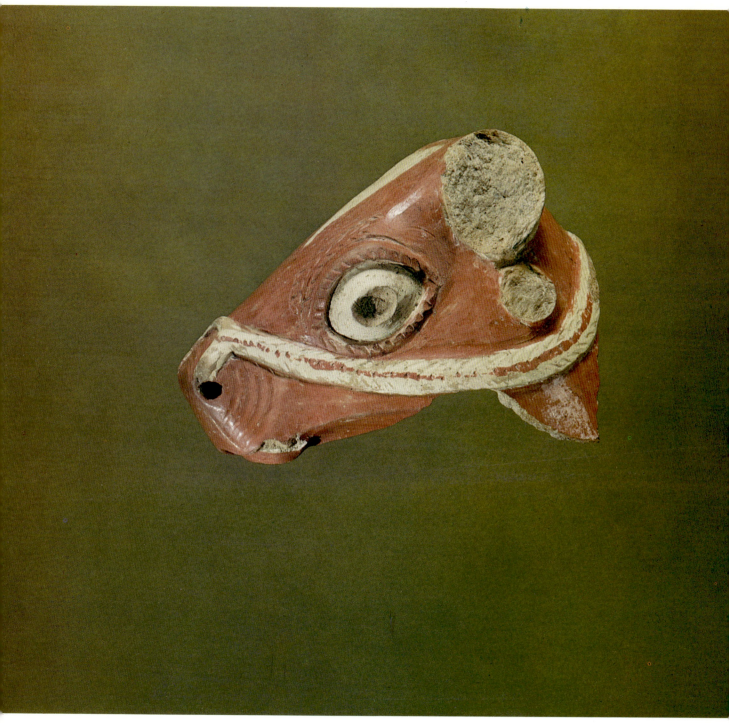

Plate IV Bull Head Fragment from a Rhyton [10]

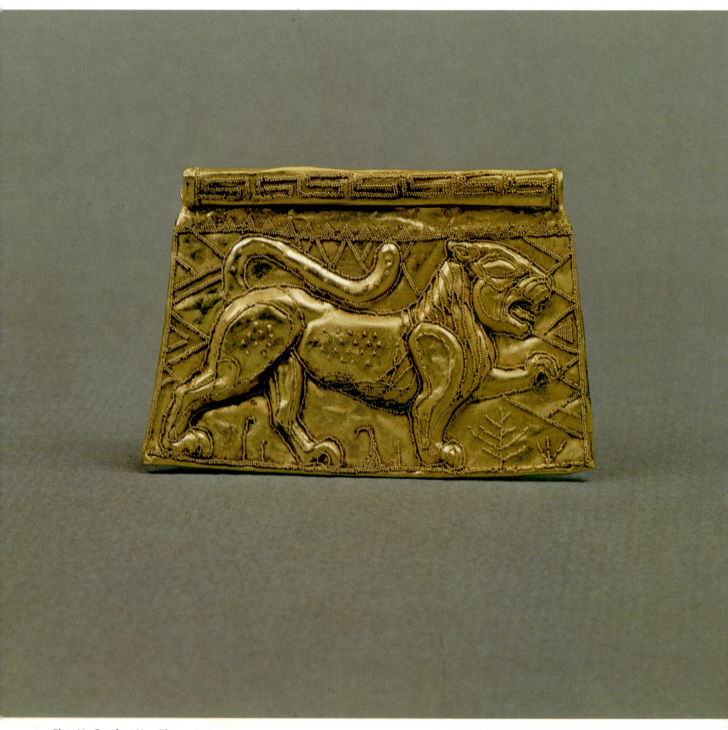

Plate V Pendant Lion Plaque [87]

54 Decorative Scarab with Baboon

Dark turquoise faience. Egypt, Dynasty XVIII, reign of Tuthmosis III (1479–1425 BC). H. 0.4 cm.; W. 0.9 cm.; L. 1.3 cm.

A baboon (probably the *cynocephalus*—see [55]) crouches with knees tucked up beneath chin and forepaws held to his mouth. His fur is hatch-marked in rows. On the underside are two pairs of addorsed *uraei* radiating on top and bottom from a horizontally bisecting row of three ovals. The piece is pierced lengthwise. A scarab with similar seal is dated to the reign of Tuthmosis III.

Monkeys and apes of all sorts were kept as pets in royal and wealthy Egyptian households. The most famous example was the monkey of Tuthmosis III, who was even honored with burial in his master's tomb. It should be noted, however, that during his lifetime the king, in self-defense, had his pet's teeth ground down. The playfulness of the more docile varieties inspired small genre sculptures, representations in painting and relief sculptures, and vessels which were precursors to vessels like [95, 98].

Condition: Intact, surface rubbed. APK

Bibliography: Unpublished.

Comparative literature: Percy E. Newberry, *Scarabs: An Introduction to the Study of Egyptian Seals and Signet Rings* (London: Archibald Constable and Co., 1908) pl. XXIX, no. 45.

54 reverse. See obverse on page 66.

55 Vigilant Baboon

Bronze, hollow cast. Probably Saite, Dynasty XXVI or slightly earlier, 7th century BC. H. 8.3 cm.; W. 3.7 cm.; L. 5.2 cm.

With his head held stiffly erect, the baboon's snout forms a strong perpendicular to his body. He sits on a flat plate cast with the body. There is an opening through the bottom of the plate into his torso where the core rested during casting. Another opening was made in the top of his head to hold his insignia, the lunar crescent and disk.

A billowing mantle of long fur cloaks the animal's shoulders and upper arms, and indents along the front mid-line, dipping to a point at the bottom center. His swelling mane echoes that effect in back. Two clumps of raised hair bulge over the ears like the bristling hackles of an angry dog in contrast to the flat-sided head of [56].

Classical authors referred to any long-nosed baboon as a *cynocephalus* or dog-headed ape. Today, two distinct groups are recognized, although Egyptologists often persist in using the misnomer *cynocephalus* when they refer to the *hamadryas*. The *Papio hamadryas* is unique in having a mane of long hair on his head and a mantle of long hair covering his body. The Mildenberg bronze's nose is especially elongated with the tip slightly tilted, another characteristic of the *hamadryas*.

The *hamadryas* baboon was sacred to Thoth, the god of wisdom and learning, who was also the moon god. When the sun god passed under the earth each night, Thoth took control over earthly affairs. He was aided in his work by the baboon, who was a spirit of the moon at night. However, at dawn, when his howling (euphemistically called "hymns" by the ancient Egyptians) caused the sun to rise, he was incarnated as a baboon.

As sacred animals, baboons were kept in moon temples, partially as mascots and partially as watchdogs. The *hamadryas* baboon is an exceptionally fierce variety, well suited for the latter task. This may explain why the word for "to be furious" in ancient Egyptian ends in a hieroglyphic sign in the form of a *hamadryas*. The bouffant appearance of the Mildenberg bronze signifies a *hamadryas* aroused or on guard and about to attack. The ferocity and aggressiveness of this beast is in direct contrast with the serenity of Thoth's other divine animal, the ibis. The ibis aspect of Thoth gained greater popularity in the Late Period and figures of ibises vastly outnumbered baboon figures. Perhaps this is a fulfillment of Thoth's statement in the Book of the Dead that words shall triumph over violence, a mythological ancestor of "the pen is mightier than the sword."

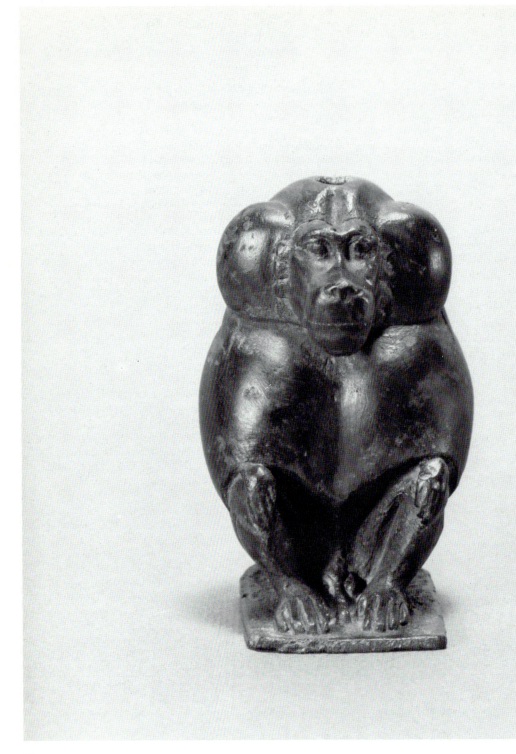

During the New Kingdom, sculptures of the *hamadryas* baboon seem to favor the aroused version. On a small sculpture from Tell el Amarna (JE 59291) and a larger example from the Karnak cachette (CG 42.187), both now in the Cairo Museum, the "hackle" hairs are beautifully incised giving the impression of rays emanating from the face. This effect observed in nature may also have had some influence on the assignment of the baboon's mythological powers. On the New Kingdom examples the mantle drops to a point at the bottom center. Although the mantle is concave in front, it does not form a gully as on the Mildenberg bronze.

A bronze baboon excavated at the Palace of Apries in Memphis is somewhat similar in style to the Mildenberg example except that the muzzle is more pointed, the mantle does not indent in front, and the mantle dips to a point on the side. The excavators dated this example by its inscription to the late eighth century BC.

The Mildenberg bronze baboon is probably a Saite revival of late New Kingdom style. It is an extraordinarily fine bronze, perhaps the finest bronze baboon of its type now extant. Its uninscribed, flat foot plate was probably originally set into the base of a large group sculpture like the ibis and baboon composition in the University Museum, Philadelphia (E 14 288). The Apries baboon was found with a bronze ibis and was probably arranged in a similar grouping.

Condition: Losses at back of head, bottom back edge of mantle, and between buttocks. These losses may have occurred from the core having slipped during casting, causing the bronze to be extremely thin in these areas. Dark reddish-brown patina. APK

Bibliography: Unpublished.

Comparative literature: J. R. Napier and P. H. Napier, *A Handbook of Living Primates* (London: Academic Press, 1967) pp. 248ff; Dorothy W. Phillips, *Ancient Egyptian Animals* (New York: Metropolitan Museum of Art, 1948) fig. 28 and opposite page (not numbered); Edward L. B. Terrace and Henry G. Fischer, *Treasures of Egyptian Art from the Cairo Museum* (London: Thames and Hudson, 1970) pp. 129-132, no. 29; Georges Legrain, *Catalogue général des antiquités égyptiennes du Musée du Caire: Statues et statuettes des rois et des particuliers* II (Cairo: Services des Antiquités de l'Egypt, 1909) pp. 54-55, pl. XLIX; W. M. Flinders Petrie and J. H. Walker, *The Palace of Apries* (Memphis II) (London: British School of Archaeology, 1909) pp. 12, 18, pl. XV; Roeder, *Bronzefiguren,* pp. 371-373, § 489, pl. 53, and p. 494, fig. 765; Günther Roeder, *Ägyptische Bronzewerke* (Hamburg: J. J. Augustin, 1937) pp. 55-56, § 232-236, pl. 34 c-f.

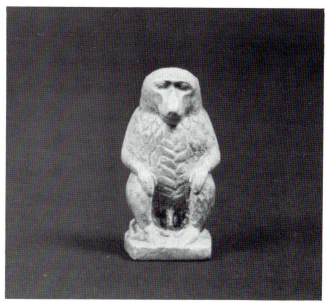

56

56 *Thoth's Baboon at Ease*

Pale turquoise faience. Ptolemaic Period (304–30 BC). H. 4.6 cm.; W. 2.2 cm.; L. 3 cm.

A male baboon (*Papio hamadryas*) squats similarly to [55]. The toes of his hind paws point inward. Mane and mantle hair is incised as a feather pattern; the mantle curves low in back. The front mid-line is marked by a herringbone pattern. Lower back, legs, and side of head are stippled. The tail curves along base beside right haunch. The base is flat in front and rounded in back.

For a discussion of the baboon in Egyptian mythology see [55]. In this later faience version the ape seems to have lost a great deal of his earlier vigor. His snout slants downward, and his mane and mantle seem to hug his back in resignation. Small faience versions of the baboon as funerary amulets lasted well into the Greco-Roman Period.

Condition: Intact. Surface slightly eroded and marked with dark patches. APK

Bibliography: Bloesch et al., *Das Tier,* p. 13, no. 58, pl. 13; *Ägyptische Kunst,* sale auction 49 (Basel: Münzen und Medaillen, 27 June 1974) no. 95.

Comparative literature: G. Steindorff, *Catalogue of the Egyptian Sculpture in the Walters Art Gallery* (Baltimore: The Walters Art Gallery, 1946) p. 152, pl. CII.

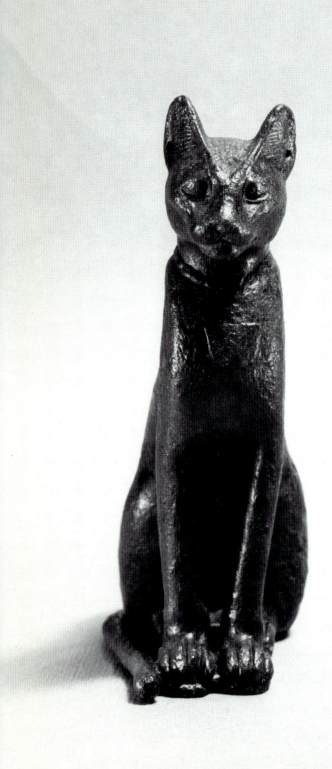

57 Coffin for a Kitten

Bronze, hollow cast. Probably Dynasty XXVI (664–525 BC). H. 13.6 cm.; W. 5.1 cm.; L. 7.9 cm.; H. of prongs 1.2 cm.

Cat sitting, tail lying at right side. Decorations are in low relief. She wears a necklace of slitted ovals suggesting cowrie shell beads. On her chest, slightly off-center to her left, is an *aegis* surmounted by the barely visible head of the cat goddess, Bastet. Her pierced ears are turned three-quarter and tufted inside. Ridges run from the inner edges of each ear to and along the sides of the nose. The eyes are rimmed. There are prongs beneath each forepaw and at the base of the tail. An opening under the haunches, 3.3 cm. in diameter, leads into the hollow body.

The cat goddess, Bastet, whose center of worship was in the Delta city Bubastis, reached the height of her popularity during the Late Period. The ease and frequency with which the unrestrained cat reproduces made it an obvious choice for fertility worship. Since cats were sacred to Bastet, the animals themselves were revered and even ceremoniously buried. The large number of hollow bronze cat figures, used as coffins for cat mummies, in museum and private collections today attests to the great importance of the Bastet cult. The small size of the Mildenburg cat suggests that it was the coffin for a still-born or very young kitten.

Condition: Surface worn from corrosion. Reddish brown patina, some areas of malachite green. APK

Bibliography: Unpublished.

Comparative literature: Roeder, *Bronzefiguren*, § 447, pp. 346-347, pl. 50. and fig. 474 on p. 347.

58 Mother Cat with Five Kittens

Bronze. Egypt, Probably Dynasty XXVI–XXX (664–343 BC). H. 4 cm.; W. 4.3 cm.; L. 6.3 cm.

The mother cat lies on her left side, her head, shoulders, and forelegs turned to her right. All four legs stretch out perpendicular to the body. Three kittens nurse, another one teases the mother at her chest, and the fifth plays with her tail. All are formed in one piece with a raised, hollow, semicircular base. The mother's fur is hatched similarly to the coat on the smaller amulet [50]. A necklace of four incised circles surrounds her neck supporting a *wedjat* eye (?) at her chest. Her tail is crudely notched with rings. An

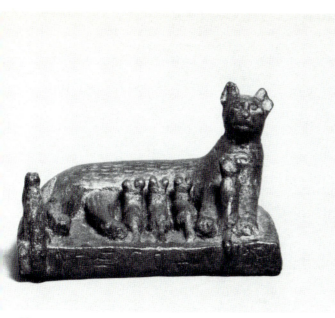

58

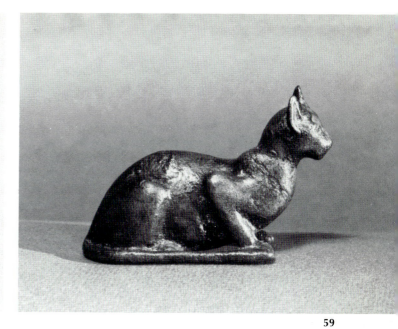

59

inscription begins at viewer's right front and continues around left side. Inscription: *B3st(y)t dd(t)* [*unintelligible*] *wšn* Ṯ*(3)-r(w)-*ṯ*(3):* Bastet who gives [unintelligible] offerings (for Tjarutja?).

Bastet's original identification was as a lioness and she was closely connected with the war goddess Sakhmet, an association that seems antithetical to her image here. Her son, the lion-god Mihos, was sacred to the area around Tell el-Mugdam in the delta.

Cat family groups were popular in both faience and bronze. The contrast of feeding and playing kittens and the beatific expression on the mother cat's face make the Mildenberg group especially charming. A similar piece, missing its nursing kittens is in Berlin (9321).

Condition: Tip of mother's left ear broken off. Green patina over all, scattered patches of cuprite, lapis blue patina over green under base. APK

Bibliography: Unpublished.

Comparative literature: Günther Roeder, *Ägyptische Bronzewerke* (Hamburg: J. J. Augustin, 1937) p. 51, pl. 33d; Roeder, *Bronzefiguren*, pp. 354-357, pls. 51l, 52d; Elizabeth Riefstahl, "A Sacred Cat," *Brooklyn Museum Bulletin* XIII, no. 2 (Winter 1952) 6, fig. 5; Neville Langton, "Notes on Some Small Egyptian Figures," *JEA* XXII (1936) 119-120, pl. VII; Werner Kaiser, *Agyptisches Museen Berlin* (Berlin: Staatliche Museen, 1976) p. 83 (illus.), no. 853.

59 Crouching Ring-Tailed Cat

Bronze, solid cast. Ca. Dynasty XXX–Ptolemaic Period (4th–1st century BC). H. of cat 4.5 cm.; W. 2.9 cm.; L. at bottom 5.6 cm.; L. of prongs 1.5 cm.

Cat (the *Felis libyca* still wild in some parts of Africa) crouches and peers straight ahead, tail lying at right side. An incised *wedjat* eye is suspended at her chest by an incised necklace of cowrie shell beads which ties in the back. Her ears are turned slightly three-quarter and unpierced. The tail is notched with rings. Two prongs are on the underside, one in front of the tail and one at the belly.

The naturalistic handling of anatomical masses suggests Greek influence. The figure types in crouching cats vary, some being comparatively thin like one in Leiden (E XVIII.175) and others being stouter like an example in the Hermitage (642). The Mildenberg cat is so round in the belly that one wonders if she isn't pregnant. Since groups of mother cats with kittens were popular (see [58]) it seems not without reason that the expectant mother cat should also be a favorite.

Condition: Harshly cleaned. Facial details are worn. Some green patina remains on underside. APK

Bibliography: Unpublished.

Comparative literature: Elizabeth Riefstahl, "A Sacred Cat," *Brooklyn Museum Bulletin* XIII, no. 2 (Winter 1952) 8-9, fig. 6; Roeder, *Bronzefiguren*, pp. 351-353, fig. 482; Neville Langton, "Notes on Some Small Egyptian Figures," *JEA* XXII (1936) 116, pl. V, no. 10; N. Landa and I. Lapis in B. Piotrovsky, ed., *Egyptian Antiquities in the Hermitage* (Leningrad: Aurora Art Publishers, 1974), no. 127.

60 *Crowned Oxyrhynchus Fish*

Bronze, solid cast. Dynasty XXVI–XXX (664–343 BC). H. 6.2 cm.; L. 11.5 cm.; W. 4.2 cm.

The Oxyrhynchus (*Mormyrus kannume*) is a long, lean fish with tapering nose; bulging eyes; pectoral, ventral, and anal fins; a small, forked tail; and a long dorsal ridge. Here, it is set upright, cast in one piece with a hollow rectangular base (uninscribed). Hathor's attribute, the sun disk embraced by lyre-shaped horns, crowns the fish. Immediately behind the disk, resting on the dorsal ridge, is a heavy triple loop for suspension. The face is smooth, the body incised with scales in neat diagonal rows.

A large number of bronze Oxyrhynchus fish, many of high quality, have appeared on the art market in recent years. Presumably they come from the area of present-day El-Bahnasa. This was the site of the ancient capital of the nineteenth nome of Upper Egypt where the Oxyrhynchus fish was worshipped and which was known in antiquity by the fish's name. The city of Oxyrhynchus flourished during the Ptolemaic Period and was the site of one of the largest finds of Greco-Roman papyri in recent times.

The fish acquired Hathor's crown because of a ritual association with her at Esna.

Condition: Intact. Rich red patina with malachite green spots. APK

Bibliography: Unpublished.

Comparative literature: Christa Meves in Erik Hornung et al., *Geschenk des Nils* (Basel: Schweizerischer Bank Verein, 1978) p. 95, no. 336.

60

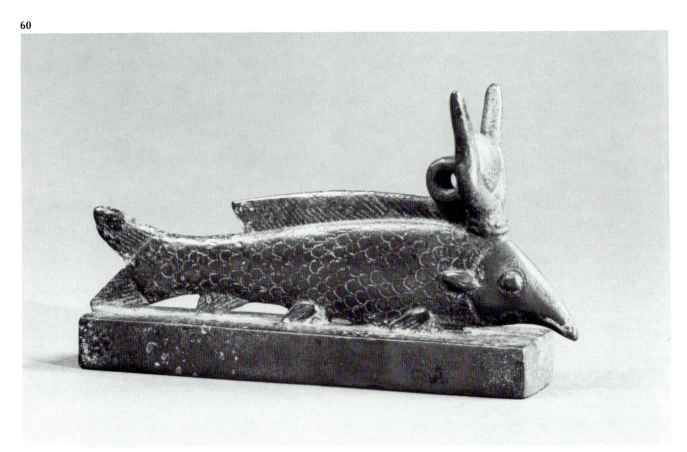

61 *Striding Apis Bull*

Bronze, solid cast, with silver leaf. Probably Memphis, Dynasty XXVI (664–525 BC), possibly later. H. 13.7 cm.; W. 4.2 cm.; L. 11.4 cm.

Apis bull of highest quality in the classic Memphite form, striding with left legs leading. Brush of tail hangs joined to right hind leg; testicles to left. Eyes are overlaid with silver. He wears the disk and *uraeus* on his head and has incised decorations as follows: on the neck a complex collar of three registers, the first a simple ladder pattern, the second a row of inverted lotus flowers, and finally a row of punched dots implying pendant beads circling the bottom of the collar (cf. inverted version in Kater-Sibbes collar, nos. 35, 36); over the withers a winged scarab; over the mid-quarters a three-paneled, fringed blanket (Kater-Sibbes blanket no. 29) with dotted guilloches on the side panels and scored triangles (called by Petrie a feather pattern) on the top panel; over the rump a vulture with wings spread carries *shen* signs in her claws. The bull stands on an inscribed, hollow rectangular base with off-center prongs at each end. The bronze was solid cast all in one piece.

Starting at the animal's left front and continuing around the right side the inscription reads: *Wsir Hp(i) di ᶜnh Kry s3 n B(3)k-(n)-nf(y):* Osiris Apis, given life, Kery son of Bak-(en)-nef(y).

Most of the bronze Apis statuettes excavated in Memphis and the surrounding area are the striding type and virtually all of those lead with the left legs. The incised decorations are a limited set of variations on a very few themes. A series of large prototypes such as the Dynasty XXX limestone sculpture found at the Serapeum, Sakkara, and now in the Louvre (N390) must have served as models for these smaller votive sculptures.

Of the hundreds of bronze striding Apis statuettes known, the Mildenberg bull is one of the finest in both sculptural quality and incised decoration. One of its few competitors is in the Liebieghaus Museum, Frankfort. The

61 See also colorplate I

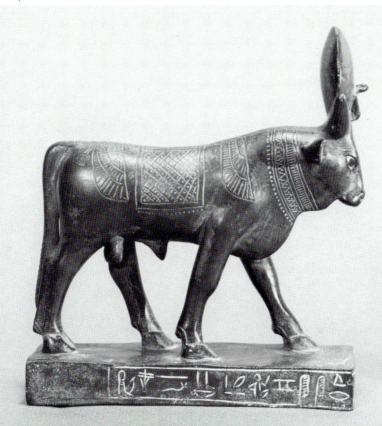

use of silver instead of gold in the eyes of the Mildenberg bull is exceedingly rare.

Condition: Pristine. Dark brown patina. APK

Bibliography: Unpublished.

Comparative literature: G. J. F. Kater-Sibbes and M. J. Vermaseren, *Apis*, 3 vols. Etudes préliminaries aux religions orientales dans l'empire romain, ed. M. J. Vermaseren, XLVIII (Leiden: E. J. Brill, 1975); Roeder, *Bronzefiguren*, pp. 325–330, esp. 412; Erich Winter, *Der Apiskult im alten Ägypten* (Mainz: Zaberndruck, 1978); see also W. M. Flinders Petrie, *Egyptian Decorative Art* (New York: Benjamin Blom, 1972) pp. 47, 51, for discussions of textile designs.

62 *Prancing Apis Bull*

Bronze, hollow cast, and gold. Roman Empire, probably provincial, ca. AD 2nd century. H. 6.3 cm.; W. 1.8 cm.; L. 6.7 cm.

Bull with three legs planted, the left foreleg raised. His head is held high and turned slightly left with a full, fleshy dewlap cascading to the brisket. The tail loops over the rump, the brush adhering to the left flank. The wide-open eyes and flaring nostrils give the image great strength and alertness. A thick, upturned crescent of nearly pure gold is embedded in the animal's left side. A deep hole for attachment pierces the poll; a groove runs from there to either side of the head. Since the gold crescent clearly identifies this bull as the Egyptian Apis, the missing head ornament must have been another crescent.

The Romans who colonized Egypt and became enamored of her exotic religions carried the Apis cult around the world with them, integrating it into their own religion and creating new representational forms based on the Roman aesthetic. Prancing Apis bulls turned either left or right have been found throughout the Roman Empire, except ironically in Egypt. Instead, the traditional Memphite pose (see [61]), with the occasional enlivenment of a slightly turned head in Hellenistic times, held sway in Egypt.

By far the largest and finest of the left-oriented Roman Apis bulls is in the Cincinnati Art Museum (1956.13). A nearly exact duplicate of the Mildenberg bull probably from the same mold but less well preserved is in the Walters Art Gallery, Baltimore (54.1565). A near mirror image 3 cm. taller is in The British Museum (1808). A fourth bull in a private collection—with its four feet planted solidly and oriented to the right—is very close in sculptural composition and in the technique of portraying musculature. These last three certainly come from the same workshop. Numerous similar objects exist.

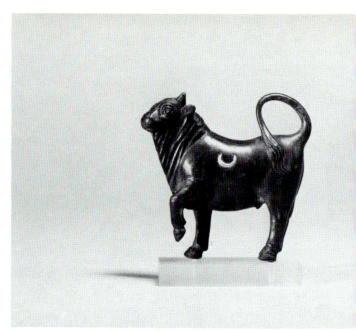

62

63

According to both Pliny and Aelian, the Apis had a bright, half-moon shaped spot on his flank. Hadrianic coins show this crescent on images of the striding bull. It appears on a stone bull found at Beneventum and on a striding bronze bull now in the Louvre (N 3763). Its inclusion on the Mildenberg example seems to be unique among bronze prancing Apis bulls.

Condition: Ancient patch on the right side; tiny casting flaws in body. Dark green patina overall.　　　　APK

Bibliography: Unpublished.

Comparative literature: G. J. F. Kater-Sibbes and M. J. Vermaseren, *Apis*, 3 vols., Etudes préliminaires aux religions orientales dans l'empire romain, ed. M. J. Vermaseren, XLVIII (Leiden; E. J. Brill, 1975) II, nos. 310, 504, III, no. 29, and all vols. *passim*; Patricia Neils Boulter, "A Bronze Bull in Cincinnati," in *Studies in Classical Art and Archeology*, ed. Günter Kopcke and Mary B. Moore (Locust Valley: J. J. Augustin, 1979) pp. 251–254, pls. LXVI, LXVII; Dorothy Kent Hill, *Catalogue of Classical Bronze Sculpture in the Walters Art Gallery* (Baltimore: Walters Art Gallery, 1949) p. 112, no. 253, pl. 51; A. Furtwängler, "Noch einmal zuttermes—Thoth und Apis." *BonnJbb* CXIV/CXV (1906) 114–115, 199–201; Walters, *BM Bronzes*, p. 281, no. 1808; Mitten and Doeringer, *Master Bronzes*, p. 140, no. 143: Erich Winter, *Der Apiskult im alten Ägypten* (Mainz: Zaberndruck, 1978), fig. 13; Bloesch et al., *Das Tier*, p. 56, no. 336, pl. 58.

63　*The Sacred He-Goat of Mendes*

Bronze, solid cast. Roman Empire, probably provincial, possibly northern, AD 1st–2nd centuries. H. 7.2 cm.; W. 1.7 cm.; L. 6.1 cm.

The goat's left legs are slightly advanced, his head lifted and turned slightly to the right. His blankly staring eyes and floppy ears give him a somewhat inebriated appearance although his perky tail reveals his high spirits. His coarse hair—arranged in patterned rows of thick, loose waves— was formed in the mold with no cold work.

The beast's identity is made certain by his purely Egyptian head gear. Actually it was the ram Banebdjed ("Ram Lord of Mendes") who was the sacred animal of Mendes during Dynastic times. In the Greek and Roman periods Banebdjed was represented as a goat to invoke the spirit of the Classical god Pan, a favorite of the Mendesians. To further strengthen the relationship between Pan's goat and Banebdjed, the horns of the model for this bronze were trained to grow in ram-horn formation. According to both Pindar and Herodotus, Mendesian women had sexual intercourse with he-goats, although Plutarch and Clement of Alexandria mention that the sacred goat preferred she-goats to beautiful women. The crown (hem-hem) was also worn by the ram sacred to the god Khnum.

Even though the subject is Egyptian, as in the prancing Apis [62], the naturalistic movement is singularly Roman. The even patterning of the animal's coarse hair suggests a provincial provenance. The Western European goat [189], displays a more exaggerated form of this patterning. It is possible that the bronze was made by a Roman craftsman in Egypt, but it is more likely, as in the case of the Apis, that the cult was carried to a distant part of the empire and influenced the creation of this bronze.

Condition: Right horn and plume tips broken from crown. Otherwise in excellent condition with dark green patina.　　　　APK

Bibliography: Unpublished.

Comparative literature: Herman de Meulenaere and Pierre Mackay, *Mendes II,* ed. Emma Swan Hall and Bernard V. Bothmer (Warminster: Aris and Phillips, 1976) pp. 2–3, 178.

64　*Hedgehog Head Fragment from an Aryballos*

Light turquoise faience. Naukratis or Rhodes, late Dynasty XXVI, ca. 550–525 BC. H. 3.3 cm.; W. 2.2 cm.; L. 4.1 cm.

Head and withers of an alert Egyptian hedgehog (*Hemiechinus auritus*) from a thick-walled *aryballos*. The eyes are extremely wide set, being placed on opposite sides of the snout. The eyes are black spots outlined by incision. A black spot decorates the center of the forehead. The spiny area is described by a deeply crosshatched pattern. Where the spines frame the smooth face they stick up like a crew cut. Traces of black remain at the broken top edge of the crew cut. The inside of the vessel received deep gouges.

The *aryballos* was the most common shape of container for precious oils and ointments in the Archaic Greek Period. The hedgehog was the most popular plastic version of this shape and was found in almost every Greek colony from Spain to the Levantine coast.

The configuration of the facial features, the "beauty mark" in the center of the forehead and the color are paralleled in two similar *aryballoi* in the Louvre (E25962 and CA609). The first was acquired through auction with no provenance, and the second is listed as coming from Rhodes. Many such *aryballoi* were found in Rhodes, but it is generally thought that these vessels were made in Naukratis, the Greek settlement in the Nile delta.

Condition: Losses from tip of nose and edge of crew cut. Decorative black spots suffered losses in their centers.　APK

64

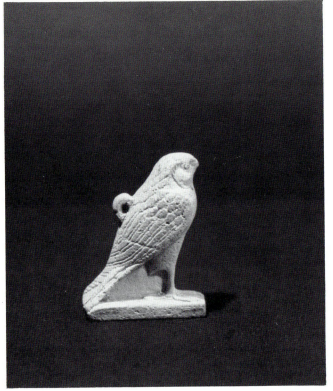

65

66

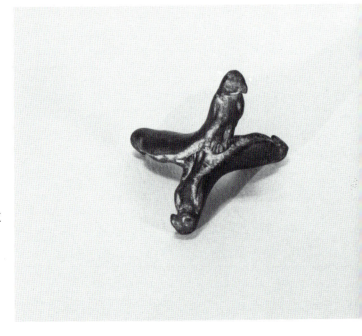

Bibliography: Important Egyptian, Greek, Roman, Etruscan, and Western Asiatic Antiquities, sale cat. (New York: Sotheby Parke Bernet, 11 December 1980), no. 297.

Comparative literature: J. Vandier d'Abbadie, *Catalogue des objets de toilette égyptiens* (Paris: Éditions des Musées Nationaux, 1972) p. 94, no. OT 367 and pp. 98, 100, no. OT 386; Virginia Webb, *Archaic Greek Faience* (Warminster: Aris and Phillips, 1978) pp. 5–7, 132–134, pls. XXI–XXII.

65 *Horus Falcon Amulet*

Faience. Egypt, Dynasty XXX–Early Ptolemaic Period, ca. 380–200 BC. H. 4.4 cm.; W. 1.6 cm.; L. 3.4 cm.

The falcon stands on a rectangular base. His crown, nape, and covert feathers are a carefully incised fish-scale pattern. The primaries and tail feathers are described by pin-stripe incisions. A quadruple ridged ring for suspension is attached to the middle of the back.

The relatively broad and deep chest and the patterning of the feathers fit into the dates suggested above.

Condition: Surface is very worn. No evidence of the glaze remains. Some loss from beak tip. APK

Bibliography: Bloesch et al., *Das Tier,* no. 71, p. 14, pl. 14.

Comparative literature: W. M. Flinders Petrie, *Amulets* (London: Constable and Co., 1914) p. 48, pl. XLI, no. 245af; G. A. Reisner, *Catalogue général des antiquités égyptiennes du Musée du Caire: Amulets* (Cairo: Institut français d'archéologie orientale, 1907) p. 198, pl. XXV, nos. 12525–12527.

66 *Four-Falcon Weight*

Bronze, solid cast, Egypt, Ptolemaic Period (332–30 BC). H. 3.9 cm.; Weight 41.5 gm.

Two pairs of falcons joined at the feet. The two birds in each pair also join at the tails creating a smooth, uninterrupted curve from one back to the other. No matter which way the piece is set down, one falcon stands upright and three rest on their heads.

The Egyptian Horus falcon is clearly evoked. The style is not one that lends itself to easy identification and could fit almost anywhere in the late Dynastic–Ptolemaic Period. All of the falcons, however, are wearing collars, a decoration which did not appear on Egyptian birds until the Ptolemaic Period.

The general appearance is that of a game jack. However, the game of jacks as we know it today is not described in antiquity. In any case, several similar pieces would have been rather heavy for the light-handed action required in that game. In order for the piece to have been used in a game of chance, one or more of the falcons would have had to be differentiated in some way, and there is no trace of this.

It is more likely that the object was a weight. Egyptian weights were often animal-shaped, although I know of no other example like this piece. The object stands solidly and is easy to handle as a single unit. Its present weight, which may differ from its original weight through losses in corrosion and wear, is close to ten times the most generally accepted weight for drachmas in Classical antiquity which ranged in weight from 4.2 to 4.4 gm.

Temples used weights to determine the value of votive objects and the religious ardor of the worshipper-donor accordingly. Perhaps the four-falcon weight was part of the furnishings of a temple or shrine devoted to Horus either in Egypt or elsewhere in the Roman empire.

Condition: Beak tips are flattened from wear. Dark green-black patina. APK

Bibliography: Unpublished.

Comparative literature: Arielle P. Kozloff, "A New Species of Animal Figure From Alexandria," *AJA* LXXX (Spring 1976) pl. 32, figs. 4–6; Department of Greek and Roman Antiquities, *A Guide to the Exhibition Illustrating Greek and Roman Life,* 3rd ed. (London: The British Museum, 1929) p. 141; Mabel Lang and Margaret Crosby, *Weights, Measures and Tokens,* The Athenian Agora, X (Princeton: Princeton University Press, 1964) p. 4.

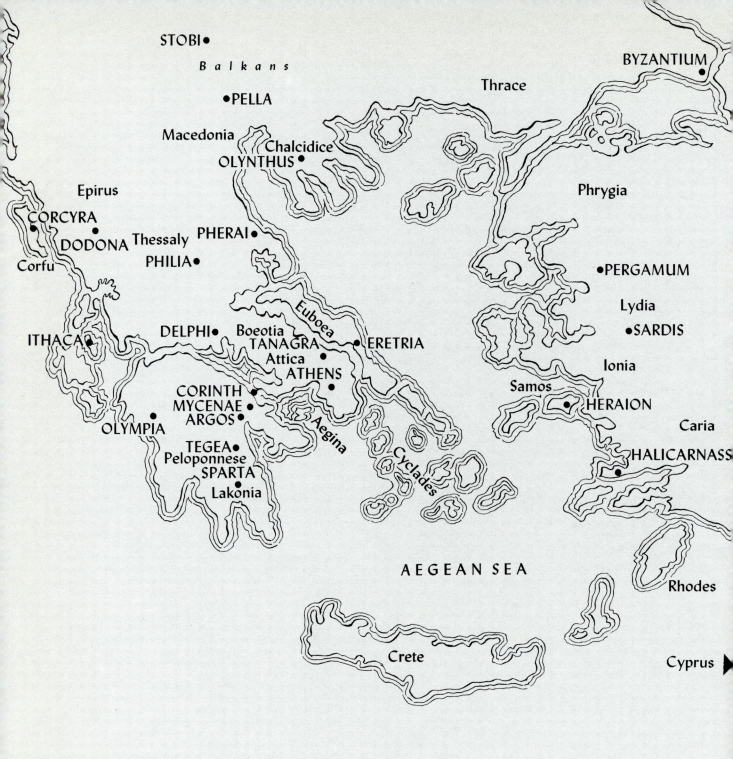

STOBI●

Balkans

BYZANTIUM●

Thrace

●PELLA

Macedonia

Chalcidice
OLYNTHUS ●

Phrygia

Epirus

CORCYRA
●
DODONA
●
Corfu

Thessaly
PHILIA ●

PHERAI ●

PERGAMUM
●

Lydia

●SARDIS

Euboea

Ionia

ITHACA●

DELPHI ●
TANAGRA
Attica
ATHENS
●

Boeotia

ERETRIA
●

Samos

HERAION
●

CORINTH ●
MYCENAE
ARGOS ●

Aegina

Caria

OLYMPIA
●

Cyclades

HALICARNASS
●

TEGEA ●
Peloponnese
SPARTA ●

Lakonia

AEGEAN SEA

Rhodes

Crete

Cyprus ►

M E D I T E R R A N E A N S E A

Animals from the Classical World

We usually think of classical civilization as profoundly, virtually exclusively, anthropomorphic in its concepts, anthropocentric in its concerns. With good reason, we sum up the Greek view of the universe as "Man is the measure of all things." Consequently, classical scholarship has with few exceptions concentrated upon the Greeks and Romans themselves, their gods, and the interaction of these divine and mortal realms in myth, history, and art. Yet, even the most superficial inquiry reveals that animals were omnipresent throughout all aspects of classical civilization—Greek, Etruscan, and Roman—and that their roles as companions, servants, adversaries, and sometimes even as spiritual surrogates were complex, sometimes fraught with profound meaning.

While not so inextricably linked with deity in the classical world as they were in Egyptian culture and religion, animals served as attributes, sometimes servants, and even vehicles of the Olympian gods. Zeus' eagle, Athena's owl, and Hermes' ram (and later, Mercury's billy-goat) are only the most obvious examples. The dogs and serpents of Asklepios, who actually ministered to patients during the healing process of "lying-in" at his sanctuaries, exemplify the power of animals to participate in and extend the beneficent involvement of gods with men. Except for possible lingering survivals, however, there do not seem to have been widespread concepts among the Greeks of animals as familiars, totemic companions, or alter-egos. Despite decades of examination, we believe that shamanism remained largely foreign to Greek religious experience and perception and to the ways in which classical peoples regarded animals. Yet, Greeks of the Classical Period, Etruscans, and Romans used animals as embodiments of virtues and values, as guardians and companions, and as sources of amusement and pleasure far beyond their merely utilitarian roles as providers of food and transportation, materials for clothing, and so forth. Many of these attitudes and values can be discovered by perusal of metaphor, simile, and epithet throughout classical literature, from the Homeric epics through the writings of the early Church fathers. Equally valid, sometimes even more vivid and eloquent, evidence is available through their representations in art. Each animal in Leo Mildenberg's collection is such a document, at once graphic and spontaneous.

The naturalistic, yet innately abstract, character of the fauna observed throughout Greek art is already present in the earliest bronze and terracotta animals, miniature votive statuettes dedicated by the hundreds at Olympia and the other newly founded sanctuaries of the Greek Iron Age, in the period we call "Geometric," from its predominant patterns of ornament. Abstract and simplified, they yet reveal acute perception of the actual appearance and character of the animals they depict. The small horses [71, 71 *bis*], cast at Olympia late in the eighth century BC, embody the qualities that early Greek aristocrats, the men who listened to Homeric poetry and shaped their aspirations and deeds through it, attributed to their horses, the symbols of their wealth and exalted social station. Likewise, horses are common products of the ceramic industry—both painted on late Geometric pottery [74] and modeled in the round [73].

The predominance of birds, on the other hand, among the votive statuettes from northern Greece—Thessaly and Macedonia—suggests a different cultural milieu, one that, while still largely Greek, shared in the wider symbolic importance of birds that extends through Italy and into central Europe during the Iron Age. Sometimes votive offerings provided with suspension loops [75] or holes as well as feet [76, 77] (often simply finials for larger objects), these birds constitute an entire aviary of seemingly endless invention and variation. There is a wildness here that hints of the swamps, lakes, and estuaries of the Balkans, where success in hunting must still have been essential for life and where Artemis—in her many local forms mistress of these fowl—must have retained an importance that she had perhaps lost in more advanced regions farther south.

The northern Greek world takes abstract shape in the scene on the catchplate of the exquisite Thessalian Geometric *fibula* [72]. Surrounded by waterbirds, a horse seems to dance as he grazes. He, too, symbolizes the values of the princely families who ruled these plains and valleys, among them perhaps the ancestors of Philip ("horse-lover") of Macedon?

No less fond of animal symbolism were the Italic Villanovan warriors and metal workers. As was the case in northern Greece, their animal forms often constitute parts of larger ensembles, such as the smaller quadrupeds and birds in the magnificent bit with horse cheek pieces [84]. The birds that perch atop the bow of a safety pin-like *fibula* [85] can be found resting on top of the crossed ends of rafters of hut urns and face each other in pairs on the cast handles of ornate bronze cups. In Italy horse and bird seem to partake of wider worlds of symbolism, from central Europe, Iran, even the Steppes, as well as of Mediterranean traditions nearer home.

The decisive impact exerted by the eastern Mediterranean world upon Italy during the late eighth and early seventh centuries BC when Villanovan villages evolved into Etruscan city-states, can nowhere be better appreciated than in representations of lions. The magnificent burnished lion [86] reclining upon the lid of a vessel made from native Italic gray impasto, reflects his maker's reference to a metal prototype; behind him stretch centuries of alert eastern Mediterranean ancestors. Similarly the minutely detailed gold plaque [87] with its repoussé lion and rich granulation demonstrates the Etruscans' fascination with exotic Oriental motives, as well as their debt to Near Eastern metallurgy.

The fauna of late Geometric and early Archaic Greek art included fantastic composite beings, creatures who originated in the East, beyond the periphery of the Greek world. Although we, of course, understand that sphinxes, centaurs, and sirens exist only in the imagination, while lions are real and potentially dangerous feline creatures of flesh and blood, the Greeks of that time made no such distinction. The lion, guardian symbol of power and majesty already for millennia in the Near East, made a timorous beginning in Greek art, as in the little bronze lion [70] on his own plinth, wide-eyed, skidding to a stop. He is pet-like, not yet ferocious, the embryo only of what is to come.

Eventually lions became quite common, assuming graphic and plastic form throughout the Greek and Etruscan worlds. Emblems of bravery, ferocity, and majesty, they recline in pediments and glare down from the eaves of temple roofs where their guardian function now merges with a new role: as waterspouts [111, 138]. They perch on the rims of cauldrons [90]

and the cross-braces of tripods, and flank the vertical handles of elaborate bronze water-jars. On bronze furniture, such as Etruscan tripod feet of incense burners and the edges of braziers, they occur in pairs, trios [104], or quartets, diminutive decorations for the silhouettes of the larger objects. In some, stylizations are reduced to what seems to us like banality [105] or mere convention. The function of lions as guardians, however, and the values inherent in their representations, remain potent far beyond the centuries of classical antiquity well into the Middle Ages.

Rams—victims of sacrifice, companions of Hermes—occur almost as widely in Archaic Greek art as do lions. Their sturdy belligerence and steadfast resistance to the foe made them popular shield devices. Ram heads decorated the cheek pieces of many Archaic and Classical Period helmets. Reclining rams flank the lower ends of the vertical handles of water-jars. Single standing rams may serve as votive statuettes, as [107, 109] where the animal's character is effectively portrayed in simplified form. The massive ram atop a monument-like plinth [108] is unique, a miniature equivalent of a votive column. Could it have been a herald's staff? Or perhaps the tip of a scepter-like instrument carried by a priest of Hermes somewhere in Magna Graecia around the time of the Persian Wars? Rams as guardians or as sacrificial victims recur too frequently in Greek art not to have evoked multiple associations, allusions, meanings in their viewers and users. Again, some of these levels of meaning were tranformed and re-used during the transition from late antiquity into the early medieval and Byzantine traditions. Although not so common in Etruscan art, a series of proud terracotta rams' heads was executed for a temple at Veii [110].

On a more decorative, functional level, a crouching ram serves as a perfume flask, the orifice on the top of its head [96]. Such small plastic vases in the form of animals were manufactured throughout the Mediterranean in the Archaic Period. The Mildenberg collection contains some particularly fine examples, namely, the Rhodian turtle [97], the Ionian duck [99], and the Etruscan ape [95].

The ape or monkey, an exotic visitor from Africa, always attracted lively attention. Its anthropoid appearance, lively activities, and often humorous antics made it a natural vehicle for commentary upon human behavior. Such is the truncated ape or monkey portrayed in the sixth-century East Greek plastic perfume bottle [98]; his bemused expression forms an effective caricature. The squatting ape depicted on an Attic late fifth-century miniature *chous* [130] is perhaps parodying a young Athenian about to be initiated in the annual wine festival, the Anthesteria. Far different is the seated terracotta ape [122]; in him, the pathos of the portrayal reaches a depth of insight worthy of an Oedipus. It dramatically illustrates how, upon occasion, the Greek observers of animals could admit them into the human world of intellect and feeling, as protagonists in fables or as individuals profoundly expressive of human traits as well as their own natures.

The full mastery of sculptural realism attained by Greek sculptors during the early fifth century BC was utilized then and in subsequent centuries to produce an astonishing range of animal portrayals in monumental sculpture. The study of these on a systematic basis has barely begun. The celebrated fidelity to its subject of Myron's bronze cow on the Athenian acropolis can be glimpsed in a superb miniature version [158], probably cast late in the fourth

century BC and perhaps the most faithful reproduction yet known. The bull with lowered head, about to repel an intruder [144], and the Tarentine horse, caught in a full forward leap [136]—a miniature counterpart of the running horse from the Artemision shipwreck—demonstrate what Classical and Hellenistic sculptors could do on small or monumental scale with animal subjects.

Animals also play a significant role in the realm of the decorative arts, where their specific attributes are put to particularly effective use. Birds for instance, flutter as pendants on Hellenistic gold earrings [154] or alight on the handles of elaborate Canosan urns [151–153]. Later, they appear in Roman frescos [164] and late Antique mosaics [196] as evocations of the idyllic world of nature. Snakes writhe, often around the arms of their owners, in the form of gold bracelets [162]. Fish and other marine fauna swim or float on the surfaces of vases, especially on South Italian fish plates produced in abundance in the late fourth century BC [149]. Much rarer is the Attic black-figure amphora [103] of the late sixth century BC with its unique array of marine fauna: octopods, crabs, fish, and water birds. These fine objects and more, demonstrate the classical artists' sensitivity to not only the variety of animal life but also the special traits of each species.

This versatility continues through the Roman period; pets become more frequent, such as the slender, sensitive hound with stippled fur who begs for attention [182] or the shaggy, wakeful, yet congenial Molossian hound [184], who probably snoozed atop a chest or chariot in an Italian household. Even pests are treated with affection in the Roman bestiary. What could be more engaging than the trio of mice [170 – 172] busily nibbling their food, one even perched upon its own circus-like base? A magnificent novelty is the large duck lamp [165] which certainly evoked admiring and humorous comments among the guests in the home where it must have been a prized possession.

Rams, lions, panthers, and dogs continued to play their accustomed roles even in a society where Christianity had replaced the traditional Olympian cults. The fleecy ram from the middle of an offering vessel or *patera* [190] evokes the sheep as the symbol of Christ, the Lamb of God, the sacrificial surrogate for sinful mankind in Christian belief. The dolphin, friend to men throughout classical antiquity, forms a hanging lamp for home chapel or public sanctuary [192]. The classical values and roles of these animals largely persisted but came to be invested with additional meaning within the emerging Christian society.

Each of the classical animals in the Mildenberg collection reveals a new, fresh insight into the role of its subject at an individual time and place within classical civilization as a whole. They stimulate as well new interest in the enormous, untapped wealth of information they can reveal about the values and attitudes of that civilization. Finally, they stand as eloquent evocations of the taste, sensitivity, and humanity of the collector who has shared them with us in this exhibition.

DGM

Alps

CARNUNTUM

PO

VILLANOVA •

Etruria

CLUSIUM • (CHIUSI)
ORVIETO •

VULCI •

TARQUINIA • VEII •
CAERE •
(CERVETERI)
• ROME

TIBER

Apennines

ADRIATIC SEA

Campania

CAPUA
•

CANOSA •
RUVO •

CUMAE
•

Apulia

POMPEII •
STABIAE •

SELE

Lucania

PAESTUM •
• METAPONTUM
•

TARENTUM
(TARANTO)

GRUMMENTUM •

THURII •

TYRRHENIAN SEA

HIMERA
•

RHEGION •

SELINUS
(SELINUNTE) •

Sicily

IONIAN SEA

• SYRACUSE

67 Bull Askos

Earthenware, fired pinkish tan. Late Cypriote II
Base-Ring Ware, ca. 1300–1225 BC. H. 8.3 cm.; W. 4.6
cm.; L. 12.7 cm.

The vase is in the form of a standing bull. A small stir-
rup handle is attached to the back; just in front of it is an
irregular hole which serves as the mouth of the vase. The
bull's muzzle is perforated to form the spout. The animal's
large circular eyes, his horns, ears, dewlap, and tail are
plastically applied to the cylindrical body. Irregular stripes
of white paint decorate the surface.

A large number of bull-shaped *askoi* have been
recovered from the tombs of Late Bronze Age Cyprus.
They are almost always produced of base-ring ware, one of
the major handmade fabrics introduced in the Late Cypriote
Period. Most are very similar to our example although some
have a perforated attachment on the snout. Occasionally, a

bronze ring is still preserved in this attachment. Whether
this is for suspending or pulling the vase is not clear. The
exact use of such vases is also in question although their
number, archaeological context, and relationship to earlier
types seem to indicate a votive function.

Condition: Tips of horns chipped; minor surface
abrasion on left flank. Paint relatively well-preserved. RDD

Bibliography: Unpublished.

Comparative literature: J. Johnson, *Maroni de Chypre, Studies in
Mediterranean Archaeology* LIX (1980) 56, pls. VII, 5; XIII, 49; XV, 58;
XXII, 118-121; XXX, 157; XXXIX, 195; XLI, 206; *CVA* British Museum 1
(Great Britain 1), pl. 9; M. Maximova, *Les vases plastiques dans
l'antiquité* (Paris: Geuthner, 1927) pl. III, 13; L. Åström, *Studies
on the Arts and Crafts of the Late Cypriote Bronze Age* (Lund:
Berlingska Boktryckeriet, 1967) pp. 42-43; H.-G. Buchholz and V.
Karageorghis, *Prehistoric Greece and Cyprus* (London: Phaidon,
1973) nos. 1724, 1726, color pl. 3.

67

68 Bull or Humped Ox

Glass. Possibly Aegean, possibly 13th century BC.
H. 3.5 cm.; Th. 0.096 cm.; L. 5 cm.

Translucent deep blue glass; probably cast in an open mold and retouched, eye drilled.

The animal is reclining with head bent around to his left side, resting on the front legs; a prominent hump counterbalances the strong rear flank; and the rear leg is tucked under the body. The curvilinear outline and the flow of arcs within the outline catch the eye and draw it from one side to the other. Considering the temperament and imposing size of the subject matter, the craftsman has rendered the animal with all the fierceness of a lap dog. The backside of the pendant was ground flat, suggesting it was used as an inlay. In turn, the hollow eye may have contained some precious material.

The style, the subject matter, and the date make this a most problematic piece. The subject matter—a humped bull or ox—is unusual in Roman art. The deep blue glass is not uncommon in small cast pendants or even blown vessels of the Early Imperial Period, but the style seems earlier. This color is also known in the late second millennium BC from inlays and jewelry of Minoan and Mycenaean sites. Most of this material is smaller and heavily weathered, but occasionally we see unweathered deep blue or turquoise beads. The pitting on the surface of the bull combined with the dark, heavy weathering crust still adhering to the fracture across the front of the face and in the eye hole might help link the piece with earlier glasses. After examination, this writer feels somewhat comfortable with an Aegean attribution but would welcome colleagues' thoughts on the style or date.

Condition: Front portion of leg and mouth broken. Mouth break has accented a large bubble on the muzzle making it appear that the upper portion of the face is broken away. Pitted surface; "worm track" weathering patterns and flow lines; some dark, thick weathering crust adhering to interior of eye and deep furrows. SMG

Bibliography: Unpublished.
Comparative literature: None.

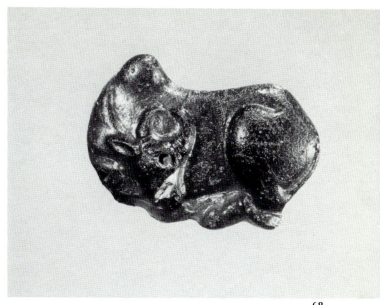

68

69 Long-Necked Bull

Bronze, solid cast (lost wax). Southeastern Europe, first half of 1st millennium BC. H. 10.3 cm.; W. 4 cm.; L. 12.5 cm.

Two main tubular forms, the neck and the body, are governed here by a rigid patternization. Smooth curves mark the transitions among the elongated, angular forms. The body is supported on its two pairs of flaring legs like a trestle. The bull's face, however, shows a high degree of sensitivity. The slightly open mouth shows a row of teeth. Both eyes and nostrils are deeply gouged by single punctures in the wax model. The ears are canted as if gently flapping. The tail is short. The genitalia add horizontality to the quietness of the animal who stares from the top of his telescopic neck as if at something beyond the fence.

Imperfections in the casting were left untouched and intimate a sense of irregularly knotted tufts of hair on the body and a sort of scaling off of the horns. Thus, living textures emphasize the cubistic construction of the animal form and miraculously add to their artistic credibility. There has been, however, a delicate reworking with the hammer along the spine and over the rump, clearing away some of the imperfections.

Similar proportions, especially the very long neck and torso, exist in first-millennium BC European bronzes. The "trestle" form occurs in ninth-century BC Iranian bronzes

and on mid-first–millennium animals from Yugoslavia. The "trestle" form, the punctate eyes and nostrils, the well-defined mouth, and the lively spirit are all properties of early Argive and Olympian votive offerings (see [70]) of the ninth and eighth centuries BC. The Mildenberg bull is probably a Yugoslavian product with certain influences from nearby Greece.

Condition: Some surface corrosion. Green to black patina. PV and APK

Bibliography: Unpublished.

Comparative literature: Emma C. Bunker, C. Bruce Chatwin, and Ann R. Farkas, *"Animal Style" Art from East to West*, exhib. cat. (New York: Asia Society, 1970) pls. 158, 136; Alfred Salmony, "L'art ancien de Bulgarie," *CahArt* VIII (1933) 210, fig. 2; William Culican, *The Medes and the Persians* (London: Thames and Hudson, 1965) p. 13; N. K. Sandars, *Prehistoric Art in Europe* (Middlesex: Penguin Books, 1968) pls. 212, 213; W.-D. Heilmeyer, *OlForsch* XII, pls. 19, 44, 45, and *passim*.

69

70 *Halted Lion*

Bronze, solid cast (lost wax). Greek, probably from the Peloponnesus, Geometric Period, second half of 8th century BC. H. of lion 2.9 cm.; W. of lion across forepaws 1.5 cm.; Max. L. 3.7 cm.; L. of lion 3.2 cm.

This wide-eyed little lion sits back on his heels as if having suddenly stopped. He has large, splayed front feet, with three toes on each. His rear and front legs are carefully separated; the sharp edges of the deep groove separating the hind legs look very much as if produced by a knife in the wax model. The lion's body is short, with a high rump. His plastically rendered tail curls over his right hip, wraps under his waist, then curls up his left side ending behind the top of his head. The top of the head is massive and rounded. Horizontal grooves outline a transverse ridge above the eyes, which are situated in concave facet-like surfaces on either side of a carination that extends to the

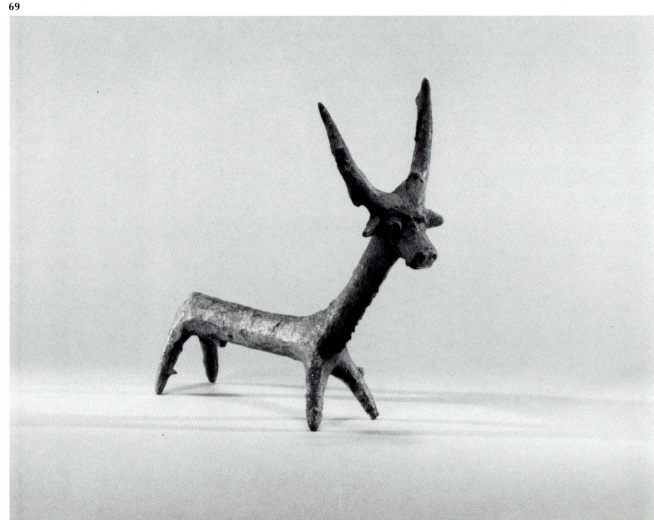

end of the muzzle. The eyes are punctate holes, similar to those often found in human statuettes (warriors, charioteers) from Olympia. A horizontal groove runs around the sides and end of the muzzle. Small fetlock joints are represented on the front legs.

The lion stands on its own plinth (3.2 × 2.7 × 0.5 cm.), rectangular from front to back and hollow beneath. Its underside displays a "St. Andrew's" cross in relief which is the same thickness as the sides of the plinth. There are two incised lines running along the top of the plinth at the right side, just at its margin.

The Mildenberg lion is one of a handful of Geometric bronze lions known. A lion is attacked by a sword-wielding man and a dog in a famous group from the Heraion, Samos, now lost. A pair of lions, arranged side-by-side, is in the Stathatos collection, National Museum, Athens; similar to them is a bronze lion in the Ortiz collection, Geneva, which stands upon a base shaped like a Boeotian shield and has punctate eyes similar to the Mildenberg lion's. While lions are conspicuously absent from the repertoire of Geometric bronze votive animals from Olympia published by Heilmeyer, the modeling of the Mildenberg lion, the form of the plinth, and its punctate eyes strongly suggest that it was produced at or in the neighborhood of Olympia. Its overly large head is reminiscent of the lions on Late Geometric Attic vases and on incised catchplates of Boeotian and Thessalian *fibulae*.

In general Geometric lions, appearing toward the end of the eighth century BC, do not seem to have been modeled either upon specific prototypes from the eastern Mediterranean region or from life. Instead, they appear to be individual artists' renditions of contemporary descriptions of lions, perhaps including those found in the Homeric poems.

Condition: Intact; covered overall by a bubbled dark gray-green patina. DGM

70

Bibliography: Unpublished.

Comparative literature: B. Schweitzer, *Greek Geometric Art* (New York: Phaidon Press, 1971) pp. 151-154 (lion combat groups; early lion on ring handle from tripod at Olympia); H.-V. Herrmann, *Gymnasium* LXXIV (1967) 484; W.-D. Heilmeyer, *OlForsch* XII, 196, n. 262; *Objets antiques et byzantins: Collection Hélène Stathatos* III (Strasbourg: en dépot chez P. Amandry, 1963) 22-23, no. 22, pl. XII, and fig. 29 (there called an occidental rendition of an Oriental prototype and compared with orientalizing ivory lions from the Bernardini Tomb); J. Dörig, *Art antique: Collections privées de Suisse romande* (Geneva: Éditions archéologiques de l'Université de Genève, 1975) no. 108 (Ortiz), there dated around 700 BC.

70 underside

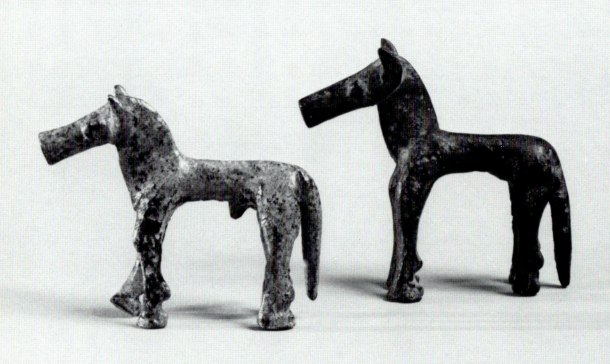

71 *Votive Horse I*

Bronze, solid cast (lost wax). Greek, from a workshop at Olympia under Lakonian influence, Geometric Period, ca. 740–720 BC. H. 5.5 cm.; W. at rear legs 1.5 cm.; L. 5.9 cm.

This horse stands on its own four feet. The cylindrical body is parallel to the surface upon which the horse rests; its head (L. 2.5 cm.) slants slightly downward. The line of the lower jaw curves upward to form the back of the ears. The eyes, placed slightly forward of the ears, are small rounded pellets. The tail, hanging vertically from the rump, almost reaches the bottom of the hooves. Details of the hooves are plastically rendered. There are prominent facets running down the foreparts of the front legs, probably produced by paring the wax model with a knife. There is no incised ornament.

This horse is an excellent example of a class of Geometric bronze votive animals popular in a number of Greek sanctuaries during the middle and last half of the eighth century, but especially at Olympia. In contrast to many such statuettes, in which the horse is cast in one piece with a solid or openwork plinth, most of the Olympia horses rest squarely upon their own feet. These small bronze horses, as well as terracotta figurines, were favorite gifts to Zeus from worshippers and perhaps participants in the athletic festival. To judge from the complexity of many of these votive offerings and the variety of regional styles represented, the athletic games must have been attracting competitors from all over the Peloponnesus, as well as from central Greece and the islands, by the mid-eighth century BC.

Such horses as this one and its mate [71 bis] were probably manufactured on the spot by itinerant bronze-casters, both locals and individuals from the major metalworking centers: Corinth, Argos, and especially Sparta. Heilmeyer has published the foundry debris and imperfect castings that prove the activity of Geometric bronze foundries at Olympia; Herrmann effectively distinguished the stylistic characteristics of Corinthian, Argive, and Lakonian Geometric bronze animals. Heilmeyer now recognizes that horses similar to the Mildenberg pair are products of local Olympia workshops originally under strong Lakonian influence which progressively lessened toward the end of the eighth century BC. A close parallel exists in the Rhode Island School of Design (54.132).

Condition: Intact. Dark gray-green surface with much bright blue on inside surface of tail, rear legs, and on the left side of the mane. DGM

Bibliography: Unpublished.

Comparative literature: For discussion of the workshop that produced these horses cf. W.-D. Heilmeyer, *OlForsch* XII, 242, pl. 73, nos. 560-561, and analysis, pp. 134, 136, 156; W.-D. Heilmeyer, "Giessereibetriebe in Olympia," *JdI* LXXXIV (1969) 1-28, esp. head of miscast horse, fig. 2; H.-V. Herrmann, "Werkstätten geometrischer Bronzeplastik," *JdI* LXXIX (1964) 20-24, figs. 1-4 (the Lakonian group); Mitten, *Rhode Island Cat.*, pp. 24-25, no. 6.

71 bis *Votive Horse II*

Bronze, solid cast (lost wax). Greek, from a workshop at Olympia under Lakonian influence, Geometric Period, ca. 740–720 BC. H. 4.75 cm.; W. at rear legs 1.9 cm.; L. 6.4 cm.

Almost identical to [71] in modeling, size, surface finish, and lack of incision, this horse differs slightly, especially in the more developed articulation of the hooves and lower legs, and in the more prominent penis. These differences might suggest that this horse is slightly later in the series than [71]; it might also, however, be simply the product of a more careful or advanced craftsman in the same workshop.

Condition: Intact. Covered with shiny light blue to gray-green patina, with darker spots on the legs. The right front foot is bent forward. DGM

Bibliography: Unpublished.

Comparative literature: See [71].

72 *Fibula, Catchplate Engraved with Horse and Bird*

Bronze, cast. Greek, Thessalian, Geometric Period, second half of 8th century BC. Max. H. 5 cm.; W. of catchplate 5 cm.; L. 10.2 cm.

This elaborate *fibula*, or safety pin-like brooch, features a bow consisting of five faceted biconical beads above the spring. It terminates in an enlarged, flat catchplate, the upcurved bottom edge of which originally received the end of the pin. Both sides of the catchplate are decorated with elaborate incised compositions. On the obverse, an incised horse faces left, a bird flying over its back, within a framing zone consisting of a number of incised lines and minute zigzags. On the reverse, framed within a broad zone of meander, is a small figural panel containing either a horse or a bird; corrosion obscures the design. The bottom portion of the catchplate, with the upturned sheath for the pin, has been broken away, as has the small round bead that formerly perched atop the upper corner of the catchplate, opposite the bow.

Two turns of the spring are preserved; it is a continuation of the faceted end of the bow. Between the spring and the first bead are six superimposed sharp-edged disks. Of the horizontal beads, the three largest and nearest to the catchplate are faceted into octagons. The fourth bead has four flat faces; both halves of the fifth and lowest are rounded. These large beads are separated by small ones, 7 mm. in diameter for the bead between the first and second bead, moving away from the catchplate. It also bears very

72

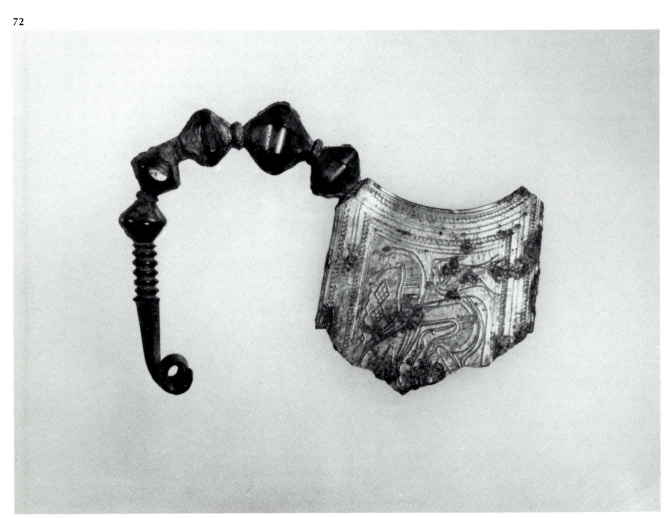

fine incisions. The corresponding small bead between the third and fourth large beads is broken away, probably damaged during mechanical cleaning. There is a flattened element marked with very fine striations similar to these small beads at the upper left-hand corner of the catchplate.

The border framing the scene with the horse consists of parallel incised lines subdividing the space into zones: three central zones, flanked by two very narrow zones filled with extremely delicate zigzag ornament. The innermost and outermost sections of the frame consist again of two open zones. The presence of the delicate zigzag for these borders is exceptional in a region where borders of *fibula* catchplates are usually decorated with compass-turned scallops or half-circles.

The horse faces left, its head in the upper left-hand corner. A zigzag line ending in a small lozenge (perhaps a bridle rein?) hangs from its mouth. Between this line and the horse's mouth are two vertically superimposed, crosshatched lozenges. A waterbird with head turned backward occupies the upper right-hand corner of the panel; it is not entirely clear whether he is flying or resting upon the horse's back. A smaller waterbird occupies the space between the horse's front and hind legs. There appears to be a triangle projecting upward between the horse's front legs. Four tiny incised triangles project downward from the top of the frame behind the larger waterbird's head; a fifth similar triangle does so between the horse's mane and that waterbird.

The horse's body, mane, and legs are outlined by parallel incised contours, within which the entire area of the horse's body is filled with minute crosshatchings: horizontal on the mane, vertical on the body, and radiating around the transition from rump to hind leg. Although the horse's body is shown in profile, its head with both tiny oval eyes is represented as if seen from above, a highly individual example of composite view in Geometric craftsmanship. A separate zone of diagonal crosshatching—similar to the placement of incised ornament on many Geometric horse statuettes—occurs on the mane. A single line, continuing the curve of the rump, then plunging straight downward, represents the tail; presumably it continued to the feet.

On the reverse of the catchplate, badly obscured by corrosion, is a smaller square or rectangular panel, enclosed within an outer frame of incised lines flanking a band of zigzag tooth ornament, then an inner zone of crosshatched meander. The subject of the panel—whether horse, other quadruped, or a bird—is obscured by the surface corrosion. Analogous smaller panels occur on the left sides of *fibula* catchplates from Pherai.

The Mildenberg *fibula* is one of the finest and most elegantly incised products of Thessalian metalworking workshops known to date. It belongs within a wider group of intricate *fibulae* with incised catchplates from Pherai. Its closest parallel, however, is a *fibula* in a Basel private collection, in which the incision—with tiny zigzag framing lines, double parallel contour lines for the horse, frontal head with two eyes and the placement and rendering of the waterfowl—are virtually identical. In the Basel example, on the other hand, the stacked lozenges in front of the horse are replaced by a tiny waterbird. Virtually intact, the Basel *fibula* enables us to visualize the bottom edge of the catchplate; there, it is formed by a border of small overlapping, compass-incised half-circles opening downward, a form of incised decoration missing on the preserved part of the Mildenberg *fibula*. A fine group of Boeotian *fibulae* with incised catchplates is in Heidelberg.

Condition: Pin beyond spring and lower part of catchplate missing; round bead originally projecting upward from upper corner of catchplate missing. Shiny dark blue-green patina on beads of bow. Hard green corrosion products still adhering in spots to second and third bead from spring end of bow. Patches adhere to obverse of catchplate, obscuring portions of the horse and waterbirds; most of the reverse is still covered by this incrustation. DGM

Bibliography: Unpublished.

Comparative literature: Kilian, *Fibeln*, from Pherai: pls. 47(1337), 48(1351), 48(1369), 50(1389), 52(1482), 53(1497), 55(1538), from Philia: pls. 54(1502), 61(1882), from Kainourgion, Haghios Demetrios: pl. 62(1884), see also p. 109, and for beads on bows: pls. 24(1524), 51(1451), 55(1533); P. Blome, "Ein mittelgriechische Plattenfibel in Basel," *AntK* XXIII (1980) 117-123, 119, fig. 2, pl. 26.2; R. Hampe et al., *Neuerwerbungen 1957–1970*, exhib. cat. (Mainz: Phillipp von Zabern, 1971) pp. 89-99, nos. 121-129, pls. 81-101; B. Schweitzer, *Greek Geometric Art* (New York: Phaidon Press, 1971) pp. 202-211, figs. 110-122.

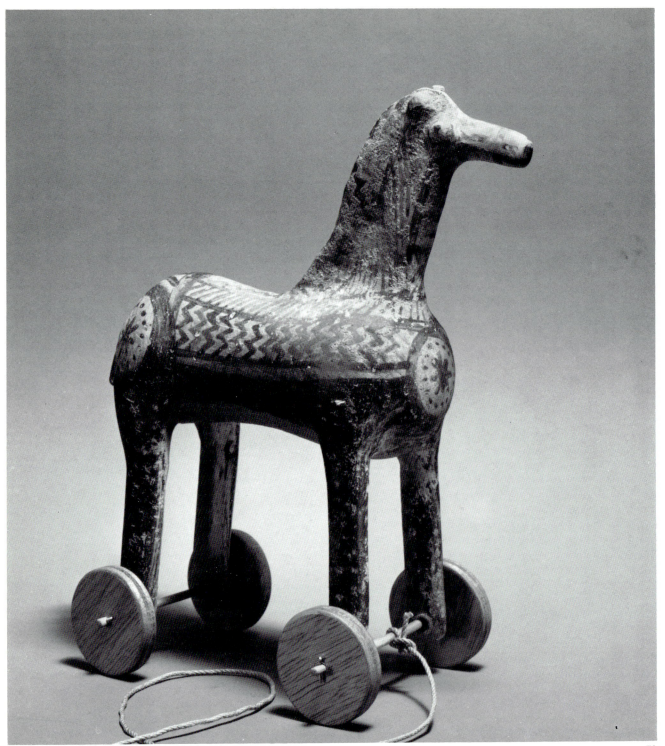

73

73 Horse on Wheels

Terracotta, fired pinkish tan. Attic, Geometric
Period, ca. 800–750 BC. H. 20.2 cm.; W. 6.1 cm.;
L. 18.9 cm.

This sturdy terracotta horse is composed of tubular forms:
body, head, legs, and tail. However, the legs are oval
in cross section and stand vertically rather than splayed
out as on most Geometric horses. The neck is a slim
(hollow?) structure with a pinched mane. Small lumps of
clay form the eyes and ears. The four hooves were
perforated before firing.

Much of the body of this horse is painted with geometric
designs in brown slip. The head is fitted with a painted
harness. On the right side the mane is decorated with
vertical zigzags, while the neck is painted with vertical lines.
The ornament is reversed for these areas on the opposite
side of the animal. The horse's shoulders and flanks are
divided into frieze-like zones of verticals and zigzags. The
underside of the neck has horizontal bands and a large
"X" at the bottom. Large medallions with circles of dots
surrounding a star-like device ornament the brisket and
both haunches. The tail is painted with small diagonals. The
lower parts of the horse, except for the reserved belly, are
simply painted in solid brown.

Ceramic horses, many with riders, were popular in
Greece from Mycenaean times. Many examples are asso-
ciated with the Geometric Period and come from Attica and
Boeotia. Perhaps best known are those which form the
handles for large covered *pyxides*. The present specimen,
however, was never attached to a clay lid as his rounded
and perforated hooves indicate. This horse must have been
fitted with wooden axles and wheels (as he has been recent-
ly) and thus became a member of a rare class of "animated"
horses. An earlier example has been excavated in the
Athenian Kerameikos. Precisely how such clay horses were
used is unknown. It is not unlikely that those with added
wheels were children's toys.

Condition: Right ear and lower portion of tail missing.
Paint misfired on right shoulder; flaking over much of
surface. General surface pitting and abrasion. RDD

Bibliography: Unpublished.

Comparative literature: K. Kübler, *Die Nekropole des 10.-8.
Jahrhunderts (Kerameikos* v, 1) (Berlin: Walter de Gruyter, 1954) pl.
142; J. Fink, "Büchse und Pferd," *AA* (1966) 483-488; D. Kurtz and J.
Boardman, *Greek Burial Customs* (Ithaca: Cornell University Press,
1971) pp. 63-64, pl. 3; K. Branigan and M. Vickers, *Hellas, The
Civilization of Ancient Greece* (New York: McGraw Hill, 1980) p.
111, top.

74 Kantharos with Confronted Horses

Earthenware, fired pinkish tan. Attic, Late Geometric
Ib Period, ca. 750–730 BC. H. with handles 17 cm.;
without handles 12.8 cm.; Diam. of lip 15.4 cm.

Known as a *kantharos*, this high-handled drinking cup
has a vertical lip passing without carination into a narrow
shoulder. The deep body tapers to a flat, footless base. This
type of *kantharos* with its high-swung handles was intro-
duced to the Attic repertoire in the late Middle Geometric
Period (ca. 800–750) and continued in popularity through-
out Late Geometric (ca. 750–700). The rim has assumed a
slightly elliptical shape as a result of the strap handles being
attached when the clay was still wet.

The painted decoration executed in a brownish-black
color is similar on the two sides. The interior and lower
body are fully glazed. The strap handles show an X in the
square above the lip, horizontal stripes at the top, and a
tall X on the outside. They are unpainted on the inside.
Framed by two horizontal lines above and three below, the
lip zone bears a single row of tangential circles with dots
in the center, twelve on side A, eleven on side B. The main
panels of the body are bordered at the sides by three hori-
zontal stripes, and below by two horizontal stripes which
encircle the vase. Rather than being divided into small
metope panels as is common in this period, the sides of the
vase display a single symmetrical composition: confronted
horses tethered to a tripod manger. Above the tripod man-
ger are four rows of thickly painted zigzags, while three
rows of zigzags fill the spaces above the horses' backs.
Behind each is a pendant double-axe poised over a cross-
hatched triangle. Other filling ornaments include dot
rosettes, dot rosettes on dot stems, and dotted circle
rosettes between the horses' legs.

Confronted horses are fairly common in Attic Late
Geometric vase painting. They are generally depicted
either held by a man standing between them or hitched
to a tripod-like object. The latter composition is often
found on the necks of closed vessels like neck-*amphorae*
(East Berlin 31005; Mainz O. 1980a; Athens, Empedokles
collection) and *oinochoai* (Munich 6249; Athens 18444).
Less frequently the motif appears on *kantharoi*; at least
two examples are known (Munich 6202; Tübingen 2658a).
In all instances the lead rope is attached to the upright ring
handles of the tripod-*lebes*. Horses and tripods are
logically combined as the latter were often the prizes in
Homeric chariot races (cf. *Iliad* 23.264ff.). Although the
object between the horses on the Mildenberg *kantharos*
is cauldron-shaped and stands on three legs, it lacks the

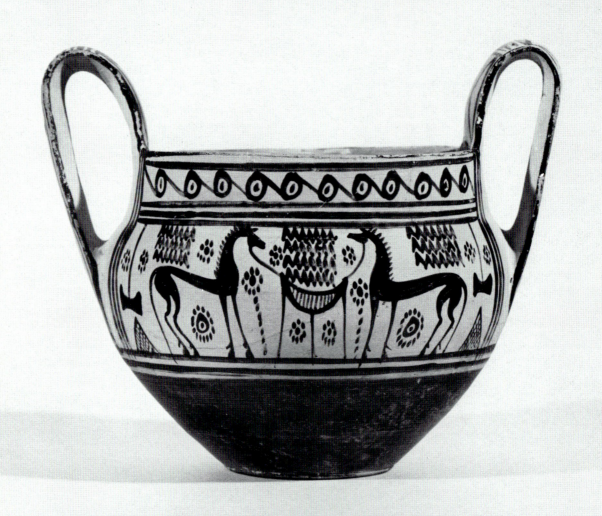

74

distinctive ring handles. Hence, it may be a crib or manger, although these are depicted as box-like troughs, usually on two legs; cf. the *kantharos* formerly in the Wülschläger collection, the neck-*amphora* in Munich (8748), or the *oinochoe* in London (77.12-7.12).

The pendant double-axes present another interesting problem. They tend to appear above the backs of horses in Euboean and Boeotian Geometric vases, as on the Cesnola Painter's name-vase in New York (74.51.965), or the *oinochoe* in Copenhagen (5371). According to Coldstream, this combination was an invention of the Cesnola Painter. However, since this painter derived many of his motives from the Attic repertoire, and since Boeotian Late Geometric painting is strongly influenced by Athenian, it would not be unreasonable to find the pendant axe motif originating in Athens and migrating to other ceramic centers.

Other details substantiate an Athenian provenance. The majority of filling ornaments can be paralleled in the products of the Hirschfeld Painter's workshop, notably the stacked zigzags and dot rosettes on dot stalks. Also the proportions and styling of the horses are quite similar to his stallions. An even closer parallel and one probably by the same hand is a Late Geometric tankard in a private collection in Basel; not only are the tangents of the circles running in the same unusual direction (upper left to lower right), but the stacked zigzags and dilute hatching are duplicated on the Mildenberg *kantharos*. This tankard, in turn, is stylistically similar to a *skyphos* excavated in the Kerameikos (Grave 71,342).

Thus, this interesting *kantharos*, while preserving some unusual traits, is nonetheless a superior example of Attic Geometric vase painting in its finest period.

Condition: Restored from fragments; repainted in areas of restoration. JN

Bibliography: Unpublished.

Comparative literature: J. N. Coldstream, *Greek Geometric Pottery* (London: Methuen and Company, 1968) pls. 14c, 8d and 13d; *CVA* Mainz 1 (Germany 42) pp. 22–23, pl. 7, 1–2; Sylvia Benton, "The Evolution of the Tripod-Lebes," *BSA* xxxv (1934–1935) 102–107, pl. 25, 2–4; *CVA* Munich 3 (Germany 9) pls. 113, 1–2 and 120, 2–3; Jean Davison, *Attic Geometric Workshops*, YCS xvi, fig. 45; *CVA* Tübingen 2 (Germany 44) pp. 34–36, pl. 23; J. L. Benson, *Horse, Bird and Man* (Amherst: University of Massachusetts Press, 1970) pl. vi, 4; Anne Ruckert, *Frühe Keramik Böotiens*, *Antike Kunst*, suppl. 10 (Bern: Francke, 1976) pl. 2, 1; J. N. Coldstream, *Geometric Greece* (London: Ernest Benn., 1977) pp. 192–193, fig. 61c; Peter P. Kahane, "Ikonologische Untersuchungen zur griechisch-geometrischen Kunst. Der Cesnola-Krater aus Kourion im Metropolitan Museum," *AntK* xvi (1973) 114–138, pls. 25–29; Bloesch et al., *Das Tier*, p. 33, no. 191, pl. 31; Karl Kübler, *Die Nekropole des 10.–8. Jahrhunderts* (Kerameikos v, 1) (Berlin: Walter de Gruyter, 1954) pl. 96 below.

75 Bird Pendant: Heavy-Bodied Fowl

Bronze, hollow-cast. Greek, Thessalian, Geometric Period, end of 8th century BC. H. 4.5 cm.; Max. W. 1.7 cm.; L. 5.2 cm.

This sturdy bird, which stands on its own two feet, is also provided with a large oval suspension loop (H.1 cm.), projecting longitudinally from its back. It has a sturdy body, a flat circular tail, a forward-curving neck, and a flat upturned beak. Two stubby horn-like eyes protrude diagonally outward from the top of the head. The thin legs, bent slightly inward at the bottom, terminate in feet, which have backward-projecting heels. This bird possesses several zones of incised ornament: three incised lines on either side of the neck, behind the eyes; three grooves across the back, forward from the base of the tail; two zones of three horizontal lines each, at top and bottom of each leg; and five horizontal lines on the chest, with vertical crosshatching.

This bird is typical of many found in sanctuary deposits throughout the Greek mainland, but concentrated in northern Greece, especially Thessaly; several similar examples occur among the bird pendants from the Enodia sanctuary at Pherai. Like its cousins in the Mildenberg aviary [76, 77, 78], this bird may have been designed to hang from the boughs of trees in the open-air religious sanctuaries that existed before the great age of temple building in Greece. Very little is known about the ritual practices at these holy places. It is not clear what species of bird was intended, other than the general weight and impression of a heavy earthbound fowl, like a hen or goose; the piece recalls aspects of both wild and domestic fowl. Perhaps birds of many kinds were popular sacrificial gifts to the divinities of the Iron Age sanctuaries of northern Greece. Birds of interest for comparisons are in the Walters Art Gallery (54.2401), the Schimmel collection, and the Rhode Island School of Design.

Condition: Intact, with dark, shiny gray-green patina, pitted and pocked in places by corrosion. A hole in the lower right side, forward from the tail, reveals that this bird was hollow-cast. DGM

Bibliography: *Early Art in Greece*, sale cat. (New York: André Emmerich Gallery, 7 May–11 June 1965) no. 92.

Comparative literature: Bouzek, *Bronzes*, pp. 13-18; cf. Kilian, *Fibeln*, pls. 85,15-16, 86,1; D. K. Hill, "Other Geometric Objects in Baltimore," *AJA* lx (1956) 36, pl. 28, 2-3; H. Lechtman, "Bronze Joining: A Study in Ancient Technology," *Art and Technology: A Symposium on Classical Bronzes* (Cambridge, MA: Massachusetts Institute of Technology, 1970) pp. 14-22, figs. 16-26; *Schimmel Catalog* (1974) no. 10; Mitten, *Rhode Island Cat.*, pp. 26, 28 nn. 12-15, no. 7.

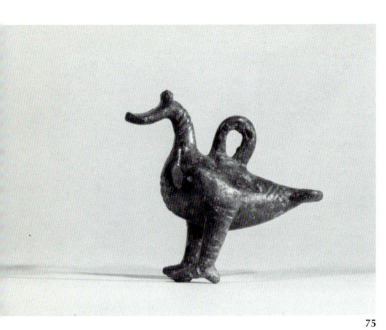

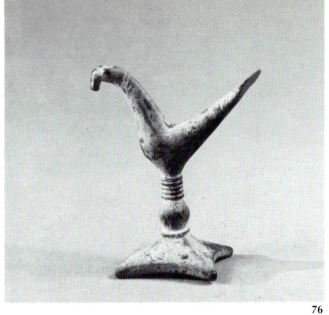

75

76

76 *Bird Pendant on Pyramidal Stand*

Bronze, solid cast (lost wax). Greek, probably
Thessalian, Geometric Period, second half of 8th
century BC. H. 4.8 cm.; L. of bird 4 cm.; stand 2.2
cm. square.

This long-necked bird perches upon a shaft which rises
from a pyramidal base with concave edges. The bird has
a long neck that curves forward, ending in a downward-
pointing beak whose tip is missing. Eyes are indicated by
tiny raised bosses. A suspension hole pierces the bird,
running diagonally downward from the back just behind
the base of the neck to the chest. The tail, seen from above,
is wide and lozenge-shaped; its rear edge is marked by
tiny incisions, and the base of the tail bears a series of fine,
incised lines. Three similar incised lines adorn the neck
behind and below the eyes. The bird perches upon a shaft
consisting of five horizontal ridges atop an oval bead; a
larger ridge separates the bead from the base. The base is
hollow beneath, with an indented groove surrounding a
square central lump.

 This pendant is another variant of the northern Greek
Iron Age bird pendant, provided both with suspension
hole and, in this case, with a base to stand upright. As in
[77] the feet of the bird are not represented but merge into
the shaft; the effect is that of a bird perching on the tip
of a pole. Similar bird pendants were found at the Enodia
sanctuary (see [75]) at Pherai, Thessaly, and also occur at the

Itonia sanctuary at Philia. Similarity of patina and modeling
suggest that this pendant and [77] may have come from the
same workshop, if not the same findspot.
 Condition: Intact, except for missing tip of beak. Mottled
gray-green patina. DGM

Bibliography: Unpublished.

Comparative literature: Bouzek, *Bronzes*, pp. 13-23; Kilian, *Fibeln*,
p. 183, pl. 84, nos. 25-30, esp. no. 26.

77 *Bird Pendant on Wheels*

Bronze, cast (lost wax). Greek, probably Thessalian,
Geometric Period, second half of 8th century BC. H.
6.5 cm.; W. of wheels 3.4 cm.; L. of bird 3.6 cm.

A wide-tailed bird with abstract, stylized body, and
upturned beak perches upon an upright shaft that rises
from the axle of a pair of wheels. The bird is not aligned
longitudinally directly parallel to the direction of the
wheels, but points slightly to the right. A hole for
suspension passes diagonally downward through the neck
from the back just behind the neck to the chest. Two small
pointed bumps at the top of the head form the eyes. The
bird rests upon a zone of four very thin ridges atop a
globular bead; its feet are not represented. Each wheel has
four circular openings; the axle projects as a small central
boss on the exterior of each wheel. There are two incised

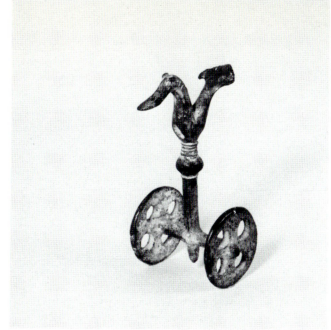

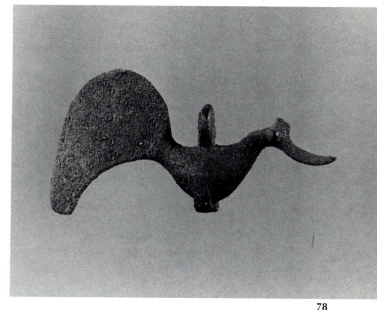

77

78

lines visible on the left side of the neck, one on the right side.

Bird pendants mounted upon pairs of wheels are yet another variant among the rich variety from northern Greece and the southern Balkans during the Iron Age where birds perch upon disks, pyramids, beads, and other solid and openwork forms. Other bird pendants on wheels are known from the Enodia sanctuary at Pherai, Thessaly, along with a host of other bird pendants. Leo Mildenberg has privately communicated with me about an identical pendant in the British Museum. See also [75, 76].

Condition: Much of the edge of the tail has been corroded away. Surface of bronze is intact, with dark gray-green patina. DGM

Bibliography: Unpublished.

Comparative literature: Bouzek, *Bronzes;* Kilian, *Fibeln,* p. 183, pl. 84, nos. 34-37, from Pherai.

78 *"Peacock" Pendant*

Bronze, cast (lost wax). Greek, probably Thessalian, Geometric Period, second half of 8th or early 7th century BC. H. 5.5 cm.; Max. W. 2.2 cm.; L. 11.4 cm.

This large, fancifully modeled bird pendant displays an exaggeratedly downcurved and enlarged blade-like tail, of the kind that has suggested "peacock" as a sobriquet for such pendants. Dotted circles pattern the tail supporting this identification. It lacks, however, the high crest that often appears on these birds. The oval body is heavy and aligned horizontally; it is not clear whether or not it is hollow-cast. A round suspension loop (W. 1.7 cm.), oriented transversely to the axis of the body, rises from the middle of the back. The bird also has short strap-like legs; they are bent inward and the tips are missing. The head projects forward horizontally, with a pronounced upturned beak with central carination. Two rounded bosses project horizontally from the sides of the head to form eyes. A tang-like projection on the top of the head forms a vestigial crest.

Fanciful birds of this kind have been found throughout the Greek mainland, chiefly in sanctuaries. They appear to be a more elaborate version of the smaller bird pendants represented in the Mildenberg collection by [75, 76, 77]. They were probably manufactured in several regional workshops, but most come from northern Greece. The form of the head and beak, with pronounced upturn and

97

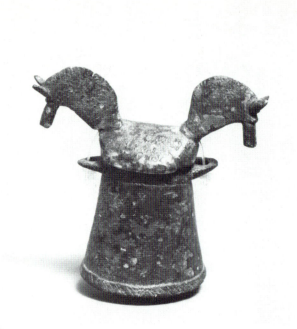

79

projecting bosses for eyes, bespeaks a northern Greek, probably Thessalian, origin for the Mildenberg "peacock."

Condition: Intact, except for missing tip of tail and tips of legs. There may be a mend in the rear portion of the tail. The surface is covered with a dull, dark gray-green corrosion product, pebbly in texture; a few spots of red cuprite show through. DGM

Bibliography: Unpublished.

Comparative literature: Kilian, *Fibeln,* pl. 86, nos. 7-14; Bouzek, *Bronzes,* pp. 19-21, p. 17, fig. 2; *Schimmel Catalog* (1974), no. 10; Mitten, *Rhode Island Cat.,* pp. 26-28, no. 7.

79 Lidded Pyxis with Horse Heads

Bronze, body and lid cast. Greek, Macedonian, probably first half of 7th century BC. H. 5.3 cm.; W. of lid including horse protomes 5.5 cm.

This miniature bronze vessel consists of a body wider at its base (Diam. 3 cm.) than at its rim (Diam. 1.9 cm.), with straight tapering sides and two oval flat lugs with vertical perforations projecting from the rim. The lid, with shallow vertical edge and hollow beneath, is slightly conical; two addorsed horse protomes project outward from it on opposite sides. Diagonal perforations slanting downward from the base of the horses' necks to their chests—similar in placement to those in the bird pendants [76, 77]—align with the perforations in the lugs on the vessel proper. They thus allow the *pyxis* to function as a pendant.

This charming miniature vessel is an unusual representative of a variety of such objects, most of which come from contexts in Macedonia, Thrace, Thessaly, or elsewhere in the southern Balkans. Where figural decoration is present, it usually consists of bird protomes—singly or in addorsed pairs—on the rim of the vessel, on the lid, or on both. Most also possess a shaft-like foot or pedestal. The *pyxis* shape in Macedonia is a persistent traditional one, with forerunners existing already in the Late Bronze Age, as Sourvinou-Inwood notes in her study of a large, elaborate bronze example with close correspondences to ceramic forms. Bouzek distinguishes several groups among these miniature bronze *pyxides,* beginning in the early eighth and extending through the early sixth century. It is not clear what, if anything, might have been contained in such little vessel-pendants; their presence in graves may suggest that they originally contained some fragrant substance, perhaps an unguent or perfume. Unfortunately, none yet derive from contexts observed precisely enough to determine where they might have been situated upon the corpse.

Condition: Intact, both lid and vessel. Both are covered with a dull, dark gray-green patina. DGM

Bibliography: Unpublished.

Comparative literature: Bouzek, *Bronzes,* ch. 2, pp. 24-37, figs. 5-10; C. Sourvinou-Inwood, "An Iron Age Macedonian Bronze Vessel in the Bomford Collection and the Iron Age Pyxis Shape," *OpusArch* XI, no. 9 (1975) 161-175.

80 Dog with Pup or Prey

Bronze, solid cast (lost wax). Greek, probably Peloponnesian, Geometric or early Archaic Period, late 8th–7th centuries BC. H. 2.1 cm.; W. at forefeet of larger animal 1.4 cm.; L. 7 cm.

This group consists of a larger animal, clearly canine (dog or fox), grasping a smaller animal in its mouth; the forepart of the captive projects head-first. The larger animal has a long cylindrical body ending in a massive stubby tail, four short legs bent forward at the tips, short upraised ears, and an open mouth. The smaller animal is modeled in general outlines only, but also has the tips of its front legs bent forward.

A number of similar figurines—both in bronze and terracotta—are known from Greek sanctuary deposits. They have been most recently interpreted as perhaps votive offerings to Artemis by successful hunters, an attractive, plausible suggestion. The possibility exists that animals carrying smaller creatures sideways in their mouths might on occasion be mothers transporting their young rather than predators with their prey or hunting dogs retrieving hares.

The elongated proportions of the Mildenberg canid suggest that a fox, not a dog, was intended by the bronzecaster. It ranks among the most individualistic examples of this type of statuette group yet known. The hollow underside of the larger animal's body recalls a similar feature on an analogous group in the Fitzwilliam Museum, Cambridge, assigned by Nicholls to a Late Minoan date. In the absence of reliable criteria distinguishing Late Bronze Age bronze animal statuettes from many Geometric and early Archaic ones, however, a date late in the eighth or well into the seventh century BC. appears to be preferable.

Condition: Intact. Surface appears worn, as if deeply attacked by bronze disease, then cleaned; shiny, dark gray in color, with numerous pits. DGM

Bibliography: Unpublished.

Comparative literature: Pinney and Ridgway, *Aspects*, pp. 194-195, no. 94, (Newark Museum 50.497); W.-D. Heilmeyer, *OlForsch* XII, 181-182, no. 221; Kilian, *Fibeln*, p. 211, pl. 87, no. 23 (dog from Pherai in Volos [M 2280]).

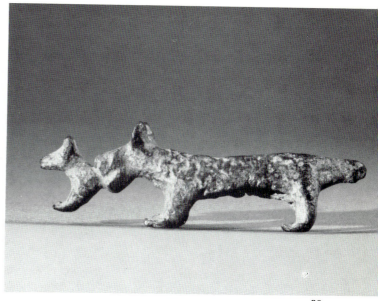

80

81 Embracing Frog Couple

Bronze, solid cast (lost wax). Greek, probably Thessalian, Geometric Period, ca. 700 BC or first quarter of 7th century BC. H. 1.8 cm.; W. of front legs 1.9 cm.; L. 3 cm. Said to come from Philia, Thessaly.

This engaging miniature group presents two frogs engaged in an erotic, even humorous, relationship. The male frog, slightly smaller than the female, lies on top of her body and embraces her by wrapping his forelegs around her neck. His right front foot overlaps his left. The female frog's front legs are extended forward horizontally; the tip of the right front foot is slightly flattened. The frogs' rear feet extend laterally; their tips, which curve forward, merge. The plastic differentiation of the two frogs is very deeply and explicitly rendered, extending to the groove separating the two bodies along the sides of the group and to the open mouths that extend across the entire width of the frogs' heads. Their eyes are rendered by large round pellets, clearly added to the frogs' heads as components in the wax casting model. The male frog's head is situated behind and slightly to the right of his mate's. The bottom surface of the group is concave, longitudinally.

The effect of this group upon the beholder, ancient as well as modern, is broadly engaging and hilariously comic; both members of this couple are hugely enjoying their activity. In nature frogs do not actually copulate; instead the male rides the female in a tight embrace (*amplexus*) until

she lays her eggs. The duration of this act can be hours or days. After the female has laid the eggs, the male dismounts and fertilizes them. Certainly the *amplexus* act carries the greatest human interest. Are the ecstatic grins on their faces the artist's attempt at humanizing bestial sex or bestializing human sex?

Can this be the earliest depiction of sexual activity in animals yet known in Greek Iron Age art? The group is unique among Greek Geometric bronze animals and groups both in subject matter and in technique; the addition of pellet "popeyes" is unique among Geometric bronzes known to me, although protruding bosses occur frequently in Geometric animal and bird statuettes both in the Peloponnesus and in northern Greece. Could the ultimate inspiration for the Mildenberg frog *symplegma* have come from a small Egyptian erotic animal group in terracotta or faience, such as that of two copulating hedgehogs in Munich? No animal *symplegmata* are recorded among the Geometric bronze votive animals from Olympia, nor are individual frogs represented there. Wild goats of the *agrimi* type copulate from the rear on a gold Minoan signet ring in London and on an early Archaic steatite disk seal from Crete, now in the Metropolitan Museum. Could the toad "mounting a turtle" on an archaic cornelian scarab in the British Museum actually be mounting another toad?

Archaic bronze frogs are well known, both from East Greece and the Peloponnesus. Examples are also known from northern Greece, where representations of frogs occur from early Neolithic times. Archaic frogs support some of the earliest mirror caryatids, from the early sixth century BC. Perhaps the best-known Archaic bronze frog is the one perching on the forehead of a lion head spout from the Heraion, Samos, of the late seventh century BC.

If the alleged findspot for this group is trustworthy, this frog couple might well be regarded as a votive vignette of the aquatic fauna inhabiting the swampy terrain that must have abounded along the streams and lake shores of Thessaly during the late Iron Age. It may have been offered to the divinity that received it as a request or thank-offering for fertility or sexual vigor; it may also have served as a talisman or charm to enhance sexual powers or prevent their decline. Whatever its intended use, it surely was made and used with a twinkle in the eye of owner and beholder alike.

Condition: Intact. There is a modern scar exposing fresh metal on the left rear side of the topmost frog, where its modern discoverers scraped it to sample the metal. There is a crack in the back edge of the male frog's left rear leg. Some pits and bubbles left by gasses escaping during

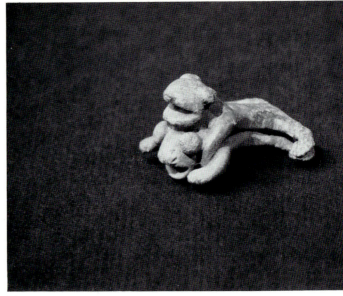

81

casting are visible in the rear surface of the frogs' hind legs. Sound blue-green patina, semi-lustrous. DGM

Bibliography: Unpublished.

Comparative literature: Absence of frogs among Geometric bronze statuettes from Olympia: W.-D. Heilmeyer, *OlForsch* XII, 196, 36-41 (for the function of wax models in casting Geometric statuettes); *Meisterwerke altägyptischer Keramik,* exhib. cat. (Höhr-Grenzhausen: Rastal-Haus, 16 September–30 November 1978) p. 215, no. 30 (hedgehog, M-Às 6054); J. Boardman, *Greek Gems and Finger Rings* (New York: Harry Abrams, 1972) pp. 123-137 (under pl. 279; goats); A. Houghton Broderick, *Animals in Archaeology* (New York, Washington: Praeger, 1972) p. 99, fig. 47; J. Boardman, *Greek Gems and Finger Rings,* pp. 123, 137, pl. 279 (disk seal); J. Boardman, *Archaic Greek Gems* (London: Thames and Hudson, 1968) pp. 67, 70 n. 20, no. 146, pl. X (scarab with toad; London 760); R. V. Nicholls, "Recent Acquisitions by the Fitzwilliam Museum, Cambridge," *Archaeological Reports for 1965–1966* (London: Society for the Promotion of Hellenic Studies, 1966) p. 49, fig. 10, p. 50, no. 27 (Archaic bronze frog; GR2.1963); Schefold, *MgK,* no. III 119 (Ortiz), pp. 19, 148, 183; R. J. Rodden, "Early Neolithic Frog Figurines from Nea Nikomedia," *Antiquity* XXXVIII, no. 152 (1964) 294-295; Bouzek, *Bronzes,* p. 142, fig. 45, 14; G. M. A. Richter, *Handbook of the Greek Collection* (Cambridge, MA: Harvard University Press, 1953) p. 34 n. 35, p. 295, pl. 22 e (mirror caryatid on frog; Metropolitan Museum, 74.51.5680); *Greek Art of the Aegean Islands,* exhib. cat. (New York: Metropolitan Museum of Art, 1979) p. 179, no. 142 (waterspout with frog from the Heraion, Samos; Athens National Museum, 16512).

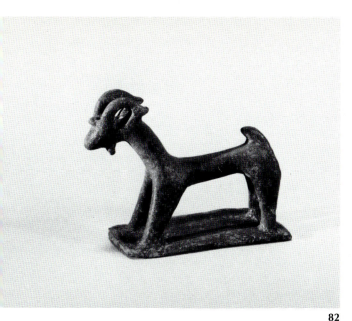

82 Goat

Bronze, solid cast (lost wax). Eastern Greek or Anatolian (?), 7th century BC. Max. H. 7.1 cm.; H. of goat 6.75 cm.; W. 2.8 cm.; L. 9.6 cm.

This sturdy goat stands on a flat plinth (8.3 × 4.2 × 0.35 cm.). His rear legs are nearly vertical, the front legs slant forward. The cylindrical body is nearly parallel with the plinth. The neck, also cylindrical, curves forward slightly. The upturned tail is grooved in back. The horns arch over the poll joining the ears at their tips. The muzzle is short, round, and featureless. A small triangular beard hangs halfway between chin and throat. A short forelock projects from between the base of the horns. There is no surface incision whatsoever.

In its lack of incision and its general proportions, this goat is reminiscent of Iranian goats. It is also, however, very similar to Greek goats, such as the well-known goat cheese grater in the Norbert Schimmel collection. The body is admirably shaped to serve as a hand-grip. It might have served as a handle, as a weight, or as a tool, perhaps to smooth plaster, stucco, or ceramic surfaces.

Condition: Intact. There is a gash into the metal on the outer side of the left rear foot, just above the base. The right front corner of the plinth is broken off. Dull, dark gray-green patina over the entire surface. DGM

Bibliography: Unpublished.

Comparative literature: Schimmel Catalog (1974) no. 22 (there dated to the sixth or fifth century BC).

83 Stylized Horse Pendant

Bronze, solid cast, perhaps in bivalve mold. Italic, southern Villanovan, mid-8th century BC. H. 8.1 cm.; Th. of body 0.4–0.7 cm.; L. 8.2 cm.

This pendant is cast in the form of a stylized horse in strict profile with a slender cylindrical, horizontal body and a slender neck situated at right angles to the body. The front and rear legs are shown as only one leg each, slanting forward slightly. They terminate in circular rings (Diam. 1.8 cm.). A small oval loop (H. 1.3 cm.) rises from the back just behind the base of the neck, where one edge is cast against the edge of the mane. The mane is a thin blade-like crest extending from the tip of the nose to the withers at which it curves inward. The tip of the muzzle is broken off just forward of the front edge of the mane. The eyes are rendered by small rounded pellets placed where the neck curves to form the head. A tiny, stumpy tail lies at the curve of the rump. There is no incised surface decoration.

The usual Villanovan horse cheekpieces (see [84]), which this horse resembles, have large circular perforations in the middle of their bodies to allow the canons of the bit proper to pass. The Mildenberg pendant is one of a few stylized objects that are smaller than the typical cheekpieces and have no hole in the middle of the body. Where their provenance is known, they appear to come from the Lucanian-Apulian region of southern Italy rather than from Etruria, the heartland of the classic Villanovan Iron Age culture. It is not known from what larger object they were suspended; the presence of the two loops at the tips of the legs suggests that they in turn possessed smaller pendants hanging from chains. Their closest relatives among the horse-form bit cheekpieces are found among von Hase's "Veii type," belonging to the second phase of the Villanovan Period. Cemeteries of Villanovan type from Pontecagnano, near Salerno, and farther south and east in Lucania attest to the diffusion of a Villanovan-like Iron Age culture or cultures virtually throughout the Italian peninsula during the eighth and early seventh centuries BC. The simple form of the Mildenberg pendant and the bits with horse-shaped cheekpieces that are most similar to it suggest a date around the middle of the eighth century BC.

Condition: Tip of muzzle broken off. A few chips broken out of the edge of the mane. Green to brown patina with some light green on mane. DGM

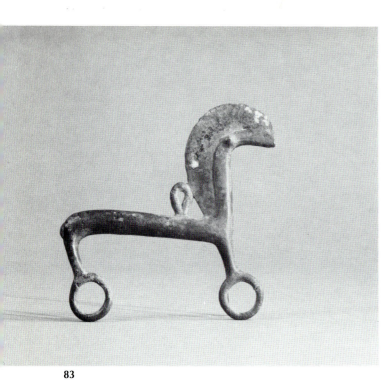

Bibliography: Unpublished.

Comparative literature: F.-W. von Hase, *Die Trensen der Früheisenzeit in Italien* (Munich: C. H. Beck'sche, 1969) p. 9, n. 5, p. 41, figs. 1, 1-7 (nos. 5-7, from Taranto, are in the Bari Museum) pp. 6-10, pls. 1-2 (bits of "Veii Type").

84 *Bit with Cheekpieces in the Form of Horses*

Bronze, elements cast (lost wax), cold worked, and then assembled; cheekpieces probably cast in bivalve molds. Italic, Northern Villanovan, last quarter of 8th century BC. Overall W., with pendants extended, 32.5 cm.; left cheekpiece: H. 9.4 cm.; Max. Th. (ears of horse) 1.2 cm.; L. 11 cm.; right cheekpiece: H. 8.9 cm.; Max. Th. (ears of horse) 1 cm.; L. 11 cm.

This bit consists of six components: two twisted canons, interlocked at the center, forming the bit proper; two rod-like pendants that swing from the rein rings; and two elaborate open-work cheekpieces in the form of stylized horses. The canons pass through the large holes in the bodies of the horses.

The muzzles of the large horses forming the cheekpieces narrow, then flare into tear-shaped tips. The pointed ears

83

84

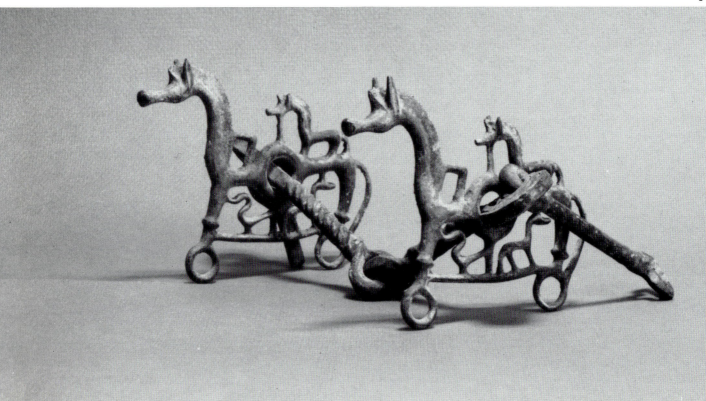

are vertically grooved. As in [83] the front legs and hind legs are each simplified into one structure. They have horizontal bodies, forward-slanting front and rear legs, and thin tails curving to the ring-shaped rear hooves. The space between the front and rear legs is compartmentalized by two rods, a thin horizontal one which connects the front and the rear fetlocks and a vertical one which reaches from the horizontal rod to the hole in the horse's belly.

The front compartment contains a stylized duck-like bird, facing forward; the rear compartment contains a small stylized quadruped (a colt?) facing backwards whose ear merges with the underside of the larger horse's body. A miniature copy of the larger horse rides on its back, facing forward; a small vertical member connects the chin of this horse with the top of the central perforation. Its small tail falls to the rump of the larger horse. An L-shaped feature fills the intersection between the base of the neck and the body of the large horse; it is not clear whether this was intended as buttress for the neck or as added provision for the suspension of pendants, now missing. The manes of large and small horses alike are serrated with tiny notches.

This bit is one of the finest and best preserved examples of von Hase's "Volterra Type," which is found both north and south of the Apennines; in a subvariety, a stylized bird is substituted for the backward-facing quadruped. The presence of these bits with horse cheekpieces in relatively few Villanovan graves may indicate the special or elite status of their owners in life, as well as a desire to make the use of horses available to the deceased in the afterlife. As has been repeatedly noted, these bits are related to, and perhaps derived from, similar bits with zoomorphic cheekpieces from western Iran. How this trait passed from Iran to Italy and by what route or routes remain uncertain. In Etruria the type dies out during the first half of the seventh century BC during the development of the initial, orientalizing phase of Etruscan culture. In strength and coherence of abstract structure and virtuosity of openwork casting, the Mildenberg bit ranks among the finest known examples of these masterpieces of Villanovan metalwork.

Condition: Intact, except for missing tip of right-hand pendant. Greenish-gray patina, overlaid by crumbly buff corrosion products. The surface was recognized by Clifford Craine of the Fogg Art Museum Research Laboratory as characteristic of high-tin bronze. DGM

Bibliography: Unpublished.

Comparative literature: P. R. S. Moorey, Catalogue of the Ancient Persian Bronzes in the Ashmolean Museum (Oxford: The Clarendon Press, 1971) pp. 104-107 (see terminology), nos. 117-120, pp. 114-118, pls. 16-17 (W. Iranian bits with horse-form cheekpieces); F.-W. von Hase, Die Trensen der Früheisenzeit in Italien (Munich: C. H. Beck'sche, 1969) pp. 9-10, fig. 1, nos. 9-13, p. 41, nos. 36-42, pp. 11-12, pl. 4, nos. 43-46 (substitute a second bird for the backward-facing quadruped in the rear compartment under the large horse's body) pp. 4-5, 53-56 (for function and symbolism); H. O'N. Hencken, Tarquinia, Villanovans and Early Etruscans, (American School of Prehistoric Research, Bulletin no. 23, (Cambridge, MA: Peabody Museum, 1968) II, 564-565; H.-V. Herrmann, "Frühgriechischer Pferdeschmuck von Luristantypus," Jdl LXXXIII (1968) 1-38, esp. 22-24; cf. G. Kossack, Studien zur Symbolgut der Urnenfelder-und Hallstattzeit Mitteleuropas (Berlin: Walter de Gruyter, 1954).

85 *Fibula with Three Ducks on Bow*

Bronze, cast. Italic, Villanovan, late 8th to early 7th century BC. H. 5.3 cm.; W. of bow 3.1 cm.; L. 6.2 cm. Formerly Else Bloch-Diener, Bern.

This *fibula*, of the so-called *sanguisuga* or "leech" type, has a broad oval bow, a spring with three turns, and an elongated catchplate. It is cast with three stylized duck-like birds in single file along the apex of the bow, facing toward the catchplate. The top of the bow, on either side of the middle bird (H. 1.7 cm.), is incised with fine striations

85

running parallel to the axis of the *fibula*. A zone of similar striations, incised transversely to the axis, lies on either side of the middle bird. Shorter sections of longitudinal striations flank the front and rear birds; finally, horizontal bands of striations adorn the ends of the bow just above the spring and catchplate.

Several *fibulae* identical to the Mildenberg example except for being adorned with birds' heads, not entire birds, have been found at Tarquinia in graves of Villanovan II B date, suggesting that the Mildenberg *fibula*, too, may come from Tarquinia or its vicinity. Stylized birds of this variety occur frequently in Villanovan cast bronzework: as adjuncts on cheekpieces for bits, in addorsed combination on handles of vessels, and elsewhere. The symbolic meaning of birds in Villanovan and early Etruscan contexts is still not clearly understood, although birds are important symbols in northern Greece at the same time. Some kind of underlying connection linking the Iron Age Balkans and northern Italy with central Europe seems assured.

Condition: Intact, except for missing tip of pin and catchplate. Catchplate bent upward. Semi-lustrous, dark gray-green surface. DGM

Bibliography: Bloesch et al., *Das Tier*, no. 302.

Comparative literature: H. O'N. Hencken, *Tarquinia, Villanovans and Early Etruscans*, American School of Prehistoric Research, Bulletin no. 23, (Cambridge, MA: Peabody Museum, Harvard University, 1968) I, 186, fig. 171, p. 189, fig. 174, p. 191, p. 407, fig. 398, II, 519-530 (significance of horned birds); G. M. A. Richter, *Handbook of the Etruscan Collection* (New York: Metropolitan Museum of Art, 1940) p. 5, fig. 14 (possibly a modern pastiche).

86 *Reclining Lion Lid Handle*

Bucchero-like *impasto* hand-modeled. Italic, probably south Etruscan, last third of 7th century BC. H. of lion 8.3 cm.; W. of lion across front paws 3.7 cm.; Th. of lid 0.9–1 cm.; L. of lion 15 cm. Ex private collection, Ticino, Switzerland.

A lean, almost canine lion reclines on top of this fragment of a lid for a covered vessel. His head is upright, mouth open as if roaring; no teeth are shown. His eyes gaze intently straight ahead. His front paws extend parallel, straight in front of him; his hind feet parallel his body. On each front paw all five claws are separated by incision; there are three incisions on the left rear paw, four on the right rear paw. The lion's long cylindrical tail curves upward to the rump; its tip is broken off.

The lion's most distinctive feature is his prominent plastically modeled mane that surrounds his neck like a ruff. Its surface is covered with short incised lines that converge beneath the chin. The incised strokes also occur on the edge of the mane, the forehead, crown, and the back of the head; where they are oriented along the axis of the body. The front edge of the mane, at forehead and sides of the head, is precisely delineated as an offset, by incision. The short ears with curving upper edges are set into grooves in the mane. The shoulders and haunches are summarily rendered. This contrasts with the precise and highly detailed modeling and ornamentation of the head and mane. Short diagonal incisions demarcate the cheeks. The nose is formed by a flattened ridge with concave sides running from the forehead to the tip of the muzzle. Above the two punctate nostrils are four rows of minute stipples, and a few individual dots lie between them. The mouth is outlined by an incised groove. The eyes are oval, horizontally set, slanting slightly downward at the outer corners. The lower lids are formed by two lines meeting at an angle; the upper lids are curving lines.

In detailing—particularly in the extremely explicit, precisely incised features of head and mane—this hand-modeled *impasto* lion clearly imitates a cast bronze lion statuette, added to the lid of a *pyxis* or *cista*. While much *impasto* and *bucchero* pottery, whose distinctive fabric, fired gray to black throughout, has long been recognized as imitating metal vessels, this lion's debt to a metal prototype is especially unmistakable.

From late Villanovan times onward, vessels whose lids have figural grips have abounded in Etruscan *impasto* pottery. These vessels recall the elaborate Late Geometric Athenian *pyxides* with horse figurines on their lids. Most of the Italic lids, however, are conical, in contrast to the flat lid to which the Mildenberg lion belongs. In shape, with slightly down-turned edges, it resembles nothing so much as the lid for a ceramic predecessor of a Praenestine *cista*, the elaborate cylindrical bronze toilet boxes of the fourth and third centuries BC. Also brought to mind are the sixth-century funerary lions in *nenfro* from Vulci, and the lions that crouch on the crest of the roof of the red-ware house-shaped sarcophagus from Caere, in the Villa Giulia Museum, of the mid-sixth century BC.

Plastic vases from the Greek world, however, furnish the closest parallels now available for the Mildenberg lion. While the pose is similar to that of the elaborate Cretan lion vase from Arkades, in Herakleion, which must date a little after 650 BC, the closest parallel in all respects is the Early Corinthian plastic lion vase from Syracuse. Although its modeling is much more compact than in the

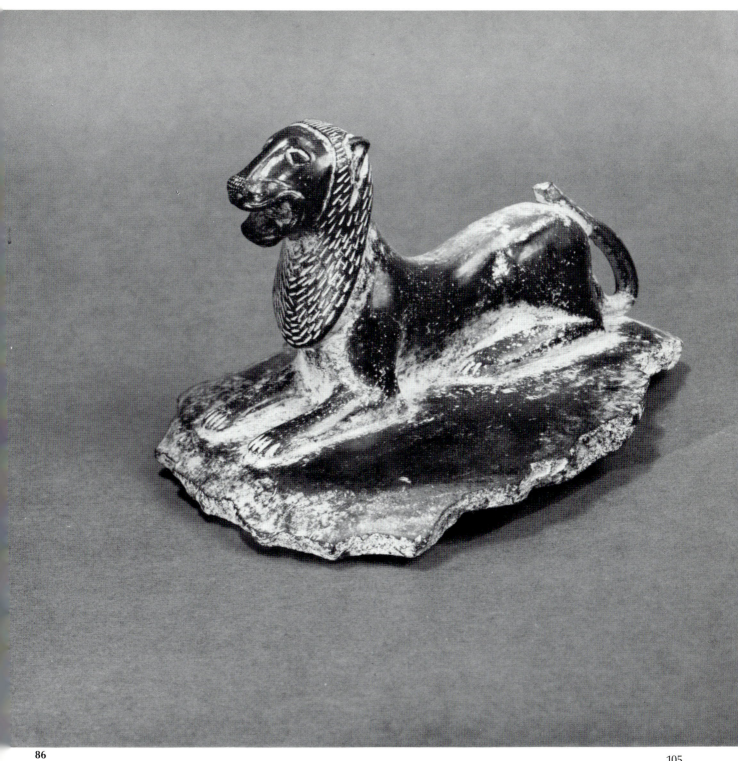

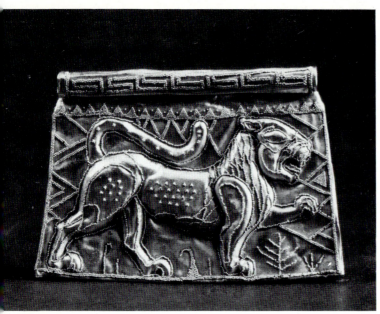

87 See also colorplate v

87 Pendant Lion Plaque

Gold with fine granulation. Etruscan, Orientalizing, ca. 650–600 BC. H. 3.5 cm.; L. 5.5 cm.; Diam. of suspension tube, 0.3 cm.

Thin, truncated gold sheet (edges folded back) decorated with a repoussé lion. The animal strides boldly to the right with left front paw raised and tail curled above its back. The lion almost fills the space available on the trapezoidal surface. The figure is decorated throughout with fine granulation arranged either in rows (outlining the body, the facial features, the mane, the leg muscles, and paws) or in small clusters (on the tail, ribs, and haunch). The flat background is decorated with granulated geometric designs (chevrons, triangles) and a few plant-like forms at the base. A separate piece of gold foil has been rolled into a tube and attached at the top. This suspension tube is decorated with a granulated meander.

This distinctive type of pendant, with long suspension tube and truncated base, is characteristic of orientalizing Etruscan jewelry and finds close parallels in the material from the Regolini-Galassi Tomb at Caere, now in the Vatican. One piece (Vatican 20564) is very similar in material, shape, construction, and technique.

The rich granulation is typical of the finest Etruscan jewelry of this period. Although the technique was borrowed from the Near East, Etruscan goldsmiths quickly mastered it and eventually produced the best examples of granulation in antiquity. Specific granulated motives on this pendant are similar to ones on objects from ancient Caere and Tarquinia.

Finally, the lion itself is a popular subject for much orientalizing art both in Etruria and Greece. The Etruscans often crowded scores of tiny lions onto their gold pins, necklaces, bracelets, or pectorals. Since they appear with many other creatures, both real and imaginary, it is not clear that the Etruscans attached any specific symbolism to the animal. Although large sculpted lions acted as guardians outside some tombs, it is likely that their appearance on jewelry simply reflects the Etruscan attraction to exotic artistic elements from the eastern Mediterranean. (See also [88].)

Condition: Excellent. Intact with some minor dents on suspension tube.

RDD

Mildenberg lion, the close correspondence in pose and the presence of a similar plastically rendered ruff and beard-like mane (the so-called "Assyrianizing" mane) date the Mildenberg lid lion during the last quarter of the seventh century or very early in the sixth. It was probably made in one of the major artistic centers of southern Etruria—Tarquinia, Caere, or Veii. At present, it is unique in its exceptional quality and fidelity to both bronze and ceramic prototypes.

Condition: Lion intact, except for missing tip of tail. Edge of circular lid completely broken away. On the right side of the lid, the lustrous black surface fades to a grayish-brown.

DGM

Bibliography: Unpublished.

Comparative literature: H. O'N. Hencken, Tarquinia, Villanovans and Early Etruscans, American School of Prehistoric Research, Bulletin (Cambridge, MA: Peabody Museum, 1968) I, fig. 250, p. 267, figs. 363-364, pp. 370-371 (backward-bending acrobat), fig. 379, p. 389; N. Coldstream, Geometric Greece (London: St. Martin's Press, 1977) p. 112, fig. 34 e (horse on pyxis lid); Brown, Etruscan Lion, pl. XII, c-d (similar but earlier bronze lions), pp. 62-72, pl. XXV (later monumental lions ca. 550 BC) pl. XXXVI, b, XXXVII (sixth-century bronze lions); Brendel, Etruscan Art, pp. 231, 229, fig. 157 (Caere sarcophagus); Payne, Necrocorinthia, p. 173, fig. 76 (lion aryballos); H. Gabelmann, Studien zum frühgriechischen Löwenbild (Berlin: Gebr. Mann, 1965) p. 113, no. 28, pl. 4, 1-2, pp. 43-44, no. 18, p. 112, pls. 3, 1-2.

Bibliography: Unpublished.

Comparative literature: L. Pareti, La tomba Regolini-Galassi (Vatican City: Tipografia poliglotta vaticana, 1947) no. 674, pl. VII, 15-16, pp. 187-188, no. 677, pl. X, no. 64; G. Becatti, Oreficerie antiche dalle minoiche alle barbariche (Rome: Istit. poligrafico dello Stato, 1955) p. 175, no. 238, pl. L; F. H. Marshall, Catalogue of the Jewellery . . . (London: British Museum, 1968) pp. 124-125, nos. 1358-1359, pl. XVIII; I. Strøm, Problems Concerning the Origin and Early Development of the Orientalizing Style (Odense: Odense University Press, 1971) figs. 60-61; M. Rosenberg, Geschichte der Goldschmiedekunst auf technischer Grundlage: Granulation (Frankfurt am Main, 1918) p. 45, fig. 68, p. 73, fig. 122; Brown, Etruscan Lion, pls. XV, a, XXI, c.

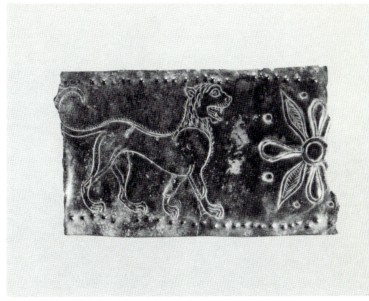

88

88 Decorative Strip with Lion and Rosette

Hammered bronze. Greek, Corinthian, third quarter of 7th century BC. H. 4 cm.; L. 7 cm.; L. of lion 5.5 cm.

The object is a rectangular segment broken from a longer strip of decorative sheet bronze. On it, a sprightly, wiry lion walks to the right, seemingly along a ground line of twenty-seven small bosses which have been punched from the reverse of the sheet; a similar border of twenty-six bosses runs parallel to it, along the top edge of the strip. The lion strides toward a large petaled rosette in which tear-shaped petals alternate with pointed, lozenge-shaped ones, the interiors of which are filled with tiny concentric chevron-shaped incisions pointing outward. Petals and the circular center of the rosette are bounded by double parallel lines. The spaces between the petals contain small incised circles.

The lion is carefully incised in delicate, precise contours. He steps forward with his right front foot, while his right rear foot is drawn back. Interior lines define tendons, joints, and musculature. The individual toes are carefully delineated. The front contour of the body continues backward in a circular curve, describing the shoulder (see similar feature in Egyptian lions [51, 52]). The artist incised two almost coinciding lines along the small of the back. Tiny slanting incisions represent bristle-like fur on the top and front profiles and whiskers or wrinkles on the upper lip. The lion's mane is rendered in a series of short curving locks which overlap on the forehead behind the eye and down the neck to the shoulder contour. The oval-shaped ear has an interior oval contour. The large round eye, with circular pupil and minute incisions at the corners, is set within a wide rounded eyebrow. Canine teeth in the upper and lower jaw, teeth in the upper jaw, and the tongue paralleling the lower jaw, are depicted clearly.

This lion is one of the most beautifully drawn small animals yet known in Greek orientalizing metalwork. In detailing such as the bristle-like fur, it appears to be unparalleled. Its stride, with right front leg advanced and right rear foot drawn back, contrasts with the usual pace of Corinthian felines, in which right and left feet on both sides of the body move in step. The close resemblance of the Mildenberg lion to Late Proto-Corinthian and Transitional lions, in which the mane exists but has not yet become fully developed, dates our lion in the third quarter of the seventh century BC, perhaps around 630. The often-cited relationship in technique and aesthetic between incised metalwork and the black-figure style in vase painting can nowhere be more fully appreciated than in this piece. The superb taut draftsmanship and precise proportions of this lion's anatomy argue strongly for Corinth as its origin; it is a worthy successor to the finest achievements of the Proto-Corinthian tradition of exquisite miniature draftsmanship.

The function of this fragment remains uncertain; no holes for attachment have been preserved. It most likely formed part of an ornamental bronze strip that decorated a chest or piece of furniture.

Condition: Broken edges run vertically through the left edge of the lion's tail and along the right margin of the center of the rosette. A crack passes through the lion's right front leg and shoulder, two-thirds of the way up the piece. The surface is covered with a shiny, dark green patina, with a few spots of lighter green. DGM

Bibliography: Unpublished.

Comparative literature: Payne, *Necrocorinthia,* all painted lions: pl. 8, no. 31, 3 (left-hand lion; tail and stride same); pl. 16, 6 and 8 (right-hand lions); pl. 12, 2 (lion); H. Salskov Roberts, "Some Bronze Plaques with Repoussé Decoration in the Danish National Museum," *ActaA* XXXIV (1963) 135-184; F. Johansen, *Reliefs en bronze d'Etrurie* (Copenhagen: Glyptotek Ny Carlsberg, 1971) *passim,* esp. pl. 1 (showing hypothetical use).

89 Lion Fibula

Bronze, hollow cast. Greek, ca. 580 BC.
H. 4 cm.; W. 2.1 cm.; L. 6.2 cm.

A ferocious lion, lying upon his belly with his gaze directed forward, mouth open wide, tongue drooling, and teeth bared, forms the decorative head to this ancient *fibula*. The lion's forepaws are outstretched and rest upon two pierced spools, each encircled by three incised lines; these spools originally formed the hinge of the pin, from which moved the now missing pin shafts. Fashioned into an elegant serpentine coil, the tail of the lion rises to touch the top of his rump and doubles back to terminate in a bearded snake head, the tip of the beard flowing back into the tail. Emerging from the rump, beneath the point where the tail is attached, is a double hook of anchor shape which served as the clasp of the double-shafted pin. Fine incisions can be seen around the eyes, on the forepaws, and in the mane of the lion. From the front the mane forms a close fitting oval frame around the lion's face, with incised lines radiating from the face to the carinated edge of the mane. In profile the mane falls in loosely incised waves down the back of the head and neck and over the shoulders, with no clear line of demarcation between body and mane.

Lion *fibulae* similar to this one have been found at a number of Peloponnesian sanctuary sites, including those of Artemis Orthia and the Menelaion at Sparta, Apollo Tyritios near Tyros in Kynouria, the Argive Heraeum, and Olympia, as well as on the Athenian acropolis. These heavy brooches were apparently popular offerings to the deities in Archaic Greece; indeed, one of the lion *fibulae* from Kynouria bears the inscription, "I am Apollo's." Both Sparta and Corinth have been suggested as the place of manufacture for these lion *fibulae*–the first by Neugebauer and more recently Gabelmann, the second by Lamb.

A relatively early date in the Archaic Period, one ca. 580 BC, is suggested for this piece because of the very early Archaic pottery associated with some of the lion *fibulae*.

Condition: Small piece missing in back mane; otherwise intact. Green patina. Worn surface. KPE

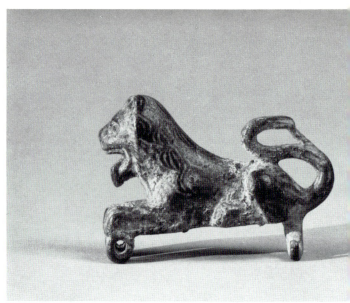

89

Bibliography: Unpublished.

Comparative literature: Lion *fibulae,* from Sparta: W. Lamb, *Greek and Roman Bronzes* (1929; London, rev. ed., 1969) 77, pl. 23a; BSA XIII (1906) 114, figs. 4b and XV (1908-9) 147, pl. 9, no. 7; Reinach, *Répertoire* IV, 458.7, and V, 426.1; from Olympia: K. Neugebauer, *Antike Bronzestatuetten* (Berlin, 1921) 36-37, pl. 20 (Berlin Antiquarium); from Kynouria: *The Beauty of Ancient Art . . . Norbert Schimmel Collection,* ed. H. Hoffmann (Mainz: Philipp von Zabern, 1964) no. 10 (inscribed with dedication to Apollo, now in the Leonidion Museum in Kynouria); Reinach, V, 425.1, 427.5; *Praktika* (1911) 265, fig. 7; from the Acropolis: de Ridder, *Acro. Cat,* p. 167, no. 464; a similar one, found in the area of the Parthenon, is in the collection of J. Lionberger-Davis, St. Louis, MO; from the Argive Heraeum: C. Waldstein, *The Argive Heraeum* (Boston and New York: Houghton, Mifflin and Co., 1902-1905) II, pl. 88 no. 946; elsewhere: H. Gabelmann, *Studien zum frühgriechischen Löwenbild* (Berlin: Gebr. Mann, 1965) 116, no. 67, pl. 10, figs. 1-2 (Munich), 3 (Vienna). For stylistically similar lions, cf. *BCH* XI (1887) pl. 11 bot. (from Temple of Apollo Ptoos, a recumbent lion), and K. Neugebauer, *Katalog der statuarischen Bronzen in Antiquarium,* vol. I (Berlin and Leipzig: Walter de Gruyter, 1931) 63-4, no. 160 (crouching lion from Olympia) with discussion of manufacture site.

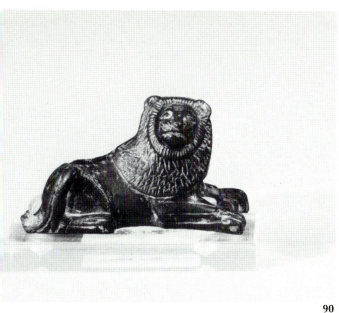

seems to indicate that unforeseen alterations were required to fit the lion to its original attachment surface.

Most conspicuous here are the outer and inner manes which, with their strong outlines, resemble a heavy hood with a snugly fitting ruff about the lion's face. Pronounced angularity, sharp contrasts, and decorative patterns dominate the work. Fine incision is visible everywhere: a line of chevrons runs down the carinated backbone; a curving line with tiny, horizontal incisions marks the carinated edge of the rib cage; long lines ornament the fore- and hind legs; shorter lines depict the claws of the forepaws; and randomly scattered chevrons and lines decorate the raised surface of the outer mane, while closely spaced lines within the inner mane radiate from the face. So singular is the attitude and so unusual the style of this lion that no very close parallels seem to exist. For a similar pose, see [50].

Condition: Tail broken off at lower rump. Shiny, dark greenish-brown patina. KPE

90 *Decorative Recumbent Lion*

Bronze, solid cast. Greek, ca. 550 BC.
H. 3.2 cm.; W. 1.9 cm; L. 6 cm.

Lying on his stomach, this mighty beast pricks up his ears attentively and turns his head sharply to the right. At first glance, he does not seem ferocious, for the usual gaping mouth with protruding tongue and prominent incisors is absent (cf. [89]). Upon closer inspection, however, his scrutiny appears calm but menacing. A sneer crosses his face, his nostrils dilate, and his mouth opens ever so slightly as if to emit a low growl through clenched teeth.

Reclining lions such as this, solid cast with a flat bottom and heads turned to one side, regularly stood guard over the rims of vessels or along the edges of pieces of furniture in Archaic Greece; occasionally, separately cast lions like this formed part of the upper ornament of vertical *hydria* handles, although normally heraldic pairs of lions merge into the handle with which they were cast in one piece. Here a rivet hole together with remains of an ancient rivet for attachment can be seen on the bar which the lion grasps with his extended forepaws. A similar hole in the broken surface left by the missing tail would have held a second rivet. The lower portion of this lion is not even summarily finished at the back, but is instead rough with a deeply cut, curving groove running from the rump to the foreleg. This

90

Bibliography: Bloesch et al., *Das Tier*, no. 156, with literature.

Comparative literature: *BCH* XI (1887) pl. 11 mid. from the Temple of Apollo Ptoos (close to [90]); E. Babelon and J. A. Blanchet, *Catalogue des bronzes antiques de la Bibliothèque Nationale* (Paris: E. Leroux, 1895) 470, no. 1113; de Ridder, *Acro Cat.*, 167-168, nos. 465-468 and *Les bronzes antiques du Louvre*, vol. II: *Les instruments* (Paris, 1915) 150, no. 3142, pl. 111 on the rim of a large lamp suspended by chains); Brown, *Etruscan Lion*, pl. 43 b-c; H. Gabelmann, *Studien zum frühgriechischen Löwenbild* (Berlin: Gebr. Mann, 1965) no. 69 c., pl. 10.4; G. Dontas, *A Guide to the Archaeological Museum of Corfu* (Athens: T. A. P. Service, 1972) pl. 18a; Popovič et al., *Bronzes in Yugoslavia*, pp. 42 (hydria handle) and 49; C. A. di Stefano, *Bronzetti figurati del Museo Nazionale di Palermo,* Studi e Materiali II (Rome: L'Erma di Bretschneider, 1975) 81, no. 141, pl. 30 (quite similar to that here). For a similar, spreading, hood-like mane, cf. the Etruscan lion [86].

91 *Alabastron with Lion and Sphinx*

Earthenware, fired yellowish buff. Early
Corinthian, ca. 600 BC. H. 16.7 cm.; Diam.
9.8 cm.; Diam. of mouth 5.7 cm.

This typical Corinthian *alabastron* (see [92]) is decorated
with a sphinx confronting a lion. Both creatures face left,
but the lion turns his head back over his shoulder in order
to give the sphinx a fierce growl. The latter is undisturbed,
perhaps even amused, by this threat. Black is used for these
figures, but there is considerable application of red
overpaint for both lion (his haunches, underbelly, and ribs)
and sphinx (her face, neck, rear haunches, wings, and
alternate feathers). Incision is used throughout this main
frieze.

91 Side A

91 Side B

Subsidiary decoration consists of nine perfunctorily incised rosettes scattered about the main frieze, ten rays on the shoulder, twenty-eight dots on the rim, and sixteen rays on the mouth. The base has a row of twenty S-shaped devices which surround a series of thirteen rays similar to those on the shoulder and mouth.

Exotic sphinxes and lions are among the most characteristic subjects of orientalizing art and particular favorites of Corinthian vase painters. Our vase is stylistically related to the so-called "Lion Group" of painters.

Condition: Intact. Minor surface pitting. Paint flaking off from portions of rays on mouth and especially on the sphinx, where there is considerable retouching of the red overpaint. RDD

Bibliography: Unpublished.

Comparative literature: Payne, Necrocorinthia, p. 289; D. Amyx and P. Lawrence, Archaic Corinthian Pottery and the Anaploga Well, Corinth VII, 2 (Princeton: American School of Classical Studies, 1975) p. 21, no. 33, pl. 5; J. Benson, Die Geschichte der korinthischen Vasen (Basel: Benno Schwabe, 1953) pp. 31-32, no. 38.

92 Alabastron with Heraldic Cocks

Earthenware, fired yellowish buff. Early Corinthian, ca. 600 BC. H. 9.6 cm.; Diam. 5.4 cm.; Diam. of mouth 3.5 cm.

The shape (with its tapered body, rounded base, perforated handle, small opening, and concave applicator mouth) is typical of Corinthian alabastra during much of the Archaic Period. The decoration consists of two heraldic cocks which flank a large stylized plant. The birds are rendered in black glaze with details (eyes, beaks, necks, feathers) incised. Red overpaint enlivens their combs, wattles, wings, and alternate primary and tail feathers, which overlap on the back of the vase. The plant, a large lotus bud joined to a palmette, is painted in black with incisions used to define its components and red for contrast. Incised rosettes occupy the field behind each cock. Simple rays and dots form the typical decoration for the mouth and neck; a six-pointed star adorns the base.

Roosters and hens were imported to Greece, probably from Persia, during the seventh century BC. They appear to have had an instant popularity not only with farmers but also with artists. Cocks are an especially frequent subject for Corinthian vase painters who often show them with other exotic creatures, or flanking plants or snakes and lizards. The theme of our vase is often treated by the so-called "Painter of the Cocks," an artist active at the

turn of the seventh century. This vase, although not by his hand, was inspired by his work.

Later, cocks were sacred to Hermes, Demeter, Asklepios, Athena, Leto, Helios, and even Herakles. Some of the associations are obvious; others are uncertain and perhaps only very late. In the case of this vase, and others with the same subject, the cocks may have been nothing more than a novel and exotic ornament. On the other hand, we should keep in mind that alabastra were used by young men to carry scented oils. At least in the fifth century, the cock was considered the appropriate love-gift for a young man who had attracted an older man. (On the divine level Zeus often presents Ganymede with a cock in Greek art.) Thus, an

92

alabastron decorated with cocks would be a suitably suggestive gift for a young man from his lover.

Condition: Intact. Minor chips on mouth. Some pitting and flaking of red overpaint. RDD

Bibliography: Unpublished.

Comparative literature: Payne, *Necrocorinthia*, p. 282, nos. 273-276; R. J. Hopper, *BSA* XLIV (1949) 192f, n. 2; L. Banti, "Galli, Pittore dei" in *EAA* III (1960) 763-764, fig. 938; *CVA* Gela 2 (Italy 53) pl. 14, 4-7; *CVA* Heidelberg 1 (Germany 10) pl. 10, 4; *CVA* Milano, Coll. "H. A." 2 (Italy 51) pl. 4, 3-4; P. Mingazzini, *Vasi della collezione Castellani* (Rome, 1930) pl. XLI, I; P. Bruneau, "Le motif des coqs affrontés dans l'imagerie antique," *BCH* LXXXIX (1965) 90-121; J. Pollard, *Birds in Greek Life and Myth* (London: Thames and Hudson, 1977) pp. 88, 147-148; K. Dover, *Greek Homosexuality* (Cambridge, MA: Harvard University, 1978) p. 92.

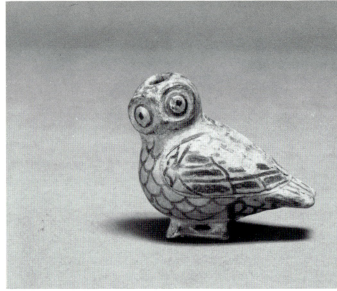

93

93 *Owl Ointment Vase (Unguentarium)*

Earthenware, fired grayish tan. Corinthian, ca. 575 BC. H. 5.7 cm.; W. 3.6 cm.; L. 5.7 cm.

This is the first of six animal-form plastic vases in the Mildenberg collection that were used to hold precious ointments. The owl's hollow body was formed in a mold, its feet modeled by hand. The head is a carved and hollowed out lump of clay which was attached to the body. An opening is cut into the top of the head. The feet are pierced in order to suspend it upside down when not in use. Dark brown and added red paint details the arrangement of the owl's feathers and further enhances the modeling. A scale-like pattern decorates the head, neck, and breast. The wings are divided from the rest of the body by an incised line and decorated with a thicker, darker paint. They consist of two parts separated by thickly painted lines, the wingbars being the same scale-like pattern already described. Three lines on each wing indicating primaries run toward the tail; the spaces in between are filled in with a thick application of the slip, sometimes over-painted in red. Two pairs of wavy lines cross the wings from top to bottom. Straight painted lines describe the tail. The area between the bird's feet is reserved.

The bird turns its head left perpendicular to its body. The beak continues into a ridge surrounding the wide-open eyes. The eyes are rendered in both relief and paint: a painted ring surrounds a raised outer ridge, and another painted ring encircles the convex dotted pupil.

Cretan and Proto-Corinthian workshops both had a fondness for vases in the shape of owls, though each represents a distinctive species. The Cretan owl is the *Scops* or North African owl displaying ears and long ear-tufts. It is similar to those represented on Rhodian and Naukratic vases. This owl form seems to have been employed rarely on the mainland where the "little owl," known as the *glaux* or *Athene noctua* type was preferred. The Mildenberg owl is the *glaux* form. These owls are round headed and earless with barred and speckled plumage. Sacred to Athena, they frequented the Athenian acropolis and were represented on Athenian coins. Painted examples are found in the late fifth century BC on a type of red-figure cup called the owl-*kotyle* (for the type, see [127 c]).

The most prolific period for the owl *unguentaria* is the Proto-Corinthian from which six examples are well known (Louvre CA 1737; Athens [number unknown] excavated at Corinth; Munich 2240; two in Swiss private collections; Cabinet des Médailles 5175). All are highly decorated with variations in plumage and eyes. The use of dots, stylized scale-like patterns, incision, and painted color varies among these six examples.

The Mildenberg owl is differentiated from the group by its lack of the precision and exquisite finesse characteristic of a miniaturist's hand. Payne notes an increased output during the ripe Corinthian Period along with a distinct falling off of the standards of production. Two examples dated to ca. 575 BC (Swiss private collection and Swiss art market) exhibit this perfunctory style and provide a date for the Mildenberg vase.

Condition: Intact. Worn in areas; paint chipped, possibly misfired or burned. BAK

Bibliography: Unpublished.

Comparative literature: Elinor R. Price, "Pottery of Naucratis," *JHS* XLIV (1924) 212; D'Arcy W. Thompson, *A Glossary of Greek Birds* (London: Oxford University Press, 1936) pp. 76-80; Payne, *Necrocorinthia*, pp. 175-177; K. Friis Johansen, *Les vases sicyoniens* (Paris: Edouard Champion, 1923) pp. 156-158, pl. XLI; John Pollard, *Birds in Greek Life and Myth* (London: Thames and Hudson, 1977) pp. 39, 143-144; *CVA* Louvre 8 (France 12) pl. 2 (France 499) 1-4; David M. Robinson, "Ointment Vases from Corinth," *AJA* X (1906) 420-426; *CVA* Munich 3 (Germany 9) pl. 149, 1-2; Bloesch et al., *Das Tier*, p. 45, pl. 45, nos. 267, 268; E. Pottier, "La chouette d'Athéné," *BCH* XXXII (1908) 533, no. 4, pl. VII 1-2 (represented only by drawing, difficult to ascertain extent of similarity to group); José Dörig, *Art antique: collections privées de Suisse romande* (Geneva: Editions archéologiques de l'Université de Genève, 1975) p. 145, no. 145; Herbert Hoffman, *Collecting Greek Antiquities* (New York: Clarkson N. Potter, 1971) p. 105, fig. 86; Flemming Johansen, "Der er Uglen," *Meddelelser fra Ny Carlsberg Glyptotek* XXXII (1975) 99-118.

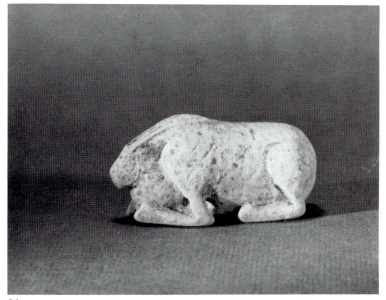

94

94 *Crouching Hare Toy (?)*

Earthenware, yellowish buff. Corinthian, 6th century BC. H. 2.9 cm.; W. 2.6 cm.; L. 6.2 cm.

This small hare was apparently formed over an aggregate of creamy white clay containing white lumpy impurities. The exterior layer of buff clay is a purer mixture, fairly fine in texture. The friable clay body was either low-fired or sun baked. The only vent-hole is located beneath the hind-quarters, just deep enough into the body to prevent its cracking in drying or firing. Only traces remain of its original brownish slip. Added red stippling over the body indicates the hare's fur. Added red delineates the interior and rim of the ears and tail and outlines the shoulders and haunches. The mouth and inner ear are incised. The pierced holes beneath the elbows may have served as a means of suspending the animal.

The crouching hare with legs pulled under the body and ears laid back is carefully modeled with an eye for the characteristic full haunches and shoulders of a hare in this position. Here attention to the musculature is more noticeable than in related perfume vases. The crouching position is the only form employed for the representation of the living hare. Xenophon (in *Cynegeticus* ["On hunting"], Book V, line 31) addresses this theme when he states, "When going quietly it springs; no one has ever seen or ever will see a hare walking." One unexplained feature is the full or bloated chest (most obvious from the hare's left side).

Plastic vases were extremely popular in the seventh and sixth centuries BC and are found throughout the Mediterranean. Representations of a wide variety of humans and animals are known from workshops located in East Greece, Rhodes, Boeotia, Etruria, and Corinth—the most productive pottery center of this period. Corinthian wares appear in many localities, attesting to its active trade connections.

The crouching hare was a favorite vessel shape of Rhodian and Corinthian workshops. Almost all that have been preserved were intended as perfume or ointment containers with pour holes in the tops of the heads. These small vases were as popular for their shape as they were for their contents, but there is no evidence that the shape became popular enough to be traded for its own sake. Only one other crouching hare figurine with a rear vent hole is known (British Museum 1961.2-13.1). It can be suggested that Mildenberg's well-worn rabbit was a child's plaything, made to mimic the ointment vases of sophisticated and well-to-do adults.

Condition: Much of the surface is worn away from use. The front right leg is chipped and broken and a fragment is missing. BAK

Bibliography: Unpublished.

Comparative literature: For Corinthian hare ointment vases, *CVA* Heidelberg 1 (Germany 10) pls. 5, 7-9; R. A. Higgins, "A Terracotta Hare," *BMQ* XXIV, no. 1-2 (1961) 45-46.

95 *Ape Aryballos*

Earthenware, fired tan or light brown. Etrusco-Corinthian, late 7th century–early 6th century BC. H. 10.4 cm.; W. 5.5 cm.

The squatting ape holds his left paw to his mouth and reaches his right paw to his right ankle. His crossed hind paws and ischial callosities (growths of hardened skin on the buttocks, common in primates) form a tripod. However, his hind paws extend down too far for the vase to stand upright; it probably originally hung from a cord around its neck. The slim body and head were mold made; the arms and legs handmade; and the ears, snout, and ischial callosities are added lumps of clay. In reserve are the callosities, the top of the thighs, calves, and stomach creases caused by the retracted hind legs. Dark brown slip was used to color the head, snout, collar, front paws,

95

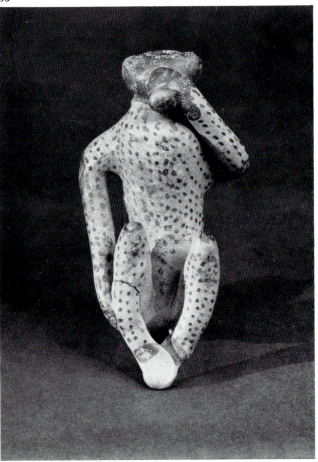

elbows, and knees. Brown slip also stipples the hide of the body, arms, and legs, and bands the hind paws. There are no traces of slip delineating the facial features or ears. The vessel opening is inconspicuously placed in the top of the head.

Various species of apes were long represented in the Near East, Egypt, Crete, and Mycenae, from whence they were introduced into Etruria and became a popular motif. Bonacelli notes that the species most often portrayed by the Etruscans is the Barbary ape; in fact the Etruscan word for ape, *arium*, refers specifically to this type. Ape figurines were quite popular in Etruria and may have held some talismanic or prophylactic significance, but it is equally likely that the attraction was solely aesthetic.

Plastic vases in the shapes of animals and humans (or parts thereof) were commonly used as perfume and cosmetic jars throughout the Mediterranean. The vessel opening or orifice in the top of the head was used for filling and pouring the precious ointments they contained. In Egypt the ape form was especially popular for *kohl* vases, from which the Greek specimens are probably derived. Like their Egyptian models, the apes of the Greek *alabastra* are most commonly shown squatting, the natural pose of the animal. Surprisingly, small ape-form *alabastra* far outnumber depictions on painted vases (see [130]).

Figure vases were introduced into Etruria particularly from Corinthian workshops and imitated on Italian soil by emigré Greek artists or native potters in such large numbers that it is difficult to distinguish one from the other. Squatting apes with paws to their snouts, eyes, ears, or throats are most common and immediately suggest the Oriental "see-no-evil, hear-no-evil, and speak-no-evil" trio (see [121]).

Winter has definitively categorized the Corinthian and Italo-Corinthian ape types according to variations in position, proportion, attributes, and painting. Szilágyi has classed a number of Etruscan wares under similar criteria. But neither strictly classifies the ape with right paw placed on the side of the right leg. An ape vase now in the Museum of Mediterranean Archaeology Nir-David, Israel, and another on the New York art market show the same unusual position as the Mildenberg example. Other examples are very close with only slight variations in paw position (i.e., right paw on knee or between legs) and painted decoration (Heidelberg 29, Munich 675, Louvre CA 3615, Mainz O. 3125, Massa Marittima excavation).

The Mildenberg ape as well as most of the known examples show signs of wear and constant use, confirming more recent theories that these vessels were used in life before being placed in the tomb, contrary to Maximova's beliefs.

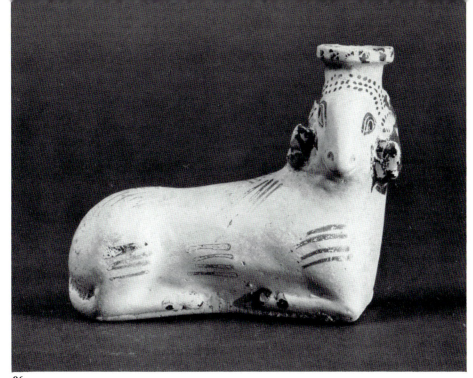

96

Condition: Deep crack on right leg in drying or firing. The slip is worn and chipped throughout. The wear pattern matches the most natural way of holding the small jar. BAK

Bibliography: Unpublished.

Comparative literature: B. Bonacelli, "La scimmia in Etruria," *StEtr* VI (1932) 343-382; William C. McDermott, *The Ape in Antiquity* (Baltimore: Johns Hopkins Press, 1938) pp. 28-30; Franz Winter, *Die antiken Terrakotten* III 1 (Berlin and Stuttgart: von W. Spemann, 1903) p. 222; J. Gy. Szilágyi "Vases plastiques étrusques en forme de singe," *RA* (1972) lll ff Schefold, *MgK*, no. II 126; *Classical Art from a New York Collection*, exhib. cat. (New York: André Emmerich Gallery, Inc., 27 September–16 November 1977) p. 41, no. 38; *CVA* Heidelberg 1 (Germany 10) pl. 6; Johannes Sieveking and Rudolf Hackl, *Die königliche Vasensammlung zu München* (Munich: J. B. Obernetter, 1912) p. 86, fig. 85, no. 769; *CVA* Louvre 8 (France 12) pl. 7 (France 504) 6, 11; *CVA* Mainz 1 (Germany 42) pl. 22, nos. 4-6; D. Levi, "La necròpoli etrusca del Lago dell'Accesa e altre scoperte archeologiche nel territorio di Massa Marittima," *MonAnt* XXXV (1933) 42-43, pl. X no. Ea; D. M. Robinson, C. G. Harcum, and J. H. Iliffe, *A Catalogue of the Greek Vases in the Royal Museum of Archaeology, Toronto* (Toronto: University of Toronto Press, 1930) p. 41; Payne, *Necrocorinthia*, p. 172, M. I. Maximova, *Les vases plastiques dans l'antiquité* (Paris: Paul Geuthner, 1927) pp. 20 ff. For further information on squatting apes see: *CVA* Robinson Collection 1 (U. S. A. 4) pl. 15 (U. S. A. 418) 32; R. A. Higgins, *Catalogue of the Terracottas in the Department of Greek and Roman Antiquities, British Museum* II (London: British Museum, 1959) 50-52, nos. 1685, 1686.

96 *Crouching Ram Aryballos*

Earthenware, fired pale buff. Rhodian, ca. 600–580 BC. H. 8.9 cm.; W. 5.8 cm.; L. 11.5 cm.; Diam. of mouth 2.9 cm.

This small terracotta vase is in the form of a crouching ram which turns its head to the right. The vase's mouth crowns the animal's head; traces of black paint indicate it was painted in typical Rhodian fashion. Black is also used to define the features of the ram, especially his horns, hooves, and tail. Three parallel rows of dots cross the head; other dots outline the ears which, in addition, have red applied to their interiors. The eyes and nostrils are indicated in black. Ten groups of four parallel strokes appear on the back and flanks perhaps as a stylized rendition of the fleece. The creature crouches on a plinth-like shelf under the belly painted with short vertical lines suggesting a bed of grass most visible in a rear view.

As always with such vases, it is difficult to ascertain a specific function. This crouching ram and the related ram head *aryballoi* could have reminded their owners of Dionysos and Pan, deities associated with the animal. On the other hand, they may have been selected for purely decorative or aesthetic reasons. Both functions—the religious or apotropaic and the aesthetic—need not be mutually exclusive.

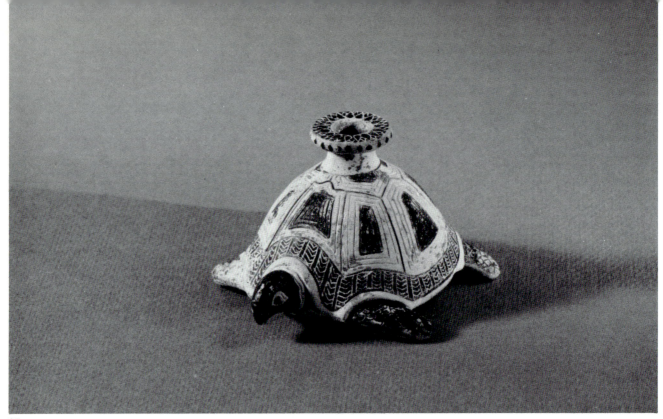

97

Condition: Intact. Cracking and flaking of paint, especially on horns, hooves and vase's mouth which is badly abraded. RDD

Bibliography: Unpublished.

Comparative literature: J. Ducat, *Les vases plastiques rhodiens,* Bibliothèque des Ecoles Françaises d'Athènes et de Rome CCIX (Paris: E. de Boccard, 1966) 100, pl. XIII, 5, 7-8, pp. 169-172; *CVA* Louvre 8 (France 12) pl. 7, 4-5 (mistakenly classed as Corinthian).

97 *Turtle Aryballos*

Earthenware, fired buff. Rhodian, ca. 580-550 BC. H. 4.6 cm.; W. 7.6 cm.; L. 8.2 cm.; Diam. of mouth 2.4 cm.

This charming vase is in the shape of a turtle. The mouth is located at the top of the creature's shell and is decorated, in typical Rhodian fashion, with incised overlapping rays (cf. [98]) and dots. The carapace (upper shell) is elaborately rendered with eight incised and painted segments or "plates" radiating from the vase's neck and mouth. The bottom edge of the carapace is a black border with delicately incised chevron bands indicating the plates. The plastron (lower shell) has neither paint nor incision but is carefully and realistically modeled, especially around the creature's tail and rear limbs. The head is painted black with nostrils pierced and eyes incised. The limbs are black with incised scales and, on the left forelimb only, claws.

The high domed carapace and club-like limbs of this creature indicate that he is a land turtle. *Aryballoi* in the shape of turtles are relatively rare. Of the six or so known most come from Rhodes or Aegina. Far more common are terracotta votive turtles which may have been sacred to Hermes. The tortoise is often associated with this god because he was believed to have invented the lyre using a tortoise shell for a sound-box.

Condition: Intact except for broken tail. Minor surface abrasion throughout; paint worn, especially on limbs. RDD

Bibliography: Unpublished.

Comparative literature: M.I. Maximova, *Les vases plastiques dans l'antiquité* (Paris: Geuthner, 1927) I, 100-101, II, pl. XII, 89 a-b; R.A. Higgins, *Catalogue of the Terracottas in the Department of Greek and Roman Antiquities, British Museum,* I (London: British Museum, 1954) p. 60, no. 103, pl. 19, pp. 79-80, nos. 191-197, pl. 35, p. 178, nos. 667-668, pl. 87, p. 25l, no. 923, pl. 132.

98 Monkey Aryballos

Earthenware, fired brownish orange. Rhodian, ca. 580–550 BC. H. 9 cm.; Diam. of body 3.8 cm.; Diam. of mouth 3 cm.

The vase represents a truncated monkey without arms. The monkey's head is covered with rows of tiny painted dots which roughly conform to the contours. Black paint outlines the eyes and forms the pupils, but the whites are incised. The nostrils and ears are outlined with black, but their interiors are painted with red. The mouth is incised; three curved lines painted at the corners indicate a smile. The flat mouth typical for an *aryballos* is placed on top of the monkey's head. A delicately incised rosette decorates the top; a frieze of alternating red and white stripes ornaments the rim. The monkey's cylindrical body is

covered with small vertical strokes to represent fur. A large dot-rosette with fifteen petals, each with a white dot, is painted on the bottom of the vase.

Only two other truncated-monkey *aryballoi* are known. They seem to be related to vases made in the shapes of other truncated animals, particularly antelopes, or other *aryballoi* (e.g., *aidoion* vases) decorated with the same distinctive dots and vertical strokes. Probably all originated in the same workshop. See also [99].

Condition: Painting well preserved. Slight chips on mouth; cracked area on left side restored. RDD

Bibliography: Classical Art from a New York Collection, sale cat. (New York: Emmerich Gallery, 1977) no. 13; the vase is listed in J. Ducat, *Les vases plastiques rhodiens,* Bibliothèque des Ecoles Françaises d'Athènes et de Rome, CCIX (Paris: E. de Boccard, 1966) 122 (Type C, no. 2).

Comparative literature: A. Fairbanks, *Catalogue of the Greek and Etruscan Vases* (Cambridge, MA: Harvard University Press, 1928) p. 179, no. 518, pl. LI; Flemming Johansen, "En Østgræsk Parfume flaske fra 6 Årch.f.kr.," *Meddelelser fra Ny Carlsberg Glyptotek* XXXIII (1976) 88, fig. 4; M.I. Maximova, *Les vases plastiques dans l'antiquité* (Paris: Geuthner, 1927) pl. XXIII, no. 94; M. Robertson, "A Group of Plastic Vases," *JHS* XVIII (1938) 41-50; Bloesch et al., *Das Tier,* p. 46, nos. 281, 282, pl. 47.

98 See also back cover

98 underside

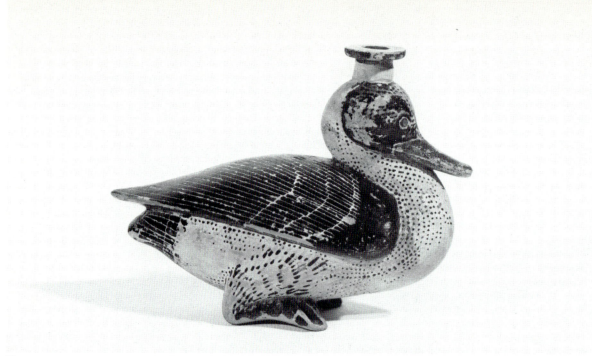

99

99 Plastic Vase in the Form of a Sitting Duck

Earthenware, fired reddish brown. East Greek
(Ionian), second quarter of 6th century BC. H. 10.1
cm.; W. 6.2 cm.; L. 14.3 cm.; Diam. of mouth 2.3 cm.

This hollow, mold-made vase in the form of a sitting duck is
an *unguentarium,* or perfume flask, as shown by the
circular *alabastron-*type mouth crowning its head. The long
ovoid body is covered by folded wings which project at the
sides and back. Underneath are tucked the webbed feet.
The duck nestles its head and neck close to its body as in
nature. The bill and round eyes are lightly incised, the
nostrils more deeply. Although not entirely preserved, the
painted plumage is as fine as the shape. The lip of the vase
and the duck's bill are simply blackish brown. The same
color is used for the dots which indicate the fine down
covering the duck's neck and lower body, with the
exception of the reserved area between the feet. The
feathers of the face and shoulders are depicted as black
dots under a dilute glaze. Longer black dashes indicate the
upper leg feathers, while the feet are brownish red. Finest
of all are the wing and tail feathers, which are black and
carefully incised. The three-tiered wingbars graduate in
length; the primaries fold diagonally back toward the rump.
The tail feathers are also delineated in graduated lengths,
and alternate two black, one red.

In terms of both shape and painted decoration, this duck
vase has close parallels in the British Museum (B 666), in a
private collection in Winterthur, and in the Würzburg
museum. These, along with a magnificent swan now in the
Toledo Museum of Art, Ohio (64.54), are included in a list of
duck vases compiled by Ducat (Type C). He dates them to
ca. 580 BC. and argues for a Rhodian origin. However,
Robertson, who originally formulated the group, calls them
Ionian, as does Higgins on account of the fabric. While the
majority of these plastic vases have been uncovered in
Etruria, the examples now known from Rhodes and
Nakratis support an East Greek provenance.

The monkey *aryballos* in the Mildenberg collection [98] is
of a similar fine-grained reddish fabric and belongs to the
same class.

Condition: Very worn in places; paint chipped. JN

Bibliography: Unpublished.

Comparative literature: R.A. Higgins, *Catalogue of the Terracottas
in the Department of Greek and Roman Antiquities, British
Museum,* II (London: British Museum, 1959) 32, 35, no. 1661, pl.
24; Bloesch et al., *Das Tier,* p. 46, no. 282, pl. 47; Ernst Langlotz,
Griechische Vasen in Würzburg (Munich: J.B. Obernetter, 1932)
pp. 20-21, no. 148, pl. 18; Jean Ducat, *Les vases plastiques
rhodiens,* Bibliothèque des Ecoles Françaises d'Athènes et de
Rome, CCIX (Paris: E. de Boccard, 1966) 92, nos. 1-3 and 6, pl. XII, 3,
and pp. 158-160; Martin Robertson, "A Group of Plastic Vases,"
JHS LVIII (1938) 41-50, pl. V, and p. 255.

100 Little Master Lip Cup with a Boar Hunt

Earthenware, fired orange. Attic, Black-Figure, ca. 550–540 BC. H. 9.7 cm.; Diam. of rim 14 cm.; Diam. with handles 19.8 cm.

At the center of side A, a large boar in black glaze faces right. Applied red appears on his neck, ribs, and haunch. Details of his body, especially the ear, eye, tusk, and back bristles, are carefully incised. At the center of side B, a small nude man rushes toward the left. He brandishes a long spear in his right hand. A few incised lines indicate that he is in three-quarter back view. Both figures occupy the lip frieze which is separated from the handle frieze by a strong black horizontal. The tondo consists of a simple black dot at the center of two concentric circles; these, in turn, are at the center of a large reserved circle. Little Master cups, like this one, generally have a relatively deep bowl, horizontal upturned handles, and a tall stemmed foot; they receive their name from their miniature black-figure decoration.

Little Master lip cups (see also [101]) are among the finest expressions of the Attic potter's sense of balance and design. The shape appears to have evolved from earlier cup shapes like the so-called Komast cup and Siana cup; the lip

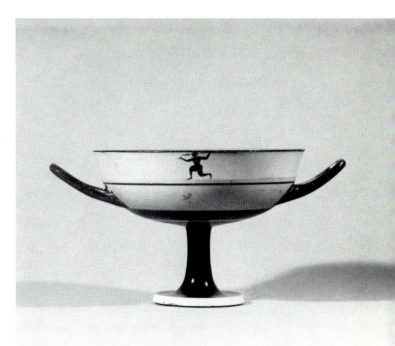

100 Side B
See also colorplate XVI

100 Side A

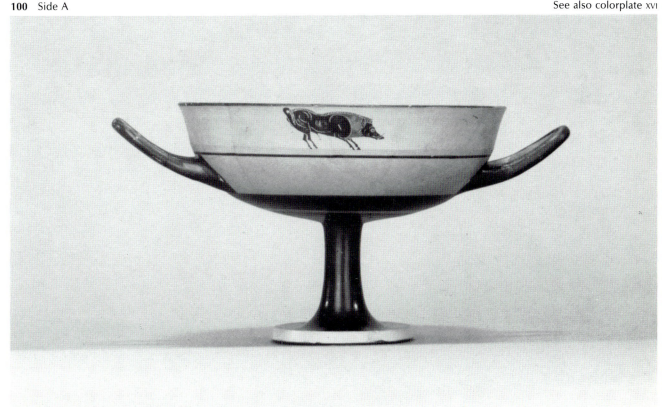

cup with its distinctive decorative format of small isolated figures was well established by ca. 550 BC in Attica. After 530 BC it was gradually replaced by the eye cup (see [102]).

A large number of Attic vase painters decorated Little Master cups. A fair number are signed by the artist and many bear greetings to the drinker. Usually, painted palmettes spring from the handles to flank such painted inscriptions. This vase has neither inscriptions nor palmettes in the handle frieze.

Boar hunts were popular subjects for ancient vase painters. They may be mythical (the Kalydonian Boar Hunt, Herakles and the Erymanthian Boar) or mundane. Our example probably belongs to the latter category despite the boar's heroic proportions. See also [145].

The closest parallels, in subject and style, for this vase are found in the works attributed to the so-called Centaur Painter.

Condition: Neatly restored from several large fragments. Minor lacunae on rim restored; handle A/B mostly restored. Small chips and abrasion on foot. Applied red on boar's neck retouched. RDD

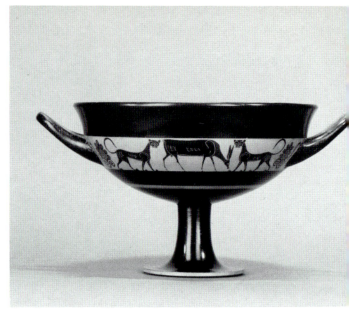

See also colorplate IX 101 Side A

101 Side B

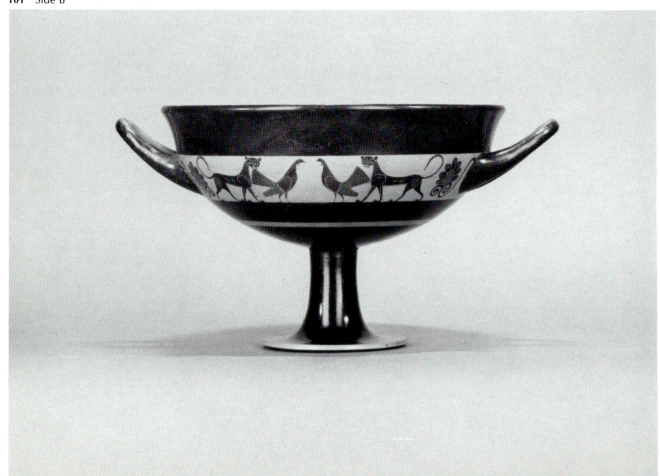

Bibliography: Unpublished.

Comparative literature: For Little Master cups in general, see J.D. Beazley, "Little Master Cups," *JHS* LII (1932) 167-204; Beazley, *Development*, pp. 53-56; *ABV*, chap. 12; *CVA* New York 2 (USA 11) pp. 4-5, pl. VIII, 8 a-b; *CVA* Taranto 3 (Italy 35) pl. 30, 3; *Ancient Art in the Virginia Museum* (Richmond: Virginia Museum, 1973) no. p. 71; K. Schauenburg, *Jagddarstellungen in der griechischen Vasenmalerei* (Hamburg and Berlin: Parey, 1969) pp. 11-14.

101 *Little Master Band Cup with Panthers, Deer, and Hens*

Earthenware, fired reddish orange. Attic, Black-Figure, ca. 540 BC. H. 15 cm.; Diam. of lip 22.2 cm.; Diam. with handles, 29.5 cm.

The variety of Little Master cups known as the band cup has a solid black, slightly concave lip which passes gradually into the body of the vase, and the decoration is restricted to a reserved band between the handles. (For the other type, called a lip cup because of its offset lip, see [100].) The rest of the vase is black with the exceptions of a wide circle on the interior, the inside of the handles and foot, a narrow fillet encircling the lower body, and the outer edge of the foot—all of which are left in the reddish orange of the fired Attic clay.

Like the shape, the decoration is fairly standard: handle palmettes with a file of figures between. Here the seven-leaved upright palmettes are anchored to the roots of the handles by means of thin black tendrils, and they are enlivened with an added red heart and red dots on the leaves. Side A shows two heraldically posed panthers on either side of a browsing deer who moves to the right; on Side B similar felines flank two confronted hens. As the animals are ultimately borrowed from Corinth, so too their elongated bodies and the added red on the necks and flanks of the quadrupeds. A row of tiny white dots (now lost) once highlighted the spine of the deer.

Band cups were a popular product of the Athenian potteries from the 550s to the 520s BC. Examples with obverse decoration very similar to the Mildenberg cup can be found in the British Museum (B 393 and B 396) and formerly on the Swiss market. In those paintings, however, the deer is grazing to the left.

Condition: Restored from numerous fragments; lip slightly chipped. A bronze plug centered on the interior may represent an ancient repair rejoining the foot to the bowl.

JN

Bibliography: Unpublished.

Comparative literature: For Little Master cups in general, see comparative literature for [100]; *CVA* British Museum 2 (Great Britain 2) pl. 16, 9 and 10; *Sonderliste G: Attische schwarzfigurige Vasen,* sale cat. (Basel: Münzen und Medaillen, November 1964) pp. 32-33, no. 61.

102 *Bilingual Cup with Dog in Tondo*

Earthenware, fired orange. Attic, ca. 525–520 BC. Related to the "Group of Leipzig T 3599." H. 7.3 cm.; Diam. of rim 19.8 cm.; Diam. with handles 26.5 cm.

The exterior of the cup is painted in the red-figure technique. At the center of Side A, a nude warrior moves quickly to the right. He holds a large circular shield on his left arm. This was drawn with the aid of compasses whose central point is visible at the focus of two incised concentric circles marking the shield's border. The inner supports, braces, and straps of the shield are clearly indicated. The warrior holds a spear, point downward, in his right hand. Portions of the spear which overlap the black background are distinguished from it by incision. The warrior wears a crested Corinthian helmet; his long, curly locks fall beneath it to his shoulder and chest.

At the center of Side B, a figure wearing a belted *chitoniskos* (decorated with groups of three dots) runs to the left. The right arm is raised with the hand behind the head; the left arm is extended in a fist. Unfortunately, much of this figure is restored rendering it impossible to determine the sex.

102 profile Side A

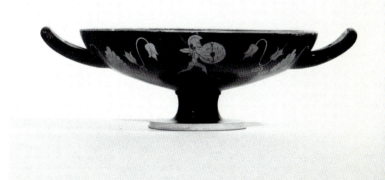

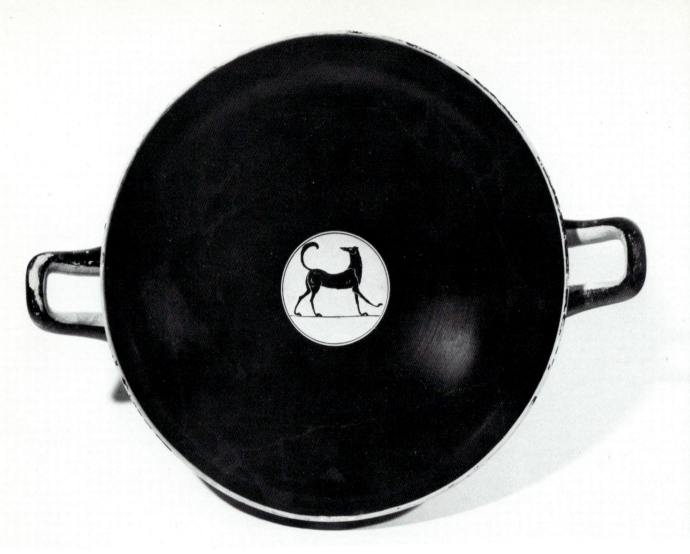

Flanking these figures on both Sides A and B are palmettes and lotus buds. The tall palmettes, one springing from each side of the handles, grow on curving tendrils. A distinctive feature is the treatment of the palmette-hearts. These are framed by two relief lines (on side A only) and are painted in applied red, rather than reserved. Near each palmette a pair of robust lotus buds is joined by another curving tendril.

On the interior a dog, executed in black-figure, occupies the small tondo. A thin but alert specimen, he stands on an *exergue* line. His right foreleg is raised as if he is about to advance but, for a brief moment, he turns his head to look back over his shoulder to the left. Incision is used sparingly.

A black circle is drawn within the perimeter of the reserved tondo. (See also a similar dog in bronze [182].)

This shape, a standard Type A eye cup, may be compared to [100], an example of the earlier Little Master cup. Type A eye cups were invented ca. 530 BC in Athens by the master potter and vase painter, Exekias. He also developed a new format of decoration consisting of large apotropaic eyes painted on the exterior. Eye cups were particularly popular with the pioneer generation of red-figure vase painters; Beazley listed over a hundred examples of "bilingual" (e.g., vases combining black- and red-figure) eye cups.

Our vase is one of this large corpus but, although its shape is standard, its decoration is abnormal. The artist has

painted lotus buds in the places where eyes should be. He has, however, retained the use of centrally placed figures on each side, flanking palmettes, and the small interior tondo—all standard elements of bilingual eye cups. In addition, the artist's minimal use of relief lines and reserve indicate that he is firmly rooted in the black-figure tradition. Cohen's discussion of this vase links the artist to the Painter of the Vatican Horseman, the Painter of the Boulogne Horse, and ultimately to Psiax. Her attribution is followed here.

Condition: Neatly restored from several fragments. A number of small lacunae around rim and some chips on foot. Restorations: Side A, warrior's lower thighs; Side B, figure's right upper arm, right ankle, left shin, and the back from the waist up to the head; several small parts of the palmettes. RDD

Bibliography: Beth Cohen, *Attic Bilingual Vases and Their Painters*, NYU Ph.D. diss., 1977 (New York: Garland, 1978) no. B21, pp. 301-302 (not illus.).

Comparative literature: J.D. Beazley, *ARV²*, p. 37-52; Beazley, *Development*, pp. 67-68; H. Bloesch, *Formen attischer Schalen* (Bern: Benteli, 1940) p. 2, pl.1; John Boardman, *Athenian Black Figure Vases* (London: Thames and Hudson, 1974) pp. 107-108; Denison Bingham Hull, *Hounds and Hunting in Ancient Greece* (Chicago: University of Chicago Press, 1964).

103 *Amphora with Marine Fauna*

Earthenware, fired orange. Attic, Black-Figure, late 6th century BC. H. 26.5 cm.; Diam. of lip 13.3 cm.; Diam. of body 19 cm.; Diam. of foot 10.5 cm.

In shape this vase represents the standard Attic neck-*amphora* of the sixth century BC. It has the characteristic *echinus*-shaped lip and *torus* foot, here elaborated in two degrees. The rim has an inset and would originally have carried a lid. The handles which spring from the middle of the concave neck and reach to the shoulder are triple-reeded.

In terms of decoration, however, this *amphora* is unique. The lip and foot are black-glazed as expected, but only the outer reeds of the handles are painted. Thin fillets, painted red, mark the junctures between the neck and body, base and foot, and there is a red stripe inside the rim. There are black rays at the base of the body—one of which is particularly thin—and a double palmette chain on the neck. While such neck decoration is standard on black-figure neck-*amphorae,* it is peculiar to find the chain dotted and palmettes and single petals in alternation. Short black tongues ring the upper shoulder. Two heavy black bands

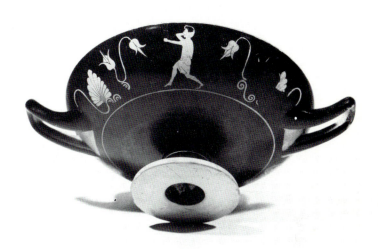

102 Side B

103 Side A

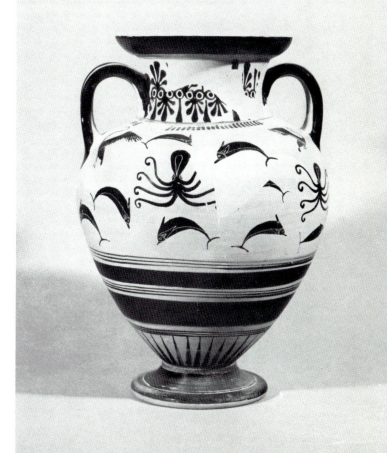

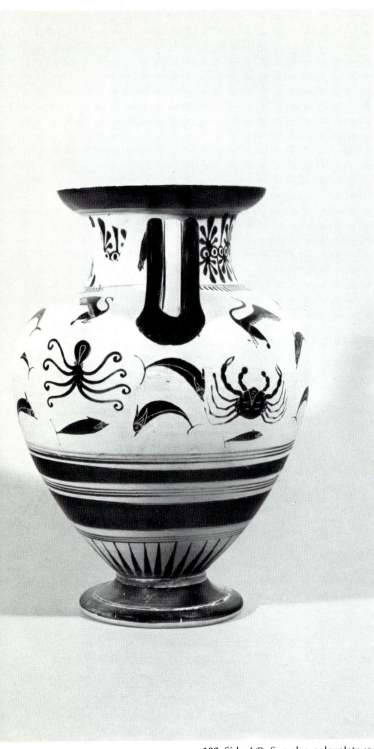

between triple black lines encircle the lower body, in place of the more traditional bands of continuous ornament, meander and lotus bud.

It is the decoration of the body, however, which is the most unusual. First, lacking the palmette complexes usually found below the handles, the frieze is continuous around the vase. Secondly, the subject matter includes no human or mythological figures instead consisting exclusively of creatures from the environs of the sea, carefully arranged and evenly spaced around the entire body of the vase. Prominent on Side A are two octopods surrounded by nine leaping dolphins and one tunny fish. Side B exhibits two large crabs to either side, and yet another octopod encircled by six dolphins. In the vicinity of each crab is another tunny fish. In the upper regions flanking the roots of the handles are four flying swans, their broad wings fluttering out behind and their feet and bee-shaped bodies dangling seawards.

While vase paintings devoted exclusively to marine life are common in the Aegean in the Late Bronze Age and in South Italy in the fourth century BC (notably fish plates, see [149]), they are rarely found in the intervening ten centuries. The only common locale for black-figure fish seems to be the tondo or interior of cups. Fish frequently serve as filler in Lakonian vase painting, but occasionally occupy an entire tondo (e.g., Amsterdam 3765, Taranto I.G. 4805 and 4806). Dolphins, on the other hand, often show up in orderly concentric rows on East Greek pottery. They may well be the source for the seven dolphins surrounding Dionysos' ship in the tondo of Exekias' famous *kylix* in Munich (2044; *ABV*, p. 146, no. 21). Much earlier (ca. 575) is the Gordion cup signed by Kleitias which shows purely piscine motifs in the tondo, three dolphins and a fish (Berlin 4604; *ABV*, p. 78, no. 13). But while fish and dolphins are occasionally found together in Attic vase painting, as on the black-figure *kalpis* in Bonn, a mixed potpourri of marine life is virtually unknown. Sea creatures appear individually in various exploits of Herakles depicted in black-figure: the crab in his encounter with the Lernan *hydra,* water fowl in the Stymphalian bird adventure, and a dolphin sporting nearby during his wrestling contest with Triton. In Attic red-figure, marine life appears in three contexts: in scenes of fishing (e.g., ARV^2, p. 173, no. 9; p. 555, no. 88), as an indication of the sea over which certain mythological figures such as Apollo and Herakles ride (e.g., ARV^2, p. 209, no. 166; p. 449, no. 2), and in depictions of the Gigantomachy where Poseidon's weapon, the island of Nisyros, is often incrusted with sea creatures (e.g., ARV^2, p. 255, no. 2). The only instances where aquatic and bird life come together appear to be in the West. The famous

103 Side A/B. See also colorplate xv

Etruscan Tomb of Hunting and Fishing shows dolphins sporting in the water, birds in the air. Likewise a Caeretan *hydria* (Villa Giulia 50643) depicting Europa and the bull has dolphins and fish underfoot and a swan near the handle. Unlike the Mildenberg amphora, however, all these scenes include human figures. It is its exclusive devotion to marine life and its unique combination of octopods, crabs, dolphins, fish, and swans that make this vase such an exceptional piece in the repertoire of Attic painting.

The amphora can be dated to ca. 500 BC by the ornament—i.e., the palmette chain—and by its lack of incision. The underside of the foot carries a *dipinto* in light red paint: HE.

Condition: Restored from numerous fragments; some repainting in lost areas.
JN

Bibliography: Unpublished.

Comparative literature: For fish in general, D'Arcy Wentworth Thompson, *A Glossary of Greek Fishes* (London: Oxford University Press, 1947); C.M. Stibbe, *Lakonische Vasenmaler des sechsten Jahrhunderts v. Chr.* (Amsterdam: North-Holland Publishing Company, 1972) p. 228, nos. 332, 333, 346, pl. 126; Bloesch et al., *Das Tier*, p. 34, no. 197, pl. 32; D.A. Jackson, *East Greek Influence on Attic Vases,* Supplementary Paper No. XIII (London: The Society for the Promotion of Hellenic Studies, 1976) pp. 68-70; Bonn-Rheinisches Landesmuseum, *Antiken aus rheinischem Privatbesitz* (Cologne: Rheinland-Verlag, 1973) pp. 41-42, no. 48, pl. 22

104

104 *Trio of Lions*

Bronze, solid cast. Etruscan, perhaps from a workshop at Chiusi, first half of 5th century BC. H. 2.6 cm.; Max. W. 1 cm.; Ave. L. 6.3 cm.

This trio of summarily modeled lions have large heads with small rounded ears and open mouths, collar-like manes, short bodies tapering to the haunches, front legs and hind legs each cast as one, and tails extending straight backward to upcurved tips. They appear to stand, not to recline. While rendered in the wax casting models, the basic contours of these lions' anatomy have been retouched by cold working.

These lions were manufactured as a set, perhaps to fit into the tops of the three legs supporting an incense burner. They may also have decorated the handle and lid of a bronze strainer. Their relative crudity and summary modeling suggest a date somewhere in the first half of the fifth century BC. Their summary modeling resembles that of some other small animals which may come from Chiusi.

Condition: Two lions are intact; the tail of the third is broken. They are covered by dull dark green patina with occasional tiny light green patches.
DGM

Bibliography: Unpublished.

Comparative literature: Brown, *Etruscan Lion,* pp. 146-148; for a strainer with three similar lion statuettes, *Kunstwerke der Antike,* sale cat. Auktion 51 (Basel: Münzen und Medaillen, 14–15 March 1975) p. 102, no. 228, pl. 61, dated in the early fifth century BC.

105 *Pair of Crouching Lions*

Bronze, solid cast (lost wax). Etruscan, late 6th to early 5th century BC. (a) H. 3.15 cm.; W. 1.95 cm.; L. 6.9 cm. (b) H. 3.2 cm.; W. 2 cm.; L. 7 cm. (b) was bought in Jerusalem.

Except for slight variations in dimensions and incised surface decoration, these lions form a virtually identical pair. Their bodies are elongated; their haunches slant down and back. Their tails are separated from the haunches by grooves and they curl full circle around their right stifle joints with the tufts coming to rest on the base of the tail. The tufts of both tails are marked with a grid of intersecting incisions: (a) three longitudinal by seven lateral on a wide tuft, and (b) two longitudinal by eight lateral on a narrower rectangular tuft. The front legs stretching forward parallel to each other, are incised longitudinally by three wide curving grooves on either side of a central groove. In both lions, these features appear as if they were initially intended to represent the claws, but were extended backward nearly to the elbows to indicate their pattern of bone and tendon structure. The undersides of the projection forming the front legs are smooth and featureless except for a lateral groove at the back edge of the paws.

A deep curving incision that extends backward from the brisket to the left shoulder of (a) is missing in (b). Both lions have rounded oval ears, laid back against the head. Ruffs marked by deep crescent-shaped incisions run under the chin from ear to ear; the incisions meet and reverse direction directly under the chins. In (a) the top of the head between the ears is smooth; that on (b) is marked by an incised grid like those forming their tail-tufts. This grid extends over the forehead above and between the eyes of (b); this lower area on (a) is marked by grooves placed diagonally over the eyes converging toward the base of the nose. The eyes are large ovals, whose pupils are enclosed by two grooves at top and bottom and an eyebrow groove above. The noses have no nostrils. The swollen upper lips of both lions, marked by vertical crescentic incisions, look like "moustaches." They extend backward to form the lions' cheeks. Deep, wide horizontal incisions create the lions' mouths. The chins are shallow, convex, and unmarked by incised decoration. These nearly identical lions are clearly made in the same workshop but differ in many modeled as well as incised features.

The lions probably crouched on top of a brazier, or, with a missing third, on the legs of a *thymiaterion,* like the lions of [104]. Ultimately derived from western Asian and Egyptian models and developed through early Italic versions like the impasto lid lion [86], their pose has now become both standardized and debased. With their crescent-shaped, incised ruff-manes, wide eyes, and puffy moustaches, they have become comic rather than menacing beasts. Their distinctive modeling, with crescentic and grid

105 a,b

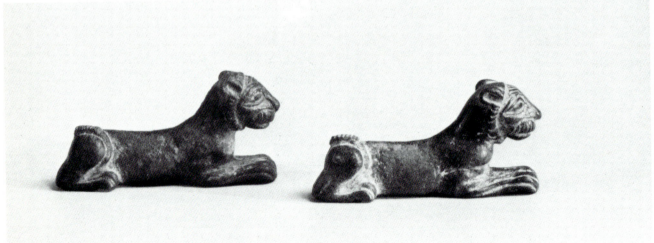

incision, distinguishes them as products of a bronze casting workshop both vigorous and provincial, which eventually should be identifiable and precisely located—probably somewhere in northern Etruria, Umbria, or even the Apennine foothills or Po Valley rather than in the sophisticated coastal centers like Vulci or Tarquinia.

Condition: Both lions are intact, covered by a dark brownish patina. DGM

Bibliography: Unpublished.

Comparative literature: Cf. Brown, *Etruscan Lion, passim*, esp. pp. 146–148.

106 *Lion Looking Backward*

Bronze, solid cast. Etruscan, probably Chiusine workshop, ca. 500 BC or slightly before. H. 2.75 cm.; W. 1 cm.; L. 5.35 cm.

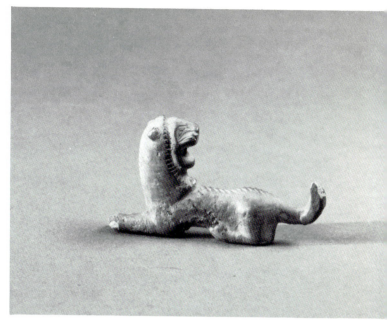

106

This miniature lion reverses his head to roar defiantly; one can almost see his upcurved tail swish in warning. His body is summarily modeled, with swelling haunches and front legs rendered as a single forward projection. A furrow passes around the shoulders and delineates the base of the mane. An incised herringbone line runs the length of the spine. Short incised strokes radiate around the plastically rendered mane at the face. Small plastically modeled ears project backward from just below the crown of the head. A Y-shaped incised wrinkle runs from the forehead to the nose, with the arms of the Y diverging toward each eye. The tiny oval incised eyes have no pupils. The wrinkled cheeks are rendered by grooves, probably cold worked, three on the left side of the muzzle and four on the right.

This isolated lion may have belonged to a set of three of similar size adorning the legs of a *thymiaterion,* like [104]. It may also, however, have sat as one of a series on the rim of a large bronze vessel, tripod, or brazier. Although tiny, this lion is still very much the guardian of whatever it originally decorated.

Condition: Intact; the tips of the right ear and of the tail have been broken off. Traces of silvery metal on underside of legs may be solder. Shiny, light gray-green patina; darker spots on right side of front paw. The corrosion surface on the left tip of the front paw has been broken through into the metal beneath. DGM

Bibliography: Unpublished.
Comparative literature: See [104].

107 *Striding Ram*

Bronze, solid cast. Greek, said to be from Sicily, late 6th–early 5th centuries BC. H. 6.7 cm.; W. 1.9 cm.; L. 7 cm.

Head held high, this solid cast bronze ram strides confidently forward. The animal is somewhat stiffly posed on his slender legs, but his bearing is erect and proud. His large head is framed by notched horns which curve around small pointed ears. The eyes, nostrils, and mouth are more summarily rendered, as are the body and short tail. Deep grooves delineate the major muscles of the body such as the shoulders and the belly. The haunches are marked by three prominently engraved vertical lines. In contrast to these schematized lines, the ram's fleece is treated in a more naturalistic manner. The muzzle, forehead, and belly are stippled, while the back of the head, neck, chest, back, and shoulders are lightly striated.

In Greek sculpture rams are frequently shown being carried on the shoulders of dedicants and in vase painting the moment of sacrifice is occasionally depicted. Since the Mildenberg statuette is firmly standing, it perhaps represents a small votive offering. It is distinguished from other late Archaic bronze rams by the more naturalistic rendering of its pelt; compare, for instance, the similarly sized ram from Syria probably of South Italian origin and now in a private collection or the ram on a column in the

107

108 Standard with Ram Finial

Bronze, cast (lost wax). Greek, from a workshop in Magna Graecia (Metapontum?), ca. 500–480 BC. Overall H. 17.8 cm.; H. of ram 4.6 cm.; W. of ram 1.6 cm.; L. of ram 7 cm.

A ram stands, right feet slightly advanced, upon a rectangular plinth (4.7 × 2.6 cm.) supported by three step-like members of decreasing size. This in turn rests upon a capital consisting of two convex *torus* moldings separated by two tiny rounded ridges and bordered at top and bottom by single ridges. A single *torus* molding, 1.8 cm. farther down the shaft, is bordered by tiny raised ridges on both edges. The hollow shaft tapers upward from its bottom (Diam. 1.7 cm.) toward the plinth. A pin passed through two holes placed opposite each other just above the bottom of the standard originally fastened it to an inserted long wooden staff. The ram is cast separately from the plinth and socket; presumably tangs projecting below the feet are inserted into holes in the top of the plinth.

The sturdy ram has a thick, elongated body with slight surface swellings to suggest his basic volumes. His legs are stumpy cylinders, with generally modeled joints and flaring hooves. His thick tail hangs to his hocks. The penis is indicated by a slight projection in the middle of the abdomen; the testicles are rendered plastically between the hind legs. The ram's head, small in proportion to his body, has a pointed muzzle, downward-curving forehead, and large plastic horns curving around the ears. Deep grooves hollow the ears. The eyes are raised and incised circles with punctate dot pupils; nostrils are punctate dots as well. The mouth is a simple incision. The short fleece on the chin and throat is stippled. The fleece on the neck and body is crosshatched diagonally; the hatching follows the contours of the major divisions of the body which it decorates. Shallow incisions delineate the tops of the hooves.

This unique object, which resembles nothing so much as a miniature votive column crowned by an animal statue, is the "standard," or finial, for a scepter-like staff of unknown length. This may have been the property of a priest, serving as an emblem of his office. A staff of this kind is carried by a male figure on a painted funerary plaque, one of the so-called "Boccanera plaques" from Caere, made between 550 and 530 BC, now in the British Museum. Small cast groups of men and rams, found in Sicily and Delphi, were fastened to the ends of staffs by metal pins; they constitute the predecessors of the Mildenberg "standard." Could this sort of standard ultimately have derived from Egyptian nome standards?

Mildenberg collection [108]. Its wooden stance and bodily proportions are closer to those of late Archaic bronze horse statuettes, for instance, those in the Baker collection in New York and in the Boston Museum (01.75.8). The incised lines on the hindquarters can be closely paralleled in Corinthian and early Attic black-figure vase painting (cf. the doe on [101]). They also appear on the sixth-century bronze equestrian statue from Grummentum (South Italy) in the British Museum. This parallel suggests a place of manufacture for the Mildenberg ram somewhere in Magna Graecia, and the pose—especially when compared with the later, more lively rams in the Mildenberg collection [143, 188, 190]— supports a date in the late Archaic Period.

Condition: Intact except for restored left front leg; green patina; surface worn in places, especially legs. JN

Bibliography: Unpublished.

Comparative literature: Richter, *Animals*, pp. 27-28, figs. 136-140, pls. 44-46; for ram sacrifices, see Pinney and Ridgway, *Aspects*, pp. 76-77; Ruth Steiger, "Ein frühklassischer Bronzewidder," *AntK III* (1960) 37-40, pls. 11-12; Mitten and Doeringer, *Master Bronzes*, p. 71, cat. no. 64; Dietrich von Bothmer, *Ancient Art from New York Private Collections*, exhib. cat. (New York: Metropolitan Museum of Art, 1961) p. 34, cat. no. 131, pls. 44, 48; Comstock and Vermeule, *MFA Bronzes*, pp. 58-59, no. 60; Ernst Langlotz and Max Hirmer, *Ancient Greek Sculpture of South Italy and Sicily* (New York: Harry N. Abrams, 1965) pl. 26, p. 259.

The ram, a favorite sacrificial animal, is often associated with Hermes, patron deity of shepherds, travelers, and tradesmen; while it is attractive to speculate that this object may have been associated with a cult of Hermes, too little is yet known about the range of associations and functions of rams in late Archaic and early Classical Greek art and religion to make this more than a hypothesis. The *kerykeion,* or *caduceus,* carried by Hermes, sometimes ends in rams' heads, as in an example with iron shaft and bronze finial in the Museum of Fine Arts, Boston. Modeling of details and the architectonic articulation of shaft, capital, and plinth suggest a workshop in Magna Graecia rather than the mainland or eastern Greece. It is the finest such staff finial known.

Condition: No breaks. However, ram was once separated from top of stand and has been rejoined and reglued. Jade-green patina.

<div align="right">DGM</div>

Bibliography: Unpublished.

Comparative literature: Cf. D.G. Mitten, "Man and Ram: A Bronze Group of Geometric Style in the Fogg Art Museum," *Journal of the Walters Art Gallery* XXXVI (1977) 31-36; R. Bianchi Bandinelli and A. Giuliano, *Les étrusques et l'Italie avant Rome* (Paris: Editions Gallimard, 1973) p. 156, fig. 181, p. 409 (Boccanera plaque, British Museum); Mitten and Doeringer, *Master Bronzes,* p. 71, no. 64; Comstock and Vermeule, *MFA Bronzes,* pp. 24-26, nos. 22-23, *kerykeia,* p. 444, no. 646.

109 *Ram*

Bronze, solid cast (lost wax). Greek, probably from a mainland workshop; first half of 5th century BC. H. 5.3 cm.; Max. W. 2.8 cm.; L. 5. cm.

This compact little ram, standing with his feet planted squarely together on a rectangular plinth (3 × 1.4 cm.), turns his head to the right as if responding to a sight or sound from that direction. His head is overly large in proportion to his body. His legs are cast together, except for a hole between the hind legs. The testicles are plastically rendered. His anatomy is simplified, yet naturalistic. The fleece over the entire body is rendered by small punch marks shaped like a reverse-C. In contrast, the tail, which hangs vertically almost to the hooves, is incised with short vertical striations. The eyes are incised ovals with punctate pupils and curving incised eyebrows; mouth and nostrils are also incised. The outward-curving horns are covered

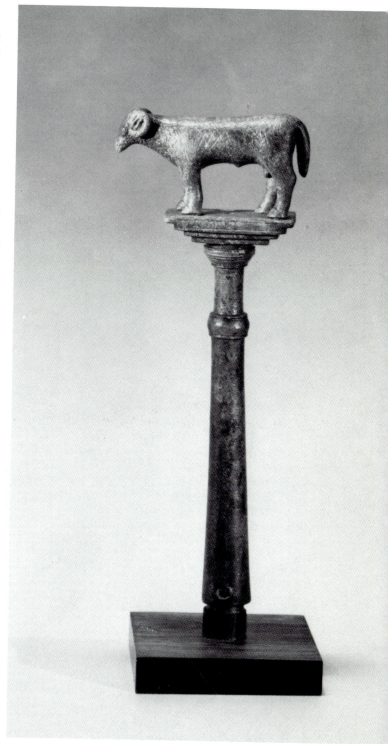

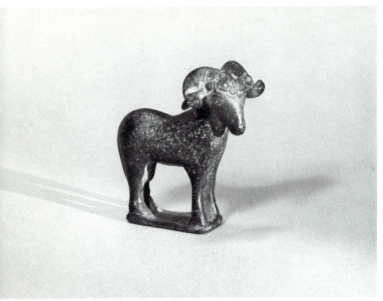

109

with curving incisions; the oval, outspread ears have longitudinal, incised grooves.

This ram was probably made to serve as a votive offering in some Greek sanctuary. The plinth, however, suggests that he might also have formed part of a larger object, perhaps perching upon the rim of a vessel or brazier. Its compressed forms suggest that it may have originated in a slightly provincial area such as Arcadia, the late sixth- and fifth-century BC bronze statuettes of which are noted for their compact vigor. The effect of the curly fleece is very similar to that on a ram in a Basel private collection; there, however, the individual curls are rendered in the casting as tiny raised disks with depressed dot centers.

Condition: Intact. Dark, semilustrous olive-green patina. Surface worn in places. DGM

Bibliography: Unpublished.

Comparative literature: Richter, *Animals,* pp. 27-28 and under no. 5; Schefold, *MgK,* pp. 224-225, no. V 261 (Basel ram); B. Schmaltz, *Metallfiguren aus dem Kabirenheiligtum bei Theben* (Berlin: Walter de Gruyter, 1980) pp. 152-153, nos. 417-419, pl. 23.

110 *Architectural Revetment in the Form of a Ram Head*

Terracotta, fired brownish orange with sandy grit. Etruscan, ca. 500 BC. H. 16.2 cm.; W. 14.6 cm.

This heavy, coarse terracotta ram head is a fine example of an Etruscan architectural ornament. It is hollow and probably mold-made. Traces of its heavy cream undercoating are preserved on the surface, and it was once undoubtedly brightly painted. The relatively small head is surmounted by large spiral horns. They are reticulated, but the herringbone grooves become progressively fainter as they near the middle of the horn at which point they cease altogether. Overlapping each horn is a small, pointed ear, pierced through to the interior. A sharp-edged, helmet-like cap of fleece frames the ram's face. Its beady eyes are set into deep cavities with prominent lacrimal ducts. The wrinkles on the nose and muzzle are modeled in low relief; the nostrils, lip division, and mouth are engraved. At once delicate and proud, this ram represents a fine example of Etruscan coroplastic art.

Related examples have been found within the famous Portonaccio sanctuary at Veii; one of them is now in the Villa Giulia (2268). The excavators believed that such heads served to cap the lower end of the last *sima* tile on the pediment of a revetted building. The preserved portion of the ram's neck, however, shows it to be at a right angle to the head. So it would appear that the head was originally posed upright rather than horizontally as reconstructed in the excavation report. Whatever its precise function, the Mildenberg ram head is clearly related in style, medium, and technique to other types of architectural terracottas from Veii; compare in particular the crisp modeling of the warrior *akroterion,* whose helmet resembles the fleecy cap of the ram.

These rams from Veii are of special interest because ram heads are generally rare in Etruscan sculpture (one example in stone comes from a tomb in Orvieto). But they do appear in the minor arts, for example on *bucchero* vases and on armor, where they are used effectively as shield bosses. A fine relief ram head stylistically close to the Mildenberg terracotta serves as a crest holder for an elaborate helmet on the front of the Monteleone chariot.

Condition: Broken at base; tips of horns chipped; much of white slip missing; traces of burning. JN

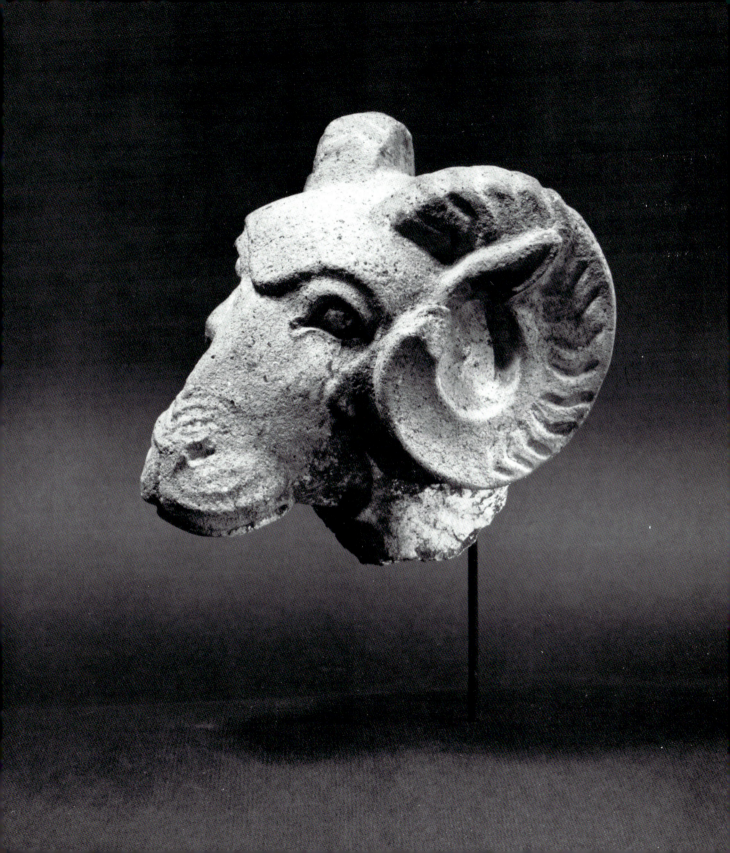

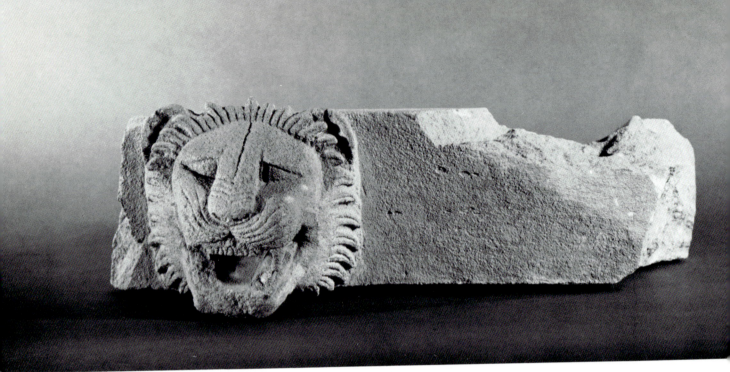

111 front

Bibliography: Unpublished.

Comparative literature: "Veio," *NSc*, ser. 8, VII (1953) 62, fig. 40; Kunsthaus Zürich, *Kunst and Leben der Etrusker* (Zürich: Kunsthaus, 1955) p. 90, no. 209, pl. 43 (ram's head), pl. 41 (warrior's head); for Orvieto ram head, Pericle Ducati, *Storia dell'arte etrusca* (Florence: Rinascimento del Libro, 1927) pl. 106, fig. 281; for shield bosses, Comstock and Vermeule, *MFA Bronzes*, p. 483, no. 711; for the Monteleone chariot, see Brendel, *Etruscan Art*, p. 147, fig. 97.

111 *Sima with Lion Head Water Spout*

Limestone, Greek (Sicilian?), ca. 500 BC. H. of fascia 15 cm.; W. 33 cm.; W. of lion head 18 cm.; L. 58 cm.

This large block is probably the cornerpiece of the gutter or *sima* of a stone building. Two faces meeting at right angles are preserved, although their juncture is missing. The block is hollowed out behind for the passage of rainwater. There are two dowel holes in the upper surface of the block: a cylindrical hole behind the spout and a square cutting at the corner. The former may have served for a molding above and the latter for the attachment of the end block of the raking *sima* or cornice.

The lion head spout fits squarely onto the fascia or face of the block with only the lower jaw and top of the mane projecting beyond. A narrow screen of stone intervening between the head and block allows the spout to tilt slightly downwards. Radiating around the cubic head is a single row of flame-like tufts, each incised down the middle. Behind the mane are two large rounded ears. The forehead is nearly flat and is bisected by a deep groove terminating at the wrinkles across the nose. The triangular eyes are set into the face on either side of the sloping rectangular nose, below which are incised the wrinkles of the muzzle. The teeth—incisors and fangs—are bared and the mouth gapes open. The undulations of the flews can best be seen from the side. The mouth is hollowed out to the middle of the head where it joins two cylindrical channels leading to the back of the block. Missing is the tip of the tongue which further concentrated the flow of water off the roof.

Although simpler and less developed in style, this lion head resembles later ones from Sicilian temples. The triangular eyes and stylized mane can be found on lion head spouts from late Archaic temples in Syracuse and Himera.

Condition: Broken on three sides; chipped in places. JN

Bibliography: Unpublished.

Comparative literature: Ernst Langlotz and Max Hirmer, *Ancient Greek Sculpture of South Italy and Sicily* (New York: Harry N. Abrams, 1965) pp. 271-273, pls. 76-79.

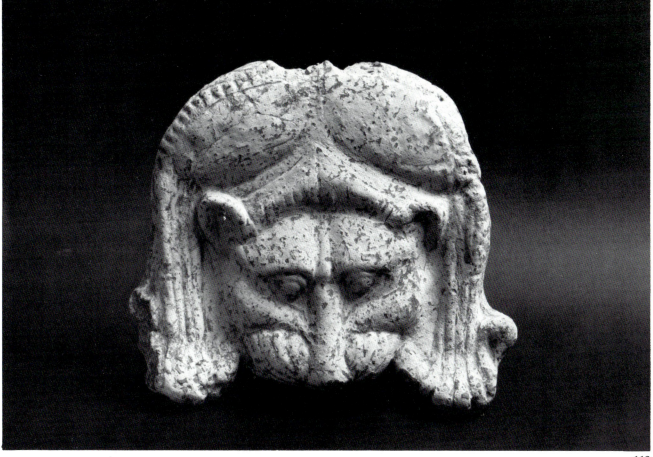

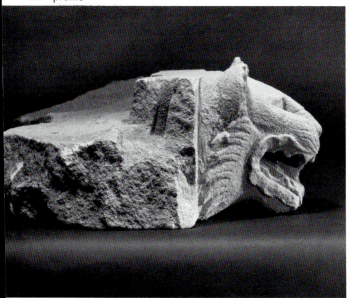

111 profile

112 *Feline Antefix*

Terracotta, buff with red inclusions. Sicilian, 5th century BC. H. 19 cm.; W. 22.5 cm.; W. of backer 18 cm.

This architectural terracotta consists of two parts—a square plaque on the front and a semi-cylindrical attachment on the back. The latter is surely a backer tile which would have been aligned with a row of cover-tiles on a terracotta roof. Thus, the front plaque, which rises well above the backer, is an antefix and serves to mask one of the semicircular holes along the edges of the eaves.

Molded onto the plaque in low relief is the upper part of a feline skin or pelt. The head is frontal and splayed out, the hefty shoulders rise up over the forehead, and the forelegs and paws hang at the sides. While the lion is often depicted as an attribute of Herakles—and refers to his first labor, wrestling with the Nemean lion—panther or leopard pelts are much more common. They are worn as cloaks— especially by Dionysos and his retinue—are used to cover

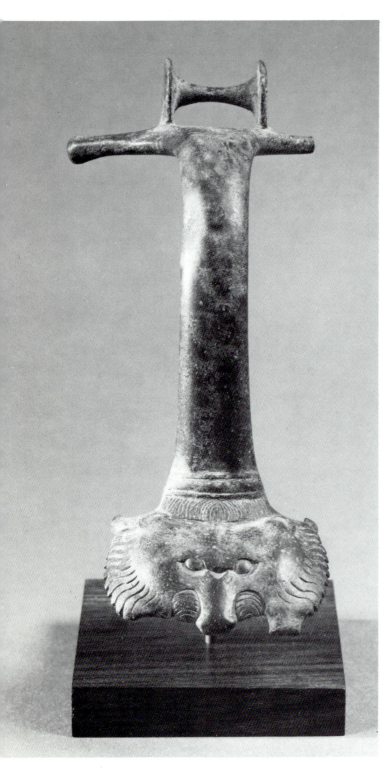

stools, and serve as the material for boots, flute-cases, etc. The physiognomy of this feline also suggests a panther rather than a lion. Not only does it lack a distinct mane, but its triangular face, small ears, beady, slanted eyes, narrow nose, and short muzzle are all characteristic of the panther.

The position of the head and the splayed appearance of the body indicate that a pelt rather than a feline mask is intended, except that the eyes are open and hence not "dead." Perhaps the frontal panther face served the same function as other mask-like antefixes, notably Gorgoneia. To ensure its apotropaic power, the eyes would have to be open to glare at any passer-by (see also discussion for [113]).

The provenance and date of this piece are problematic, as no other examples are known. It is probably Sicilian and datable to the late sixth or early fifth century BC.

Condition: Very worn; surface abraded; chipped at top. JN

Bibliography: Unpublished.

Comparative literature: For a discussion of lions vs. panthers, Brown, *Etruscan Lion*, pp. 170-174.

113 *Handle with Lionskin(?) Attachment Plate*

Bronze, cast. Greek (South Italian?), ca. 490–480 BC. W. at top 6.5 cm.; W. at bottom 5.3 cm.; L. 15.2 cm.; Est. Diam. of rim of vessel 11.4 cm.

From a base plate decorated with a frontal lionskin, a long vertical handle with half-round section rises and spreads laterally to form a curved plate with a flange on the inner edge. This fitted onto the rim of a jug—either a *hydria* (a water-jug with one vertical handle for pouring and two horizontal handles for lifting) or an *oinochoe* (a pitcher with only one vertical handle). Atop the curved, flanged plate rests a plain spool with two rotelles or disks connected by a rod with concave sides. This spool appears to have been added to the handle almost as an afterthought. The usual fashion, ignored here, is to extend the spool along the entire length of the curved upper plate, merging the rod of the spool with the plate, and placing the rotelles at the two ends.

Of particular interest here is the feline device on the base plate of the handle, for its novel appearance suggests that it was meant to represent a lion scalp or skin rather than the more normal lion head or forepart, which can be seen on

113

two other handles in this collection [114, 115]. So much broader is the design here that it must include the sides of the lion's face, rather than simply its front. This is possible only in a lionskin with splayed jaws. Unfortunately, the broken condition of the rectangular projections which were once directly below the lower ends of the mane make specific identification as either living lion or lionskin conjectural. Were the projections originally paws, as in [114], then this handle should represent the forepart of a living lion seen from above—or, possibly, but not so commonly, the forepart of a lionskin. Were the projections, on the other hand, originally splayed jaws, then the handle would unquestionably represent a lion scalp. Support for both identifications exists. An argument for a living lion forepart would stress two facts: (1) that certain examples of lionskins or scalps are exceedingly rare among the handle attachment plates for Greek bronze vessels, and (2) that the eyes of this lion are open. An argument for a lionskin or scalp, on the other hand would emphasize the unusual breadth and flatness of the face and the luxurious fullness of the mane and would at the same time point out three additional facts: (1) that such full sweeps of mane are only occasionally seen on frontal relief devices of the living lion in the Archaic and Classical periods while they are regularly visible on frontal lionskin reliefs, (2) that the inclusion of eyes here in no way precludes an identification as a lionskin, for more often than not eyes are represented in lionskins on Greek coins and in all manner of depictions of Herakles with a lionskin, and (3) that occasionally lionskins carried by Herakles and every once in a great while those worn by Herakles reveal the lion head and mouth intact, without splayed jaws. This means that with or without either paws or jaws, the unusual device here might still be part of a lionskin. Clearly, therefore, all the evidence together favors an identification here of a lionskin or scalp above one of a living lion forepart. As for the question of lionskin or scalp, it seems likely that the rectangular projections once formed paws rather than jaws, making the device here a lionskin not scalp, because in this way the piece would then represent a variant of earlier lion-forepart devices from handle attachment plates, such as [114], rather than a borrowing from other arts depicting lionskins or scalps with splayed jaws. (See also discussion [112].)

Conflation of some sort between representations of living lions and lionskins may well account for the major differences in shape and composition between this piece and other frontal lion devices used as attachment plates for bronze vessel handles. Yet this does not explain the very real differences in style. This object is technically very fine. There are, however, several uncommon features, including a rather long nose flanked by sunken circles and decorated with downturned rather than upturned curved incisions and a mane with a jagged outer edge and uniquely stylized locks with widely spaced, wavy incisions on the sides and closely spaced, arched striations on the top. So strange is the overall appearance of this lion that the possibility of its being a fox has been raised, but the round ears belie this. Because of its unprecedented appearance, the probability is slight that this piece comes from mainland Greece or East Greece, where frontal lion heads and skins look nothing like it. One provenance might explain all of the anomalies observed here—namely, that this handle was produced in South Italy around 490 BC. It could be a direct, but somewhat unsuccessful, imitation of frontal lion devices on attachment plates such as [114] and frontal lion scalps with full manes and splayed jaws on Samian Coins or their direct descendants, the coins of Zankle minted by Samian refugees from the Ionian Revolt. Neither the frontal lion scalp nor the lion head had previously been employed as coin types in Magna Graecia, and lack of familiarity with the design might account for the strange appearance of this piece. A late Archaic date around 490 BC would also be in keeping with the basically flat facial features here as well as the linear stylization of the mane and the heavy dependence upon incision overall. Moreover, after Anaxilas of Rhegion finally expelled the Samians from Zankle around 488 BC, he adopted a frontal lion type for his coinage—not a scalp, however, but a head, and one not unlike those on the bronze handle attachments from mainland Greece. If, therefore, the Mildenberg piece comes from Magna Graecia, which seems likely, it should predate the Rhegion lion coin types because, as familiar designs throughout Magna Graecia, these would have been obvious models for subsequent frontal lion head devices.

Condition: Bottom edge of rectangular projection (paw or jaw?) beneath lower right mane broken; corresponding projection beneath lower left mane entirely missing. Incision on nose worn. Light to medium green patina. Cuprite on left rotelle. KPE

Bibliography: Unpublished.

Comparative literature: See also [114, 115]; A. Furtwängler, in *Olympia IV: Die Bronzen,* ed. E. Curtius and F. Adler (Berlin, 1890) 147, nos. 923-924 (for [115]), pl. 55, also pp. 132-133, nos. 831, 839, pl. 50 for [114]; *Museum Notes, the Toledo Museum of Art,* VII, nos. 4 (Winter 1964) 80 (hydria, 64.125); F.B. Tarbell, *Catalogue of the Bronzes, etc. in Field Museum of Natural History, Reproduced from Originals in the National Museum of Naples,* Field Museum of Natural History publication 130, Anthropological series, vol. VII, no. 3. (Chicago, 1909) 128, no. 172, pl. 87, fig. 172; Pinney and Ridgway, *Aspects,* pp. 206-207, no. 100.

114 Lion Forepart from a Vessel Handle

Bronze relief, cast. Greek, 500–490 BC. H. 4.6 cm.;
W. 3.6 cm.; Th. 1 cm.

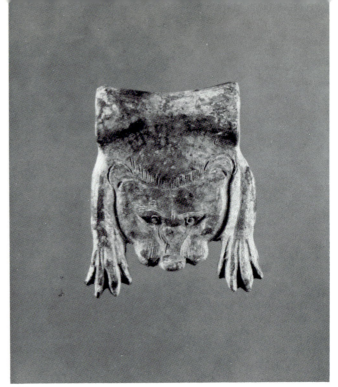

114

This lion forepart, suspended from a curved spool pierced
for insertion of a ring handle, was once the decorative
attachment plate for a movable handle of a vessel. Its
underside, which is smooth and slightly concave, was
soldered to the correspondingly convex side of a large,
open-form vessel such as a basin or bowl. Extended
forepaws frame the lion's head, which is modeled in low
relief. Fine chasing and incision are visible throughout. A
curving line of short, vertical incisions between the ears
indicates the hair of the mane, while incised lines ornament
the nose and muzzle and also mark the brow above the
eyes, which are small and round with incised pupils.

According to the criteria outlined in [113], this animal
with its open eyes most probably represents a living lion
forepart rather than a lionskin. The eyes are open and the
jaws are not splayed. Although some of Herakles' lionskins
could be cited as parallels for this, there is another very
strong argument in favor of this being a living lion forepart.

Leaping lions, very similar in style to the relief here,
appear in the round as *patera* handles of Archaic and early
Classical date, and these, if viewed from above, provide
excellent parallels for the lion on this relief. The original
concept behind lions on attachment plates and those on
patera handles is the same—namely, that of a living lion
springing out to grasp a bowl with his forepaws in the same
way that he tackles his prey. Two fixed horizontal handles
of the fifth century BC in Lyon, with frontal lion forepart
attachment plates, confirm this theory. These attachment
plates, which come from the rim of a large bronze bowl,
position each of the four lions so that they appear to be
springing upon and attacking with their forepaws recum-
bent deer represented in low relief on the exterior of the
bowl. Frequently lion heads or *protomes* with heads in the
round are used as ornament for the upper part of vertical
bronze handles. In these representations the lion stands
as either a silent sentinel or a roaring watchdog over the
contents of the vessel, leaving no doubt that it is very
much alive. Surely, there would be a living lion below to
correspond to the living lion above, especially on handles
which show lion heads at both ends. Thus, it would appear
that the majority of frontal lion relief base plates for bronze
handles show the living lion and not a lionskin.

Base plates for movable handles with similar frontal lion
devices have been found at a number of sanctuary sites in
Greece, including Olympia, Dodona, and the Athenian
acropolis, as well as further north in Olynthus in the

Chalcidike and Stobi in Yugoslavia. All appear to be late
Archaic or early Classical in date, the earlier ones exhibiting
rather flat facial features, the later ones more modeled
features. Many are represented without paws (cf. [115]
here); others reveal very conventionalized but still
recognizable paws or quite naturalistic paws, such as those
here, which are ably modeled. Unusual, however, is the
combination here of relatively flat facial features with
realistically modeled paws—a contradiction which suggests
a date around or shortly after 500 BC, during the transitional
period from the late Archaic to the early Classical.

Condition: Intact. Light to medium green patina. KPE

Bibliography: Unpublished.

Comparative literature: See also [113, 115]; U. Liepmann,
*Griechische Terrakotten, Bronzen, Skulpturen, Bildkataloge des
Kestner-Museums, Hannover XII* (Hannover, 1975) p. 109, no. B 13;
S.I. Dakaris, *Archaeological Guide to Dodona* (Ioannina, 1971) pl.
36, no. 171; Popovič et al., *Bronzes in Yugoslavia*, no. 50; H.
Goldman, "The Acropolis of Halae," *Hesperia* XI (1940) 415-416,
nos. 1-2, and fig. 59; S. Boucher, *Bronzes grecs, hellénistiques et
étrusques des Musées de Lyon* (Lyon, 1970) 39, nos. 19-20; G.M.A.
Richter, *Greek, Etruscan and Roman Bronzes, The Metropolitan
Museum of Art* (New York, 1915) 33, nos. 52-53; U. Jantzen,
Griechische Griff-Phialen, 114. Winckelmannsprogramm (Berlin,
1958) figs. 1-2; de Ridder, *Acro. Cat.*, pp. 78-9, nos. 233-234 (lion
patera handles); C.M. Kraay, *Archaic and Early Classical Greek
Coins* (Berkeley and Los Angeles: University of California Press,

1976) nos. 96 (Samos), 141 and 143 (Gortyna), 173 (Athens), 780 and 782-784 (Rhegion), 878-885 (Samos), 988 (Lycia, Zagaba); G.K. Jenkins, *Ancient Greek Coins* (New York: Putnam, 1972) figs. 72 (Athens, with paws), 146 (Zankle), 148 (Messana), 284 (Samos), 255 and 257 (Rhegion); Comstock and Vermeule, *MFA Bronzes,* pp. 285-286, 288-289, 291, nos. 410-411, 413-414, 416 (living lion protomes on vertical handles); de Ridder, *Acro. Cat.,* pp. 42-43, no. 20, fig. 16.

115 *Handle with Lion Head Attachment Plate*

Bronze, cast. Greek, 480–450 BC. H. of attachment plate 4.6 cm.; W. of handle at volutes 5.9 cm.; L. of handle 16.4 cm.

Increasing gradually in width as it approaches what was once the bowl of a libation vessel, the horizontal handle assumes at the join a semicircular edge flanked by two small volutes. At its other extremity, the tapering end of the handle curves under and becomes round in section. Although its tip is broken off, comparison with similar handles suggests that the tip was fashioned into the graceful head of a waterbird. The upper surface of the handle has a raised, slightly concave center which closes at the tapering end with a five-leafed palmette in low relief, outlined internally by incision. Elaborate ornament is visible everywhere. At the opposite end it is ornamented by an arc of incised zigzags running between the volutes, which are given incised spiral centers. The underside of the handle reveals the remains of a hanging hook soldered midway along the continuous curve running from the broken tip to the bottom of the lion head attachment plate. The lion head itself is finely modeled particularly in the brow, and decorated with incisions on the nose and muzzle. A deep groove between the ears marks the top of the head while above, an unusual triangular arrangement of wavy pairs of incised lines indicates the mane. As in the ring handle [114], a lion head, not a lion scalp, is represented—but this time without paws. Contrary to previous interpretations of this type of lion device, the pointed elements framing the lion's face are not very conventionalized paws, nor are they inanimate prototypes for naturalistically modeled paws such as those in [114]. This is clear from several other handle attachment plates which show similar lion devices—among these, one in Olympia, another in Princeton, and a third in Boston. Both the Olympia and the Princeton pieces (the former from the base of a vertical handle and the latter from that of a movable ring handle) show the abovementioned pointed elements *and* extended forepaws; moreover, the pointed elements are decorated with wavy locks of the manes which encircle the lions'

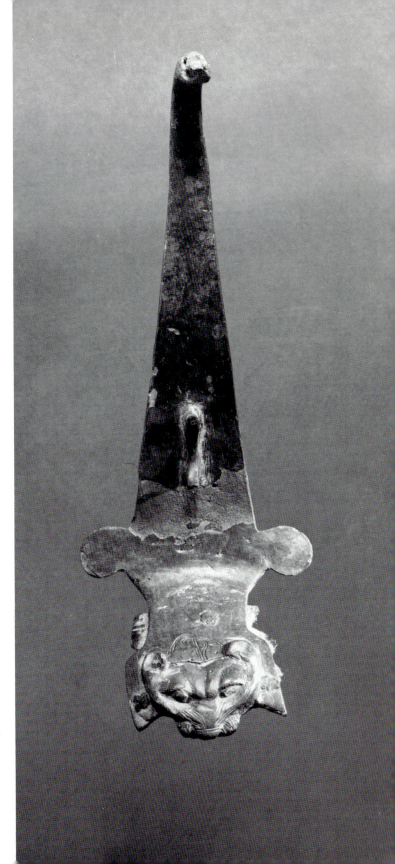

heads. Similarly, the Boston specimen, which belongs to a horizontal handle similar to this one, exhibits the pointed elements—this time without paws—and again decorates them with striated locks of the lion's mane. Thus, it would appear that the pointed elements framing the lion head or scalp devices should, if anything, be considered conventionalized manes, and not paws. In addition, many lion head devices, including this one, prove that these pointed elements cannot be regarded as earlier in date than the more naturalistic paws, for they are combined with plastic handling of the facial features. Stylistically advanced facial features simply would not be joined with such "primitive paws" as the pointed elements here.

Long, flat horizontal handles like this once ornamented round libation bowls, which resemble in shape the modern skillet or frying pan. A small portion of the bowl itself, in fact, survives here as a thin sheet of metal, broken on three sides, with an inward thickened rim decorated on the exterior with two horizontal grooves. This thin fragment of the bowl is still riveted to the thicker attachment plate of the handle. Three rivets are visible on the exterior of the attachment plate, one above the lion's head and one on each of the pointed elements framing the lion's face— which suggests the possibility that the pointed elements originated from technical necessity, as suitable areas for riveting outside the decorative device and only later, in the absence of rivets, were transformed into the lion's mane.

Horizontal handles very similar to this in style and decoration have been found on the Athenian acropolis and at Olympia; others exist in Boston and in the Louvre. More than likely, the libation vessels to which these handles were once attached were offered to the deities of ancient Greece, for the majority of very decorative bronze vessels or vessel fragments of the Archaic and early Classical periods— particularly of the type here—have been excavated in sanctuary contexts. In fact, the handle closest in style to that here—one which comes from the Athenian acropolis— exhibits a dedicatory inscription on the raised center of its upper surface: "Callicrates dedicated (me)."

A date within the early Classical Period, around 480–450 BC, appears probable because such advanced modeling of the lion head could not be much earlier while such patterned incision in the facial features and mane could not be much later.

Condition: Tip of handle, half of attachment hook, and most of bowl missing. Surface worn in places, especially on underside of handle between volutes and hook. Some tiny holes from bubbles caused in the casting are visible in the lion head and on the handle. Shiny, medium to dark green patina. KPE

Bibliography: Unpublished.

Comparative literature: See also [113, 114]; Comstock and Vermeule, *MFA Bronzes,* p. 493, no. 451A (supplement); A. de Ridder, *Les bronzes antiques du Louvre, vol. II: Les instruments* (Paris, 1915) 138, no. 3030, pl. 107; de Ridder, *Acro. Cat.,* pp. 74-75 no. 226; U. Jantzen, *Griechische Griff-Phialen,* 114. Winckelmannsprogramm (Berlin, 1958) figs. 15–16; Pinney and Ridgway, *Aspects,* pp. 206-207, no. 100; A. Furtwängler, *Olympia IV: Die Bronzen,* p. 147, no. 923, pl. 55.

115 underside

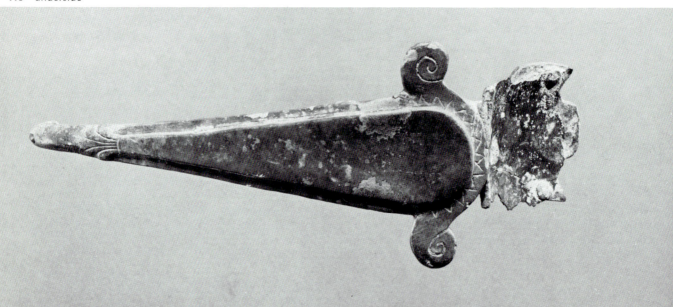

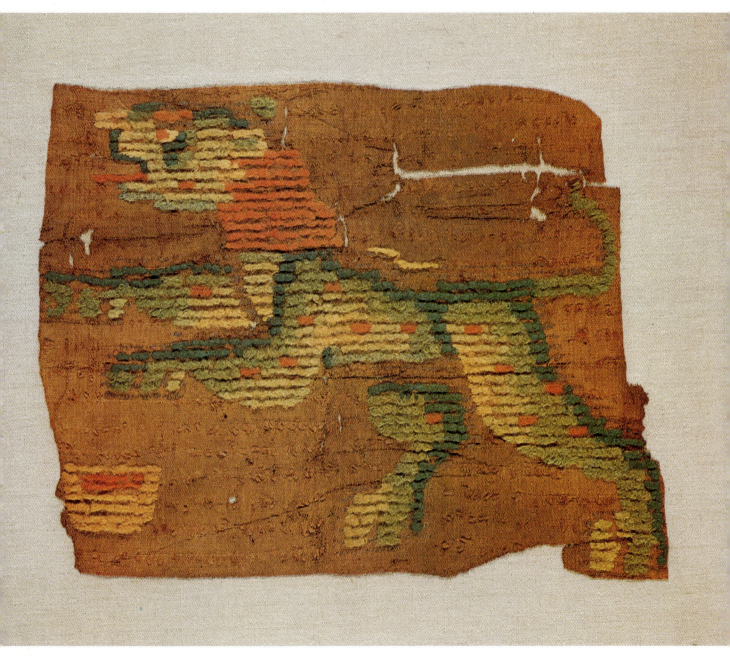

Plate VI Lion Textile Panel [181]

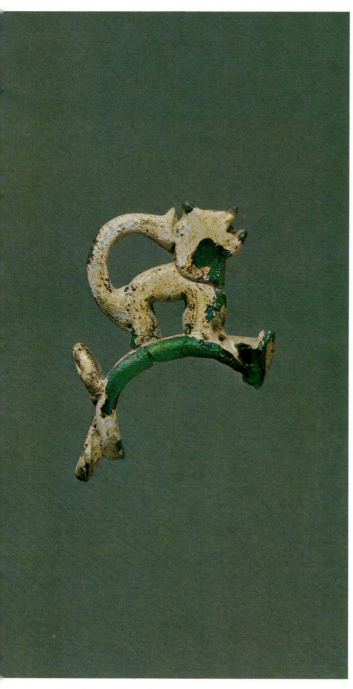

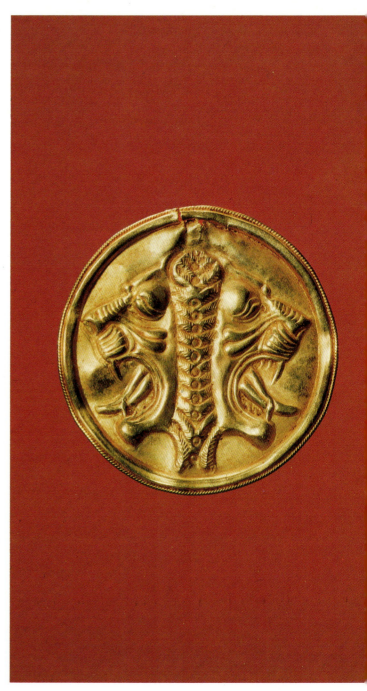

Plate VII Handle with Lion Attachment [44]

Plate VIII Bracteate with Janiform Lions' Heads [30]

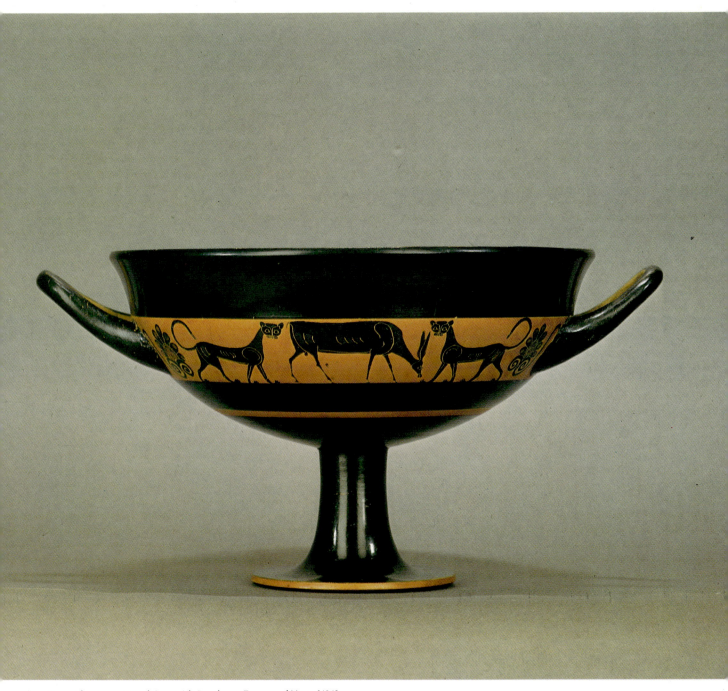

Plate IX Little Master Band Cup with Panthers, Deer, and Hens [101]

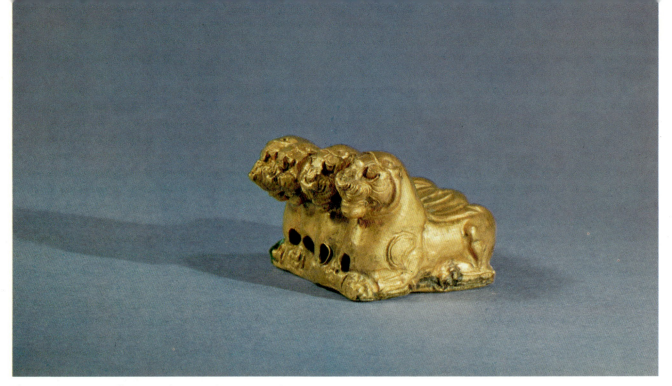

Plate X Ornament in the Form of a Team of Four Lions [20]

Plate XI Recumbent Lion Amulet [52]

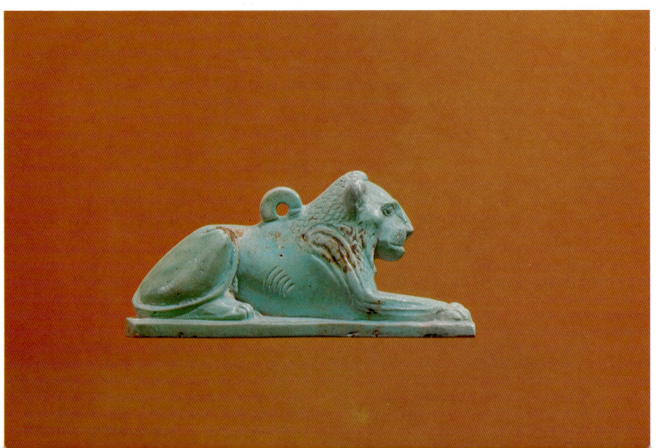

116 Menacing Lion Pendant

Bronze relief, cast. Greek, 5th century BC. H. 2.6 cm.; W. 0.7 cm.; L. 3.7 cm.

A lion—head lowered and haunches raised, ready to spring—holds his quarry at bay with mouth opened wide and fangs in full view. Presumably this miniature lion was once suspended from a necklace, brooch, or another item of jewelry, for a ring cast in one piece with the lion rises from his withers. Possibly, however, it served as an appliqué ornament for clothing although such pieces usually exhibit holes, not rings, for attachment.

Powerful modeling, exciting lines, and fine detail distinguish this piece. A diagonal line, plastically rendered, separates the lion's mane from his body, while wavy incisions indicate the locks of the mane. Only one forepaw and one hind paw of the lion are shown on this thin plaque; the claws are picked out by incised lines—four on the forepaw and three on the hind paw. A small hole in the rump marks the spot where a tail was once attached.

Lions, lionesses, and *chimaerae* of similar stance, crouching and ready to spring at some unseen foe, can be seen in the minor arts of the late Archaic and Classical periods, on intaglio gemstones and finger rings, on coins, and even on the feet of Praenestine *cistae*. They can also be found in larger scale stone and metal relief and in sculpture in the round. Yet the subject seems to be unique for pendants of that time. The stance of the Mildenberg lion pendant finds many parallels from the sixth to the third centuries BC. Yet its style—being more modeled than the Archaic and less plastic than the late Classical and Hellenistic—remains closest to pieces of the fifth century BC, in particular two *patera* handles from the Athenian acropolis which take the form of leaping lions.

Condition: Tail missing. Shiny, dark green patina. KPE

Bibliography: Unpublished.

Comparative literature: C. Blinkenberg, *Lindos, Fouilles de l'Acropole 1902–1914, vol. I: Les petits objets* (Berlin: W. de Gruyter, 1931) p. 211, no. 683, pl. 28; U. Jantzen, *Griechische Griff-Phialen,* 114. Winckelmannsprogramm (Berlin, 1958) figs. 1-2 (Athens, National Mus. 6652, and Berlin, Staatliche Mus., FR 1477, respectively); de Ridder, *Acro. Cat.,* pp. 78-79, nos. 233-234; C.M. Kraay, *Archaic and Classical Greek Coins* (Berkeley and Los Angeles, 1976) no. 49, pl. 2 (Sikyon), nos. 694-697, pl. 40 (Velia); J. Boardman, *Greek Gems and Finger Rings* (New York: Harry N. Abrams, 1970) nos. 388, 520, 577, 692; Comstock and Vermeule, *MFA Bronzes,* p. 309, no. 435 (from vessel), pp. 376-378, no. 523 (attachment plate for *cista* foot); Mitten and Doeringer, *Master Bronzes,* p. 101, no. 99 (from vessel), pp. 202-203, no. 206 and pp. 206-207, no. 210 (attachment plates for *cista* feet); Brown, *Etruscan Lion,* pp. 144-162, pls. 52-58, with good discussion of springing types.

116

117 Running Hare from a Caryatid Mirror

Bronze, solid cast. Greek, 5th century BC. H. 2.1 cm.; W. 0.8 cm.; L. 4.3 cm.

Solid cast with a thin, slightly curved base for attachment to the edge of a mirror disk, the hare is rendered with little depth and, seemingly, a single foreleg and a single hind-leg, both of double width but lacking a separation line to indicate two of each. Clearly the silhouette style was intended to reduce the weight of the ornament along the mirror edge and to compress the figures to the depth of the mirror disk. Neither the hare's flatness nor its missing legs would have been noticeable, however, when it was in place on the mirror.

Short horizontal incisions, regularly arranged in three encircling bands (at the shoulder area, mid-body, and rump) on the body, indicate the hair of the animal. Stippling occurs on the left side of the face and ear of the hare but not on the right—perhaps evidence that the left side of the hare faced the front of the mirror. Incision appears over the eyes and on the nose as well.

In its original context, this lean hare would have appeared to be running around the circular edge of a caryatid mirror—that is, a mirror disk supported by a standing human figure, usually a draped female, regularly mounted on a base. Such mirrors were produced in the Greek world from the middle of the sixth century to the end

of the fifth century BC and were generally very decorative, due to the addition of small human figures on either side of the attachment plate connecting the mirror disk to its stand and small animal figures or florals along the edge of the disk. The running hare here reflects a favorite theme for the edge of caryatid mirrors—namely, the hare chase. Close upon the heels of this hare, bounding round the edge of the mirror with legs and tail outstretched, would have been a fox or a hound in hot pursuit—which would explain the hare's mad dash.

A date around the mid-fifth century BC is suggested by the sleek and exciting outline of the extended hare and the capable modeling of its body.

Condition: Small piece missing at back left neck. Small indentation for missing piece or attachment area on base near left hind leg. Medium green patina. KPE

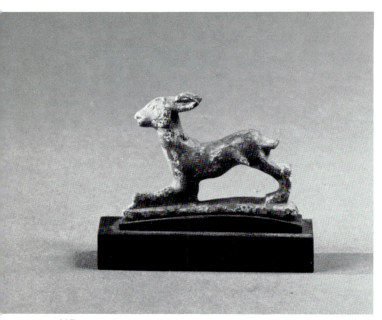

117

118

Bibliography: Unpublished.

Comparative literature: G. Seiterle, "Ein griechischer Standspiegel im Basler Antikenmuseum," Zur griechischen Kunst, Festschrift Hansjörg Bloesch (Bern, 1973) pp. 106-111, pls. 37, 39.5; Comstock and Vermeule, MFA Bronzes, pp. 245-246, no. 355; F. Schottmüller, Bronze Statuetten und Geräte, Bibliothek für Kunst- und Antiquitätensammler, VII (Berlin, 1921) fig. 14; A. de Ridder, Les bronzes antiques du Louvre, vol. II: Les instruments (Paris, 1915) p. 44, nos. 1691-1692; and another in the Dresden, Skulpturensammlung; C. Rolley, Greek Minor Arts, fasc. 1, Monumenta graeca et romana, vol. V (Leiden, 1967) no. 174 (Ny Carlsberg Glyptotek, 294); de Ridder, p. 43, no. 1687; L.O. Keene Congdon, "Greek Caryatid Mirrors, Technical, Stylistic and Historical Considerations of an Archaic—Early Classical Series" (Ph.D. diss., Harvard University, 1963); for descriptions of hare-hunting among the ancient Greeks, Xenophon, Cynegeticus (On Hunting) VI.11-17, and K.D. White, Country Life in Classical Times (Ithaca: Cornell University Press, 1977) pp. 119-120, 122.

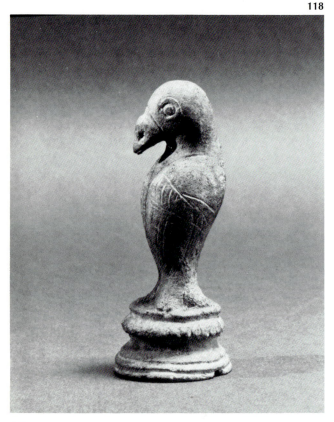

118 Waterbird Finial from Candelabrum

Bronze, solid cast with base. Etruscan, 5th century BC. H. 7.5 cm.; W. 3.1 cm.; Diam. of lower base 3.1 cm.

Standing at attention, upright and erect, its wings hugging a plump body, its breast outflung and shoulders thrust back, this curvaceous creature with the general appearance of a bird and the proud carriage of a military man once served as a finial for an elaborate Etruscan candelabrum. A large, strong beak, distinctively downturned with prominent nostrils, is offset from the round head by another groove. Sizable, round eyes are encircled by a deep incision and outlined above by an incised line. Most unusual is the way

in which the wings are brought forward, as if the bird were huddling within a cloak. Curving incisions cover the wings, creating the impression of a feathered surface. Separated at the front by modeled edges and at the back by an incised line, the two wings are almost indistinguishable from the body and flow into the feet in one continuous curve; the ambiguity is such that it remains unclear whether the bird actually has pointed, claw-like feet or whether it is walking upon wing and tail feathers. For want of a good comparison in either nature or ancient art, this strange creature has been published as a "fantasy bird." However, imaginary creatures in ancient art are usually wild and obvious aberrations of nature and not tame members of a seemingly recognizable order or genus such as we have here. Specific identification of the bird type here must, however, remain open. The cockatoo, a type of parrot endowed with an amazingly powerful beak, has been suggested, but the absence of a crest must rule this out. Other, uncrested parrots and eagles do come to mind because of the bird's upright stance and large, curved beak; yet these, too, must be dismissed because the tip of the beak here is not sufficiently curved and because parrots were only introduced into the Classical world after the eastern campaigns of Alexander. An alternate identification has also been proposed, namely, a waterbird—which does seem the most likely identification. Some waterbirds such as gallinules and coots have beaks not unlike the one here. Moreover, a waterbird identification would help to explain both the large nostrils and the sleek character of the wings—if the latter were meant to be wet—although not the ramrod-like stance of the bird.

A telltale clue to the original purpose of this piece is provided by the round, molded base upon which the bird stands. This base, solid cast in one piece with the bird and hollowed out on its underside, is of a standard type (which recalls an Ionic column base with incised decoration on the upper *torus*) that crowned the tall slender candelabra of ancient Etruria. Such bases stood in the middle of flaring projections which once held candles, and they carried atop their upper surface a statuette or statuette group, usually human, not animal. This base is as typical for Etruscan candelabra, as the bird atop it is unique in appearance and context. Sleek but sophisticated stylization, minimal modeling and heavy use of incision suggest a date within the fifth century BC.

Condition: Intact. Light blue-green patina. KPE

Bibliography: Bloesch et al., *Das Tier,* p. 52, no. 315, pl. 1.

Comparative literature: de Ridder, *Acro. Cat.,* p. 199, no. 543; A. de Ridder, *Les bronzes antiques du Louvre, vol. II: Les instruments* (Paris, 1915) 152, no. 3153, pl. 112; F.B. Tarbell, *Catalogue of Bronzes, etc. in Field Museum of Natural History, Reproduced from Originals in the National Museum of Naples,* Field Museum of Natural History publication 130, Anthropological series vol. VII, no. 3 (Chicago, 1909) 101, no. 15, pl. 41, fig. 15 (cock); for Etruscan candelabra, Brendel, *Etruscan Art,* pp. 216, 299-303 and n. 30 with bibliography; E. Pernice, *Gefässe und Geräte aus Bronze,* Die hellenistische Kunst in Pompeji, ed. F. Winter, vol. IV (Berlin, Leipzig: W. de Gruyter and Co., 1925) 43ff. For birds in ancient Greece: J. Pollard, *Birds in Greek Life and Myth* (London: Thames and Hudson, 1977) pp. 64-75.

119 *Reclining Ram*

Bronze, solid cast (lost wax). Greek, probably from the mainland; first half of 5th century BC. H. 2.7 cm.; W. 1.15 cm.; L. 5 cm.; L. of tail 1.5 cm. Mate to [120].

This ram, with elongated body and neck, turns his head to his left. He tucks both pairs of legs under his body. His long cylindrical tail, projecting straight behind him, curves upward slightly; a single incised groove spirals along it. The underside of the body is marked by a longitudinal concave channel. Pointed ears overlap the small, curving horns which are pressed closely against the sides of the head. The eyes are rounded ovals set on either side of the head. A transverse groove lies above the incised nostrils and

119

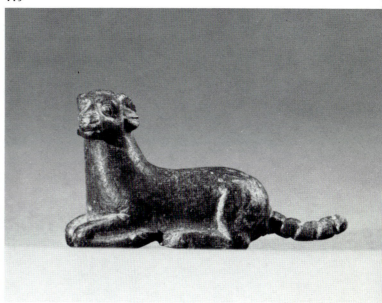

mouth. Details of the left front hoof are rendered in the casting. No attempt was made to render the texture of the fleece.

This diminutive reclining ram and its feline companion [120] probably originally rested on top of the rim or shoulder of a larger object, perhaps a *krater* or cauldron, or served as decorative attachments for a rod-tripod. Their modeling and sense of proportion mark them as Greek products; their pronounced individuality is the product of a workshop not yet identified. A more usual choice as figural adornments for the rims and shoulders of vessels is the billy-goat, a number of which are known; a Corinthian or northern Greek origin for some of these has been suggested. The modeling and proportions of the Mildenberg ram statuette are consistent with a date within the first half of the fifth century BC.

Condition: Intact. Semilustrous dark brown patina overall; spots of cuprite visible on right side of back. DGM

Bibliography: Unpublished.

Comparative literature: U. Jantzen, *Griechische Greifenkessel* (Berlin: Gebr. Mann, 1955) p. 92, pl. 63, 4-5 (reclining lions); B. Filow, *Die archaische Nekropole von Trebenischte am Ochridsee* (Berlin: Walter de Gruyter, 1927) p. 53, pl. 52 (billy-goats); cf. more recently, *Schimmel Catalog* (1974) no. 21; J. Dörig, *Art antique. Collections privées de Suisse romande* (Geneva: Éditions archéologiques de l'Université de Genève, 1975) no. 176; B. Schmaltz, *Metallfiguren aus dem Kabirenheiligtum bei Theben* (Berlin: Walter de Gruyter, 1980) p. 148, no. 409, pl. 23.

120

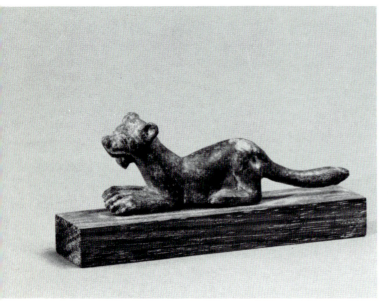

120 *Crouching Panther*

Bronze, solid cast (lost wax). Greek, probably from a mainland workshop; first half of 5th century BC. L. 6 cm.; H. 2 cm.; W. of head 1.1 cm. Mate to [119].

This winsome panther-like feline reclines with both pairs of legs extended straight in front. Its head is upright, eyes gazing straight ahead. As with the ram [119] the panther's tail is extended straight back from the body, held above the surface upon which the animal rests. The panther has large oval eyes (with eyebrows rendered), rounded concave ears projecting diagonally backward from the crown of the head, and an open mouth with a wide upper lip outlined by a groove and protruding tongue.

Like its counterpart [119] which is nearly the same size, this panther probably adorned the shoulder or rim of a *krater* or cauldron, or a rod-tripod; perhaps both originally belonged to the same object. An analogous animal, crouched in a more sinuous pose, head turned to the right, is in the Walters Art Gallery, Baltimore.

Condition: Intact. A depression in the left buttock behind the haunch may be a casting defect. Covered by a dull brown to reddish patina. DGM

Bibliography: Unpublished.

Comparative literature: See [119]. D. K. Hill, *Catalogue of Classical Bronze Sculpture in the Walters Art Gallery* (Baltimore: Walters Art Gallery, 1949) p. 121, no. 278, pl. 54.

121 *Monkey Riding on Turtle*

Terracotta, fired orange-buff. Greek, probably Rhodian, late 6th to mid-5th century BC. Overall H. 8.5 cm.; W. of front flippers 7.4 cm.; Overall L. 10.4 cm.

A handmade terracotta tortoise, upon whose back rides a separately made monkey or ape. The turtle appears to be at least partially hollow, judging from the hole in the bottom just opposite the base of the neck. The turtle raises its head as it appears to make its way slowly forward, propelled by the tips of its arms, which are flattened into flippers; its pointed rear flippers trail straight backward. Extensive areas of heavy white slip adhere to the head, top, and left side of the turtle and the left side of the monkey. The monkey sits or kneels on the tortoise's back, right arm folded across its chest, left arm raised to its face. Its head was modeled by light pressure of the coroplast's fingers into facets suggesting its face and ears. Small Greek statuettes of monkeys or apes have made such characteristic gestures—like the Japanese

monkeys which "see no evil, hear no evil, speak no evil"— since Geometric times (see [95]). Bronze monkeys or apes from the sixth century BC perform similar gestures; they almost always seem comical, even satirical, in mood. A group similar to, but smaller than, the Mildenberg piece (in the James Chesterman collection, London) is thought to be a Rhodian product, as are similar groups and monkeys in the British Museum.

The motif of a monkey (or man) riding a tortoise suggests a fable, perhaps alluding to the frustration of choosing so slow a steed. A human figure rides a tortoise to the right in one of the metopes of the Sele Heraion, north of Paestum (now in the Paestum Museum). Schefold has interpreted this as Odysseus saved after his shipwreck from the whirlpool of Charybdis looking across to Skylla. Van Keuren Stern views this as representing Tantalos. Hence, it may be possible to view the Mildenberg terracotta as a parody or burlesque of an epic theme current earlier, but certainty at this time eludes us. The group belongs, however, to the large numbers of handmade terracotta figurines of animals and birds used for votive offerings as well as funerary gifts during the fifth century BC in Boeotia, Rhodes, and Attica.

Condition: Intact, monkey's right arm was broken off at the elbow but glued back on. DGM

121

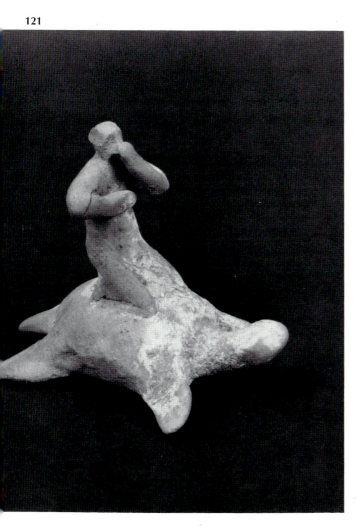

Bibliography: Unpublished.

Comparative literature: F. Winter, Die Typen der figürlichen Terrakotten (Berlin, Stuttgart: W. Spemann, 1903) i. 223:2 (ape riding turtle); J. Chesterman, Classical Terracotta Figures (London: Ward Lock, Ltd., 1974) pp. 38, 40, fig. 29 middle (Rhodian "boy" on turtle); R. Higgins, Catalogue of the Terracottas in the Department of Greek and Roman Antiquities, British Museum I (London: British Museum, 1954) p. 60, no. 105, pl. 20 (monkey riding pig, Walters B297) p. 61, no. 106 (monkey squatting, with lyre, Walters 296) (Higgins defines a "large class of hand-made crouching monkeys with cylindrical bodies and sketchily modelled limbs, datable by tomb-groups to the 6th century," pl. 1, nos. 191-197), pp. 79-80, pl. 35 (mold-made turtles, mid-fifth century BC); P. Zancani Montuoro, U. Zanotti-Bianco, Heraion alla Foce del Sele II (Rome: Libraria dello Stato, 1954) 301 ff.; K. Schefold, Götter- und Heldensagen der Griechen in der spätarchaischen Kunst (Munich: Hirmer, 1978) pp. 268-269, with bibliography, fig. 361; F. van Keuren Stern, "Turtle-Rider from Foce del Sele: Odysseus, Herakles or Tantalos?" Abstracts III (1978) Section I B (paper read at the Eightieth General Meeting of the Archaeological Institute of America, Vancouver, British Columbia, 28–30 December 1978) p. 5; for the mythological great sinners in the Sele Heraion metopes, E. Simon, "Die vier Büsser von Foce del Sele," JdI LXXXII (1967) 275-295.

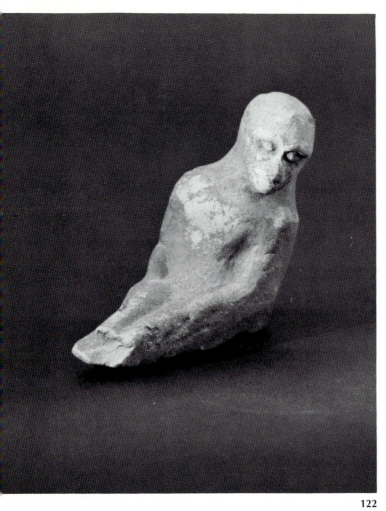

In striking contrast to the summarily rendered body, the ape's large head, which he tilts down and to the left, is modeled with the utmost delicacy and sensitivity. It expresses a powerful, yet understated pathos, achieved both through the inclination and attitude of the head and by the deep contours of shadow that gather around the projecting oval eyes and under the strongly, simply modeled brow-ridges. The mouth is finely modeled. The lip curves slightly and pulls to the left, completing an expression of brooding introspection.

The sensitive observation of the coroplast is conceptualized with extremely careful execution in attitude and expression to create a primate with an *ethos* as effectively moving as any of the moods visible in the protagonists in the metopes of the Temple of Zeus at Olympia or contemporary Attic red-figured vases. No other terracotta figurine known to the writer achieves this height of expression, a creation worthy of Polygnotos or Rodin. It is as if through subtle combination of inclination of head and facial expression, this ape was made to express and compress all of the transience and painful experience of life, animal as well as human. In so doing, it achieves a sublimity and tragic power present in few other small-scale works of Classical Greek art.

Condition: Intact, except for missing feet. Dark brown surfaces. Some diagonal scratches are visible on the right rear side of the body at the hips. DGM

Bibliography: Unpublished.

Comparative literature: W. C. McDermott, *The Ape in Antiquity* (Baltimore: Johns Hopkins University Press, 1938); D.G. Mitten, in *Schimmel Catalog* (1974) no. 23; L.E. Preston, "Four Boeotian Ape Figurines from the J. Paul Getty Museum," *The J. Paul Getty Museum Journal* II (1975) 121-126; B. Ashmole and N. Yalouris, *Olympia: The Sculpture of the Temple of Zeus* (London: Phaidon Press, 1967) pp. 22-29, figs. 143-211; G. Neumann, *Gesten und Gebärden in der griechischen Kunst* (Berlin: Walter de Gruyter, 1965) *passim*.

122

122 *Tragic Ape*

Terracotta, mold-made, fired light buff. Greek, perhaps Rhodian, middle or second half 5th century BC. H. 7.9 cm.; W. 4.1 cm.; L. 8.4 cm.

The ape sits on his buttocks, with legs extended straight in front of him. His arms, bent at the elbows, hang parallel to the sides of his body and extend to the knees. The thumbs are separated from the rest of the fingers, which are represented as a single mass. The ape may originally have sat in a boat, a bathtub, or the bottom of a wagon or cart. The sides and back of the figurine are smoothed; the right shoulder and arm are faceted by a knife or other instrument before firing. A depression 1 cm. deep extends upward into the body from the underside.

123 *Ram Askos*

Earthenware, fired brownish orange. Sicilian, 5th century BC. H. 12.1 cm.; W. 9.8 cm.; L. 19.5 cm.; Diam. of mouth 2.9 cm.

The body of the *askos* retains the characteristic spiral grooves of wheelmade pottery. To this cylindrical shape were added the animal elements which transformed it into a stylized ram. The vase's mouth, flanked by two small strap handles, projects from the creature's back. A tubular spout extends from the ram's left shoulder. The four small legs, the tail, neck, and head are all applied plastically. Small plastic ears, eyes, and curved horns make the head the least abstract of these elements. Decoration consists of simple daubs of paint (clearly made with a brush) in three roughly horizontal rows on the upper half of the ram's body. The neck received a necklace of similar daubs; the horns, eyes, and muzzle have small dots of paint. Perfunctory applications of paint also appear on the ram's tail and on the spout, mouth, and handles.

Such vessels, popular in ancient Sicily, are often found in funerary contexts. In domestic life they may have served as baby feeders (see also [124]). Their tapered spouts seem appropriate for this function as do their delightful shapes.

Condition: Intact. A large chip on right shoulder. Paint poorly fired and flaking, especially on right side and on the ram's head. Incrustation over much of the body. RDD

Bibliography: Ars Antiqua, Lagerkatalog IV (Lucerne, 1969) no. 22; Bloesch et al., *Das Tier,* p. 47, no. 289, pl. 48.

Comparative literature: See [124].

123

124 *Cow Askos*

Earthenware, fired pale orange. Sicilian, 5th century BC. H. 10.5 cm.; W. 6.5 cm.; L. 15.9 cm.; Diam. of mouth 3.2 cm.

This vase—similar to [123] but more realistic—is in the form of a kneeling cow. The *askos'* funnel-shaped mouth is placed on the animal's back; it is flanked by tubular handles which join the cow's body at the ribs and back. A tapered spout projects obliquely from the animal's rump. The cow's head and other features of its body, including tail and dewlap, are realistically modeled. The creature's facial features, hind hooves, tail, and mottled skin are painted in brown slip. The ears are dotted, and the poll painted with short vertical strokes.

This type of vessel seems to be of Sicilian origin. Several examples, including a horse-shaped variety, have been discovered in the region around Selinunte (Selinus). Our example is more realistically modeled and painted than most. The shape of the spout like that of [123] suggests that such vases may have served as baby feeders.

Condition: Both horns broken at the poll. Surface abrasion, especially on tail and around vase's mouth and spout. Cracks, especially on back and above left hind leg. Paint poorly applied. RDD

Bibliography: Unpublished.

Comparative literature: P. Baur, *Catalogue of the Stoddard Collection . . .* (New Haven: Yale University Press, 1922) p. 43, no. 47, p. 39, fig. 6 (mistakenly identified as Late Minoan III); Bloesch et al., *Das Tier,* p. 48, no. 290, pl. 48; *Schimmel Catalog* (1974) no. 67; *AA* (1964) 785, fig. 89; *Ars Antiqua,* sale cat., Auktion 5 (Lucerne, 1964) no. 108, pl. 38; *Ancient Glass, Jewellery and Terracottas from the Bomford Collection* (Oxford: Ashmolean Museum, 1971) p. 58, no. 148.

125 *Mouse Askos*

Earthenware, fired pale orange. Sicilian, ca. 425–400 BC. H. 6.2 cm.; W. 5.5 cm.; L. 11.1 cm.; Diam. of mouth 2.1 cm.

This small *askos* is in the shape of a crouching mouse. The creature has painted eyes and plastic ears outlined in black glaze. His four legs and tail are applied plastically but tightly compressed under the body. A small round mouth at the top of the mouse's back admitted liquid which could then be drained through the narrow, oblique spout on his rump. Small suspension lugs flank the mouth. The most interesting decoration appears on the mouse's sides. Here two large octopods—their tentacles symmetrically unfurled—seem to swim upward.

A number of these delightful vases have survived. Most are somewhat larger than our example and are decorated with vegetal or geometric ornaments. Nothing so arresting as the twin octopods occurs. One example of identical shape has been given a snout and thus transformed into a pig.

These vases may have dispensed ointments although their tapered spouts seem better suited to feeding young children. Hampe has suggested that the mouse *askoi* may be related to the cult of Apollo Smintheus, the mouse god, or to Demeter and Kore, goddesses of grain, a substance dear to mice and men. In either case, such objects would make excellent votive gifts after they were no longer needed in the home. If the Mildenberg vase was made with Apollo in mind, dolphins would have been more appropriate than octopods.

Condition: Some separation around mouth, spout, and lugs. Tops of both ears and rim of mouth abraded. Part of tail and left hind leg chipped. RDD

Bibliography: Unpublished.

Comparative literature: R. Hampe, *Heidelberger Neuerwerbungen 1957–1970* (Mainz: Philipp von Zabern, 1971) p. 68, no. 103, pl. 69; Bloesch et al., *Das Tier*, p. 48, no. 292, pl. 49 (now Cleveland Museum of Art, 75.91); *Ars Antiqua,* sale cat., Lagerkatalog 4 (Lucerne, 1969) no. 23; *Greek Pottery from South Italy,* sale cat. (London: Charles Ede, 1973) no. 37; J. Dörig, *Art Antique: Collections privées de Suisse Romande* (Mainz: Philipp von Zabern, 1975) no. 147.

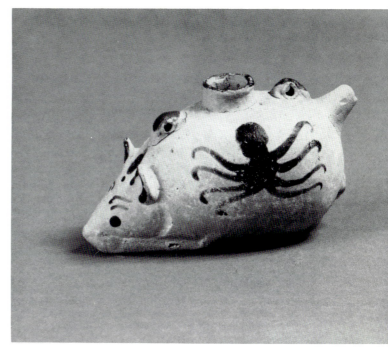

125

126 *Single-Handled Vase with Octopus*

Earthenware, fired brownish orange. Greek (?), late 5th century BC. H. 7.1 cm.; Diam. 7.5 cm.; Diam. of mouth. 3.9 cm.

An ivy wreath painted in black glaze encircles this small vase's neck. The rim, mouth, and handle are also painted black as are the two parallel bands which separate the neck from the belly. Below, and extending to the base, is the major decorative element: a large octopus. This creature is positioned with his head below the handle and his eight tentacles radiating from his mouth. Details on his head, eyes, and mouth are incised; applied red is used for the eyes and for a curious spiral added to the second left tentacle.

Octopods, perhaps because of their inherent symmetry, are favorite subjects of ancient artists. In Greece they were popular decorative motives on many Minoan and Mycenaean vases and even appear on floor paintings at Pylos and Tiryns. Much later, they make frequent appearances on Greek, and especially South Italian, pottery (cf. [149]). Octopus was a favorite food of the ancients; the best fishing grounds for it were off Thasos and Caria. It was admired not only for its sweetness but also because it was thought to be an aphrodisiac.

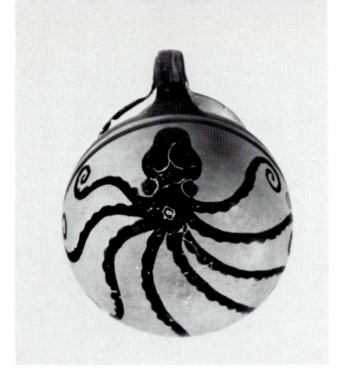

126 underside

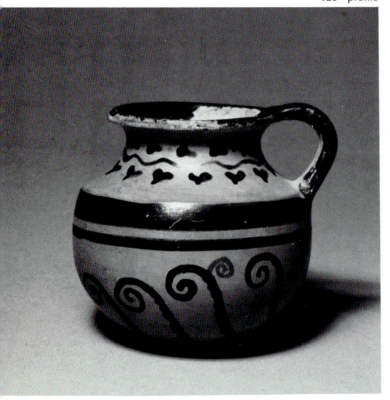

126 profile

A close parallel for this small vase has not been located. Somewhat similar vase shapes occur in Apulian pottery. On the basis of technique and style, especially of the ivy, we may assign this tentatively to the late fifth century BC.

Condition: Intact. Minor crack below handle's attachment to rim. Some wear around rim and cracking of paint on octopus. RDD

Bibliography: Unpublished.

Comparative literature: For the decoration, cf. *Ars Antiqua,* sale cat., Auktion 2 (Lucerne, 1960) no. 142, pl. 59.

127 *Three Miniature Lekythoi with Animal Figures*

Earthenware, fired orange. Attic, Red-Figure, late 5th century BC.
(a) H. 11.9 cm.; Max. Diam. 4.2 cm.; Diam. of foot 3 cm.; Diam. of mouth 3 cm.
(b) H. 13 cm.; Max. Diam. 4.6 cm.; Diam. of foot 3.2 cm.; Diam. of mouth 3.1 cm.
(c) H. 12.5 cm.; Max. Diam. 4.7 cm.; Diam. of foot 3.4 cm.; Diam. of mouth 2.9 cm.

These three small oil vessels belong to the secondary or simpler variety of *lekythoi.* Their shape is rather nondescript: a tall narrow neck capped by an *echinus*-shaped mouth, a tapering body, and a disk foot. Unglazed areas include the upper surface of the lip, the neck, and shoulder, and all but the top of the foot. The necks of these vases bear a reddish slip known as *miltos,* applied to enhance the red color of the clay. On the shoulders appears the traditional ornament: rudimentary black bars. Subsidiary decoration on the body is limited: a meander below the ground line on the first, an *ovolo* at the top of the body on the second, and a meander in the same position on the third.

Small, simple *lekythoi* such as these usually bear a single figure on the front, often a woman, more rarely an animal. In Attic late red-figure animals appear with greater frequency on other types of small vases, squat *lekythoi* and *askoi.* In the case of the Mildenberg vases, the animals are clearly transplanted from other contexts. The spotted deer, for instance, looks startled and seems to have leaped into midair. Such deer are often shown either being chased by another animal or carried by a flying Eros, as on the Pan Painter's *lekythos* in Boston (01.8079). It has been suggested that the two small *lekythoi* in a German private collection— one of which shows a startled deer, the other an attacking panther—constitute a pair and that the deer is

148

fleeing its attacker. Although the Mildenberg deer lacks a pursuer, the pose of the animal is only understandable in this context.

While a single bird is not unknown on this type of vase (e.g., Milan 135VII), a pair is unusual. More often like pairs of animals appear on opposite sides of red-figure *askoi*, and it is perhaps from such a context that the Mildenberg swans are derived. A similar pair of young stippled swans decorates an *askos* in the British Museum (E 753), and it has been suggested that the scene is one of sexual pursuit.

Finally, the Archaic staring owl owes its popularity to Athenian coinage and more directly to the owl-*kotyle* or *glaux*, a popular vase in the later fifth century BC. As on the *kotylai*, so here an olive spray accompanies the symbol of Athens. The Mildenberg owl resembles others on *kotylai* of Group II, dated to the third quarter of the fifth century BC; characteristic of this group are the lines of dots paralleling the eyebrows. Thus, while these animals find their natural

habitat on other vase shapes, they were freely adapted to miniature *lekythoi* such as these.

Condition: (a) Mouth broken and repaired; slip and paint slightly chipped. (b) Intact; rim and handle worn. (c) Intact: slightly chipped. JN

Bibliography: Unpublished.

Comparative literature: J.D. Beazley, *The Pan Painter* (Mainz: Philipp von Zabern, 1974) pp. 7-8, 14, no. 67, pl. 6,3; Wilhelm Hornbostel, *Aus Gräbern und Heiligtümern, Die Antikensammlung Walter Kropatscheck* (Mainz: Philipp von Zabern, 1980) pp. 148-149, no. 86; *CVA* Milan 1 (Italy 31) pl. 11, 5; Herbert Hoffmann, *Sexual and Asexual Pursuit: A Structuralist Approach to Greek Vase Painting,* Occasional Paper no. 34 of the Royal Anthropological Institute of Great Britain and Ireland (London: Royal Anthropological Institute, 1977) pp. 3, 11, pl. IV, 1; Franklin P. Johnson, "An Owl Skyphos," *Studies Presented to David M. Robinson,* vol. II, ed. G.E. Mylonas and D. Raymond (St. Louis: Washington University, 1953) 96-105; Franklin P. Johnson, "A Note on Owl Skyphoi," *AJA* LIX (1955) 119-124, pls. 35-38.

127 c,b,a

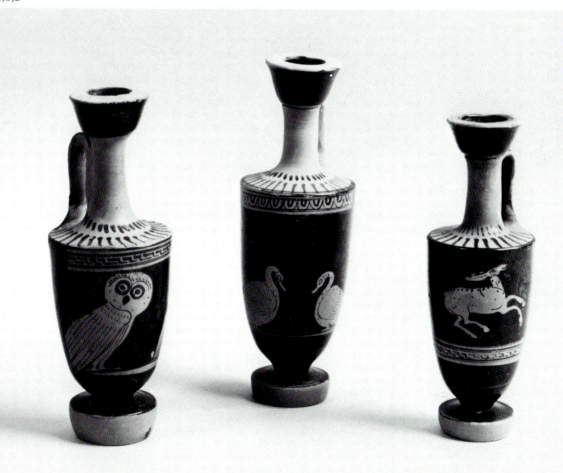

128 *Dwarf Lekythos with Leaping Deer*

Earthenware, fired orange. Attic, Red-Figure, late 5th century BC. H. 8.1 cm.; Max. Diam. 3.8 cm.; Diam. of foot 2.4 cm.; Diam. of mouth 2.4 cm.

This miniature *lekythos*, even smaller than the preceding three [127], also has a shorter neck, squatter body, and lower foot, shaped in two degrees. Overall the shape is dumpier, and less well proportioned. Likewise the black glaze covering the lip, body, and foot is thinner, less lustrous, and unevenly applied. The ornament is minimal: short bars at the base of the neck and longer ones on the shoulder.

On the front a lone, dappled quadruped raises its head and rears, with only the right hind leg still resting on the reserved ground line. In pose the animal resembles a horse on a similar *lekythos* formerly on the Swiss market. However, its body form, long ears, and spotted hide suggest a deer. Compounding the problem of identification is the horn-like projection from the animal's forehead. One wonders if the painter had originally intended a frontal or three-quarter view showing the ears pointing in opposite directions, as on the deer depicted on another small *lekythos* formerly on the Philadelphia market. Whatever his intentions, the artist has painted a ponderous beast admirably suited to the stout pot.

128

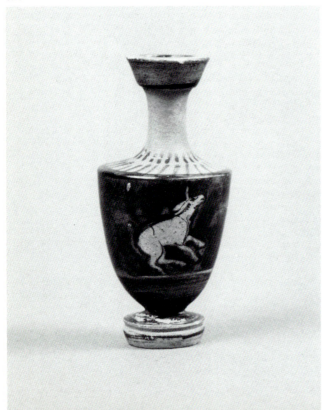

Condition: Intact; lip slightly chipped; paint chipped in places. JN

Bibliography: Unpublished.

Comparative literature: Attische rotfigurige Vasen, sale cat., Sonderliste N (Basel: Münzen und Medaillen A. G., May 1971) p. 33, no. 40; *Hesperia Art,* Bulletin XII (Philadelphia, 1960) no. 105.

129 *Lekythos with Female Leopard*

Earthenware, fired orange. Attic, Red-Figure, late 5th century BC. H. 17 cm.; Max. Diam. 6.2 cm.; Diam. of foot 4.3 cm.; Diam. of mouth 3.6 cm.

This vase is the largest and most elaborate of the red-figure *lekythoi* in the Mildenberg collection. Still smallish in size, it exhibits the decorative scheme typical of all secondary *lekythoi*: black-glazed mouth and body; reserved lip, neck, shoulder, and foot (except the top). The base of the neck bears short, black bars, the shoulder much longer ones. Bordering the top of the figural frieze is a sort of stopped meander, and at the bottom is a simple reserved ground line. On center stage is a spotted panther or leopard, clearly female with her prominent teats. Her lithe body is posed to the right with her long tufted tail curling up behind. The awkward bend of the left foreleg makes it look as if she were prancing; her frontal face and downward staring eyes add to the playful nature of the image. Dilute glaze is used to distinguish the animal's pelt and facial fur, while pairs of black dots indicate her spots.

Hunting leopards or cheetahs (*Acinonyx jubatus*) can be found in many Attic fifth-century BC vase paintings. They are commonly depicted as cubs and are displayed as pets or status symbols of aristocratic Athenian youths. By the end of the century, they begin to appear alone on smaller, cheaper vessels, such as *askoi* or squat *lekythoi,* and usually with frontal faces. While it belongs to this latter category, the Mildenberg leopard is considerably better in terms of drawing than the mass-produced, inaccurately proportioned specimens from the later period. The artist has not only correctly observed the litheness and delicacy of the long-tailed animal, but has demonstrated his originality in depicting the female of the species.

Condition: Broken at neck and repaired; surface pitted and encrusted. JN

Bibliography: Unpublished.

Comparative literature: Brown, *Etruscan Lion,* pp. 170-174; Ann Ashmead, "Greek Cats," *Expedition* XX (1978) 38-47.

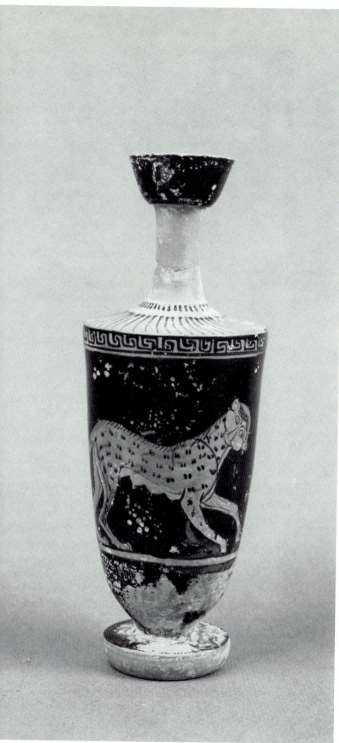

129

130 *Miniature Chous with Playing Ape*

Earthenware, fired brownish orange. Greek, Red-Figure, late 5th century BC. H. 7.2 cm.; Max. Diam. 5.4 cm.; Diam. of foot 3.8 cm.

This miniature *oinochoe,* or wine jug, of the type known as the *chous,* has a trefoil mouth and a squat bulging body resting on a ring foot. The exterior—with the exception of the underside of the foot—and the interior of the lip are covered with a shiny black glaze with a metallic sheen. The reserved figure on the front is a long-nosed, hirsute ape; the hair on his body is rendered in short strokes of dilute glaze. He is depicted squatting, the most natural position for the animal, and holds forth a rattle or top on a stick in his right hand. Before him is a plant consisting of three curved stalks. Below the ground line is a band of dotted *ovolo.*

The *chous* is the type of *oinochoe* used primarily in the celebration of the Anthesteria, a three-day Athenian festival held in honor of the wine god, Dionysos. The second day of the festival was, in fact, called "Choes" after the wine jugs used by adults in drinking contests. Miniature replicas were given along with toys and other gifts to three-year-old children who received their first taste of wine at this time. While these vases were manufactured primarily in Attica,

130

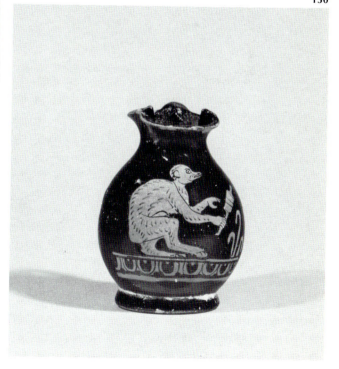

where the majority have been found, often in children's graves, they were also widely imitated in South Italy. In date they are generally restricted to the late fifth and early fourth centuries BC.

Iconographically the *choes* reflect their use in the spring festival. The miniature ones, in particular, are adorned with young children playing, often with their new toys or pets. While the ape is not a common plaything, it is occasionally shown in scenes with children. On the other hand, some *choes* parody the religious events of the festival; hence, this simian creature may well be aping a young Athenian celebrating his first Anthesteria. But, whatever his meaning, since the ape was known to be especially fond of wine, his presence is appropriate here.

Condition: Intact; rim slightly chipped and worn; paint chipped in places. JN

Bibliography: Unpublished.

Comparative literature: H. W. Parke, *Festivals of the Athenians* (London: Thames and Hudson, 1977) pp. 107-120; G. van Hoorn, *Choes and Anthesteria* (Leiden: E. J. Brill, 1951) pp. 15-48; J. R. Green, "Choes in the Later Fifth Century," *BSA* LXVI (1971) 189-228; William C. McDermott, *The Ape in Antiquity* (Baltimore: The Johns Hopkins Press, 1938).

131 *Intaglio Ring with a Lioness*

Gold and banded agate. Greek, ca. 450–425 BC. Diam. of ring, 2.3 cm.; L. of stone 1.9 cm.; Diam. of stone 0.8 cm.

The ring is a solid gold beveled hoop. The agate is perforated and swivels on a gold wire mounted between the ends of the loop. The intaglio is a brown-and-white banded agate cut in the "sliced barrel" shape. Carved into the stone is the image of a crouching lioness which faces left. Her head is turned outward and both large eyes are visible. Her front paws touch each other; her tail is tucked between her rear legs. Five pendulous teats hang from her stomach. Her whiskers, mane, and the hair on her spine are all rendered with extreme delicacy and skill. The image is framed by a simple linear border.

Sliced cylinders and barrels are not particularly common intaglio shapes. Those which we have are almost always made of agate although some cornelians are also known. Most of the twenty-five or so examples published do not have provenances; those which do come from Athens, Corfu, Epirus, Cyprus, Tarentum, and Kerch. The most frequent subjects are animals, particularly herons, but other lionesses (usually leaping rather than crouching) are known.

Condition: Excellent; slight discoloration on the agate's base. RDD

Bibliography: Unpublished.

Comparative literature: John Boardman, *Greek Gems and Finger Rings* (New York: Abrams, 1970) pp. 199-200, 409-410, pls. 520, 522, 527; color pl. opp. p. 202, figs. 2,5; John Boardman, *Intaglios and Rings* (London: Thames and Hudson, 1975) pp. 15, 88, no. 33.

132 *Intaglio Ringstone with a Grazing Animal*

Mottled jasper. Greek, ca. 400 BC. H. 1.3 cm.; W. 0.38 cm.; L. 1.7 cm.

This mottled jasper ringstone, of reddish color with black and brown veining, has been cut into an oval shape. Top and bottom surfaces are flat; the sides are truncated.

A grazing animal, perhaps a young bull, moves to the right. Genitals and small horns just in front of the ears are visible. A simple ground line appears at the bottom, and a small leafless tree grows from the lower left spreading its branches above the animal.

Grazing animals, especially bulls and horses (see [133]), are not uncommon subjects for Greek intaglios. The ground line is a frequent device, but trees do not often appear on such ringstones.

Condition: Right edge of the stone is chipped; only the muzzle of the animal is missing. RDD

131

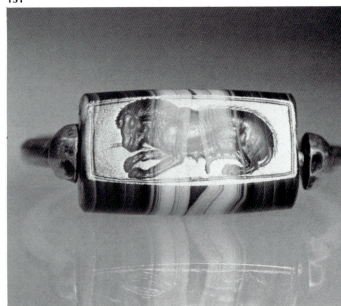

152

Bibliography: Unpublished.

Comparative literature: E. Brandt, *Antike Gemmen in deutschen Sammlungen*, vol. I: *Staatliche Münzsammlung München, part 1* (Munich: Prestel, 1968) no. 261, pl. 31; P. Zazoff, *Antiken Gemmen in deutschen Sammlungen*, vol. IV: *Hannover und Hamburg* (Wiesbaden: Steiner, 1975) p. 230, no. 1182, pl. 160.

Bibliography: Unpublished.

Comparative literature: G.M.A. Richter, *Engraved Gems of the Greeks and the Etruscans* (London: Phaidon, 1968) nos. 417, 433-435; John Boardman, *Greek Gems and Finger Rings* (New York: Abrams, 1970) no. 566; E. Zwierlein-Diehl, *Antiken Gemmen in deutschen Sammlungen*, vol. II: *Staatliche Museen-Berlin* (Munich: Prestel, 1969) p. 79, no. 172, pl. 38.

133 *Fragmentary Intaglio with a Horse*

Cornelian. Greek, ca. 400–350 BC. H. 2.5 cm.; W. 0.25 cm.; L. 2.4 cm.

The left half of a fragmentary translucent cornelian, with flat top and bottom surfaces and truncated sides, shows an engraved horse. The animal's head, neck, and left front leg are perfectly preserved. In addition, the vestiges of the front right leg and a short ground line are visible near the break.

The horse's head is lowered, but it does not seem to be grazing like most animals, particularly stags, on related gems. Perhaps the action may be explained by the horse's left front foot which appears to hang limply below the ankle. Does this indicate a broken leg? This detail could be a simple mistake, but that would hardly be consistent with the excellent quality of carving seen in other details of this animal.

Condition: Right half of stone missing; slight surface pitting. RDD

134 *Horse Head*

Terracotta, fired reddish orange. Tarentine, early 4th century BC. H. 8.8 cm.; W. 4.5 cm.; L. 12.7 cm.

This fine equine head was once part of a hollow mold-made figure. The clay is reddish orange with traces of mica and is coated with a creamy slip. Raised and turned slightly to its right, the head is forcefully modeled with emphasis on the underlying bone structure, the heavy parted lips, flaring nostrils, alert eyes, and prominent chin. That it was meant to be facing to the left is indicated by the incised wrinkles on the muzzle and the deep grooves in the mane which appear only on its left side.

Tarentum, a Greek colony in southern Italy, was a major center of coroplastic art from the seventh century BC onwards. In the fourth century in particular small-scale

132

133

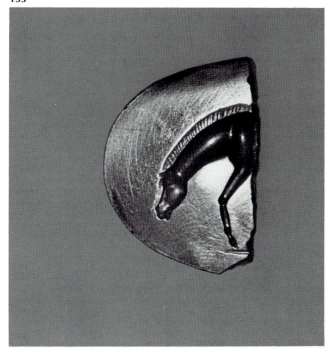

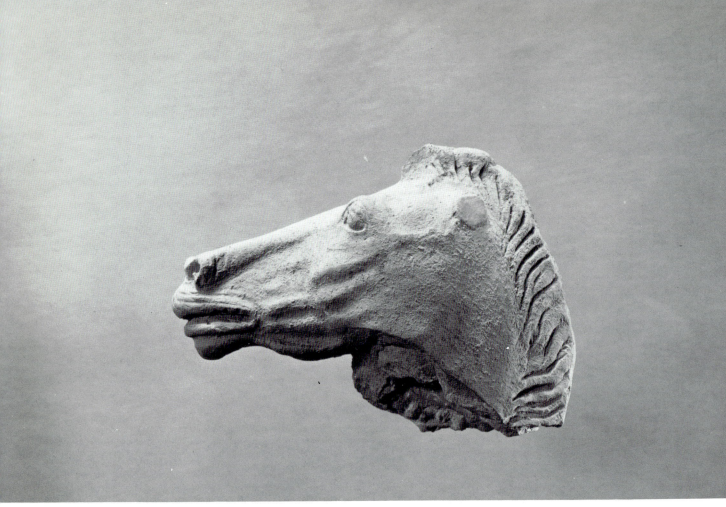

134

sculptures in terracotta reflected major monuments in stone and give evidence that the Tarentines knew and appreciated contemporary classical forms. The Mildenberg head shows close parallels not only with other terracotta horse heads from Tarentum such as those in Naples (140987), Copenhagen (I.N. 1005), and Bonn (D. 808), but also with Tarentine heads in other media, such as the marble example in the British Museum (2128) or the bronze in the J. Paul Getty Museum, Malibu (A 58.S-9). All these equine heads share a certain affinity with the spirited horses of the Parthenon frieze, although lacking some of their exquisite naturalism. Such heads no doubt once formed part of larger equestrian groups, a type of statue which must have been a popular Tarentine product. Cf. also [135].

Condition: Missing left ear and most of right; edge of mane chipped. Surface worn and encrusted especially on horse's right side. JN

Bibliography: Unpublished.

Comparative literature: Pierre Wuilleumier, *Tarente des origines à la conquête romaine,* Bibliothèque des Ecoles Françaises d'Athènes et de Rome, CXLVIII (Paris: E. de Boccard, 1939); Bonnie M. Kingsley, *The Terracottas of the Tarantine Greeks* (Malibu, CA: J. Paul Getty Museum, 1976); Alda Levi, *Le terrecotte figurate del Museo Nazionale di Napoli* (Florence: Vallecchi, 1926) p. 35, fig. 36; Ernst Langlotz and Max Hirmer, *Ancient Greek Sculpture of South Italy and Sicily* (New York: Harry N. Abrams, 1965) pl. 120, pp. 285-286; A. H. Smith, *A Catalogue of Sculpture in the Department of Greek and Roman Antiquities, British Museum* (London: British Museum, 1904) p. 217, no. 2128; Mitten and Doeringer, *Master Bronzes,* p. 104, no. 102.

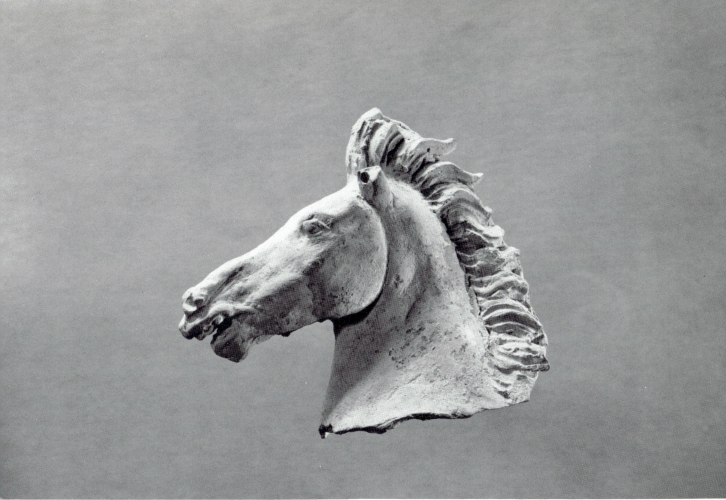

135 *Horse Head with Windblown Mane*

Terracotta, fired pinkish tan. Tarentine, 4th century BC. H. 10 cm.; L. 11.6 cm.

This second terracotta horse head, on the same scale as the last [134], is also hollow and mold-made; its surface still bears some traces of its original white slip. The head faces left, as indicated by the roughly worked right side and the small attachment hole below the horse's right ear. The mane was no doubt added by hand and worked vigorously with a tool to give it its deep striations.

Compared to its predecessor [134] this Tarentine horse head seems more spirited and dynamic, although somewhat lacking in character. The artist has chosen to accentuate the animal's flamboyant mane, broad nose, and fleshy lips which part to reveal teeth. While the one head transmits the strength of its stone model, this is a purely coroplastic rendition. It resembles another terracotta horse head in the Ny Carlsberg (I.N. 1005) acquired in Rome in 1888 and reputedly from Taranto.

Condition: Well preserved; tips of mane and ears chipped. JN

Bibliography: Unpublished.

Comparative literature: For Greek horses in general, Sidney David Markman, *The Horse in Greek Art* (Baltimore: Johns Hopkins Press, 1943); Vagn Poulsen, *Catalogue des terres cuites grecques et romaines* (Copenhagen: Ny Carlsberg, 1949) p. 22, no. 30, pl. XVI.

136 *Leaping Horse*

Terracotta, hollow mold-made, fired brownish tan. Greek, Tarentine, late 4th–3rd centuries BC. H. 11.5 cm.; W. 3.7 cm.; L. 21 cm.

This magnificent, spirited horse—springing forward in the fully extended "flying gallop"—literally breathes the excitement of chase or flight. Its lean musculature is sparsely but effectively rendered in the haunch and shoulder muscles; smaller details, such as the tendons on the legs and the hollow undersides of the hooves, are also depicted. The long tail, held straight out from the body, is marked by diagonal incised striations slanting backward from the center on either side. A small round perforation in the left shoulder may have permitted the escape of moisture during firing. The horse's male genitalia are clearly modeled.

This horse is close in modeling and spirit to the larger Tarentine terracotta horse head in the Mildenberg collection [135]; a number of smaller comparable Tarentine horse statuettes are known. Its purpose, however, is less clear. There are no obvious traces of a rider, and no holes or traces of attachments for bit, harness, or reins. How the horse

could have been mounted and how it could have supported its weight on its hindlegs without breaking are also uncertain. It appears to have been modeled in the round as votive offering, grave gift, or perhaps simply to delight its owner, and it may have been meant to be handled, not mounted on a base.

Condition: Intact. Extensive traces of whitish slip; traces of blue and black paint on right side of the head. DGM

Bibliography: Unpublished.

Comparative literature: Schefold, *MgK,* nos. VII 351 (pp. 264-265), VII 358 (pp. 265,268) (from the Museum of Mediterranean Archaeology Nir-David, Israel); E. Langlotz, *Ancient Greek Sculpture of South Italy and Sicily* (New York: Harry N. Abrams, 1965) pp. 285-286, no. 120 (Bonn); Helga Herdejürgen, *Die tarentinischen Terrakotten des 6. bis 4. Jahrhunderts v. Chr. im Antikenmuseum, Basel* (Mainz: Philipp von Zabern, 1971) pp. 1-25; Mitten and Doeringer, *Master Bronzes,* no. 212, p. 209 (Eric de Kolb Collection); *Kunstwerke der Antike,* sale cat., Auktion XXVI (Basel: Münzen und Medaillen A. G., 6 October 1963) p. 20, no. 39, pl. 11 (bronze horse second to first century BC); Manolis Andronicos, Manolis Chatzidakis, and Vassos Karageorghis, *The Greek Museums* (Athens: Ekdotike Athenon, 1974) no. 90, p. 95 (horse from Cape Artemision).

137 *Panther Appliqué*

Terracotta, fired tan. Tarentine, third quarter of 4th century BC. H. 6.5 cm.; L. 11.5 cm.

This openwork relief of fine-grained clay was made in a mold, covered with a yellow bole or sizing, and gilded with thin gold leaf. The subject is a male panther in profile to the right. He is crouching on rocky ground, his left forearm is raised, and his tongue protrudes. The body of the animal is smoothly modeled, with some areas receiving special detailing: the paws, the double curved and tufted tail, the small ears and ruff at the neck, the eye deeply set under a heavy brow, and the mouth. A cylindrical nail hole through the right shoulder served for attachment.

Gilded terracotta reliefs such as this were produced in Tarentum for approximately thirty years, ca. 350–320 BC, and probably served as decorative appliqués on wooden sarcophagi. Recurrent themes include complex groups of animal combat and griffins attacking Arimasps. Single animals such as the panther, lion, deer, and griffin were also manufactured in abundance. Similar panthers can be found in the Ashmolean Museum in Oxford (1888.1486) and in the Charles Morley collection in New York.

Condition: Intact; much of the gilding missing. JN

Bibliography: Herbert A. Cahn, *Classical Antiquity,* sale cat. André Emmerich Gallery, 1975) no. 33.

Comparative literature: Reinhard Lullies, *Vergoldete Terrakotta-Appliken aus Tarent* (Heidelberg: F. H. Kerle, 1962) esp. p. 72 and pls. 14, 1 and 15, 1 and 3; Schefold, *MgK,* pp. 93-94; Helga Herdejürgen, *Die tarentinischen Terrakotten des 6, bis 4. Jahrhundert v. Chr. im Antikenmuseum Basel* (Mainz: Philipp von Zabern, 1971) pp. 61-70, nos. 55-77.

137

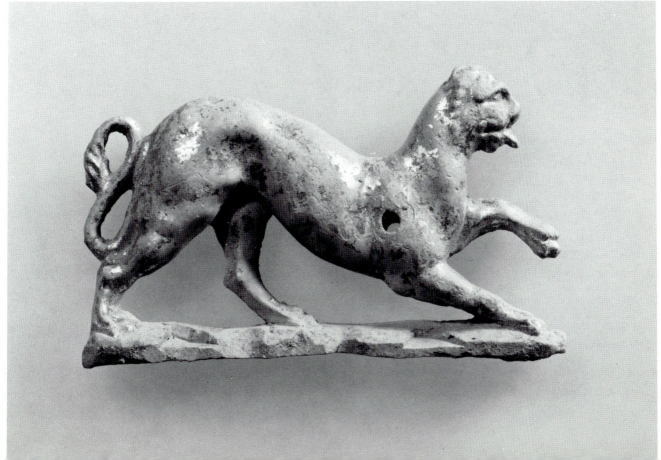

138 *Lion Head Water Spout*

Sandstone.111 Tarentine, 4th century BC. H. 15.5 cm.;
W. 20 cm.; W. of spout 9 cm.

This fragment preserves the upper portion of a sculpted
lion head water spout, its function indicated by the square
channel at the back which leads into the hollow mouth. The
hemispherical face is framed by a wavy mass of flame-like
tufts with two rounded ears projecting behind. A deep
central groove bisects the forehead and terminates at the
heavy, knitted brows of the lion. Its round eyes are deep set
behind the large wrinkled nose. The mouth is wide open
baring a neat row of incisors framed by pointed fangs. The
wrinkles of the muzzle are incised, and the flews have a
rippled edge.

Originally this head would have been part of the stone
sima or gutter of a building (for its position on a *sima* block

see [111]). Its protruding concave tongue would have chan-
neled the rainwater down and away from the building, not
unlike a modern downspout. Effective functionally as well
as visually, lion head spouts were ubiquitous in the ancient
Mediterranean. The Mildenberg lion head is close both
stylistically and in terms of the stone used to lion head
spouts from Taranto of which six more complete examples
reside in the Allard Pierson Museum in Amsterdam (1570,
1571, 1574–1576, 1579).

Condition: Broken below and at back; missing lower jaw
and tongue. JN

Bibliography: Unpublished.

Comparative literature: C. S. Ponger, *Katalog der griechischen
und römischen Skulptur, der steinernen Gegenstände und der
Stuckplastik im Allard Pierson Museum zu Amsterdam* (Amsterdam:
N. V. Noord-Hollandsche Vitgeuers Maatschappij, 1942) pp. 72-73,
nos. 156-161, pl. 36.

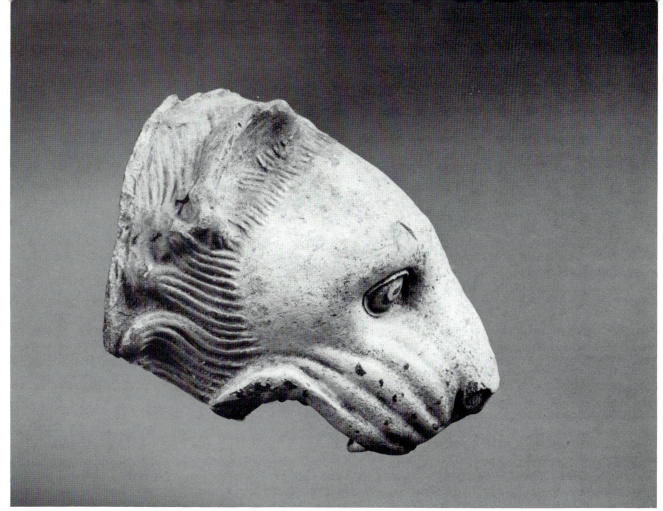

139 *Lion Head Water Spout (?)*

Terracotta, pale orange with sandy grit.
West Greek, early 4th century BC.
H. 10 cm.; L. 14 cm.

This fragmentary architectural terracotta preserves the right half of a hollow lion's head. A seam along the broken edges indicates that the piece was made in two layers: a coarse, handmade inner core surmounted by a molded outer layer made of finer clay. This outer layer preserves a finished edge at the back, which is coated with a dark red resinous material (some sort of sealing?). The inner layer has a broken edge and apparently continued as an inset. The lion head is not a mask, but projects boldly from its backing. The modeling is forceful—heavy brow, deep-set eyes, wrinkled muzzle, and heavy lips. The mouth is wide open, baring the canines and incisors, one of which is missing.

Parts of this lion head were worked by hand after removal from the mold, namely the large cup-like ear and the thin strands of the mane which flow back off the forehead. What makes this terracotta exceptional is the fine state of preservation of its painted decoration. Extensive traces of yellow and red are visible on the mane. The lips, nose, whisker dots, rim of the eye, and pupil are brownish black. Lighter red is used on the eyebrows, iris, and gums.

A similar fragmentary lion head was sold at auction in 1974 and is now in the Greek Museum at the University of Newcastle-upon-Tyne (548). Preliminary investigation shows that it joins the Mildenberg piece and so constitutes the upper left half of the lion's head. Unfortunately, the bottom including the lion's jaw is missing, so it is not absolutely certain that this piece functioned as a water spout, although it is probable.

140

Bloesch has dated this lion head to the late fourth century BC on account of its look of pathos and the slightly archaizing treatment of the mane. These qualities are certainly evident on the freestanding lions of the Mausoleum at Halicarnassus; they, too, have deep-set rounded eyes and manes consisting of pointed locks with sharply chiselled individual hairs. However, the heavy doughy modeling on the Mausoleum lion heads is lacking in the terracotta example. In this respect the Mildenberg lion head is much closer to the Attic lions in Boston (65.563) and Rhode Island (15.003) dated to 390 BC, and so the first rather than the second half of the fourth century BC seems a more likely date.

Condition: Left half and lower jaw missing; slightly chipped and incrusted. JN

Bibliography: Bloesch et al., *Das Tier, p. 31, no. 183, pl. 29.*

Comparative Literature: For a general study of Greek lion head water spouts, Franz Willemsen, *Die Löwenkopf-Wasserspeier vom Dach des Zeustempels, OlForsch* IV (Berlin: Walter de Gruyter, 1959); *Antiquities,* sale cat. (London: Christie's, 10 July 1974) p. 25, no. 70, pl. 20; G. B. Waywell, *The Free-Standing Sculptures of the Mausoleum of Halicarnassus in the British Museum* (London: Trustees of the British Museum, 1978) pp. 68, 180ff, pls. 37ff; Cornelius Vermeule, "Greek Funerary Animals, 450–300 B.C.," *AJA* LXXVI (1972) 49–56, pls. 11–14; Brunilde Sismondo Ridgeway, *Classical Sculpture* (Providence: Museum of Art, Rhode Island School of Design, 1972) pp. 32–33, no. 10, illus. pp. 147–148.

140 *Gold Ring with Lion Head Finials*

Gold, blue glass. Greek, 350–300 BC.
Diam. 2.25 cm.; Max. W. 0.8 cm.

The ring consists of a heavy gold core to which twenty-two pieces of braided wire and one plain wire have been attached in parallel rows. Each end of the ring terminates in a lion head and decorated collar. The lions have blue glass eyes; their chased manes are arranged in two tiers. The collars are elaborately decorated with groups of heraldic reverse spirals made of rope-wire; individual granules of gold are placed between the spirals, between each group, and at top and bottom of the frieze. The collar is bordered by rows of plain and beaded wire. A row of leaves outlined with wire forms the transition between collar and ring.

The most unusual feature of this ring is its striking similarity to the many bracelets with lion head finials. Hoffmann and Davidson have made the plausible suggestion that the ring once belonged to a set of matching bracelets, earrings, and necklace. See [141, 156].

Condition: Left half and lower jaw missing; slightly chipped and incrusted. RDD

Bibliography: H. Hoffmann and P. Davidson, *Greek Gold: Jewelry from the Age of Alexander,* exhib. cat. (Boston: Museum of Fine Arts, 1965) p. 243, no. 101.

Comparative literature: F. H. Marshall, *Catalogue of the Finger Rings, Greek, Etruscan, and Roman in the Departments of Antiquities* (London: British Museum, orig. publ. 1907, reprinted 1968) no. 923, pl. XXIII.

141 *Pair of Hoop Earrings with Lion Head Finials*

Gold, blue glass inlays. Greek, probably Tarentine, ca. 325–300 BC. (a) and (b): Diam. 2.1 cm.; Diam. of large lion 1.3 cm.; Diam. of small lion 0.5 cm.

A series of rolled hollow wires are twisted around each other to form a single tapering hoop. Each end terminates in a lion head and collar. The lion heads, although of different size, are virtually identical in construction and decoration. Each is made of symmetrical halves brazed together; surface details are delicately chased. The eyes, some now missing, are of blue glass inlays. Each of the large collars consists of rows of large spiral-spool wire, plain wire, braided wires, and a leaf border outlined with plain wire.

Hoop earrings were probably inspired by fifth-century Macedonian prototypes with knobs for finials. The use of animal or human head finials appears to be a Greek refinement and assured the popularity of this type throughout the Hellenistic Period. Lion head finials are, by far, the most common (cf. [156]). It is less common to find

finials at both ends of the loop; when this does occur the animals are usually different. For instance, lions are normally paired with rams not, as is the case here, with smaller lions. Examples of this type have been found at Tarentum, Capua, Cumae, and Ithaca.

Condition: Some slight dents on largest hollow wires forming the loop; general bending of axes when seen from front. Eyes missing from smaller lion heads. RDD

Bibliography: Unpublished.

Comparative literature: H. A. Cahn, *Art of Ancient Italy,* sale cat. (New York: André Emmerich Gallery, 1970) p. 42, no. 64; B. Segall, *Zur griechischen Goldschmiedekunst des vierten Jahrhunderts v. Chr.* (Wiesbaden: Steiner, 1966) pl. 41; F. H. Marshall, *Catalogue of the Jewellery: Greek, Etruscan and Roman in the Departments of Antiquities* (London: British Museum, orig. publ. 1911, reprinted 1968) p. 191–192, nos. 1768–1771, 1777, pl. XXXI; *Ori e argenti dell' Italia antica* (Torino: Fratelli Pozzo-Salvati-Gros Monti, 1961) no. 312, p. 107, pl. XXXVI; Bloesch et al., *Das Tier,* nos. 381–382; Pinney and Ridgway, *Aspects,* pp. 285–287; A. Greifenhagen, *Schmuckarbeiten in Edelmetall* (Berlin: Gebr. Mann, 1970) I, pls. 44,1, 45,5.

141

142 *Ram Head Pendant*

Gold with filigree. Greek (perhaps South Italian), 4th century BC. H. 2 cm.; W. 1.2 cm.; Diam. of round attachment, 0.7 cm.

This hollow gold ram's head has perforations for the eyes (now lost) and incised details indicating fleece, eyebrows, and horns. The head is fixed to a cylindrical collar which is perforated for suspension. The collar is carefully decorated with a "snake" of plain wire flanked by plain and beaded wires. Two circles of beaded wire support a large gold granule on the collar's circular cap.

Ram heads form finials for *fibulae*, earrings, and armbands from the sixth-century BC but appear to be particularly popular on fourth-century jewlery. Our piece, especially because it has a perforated collar, was probably the central pendant of a necklace.

Condition: Eyes missing. Small cracks in front of left ear and behind left horn. RDD

Bibliography: Unpublished.

Comparative literature: B. Segall, *Zur griechischen Goldschmiedekunst des vierten Jahrhunderts v. Chr.* (Wiesbaden: Steiner, 1966) pls. 35, 45; H. Hoffmann and V. von Claer, *Antiker Gold- und Silberschmuck* (Mainz: Philipp von Zabern, 1968) no. 94, pp. 148–149; A. Greifenhagen, *Schmuckarbeiten in Edelmetall* (Berlin: Gebr. Mann, 1970) I, pl. 34, 1, II (1975), pls. 5, 1–2, 10; G. Becatti, *Oreficerie antiche dalle minoiche alle barbariche* (Rome: Istit. poligrafico dello Stato, 1955) no. 313, pl. LXXVII.

142

143 Shorn, Bleating Ram

Bronze, solid cast (?). Greek, 4th century BC,
or Hellenistic. H. 5.8 cm.; W. 1.9 cm.; L. 5.6 cm.

Striding forward with left foreleg advanced and right hind leg extended, this lean, lithe ram turns his neck to the left, raises his head, and opens wide his mouth to bleat loudly. So energetic is the stance that the reason for the ram's forceful bleating becomes of some interest. Perhaps he belonged to an animal group and senses here the impending attack of a savage predator, for the encounter of wild and domestic animals was popular subject matter throughout classical antiquity. Possibly he accompanied a mortal, or even a deity such as Hermes, with whom rams as well as goats were often associated. Or he may simply have been represented together with other domestic animals or even alone, reflecting the Greek love of nature. Whatever the case, this ram with its dramatic pose, finely modeled body, and very sensitive handling of bone, muscle, and fleece, is an exceptional work of art. Particularly successful are the textural effects, with the contrasts between the fine stippling over the body, the plastic rendering of the soft fleece between the horns and beneath the chin, and the hard curving lines of the horns.

A Hellenistic date has been proposed, which is in keeping with the upraised head, for in that time dogs bay, lions and panthers growl, and goats, rams, and ewes bleat with upraised heads. One difficulty with such a date arises, however, in the very visible musculature and fine stippling of the lean body, since thick, fleecy locks concealing the musculature were in vogue during the Hellenistic and Roman periods for representations of rams, ewes, goats, and indeed most other animals with hairy coats (cf. [188-190]). Such naturalistic locks were, of course, direct descendants of the stylized fleece patterns of the Archaic and Classical periods, which included incised circles, raised whorls, short incised lines, and long, incised or scored lines (cf. [107,108]). Both types of fleece, the naturalistic and the stylized, can be seen on the famous Scythian gold pectoral dated to the fourth century BC—the naturalistic on an animal skin being sewn into a shirt and the stylized on a ewe being milked. On the Mildenberg ram, however, the impressionistic handling of the fleece around the face provides such a stark contrast to the stippling of the body fleece as to confirm the suspicion that this lean ram has just been shorn. Is that perhaps why he bleats so forcefully and why his muscles are so visible? Certainly, scenes of herdsmen tending their livestock—so well attested on the Scythian pectoral—must also have been produced for the home market. Possibly this unique shorn ram comes from such a context.

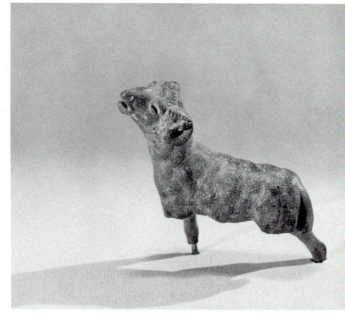

143

Stance and style permit a date as early as the fourth century BC, but a Hellenistic date seems more likely.

Condition: Left legs and tail broken off level with body; right lower legs and feet missing. Three deep horizontal gouges in right side of neck. Eye cavities possibly originally filled with inlay. Medium to dark green patina. KPE

Bibliography: Unpublished.

Comparative literature: Reinach, *Répertoire*, II (1908), 750-754, III (1920) 43.7 (silver Hermes with ram), 45.2 (bronze Hermes with ram), 220, IV (1913) 507-514, V (1924) 446-449; Comstock and Vermeule, *MFA Bronzes*, p. 139, nos. 162-163, p. 146, no. 170a, pp. 181-182, no. 217; C. Boube-Piccot, *Les bronzes antiques du Maroc I. La statuaire*, Etudes et Travaux d'Archéologie Marocaine IV (Rabat: Direction des Monuments Historiques et des Antiquités, 1969) p. 232, no. 266 (texte), pl. 190.1; M. Robertson, A. Frantz, *The Parthenon Frieze* (New York: Oxford University Press, 1975) north frieze IV. 10-11; Farkas, Piotrovsky, et al., *Scythians: Treasures*, p. 126, no. 171, col. pls. 31-33; C.A. di Stefano, *Bronzetti figurati del Museo Nazionale di Palermo* (Rome, 1975) pp. 19-20, nos. 28, 30, pl. 8 (bronze Hermes with ram), pl. 30, no. 134; G. Hafner, *Art of Rome, Etruria and Magna Graecia* (New York, 1969) p. 166 (Hellenistic monumental bronze ram from Syracuse); Mitten and Doeringer, *Master Bronzes*, p. 71, nos. 63-64; P. Lebel, *Catalogue des collections archéologiques de Besançon V. Les bronzes figurés* (Paris: Société d'Editions "Les Belles Lettres," 1959) pls. 57.2-58; de Ridder, *Acro Cat.*, p.191, no. 526; Popović et al., *Bronzes in Yugoslavia*, no. 88 (bronze Hermes with ram); A. Kaufmann-Heinimann, *Die römischen Bronzen der Schweiz I: Augst* (Mainz, 1977) 36-37, nos. 31-32, pls. 21-25.

Plate XII Pavement Fragment with Bird [196]

Plate XIII Rearing Cobra (Uraeus) [48]

Plate XIV Oval Medallion with Eagle and Two Swans [34]

Plate XV Amphora with Marine Fauna [103] ▶

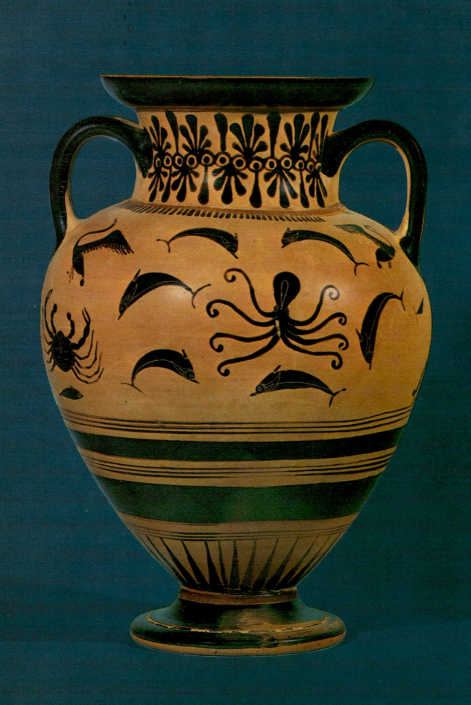

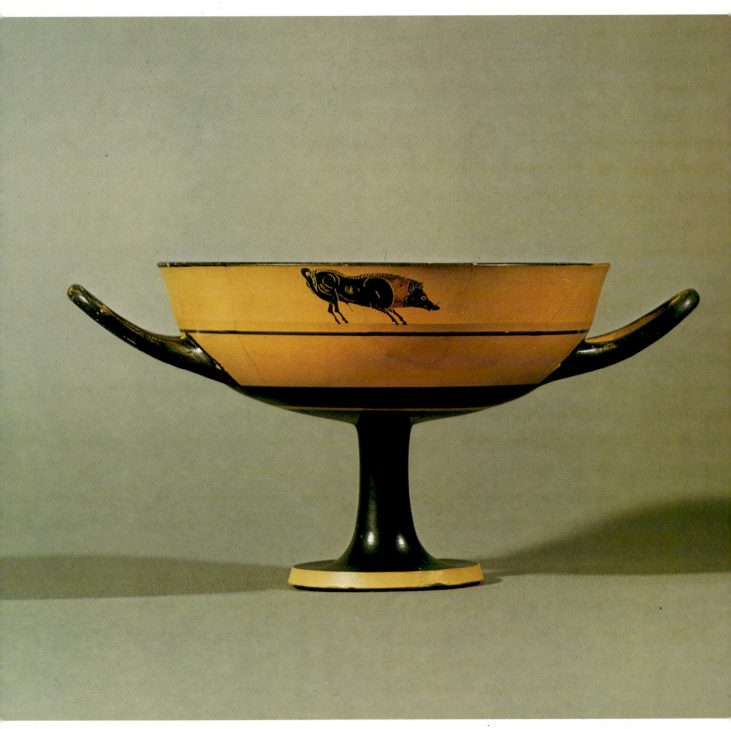

Plate XVI Little Master Lip Cup with Boar Hunt [100]

144 Bull at Bay

Bronze, solid cast (lost wax). Greek, late Classical or early Hellenistic, late 4th or first half of 3rd century BC. H. 3.9 cm.; W. 2.3 cm.; L. 8.4 cm.

This powerful bull is arrested in a dynamic pose, ready to repel all comers, with his head lowered and turned to his right. His right legs are slightly advanced; his left legs drawn back. His sculptor has modeled his body with powerful, somewhat angular treatment of his muscle and bone structure. His ribs are especially visible beneath the skin on the right side. His genitalia are plastically modeled. A mane of crescentic incisions opening forward runs down either side of the neck from the poll to the withers. These locks look as if they were initially cast, then touched up and deepened by cold working. The left horn appears to have been bent backward over the left ear. The bull has recessed oval eyes with heavy upper eyelids. Nostrils and mouth, probably cast, are visible in the sides of the wide muzzle.

This impressive bull, monumental in conception despite his small size, is a miniature counterpart to such large-scale guardian figures as the butting bull on top of a fourth-century BC grave monument from the Kerameikos, Athens. His pose is also reminiscent of those assumed by the butting or charging bulls on the silver coins of Thurii, in southern Italy. While more restrained, the mood is not unlike that of the angry bronze sow in Boston, probably Hellenistic in date.

Because the legs are missing, it is no longer possible to determine how or upon what this statuette was mounted. While it could have been an unusually dynamic votive statuette, it might also have been mounted on the rim of a vessel facing its opponent, human or animal, in a fashion similar to the confrontation between an early Classical bronze boar and lion in Boston, or it might conceivably have formed part of a hunting group. Whatever its original function and setting, it ranks among the finest surviving Greek animal bronzes from the late Classical and early Hellenistic decades.

Condition: All four legs broken off, as is right horn. Tail, which curled left upward, is broken away, except for a remnant of the tuft which adheres to the rump. Shiny, dark to light olive green patina. DGM

Bibliography: Unpublished.

Comparative literature: Richter, *Animals*, p. 66, fig. 103, pl. XXXIV; C. Kraay and M. Hirmer, *Greek Coins* (New York: Harry N. Abrams, 1966) nos. 251-254, p. 308, pls. 86-88; B. Schmaltz, *Metallfiguren aus dem Kabirenheiligtum bei Theben* (Berlin: Walter de Gruyter, 1980) pp. 87-88, nos. 346-349, pl. 20; Comstock and Vermeule, *MFA Bronzes*, p. 86, no. 92 (64.510), also lion and boar, pp. 308-309, nos. 434-435 (10.162, 10.163).

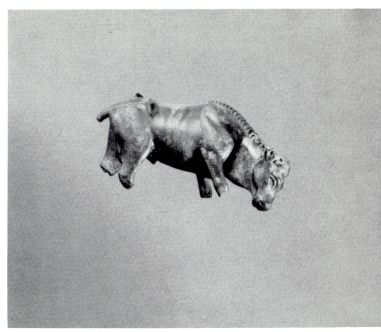

144

145 Wild Boar

Bronze, solid cast. Hellenistic or Roman. H. 9.3 cm.; W. 4.2 cm.; L. 6.4 cm.

This small bronze boar takes an attitude characteristic of the ferocious beast: front legs planted stiffly forward, rear legs slightly bent, head turned to its side, short tail curled over the back. Its alertness is indicated by the pricked ears and its aggressiveness by the open mouth from which protrude its up-curving tusks. This posture, at once offensive and defensive, is matched by the ferocity of the animal's expression, exemplified by its craggy brows and piercing eyes with their drilled pupils. Its short bristly hair is rendered by incised dashes, the razorback spine and mane-like tufts around the face by wispy ridges in low relief. The boar's body, usually ungainly, is here lank and muscular.

The wild boar (*Sus scrofa*) was the most dangerous of the beasts that roamed the ancient countryside and the most challenging to hunt. Hence, it was usually tracked by a large entourage of men and hounds, and such expeditions often assumed mythic proportions, such as the famous Calydonian boar hunt. This theme was especially popular in early Attic vase painting, appeared in the pediment of the Temple of Athena Alea at Tegea (ca. 370 BC), and later on Roman sarcophagi. In terms of

145

146 *Pig Rattle*

Terracotta, cream colored. Cypriote, 4th century BC. H. 7.7 cm.; L. 13.2 cm.; Diam. of body 5.9 cm.

This hollow, terracotta figure is made of a semi-course, cream colored clay. Its stout cylindrical body was thrown on the wheel along with the head and snout. The stubby conical legs, short curly tail, spinal ridge, and triangular ears were all handmade and hastily added. The eyes and mouth are pierced through to the interior, perhaps acting as vents in the firing process. Deep slashes indicate the bristles covering the ears and upper body, while incised lines delineate the arched brows and mouth. The face is irregularly stippled. Overall the workmanship is rough and somewhat hasty resulting in an imbalanced stance with the rear left leg well off the ground. Inside are loose, small clay balls.

While mold-made pigs are fairly common in mainland Greece—where they perhaps served as less expensive substitute dedications in sanctuaries and graves, the wheel-made variety is common in Cyprus. Closely related examples, all from Cyprus, can be found in the Cesnola collection, in the British Museum (A 446), in the Ashmolean (1933.1689), and in the Cyprus Museum (Room XIV, Case D). In the last two examples the ears rather than the snout are pierced. Similar pigs of unknown provenance are in the museums of Munich (425), Berlin (University E2), and Dresden (ZV2814), and yet another resides in a private collection in Basel. That these Cypriote rattles were not restricted to porcine forms is indicated by a wheel-made bird of similar fabric formerly in the Cesnola collection and now in the Metropolitan Museum in New York (74.51.840).

The spherical balls on the inside produce a distinct rattle, and hence such objects may have served as toys. Since both terracotta pigs and rattles have been found in children's graves in mainland Greece, this interpretation seems plausible.

Condition: No signs of wear; tip of left ear and end of tail missing. JN

style the tendency in earlier Greek art is to depict the boar facing forward with a smooth body and only the dorsal bristles incised. Hellenistic boars are more naturalistic, especially in the treatment of the hair, and their poses are more dynamic. This practice continued in Roman times, and so the Mildenberg bronze boar with its tufted mane and hatched body could belong to either epoch. For an Attic painted boar, see [100].

Condition: Dark green to reddish brown patina; right leg reattached. JN

Bibliography: Unpublished.

Comparative literature: Denison Bingham Hull, *Hounds and Hunting in Ancient Greece* (Chicago: University of Chicago Press, 1964) pp. 103-105; G. Daltrop, *Die kalydonische Jagd in der Antike* (Hamburg: Parey, 1966); Gutram Koch, *Die mythologischen Sarkophage,* Teil 6: Meleager (Berlin: Gebr. Mann, 1975); Bernhard Andreae, *Die römischen Jagdsarkophage* (Berlin: Gebr. Mann, 1980) pp. 108-110; Richter, *Animals*, pp. 23-25, pls. 36-38; Toynbee, *Animals*, pp. 131-136.

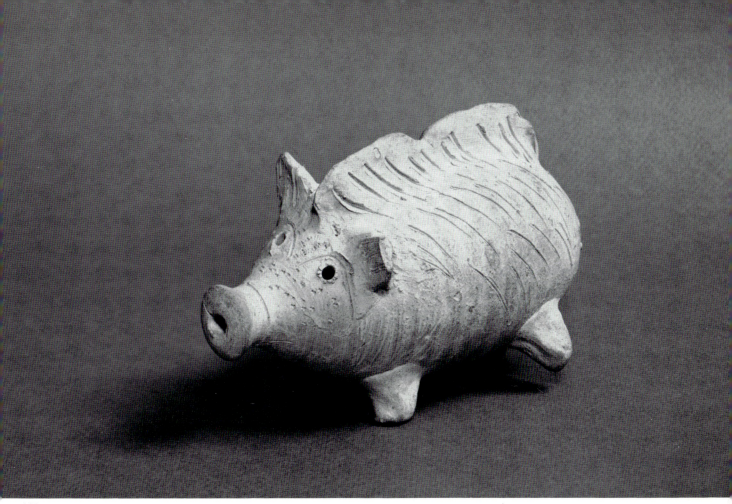

146

Bibliography: Unpublished.

Comparative literature: Pinney and Ridgway, *Aspects*, pp. 238-239, no. 116; Louis Palma di Cesnola, *Cyprus* (London: John Murray, 1877) p. 99, pl. VIII; H.B. Walters, *Catalogue of the Terracottas in the Department of Greek and Roman Antiquities, British Museum* (London: British Museum, 1903) p. 68, no. A 446; Oxford University, Ashmolean Museum, Department of Antiquities, *Animals in Early Art* (Oxford: Ashmolean Museum, 1978) p. v, no. 26; Anita E. Klein, *Child Life in Greek Art* (New York: Columbia University Press, 1932) pp. 5, 46, n. 44, pl. IV A; Bloesch et al., *Das Tier*, p. 47, no. 288, pl. 48; Donna C. Kurtz and John Boardman, *Greek Burial Customs* (London: Thames and Hudson, 1971).

147 *Black-Glazed Boar Askos*

Earthenware, fired brownish orange. Apulian, ca. 320–290 BC. H. 9.5 cm.; W. 6.3 cm.; L. 16.1 cm.; Diam. of mouth 2.1 cm.

This container is in the shape of a fat swine, probably a boar, which sits on its haunches. The figure is covered with black glaze which extends to the channeled handle on the animal's back and the vase's mouth (almost a small funnel) on top of its head. White overpaint is used for the tusks, eyes, a diamond-shape marking on the forehead, and for the crosshatching on a reserved band which encircles the pig's belly. The bristles extending along the spine, under the handle, and around the vase's mouth were incised before the clay was glazed. Other incisions appear on the hind feet and on the curled tail. The creature's snout is perforated by three small holes.

Approximately a dozen close parallels and several related examples are known for this vase. Clearly this type is closely affiliated with other animal *askoi* like [148]. Those with known provenance are, with few exceptions, from Italy and were found in funerary contexts.

One of the puzzling features of many of these vases is the ribbon-like band encircling the swine's belly. Mingazzini, who has listed several examples in connection with his publication of Villa Giulia 50575 (the Mildenberg vase's closest parallel), suggests that the band is similar to those often shown on animals, including swine, intended for sacrifice. Pigs were often sacrificed to the goddess Demeter. It should be noted, however, that certain species (e.g., modern Hampshires) have a distinct stripe as part of their natural coloring. Perhaps such banded pigs are a particular kind of pig which the ancient artists were trying to indicate. Supporting this idea is the fact that the white hatch marks on the Mildenberg example (and others) give the impression of hair, not a sacrificial fillet. Depictions of certain boars in later manuscripts do, in fact, show more realistic versions of our species with its characteristic white stripe.

Condition: Minor surface pitting. Left ear missing; right ear chipped. Small chips on front hooves. RDD

Bibliography: Unpublished.

Comparative literature: P. Mingazzini, *Vasi della Collezione Castellani* II (Rome: "L' Erma" di Bretschneider, 1971) 232-234, no. 802, pl. CCXIV, 5; Bloesch et al., *Das Tier*, p. 47, no. 287, pl. 48; *Greek Pottery from South Italy,* sale cat. (London: Charles Ede, 1973) no. 38; *CVA* Fogg-Gallatin Coll. (U.S.A. 8) pl. 63,7; Toynbee, *Animals*, pp. 134-135; M. Salmi, *La miniatura italiana* (Milan: Banca Nazionale del Lavoro, 1955) pl. XXIV, B.

148 *Black-Glazed Dog Askos*

Earthenware, fired brownish orange. Apulian, ca. 320–290 BC. H. 10.6 cm.; W. 6.1 cm.; L. 16.5 cm.; Diam. of mouth 3 cm.

The vase, in the shape of a dog sitting on his haunches, has a small mouth and channeled handle mounted on the animal's back. The pouring spout is a small hole in the dog's mouth. The facial features, ears, and paws are modeled but not distinguished by applied color. The entire vase is covered with black glaze.

This vase, along with its close relative [147] belongs to a black-glazed Apulian menagerie. Some of these animals, like those in the shape of a cat or dog, are pouring vases. Others, the swine *askoi*, were probably meant to sprinkle their contents.

Condition: Surface cracks especially around left hind foot and right haunch. Flaking on vase's mouth and the animal's ears and paws. RDD

Bibliography: Unpublished.

Comparative literature: P. Baur, *Catalogue of the Stoddard Collection...* (New Haven: Yale University Press, 1922) pp. 226-227, no. 454, fig. 101; *CVA* Fogg-Gallatin Coll. (U.S.A. 8) pl. 63,8.

148

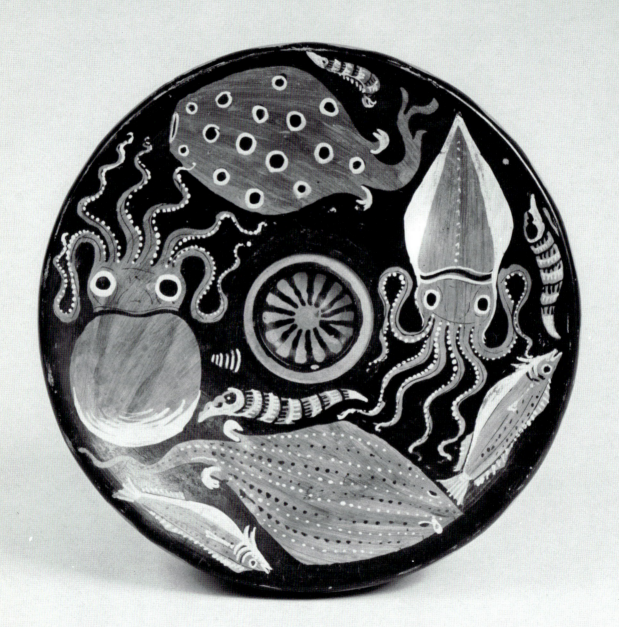

149

149 Fish Plate

Earthenware, fired pinkish tan. Apulian, ca. 320–300 BC. H. 6.3 cm.; Diam. 24.7 cm.; Diam. of foot, 9.2 cm.

Ten colorful sea creatures swim counterclockwise on the concave surface of this large fish plate. Their bodies are painted in dilute glaze with markings often added in white and yellow. A squid (*Loligo vulgaris*) appears at the right in the "3 o'clock" position. The artist has indicated only six of the standard eight sessile arms and omitted completely the two longer tentacles. There is an abundant use of white overpaint for the caudal fins, for markings on the head and around the eyes, and for the suckers on the arms. To the right are a small shell and a mackerel, probably a Spanish mackerel (*Scomber colias*). Above, in the "12 o'clock" position, is a large electric ray (*Torpedo marmorata*) whose black spots are outlined in white. A small creature, perhaps a shrimp, swims between the ray and the plate's rim. Swimming in the "9 o'clock" position is a large octopus; again the artist has omitted two of the normal eight tentacles. At the bottom of our figure is a spotted skate (*Raia batis*). Two shells and a second mackerel flank this creature. Relief lines are used on the tentacles of both octopus and squid and on the two mackerels.

The wide rim of this plate is decorated with a perfunctory leaf border in reserve. At the center of the plate is a small depression (Diam. 4.7 cm.) hastily decorated with fourteen rays in reserve. Such depressions, characteristic features of fish plates, were almost certainly used to hold the fish sauces and dips so popular in antiquity. These were served with morsels arranged around them on the plate's concave surface. The best-known sauce, *garum*, was made from mackerels like the ones illustrated on this plate.

Although red-figure fish plates appear in Attica as early as the mid-fifth century BC, they were not popular until the South Italian workshops begin to produce them in quantity during the last decades of the fourth century. The marine creatures depicted on them are often stylized but usually recognizable.

Some scholars, notably Schefold, have proposed that fish plates were used at funerary banquets; the fish symbolize the sea across which the soul travels to the afterlife. Others believe that the plates are simply decorated with subjects appropriate to their mundane function as seafood platters. See also [103, 125, 126].

Condition: Intact. Some surface abrasion on rim; large, deep scratch on the skate repaired and repainted. Overpaints are worn thin, especially on the squid. RDD

Bibliography: Unpublished.

Comparative literature: L. Lacroix, *La faune marine dans la décoration des plats à poissons* (Verviers: Lacroix, 1937); A. D. Trendall, review of Lacroix, *JHS* LVII (1937) 268-269; K. Zimmermann, "Unteritalische Fischteller," *Wissenschaftliche Zeitschrift der Universität Rostock* XVI (1967) 561-570; R. Hampe and H. Gropengiesser, *Aus der Sammlung des Archäologischen Institutes der Universität Heidelberg* (Berlin: Springer, 1967) pp. 68, 109, pl. 28; K. Schefold, *Kertscher Vasen* (Berlin: Keller, 1930) p. 11, fig. 1, p. 147; D.M. Robinson, *Excavations at Olynthus* V (Baltimore: Johns Hopkins, 1933) nos. 231-232, pl. 113, XIII (1950) nos. 73-74, pls. 80, 92; *CVA* Capua 1 (Italy 11) pls. 1-6.

150 Lekanis Lid with Beribboned Duck

Earthenware, fired pinkish tan. Apulian, ca. 320–300 BC. H. 10.8 cm.; Diam. 23.2 cm.; Diam. of knob, 8.8 cm.

On side A, a large duck walks to the left. His left wing is raised to reveal colorful feathers and markings which contrast effectively with his white body. Tail feathers, bill, and eye are painted in dilute slip. Around his neck he wears a yellow ribbon and holds a white one in his mouth. A small flower blooms in the field below his breast; a rosette floats above his right wing tip.

On side B, a woman sits with her body in three-quarter view facing right but turns her head to the left. She wears a *chiton* belted at the waist. Her hair is worn in a *kekryphalos* with unfurled fillets. She wears bracelets, necklace, diadem, and small pins, all painted in white. She holds a large basket in her left hand. Remnants of a flower and some fillets are in her right hand. A large stylized flower appears below her and a floating *patera*-like object with fillets is painted above her feet.

The sides are separated by large reserved palmettes, the leaves of which spring from semicircular hearts. The central depression on the knob is decorated with a simple ray pattern in black glaze. The knob's rim is reserved.

The *lekanis* was a popular shape in South Italian pottery workshops and so numerous decorated lids survive. Our vase is a typical example of the format used: large figures (often profile heads of women) separated by large palmettes. The subject of side B appears with monotonous regularity on many vases from Apulia and Campania. The duck (or goose?) on side A is not as frequently employed. Precisely what either subject means and why they should decorate a *lekanis* lid is unknown. The style of our lid appears to be related to the "Menzies Group" of late Apulian painters.

Condition: Paint well preserved; some wear on rim and knob, the latter cracked but restored. Several large cracks on the lid. Restorations on side B: portions of woman's hips, knees, and the lower hem of her dress; central portion of the basket and areas of the field below it and below the woman's right arm. RDD

Bibliography: Unpublished.

Comparative literature: G. Dareggi, *Vasi apuli nella Collezione Magnini a Deruta* (Rome: De Luca, 1975) p. 36, no. 40, pl. XXVI, 3; A. D. Trendall in *Taranto nella civiltà della Magna Grecia: Atti del X° Convegno di Studi sulla Magna Grecia* (Naples, 1971) p. 262; A.D. Trendall, *Notes on South Italian Red-figure Vase-Painting* (Melbourne: La Trobe University, 1975) 28; *CVA* Capua 1 (Italy 11) pl. 49, 18.

150 Side B

150 Side A

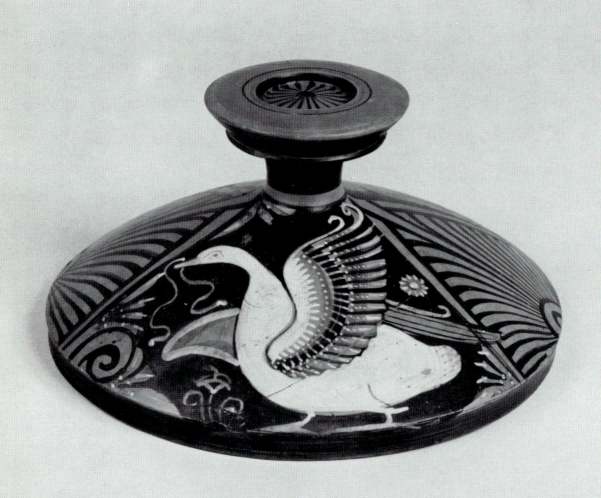

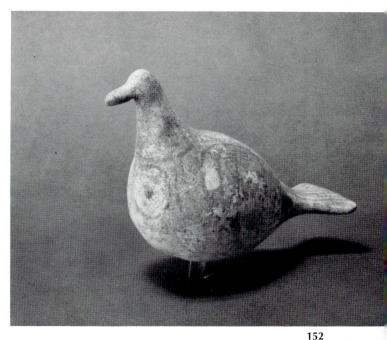

151

152

151 Dove

Terracotta, fired tan. Canosan, late 4th to 3rd century BC. H. 7 cm.; Max. W. 5.3 cm.; L. 15 cm.

This solid terracotta dove is handmade of a tannish clay and coated with a chalky white slip. There is little articulation of its ovoid body with the exception of two parallel ridges down its back and the flat ogival wings which were added separately. The fan-shaped tail is slightly upturned and balances the slender abstract neck, head, and long beak at the other end.

A cylindrical hole in the base indicates that this bird once served as a plastic ornament on a South Italian vase. The most common vase shape with such decoration is the *sphageion*, a local type which is found primarily in Canosa, a town in northern Apulia. A globular vase with double vertical handles and widely splayed mouth, the *sphageion* was often heavily incrusted with Tanagra-like figurines and relief appliqués (see [137]). Doves are generally found perched on the handles, as on a Canosan vase in Gotha (Ahv. 146). For a painted example, see [152].

Condition: Intact; surface incrusted and discolored; head and tail worn. JN

Bibliography: Unpublished.

Comparative literature: CVA Gotha 2 (Germany 29) p. 39, pl. 86, 3–5; cf. also the duck in the Newark Museum (50.722) published in Pinney and Ridgway, *Aspects*, pp. 118–119, no. 56.

152 Painted Dove

Terracotta, fired tan. Canosan, late 4th to 3rd century BC. H. 8.8 cm.; Max. W. 5.2 cm.; L. 16 cm.

While similar in function and fabric to [151], this dove has painted instead of applied decoration. Red is used for the ten divisions of the tail, the two lateral stripes at its base, the two parallel stripes down the dove's spine, the band around its lower neck, the dot and vertical lines on its breast, and its beak. The wings, also decorated in red, are ovoid with short upper feathers and longer ones tapering towards the tail. The circle at the center of the breast and the eyes are painted a brownish-black. These colors, added after firing, make a nice contrast to the white slip and add a decorative effect to the otherwise simple, abstract shape.

The dove is looking slightly to its right and so presumably sat on the left handle of a Canosan vase. Cf. [151, 153].

Condition: Intact; paint chipped in places. JN

Bibliography: Unpublished.

Comparative literature: See [151].

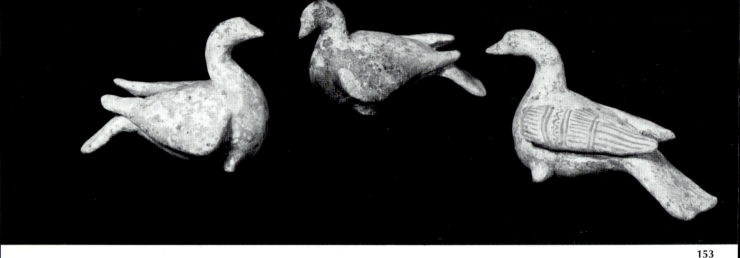

153 Three Canosan Doves

Earthenware, fired pinkish tan. Canosan, late 4th to 3rd century BC.
(a) H. 6.4 cm.; W. 5.1 cm.; L. 10 cm.
(b) H. 5.5 cm.; W. 5.2 cm.; L. 9.6 cm.
(c) H. 6.7 cm.; W. 5.8 cm.; L. 9 cm.

These three terracotta doves are different from the foregoing ones [151, 152] in that they are slightly smaller and their hollow bodies have greater added articulation. Stubby conical feet are tacked on the bases, the wings project from the sides of the body and flutter out behind, and the tails are turned downward, giving added stability to the figures. However, the fabric is the same tan color with an added white slip, and the cylindrical holes on the undersides indicate that they served the same purpose, as added decoration on one or more Canosan vases.

The longest of the three birds (a) preserves its painted decoration better than the others. There are traces of red on the beak, breast, wings, and tail. The decorative design on the dove's left wing is quite distinct: upper wing feathers separated by a dotted wave pattern between transverse bands and longer lower feathers stretching to the tip of the wing.

Condition: Worn and encrusted; slip and paint largely missing. JN

Bibliography: Unpublished.

Comparative literature: See above [151].

154 Earring with Bird Pendant

Gold. Greek, Hellenistic, 3rd century BC. H. 2.9 cm., Diam. of disk 0.8 cm., L. of bird 1.8 cm.

The disk and pendant earring is a common type in the Hellenistic Period. On this example the rosette disk is rimmed on the front by a raised, beaded wire. Within are a rope braid, consisting of two twisted wires laid side by side, and a rosette with nine petals. The center would have held an inlaid colored glass, now missing. The wire hook is soldered to the back of the disk and passes through the hoop attached to the bird's back. Like the disk, the bird is hollow. In general the bird resembles a dove with the exception of its curved hawk's beak, which, however, is a deformation that can occur in nature. Added separately are the scaled feet with three toes in front, one in back. Its feathers are finely engraved, those on the neck, body, and wings being differentiated. The empty eye sockets would have held inlaid stones or glass.

This variety of Hellenistic earring often took for its pendant a winged, flying figure, such as Nike (Victory), Eros, or Zeus as an eagle abducting Ganymede. Such types would flutter appropriately when the wearer moved her head. Birds, usually doves or eagles, were also common, probably for the same reason. On the majority of bird pendants, the wing markings are added in filigree, rather than engraved. However, a dove earring (not a pendant) from Ruvo and now in the British Museum (1923) as well as one in Toronto (16495) have incised details. The rosette disk

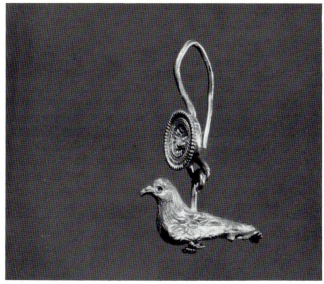

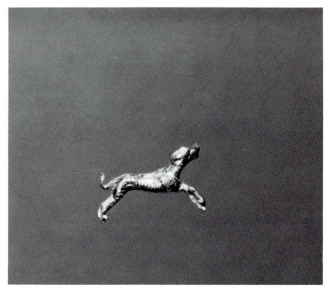

154

155

is very close in style to those on pendant earrings with Erotes from Tarentum and may suggest a provenance for the Mildenberg singleton.

Condition: Missing inlays; slightly dented, especially tail which has become partially detached. JN

Bibliography: Unpublished.

Comparative literature: R. A. Higgins, Greek and Roman Jewellery (London: Methuen and Co., 1961) pp. 165-168, pl. 48; Herbert Hoffmann and Patricia F. Davidson, Greek Gold: Jewelry from the Age of Alexander, exhib. cat. (Brooklyn: The Brooklyn Museum, 1965) pp. 84-94, nos. 13-18; Adolf Greifenhagen, Schmuckarbeiten in Edelmetall, II (Berlin: Gebr. Mann, 1975) pp. 48-53, pls. 40-42; F. H. Marshall, Catalogue of the Jewellery: Greek, Etruscan, and Roman in the Department of Antiquities, British Museum (London: Trustees of the British Museum, 1911) p. 210, no. 1923, pl. XXXIII; Giovanni Becatti, Oreficerie antiche dalle minoiche alle barbariche (Rome: Istituto Poligrafico dello Stato, 1955) pp. 198-199, nos. 400, 402-403, pl. CVI.

155 Ornament in the Shape of a Dog

Gold. Greek, probably Early Hellenistic, ca. 300 BC.
H. 0.08 cm.; W. 0.03 cm.; L. 1.4 cm.

This minute gold dog holds his head high and leaps forward vigorously. Short parallel lines are chased over most of his body to indicate hair. Details of the head—especially the eyes, muzzle, and ears—are carefully modeled. The ornament is composed of two nearly identical halves, each solid-cast, brazed together. There is no trace of solder. Under magnification a small seam running around the figure indicates that the two halves are not precisely aligned. The left half of the dog's body is slightly higher than the right half. A very slight gap separates the front legs; their flat inner surfaces again indicate the solid-cast nature of each half. The back legs and each half of the tail are joined.

The exact function of this piece is difficult to ascertain. The scale and material suggest that it once formed part of a piece of jewelry, but there is no sign of attachment (e.g., for a suspension loop) or adhering fragment of another element (e.g., wire frame). There is one clue: the dog's right paw is missing. This could have been the point of attachment to a larger element. Similar dogs chase hares on a spectacular gold Greek pectoral from a Scythian tomb now in the Kiev Historical Museum. Here the animals are soldered to a frame creating an open frieze-like arrangement. Small gold lions also appear in the running or leaping position of the Mildenberg dog. These are often incorporated on complex Hellenistic earrings or the head of elaborate pins. There are a number of Hellenistic necklaces and diadems with abundant openwork floral motives whose gracefully convoluted tendrils offer sanctuary for small gold figures of cupids, animals, and even insects. Our energetic dog may once have pursued a miniature hare through the golden vines of such a piece of Greek jewelry.

Condition: Excellent. The right front paw missing; some brown incrustation on muzzle, neck, belly, and tail. RDD

Bibliography: Unpublished.

Comparative literature: Farkas, Piotrovsky, et al., *Scythians: Treasures,* p. 126, no. 171, pl. 31; M. Artamonov, *The Splendor of Scythian Art* (New York: Praeger, 1969) fig. 295; H. Hoffmann and P. F. Davidson, *Greek Gold: Jewelry from the Age of Alexander,* exhib. cat. (Brooklyn: The Brooklyn Museum, 1965) pp. 60-62, no 3, pp. 181-187, nos. 69-70.

156 *Hoop Earrings with Lion Head Finials*

Gold. Greek, 3rd century BC.
(a) H. 1.90 cm.; Diam. 1.15 cm.
(b) H. 1.95 cm.; Diam. 1.05 cm.

Three pairs of tapering, hollow gold tubes twisted about each other are further braided to form a loop, the end of which is hooked. At the other end, a hollow lion's head is attached to a flat plate which forms the mane. The modeling of the animal is particularly strong. The lion grasps a solid ring in his mouth. The base of the flat plate joins a collar which encloses the twisted loop wires. The collar is decorated with a single filigree scroll flanked by smaller spirals made of rolled wire. Single granules punctuate the gaps between the spiral filigree. These elements are framed by borders of larger twisted wires flanked by plain wires. Plain wires outline a row of leaves at the bottom.

For this type in general see the comments for [141]. Similar examples have been found in southern Italy, especially at Tarentum.

Condition: Large spiral tubes dented; on (b) a small filigree spiral of the collar decoration is missing. RDD

Bibliography: Unpublished.

Comparative literature: H. A. Cahn, *Art of Ancient Italy,* sale cat. (New York: Emmerich Gallery, 1970) p. 42, no. 63; A. Greifenhagen, *Schmuckarbeiten in Edelmetall,* II (Berlin: Gebr. Mann, 1975) pl. 44, 4-5; H. Hoffmann and V. von Claer, *Antiker Gold- und Silberschmuck* (Mainz: Philipp von Zabern, 1968) pp. 113-114, nos. 71-72.

156

157

157 Reclining Lion Attachment

Bronze, solid cast. Graeco-Roman, from the
Hellenized East (?), 3rd–1st centuries BC or later.
H. 2.7 cm.; W. 2.5 cm.; L. 4.9 cm.

No ferocious king of the jungle does this lion seem but
instead a tame, almost cuddly, household pet, lying at ease
in his den, his head low and relaxed rather than raised
attentively, his mouth closed. He rests on his belly with his
forepaws extended, his gaze directed forward and slightly
left, and his tail curled about his left haunch. A short inner
mane encircles the lion's face like a snug, round collar,
while the outer mane descends to his shoulders in a series
of round little mounds. Similar stylization on the lion's belly
recalls hair patterns on the bellies of Near Eastern lions. A
somewhat ungainly appearance—due to the round head
which seems disproportionately large for the body—only
heightens the appeal of this piece.

Small recumbent lions ornamented the rims of vessels,
the legs of stands, and the edges of pieces of furniture in
antiquity, especially in Archaic and Classical times. However,
the placement of what appear to be attachments—a small
one on the flat underside and another non-connecting one
in the middle of the lion's back—seems unprecedented in
such contexts. Perhaps this lion comes from a utensil or
object with lions pressed between two bands, in a manner
similar to that seen on the famous Scythian gold comb.
There five lions recline in a row in a predella register
above the comb teeth and below the combat scene of
the main register.

Rough cast as the Mildenberg lion is, with little
subsequent tooling, it is difficult to analyze stylistically.
Certainly, the plastic, almost impressionistic, handling of
the bubbly mane together with its natural meshing with the
lion's coat at the back, would suggest a date no earlier than
the Hellenistic Period, but the piece could also be much
later provincial Roman. In either case, however, this lion is
almost certainly from the East, for it reveals a round face
with a short muzzle, a collar-like inner mane, and a rather
fleecy outer mane and belly—all of which ultimately reflect
Mesopotamian derivation. Close in pose and style to this
lion is a recumbent lion in Boston, which comes from
Istanbul and is tentatively dated to the fourth century BC or
later and described as an "Anatolian provincial work in the
East Greek style."

Condition: Intact. Medium green patina. KPE

Bibliography: Unpublished.

Comparative literature: Comstock and Vermeule, MFA Bronzes,
p. 308, no. 433A; Farkas, Piotrovsky, et al., Scythians: Treasures,
p. 109, no. 71, pls. 12-13; Brown, Etruscan Lion, pp. 15f., pl. 61f
(eighth-century BC Assyrian bronze weight from Khorsabad,
now in Paris).

158 Cow

Bronze, cast (lost wax). Mainland Greek, said to be
from Thessaly, first half of 4th century BC. H. 6.5 cm.;
W. 4. cm.; L. 11.3 cm.

This cow walks slowly forward, with its left front foot
advanced, the left rear foot drawn back. She raises her head
slightly, turning it to her left. Horns are absent. She has a
massive body, with pendulous, rounded stomach and
massive dewlap. The tension of skin stretched over the
internal anatomy of muscle, organs, and skeleton,
responding both to gravity and motion, is masterfully
captured through surface modeling which, while rounded,
is highly specific and naturalistic. The placid, ponderous,
indeed bovine, character of the animal emerges in this
naturalistic but not yet veristic statuette, one of the finest
late Classical Greek animal bronzes known. Specific details
like the eyes, udder, and tail are rendered totally by
modeling; there is no incised decoration.

In contrast to the vast majority of Greek votive bronze
statuettes of cattle, in which a bull is represented, this
creature is clearly a cow. It thus joins a small group of cow
statuettes that recall and may indeed be derived to varying
extents from Myron's famous bronze statue of a cow,
dedicated on the Athenian acropolis. Numerous ancient
anecdotes describe the response of both human beings and
animals to its fidelity to the appearance and character of its
subject. It joins two other statuettes invoked in connection
with Myron's statue, a large bronze statuette from
Herculaneum, in the Cabinet des Médailles, Bibliothèque
Nationale, Paris (probably first century BC in date, not second
half of the fifth century BC), and a small silver cow, in a
German private collection, dated by Hoffmann to 450 BC.

The Mildenberg cow falls midway between the elongated
physique of the Cabinet des Médailles statuette and the
compactness of the silver cow. It is a mature cow, not a
heifer, that is represented here. To speak of it as a version
or adaptation—not a copy—of Myron's statue would not
be inaccurate. The masterly modeling, embodying
acute observation of the living animal in an individual
interpretation, suggests that the Mildenberg cow may have
been cast in the first half of the fourth century BC.

Condition: Intact. Left rear hoof bent upward. Surface
has been treated for spots of bronze disease. It is uncertain
whether a mass of bronze between the forelegs is part of
the dewlap or a casting flaw. DGM

175

Bibliography: Unpublished.

Comparative literature: For Myron's cow, s.v. "Mirone," *EAA* v (1963) 113; Richter, *Animals,* p. 65, fig. 98, pl. XXXII (Cabinet des Médailles statuette); H.W. Hornbostel, *Kunst der Antike: Schätze aus norddeutschen Privatbesitz* (Mainz: Philipp von Zabern, 1977) p. 467, no. 403 (miniature silver cow); for Myron's cow in connection with the development of Greek bronze votive statuettes of bulls, B. Schmaltz, *Metallfiguren aus dem Kabirenheiligtum bei Theben* (Berlin: Walter de Gruyter, 1980) p. 111 and *passim.*

159 *Cow and Calf*

Terracotta. Greek, Hellenistic. H. 10.5 cm.; W. 8.1 cm.; L. 27 cm.

This hollow, mold-made terracotta is open below and unmodeled on the back where there is a circular vent hole. The figure is a cow standing to the left on a short rectangular base, with a suckling calf underneath in lower relief. It serves to fill the void between its mother's legs. The forequarters of the cow are turned towards the viewer. As a result, three of the four legs are visible and the head and chest are modeled in the round. Crowning the head are widely spaced horns and round ears. The nose and mouth are incised. Slightly top heavy with its prominent dewlap, the hefty body rests

158

on short legs and cloven hooves. The calf appears to be kneeling on its forelegs.

The figurine was apparently painted white with certain details such as the horns and spot on the forehead in black. As a result of intense firing or burning, the surface has a shiny, glazed appearance.

The motif of the cow suckling her calf is an old one, occurring first in Babylonian art, and with great frequency in Phoenician ivories. It appears as a Greek coin-type, first in Euboea, and for three centuries in Corcyra. While I know of no exact parallels for this piece in terracotta, a goat nursing her kid in the Louvre (CA 1655) is formed in the same way, i.e., half relief with an open base. Since it is dated to the late Hellenistic Period, it provides a likely date for the Mildenberg cow and calf.

Condition: Restored from numerous fragments. Burned, paint slightly chipped. JN

Bibliography: Antiquities (Part I), sale cat. (London: Christie's, 10 July 1974) p. 26, no. 75, pl. 21.

Comparative literature: R. D. Barnett, *A Catalogue of the Nimrud Ivories,* rev. ed. (London: British Museum, 1975) pp. 143-145, 173-174, pl. 5; Colin M. Kraay, *Archaic and Classical Greek Coins* (Berkeley and Los Angeles: University of California Press, 1976) pp. 92,128, pls. 15, no. 272, 24, nos. 446-451; Simone Besques, *Catalogue raisonné des figures et reliefs en terre-cuite grecs étrusques et romains,* III (Paris: Editions des Musées Nationaux, 1972) text p. 72, no. D 449, pl. 98, c.

159

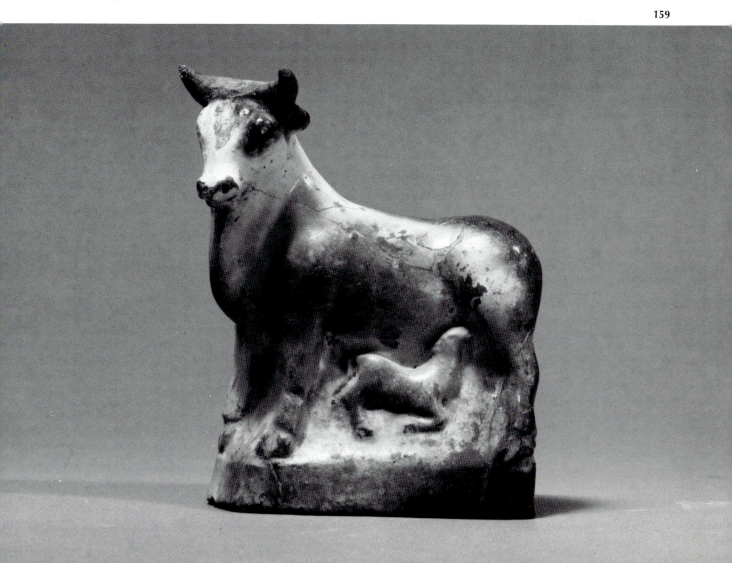

160 *Frog*

Bronze, hollow cast. Hellenistic, 3rd–1st centuries BC. H. 2.4 cm.; W. 6.5 cm.; L. 5.4 cm.

The frog or toad squats on his hind legs. He lifts up his head with two lumps of metal (bronze?) representing the globular eyes; his forelegs are raised showing their webbed toes. In order to make the wax casting easier and lighter, an oval cavity was left underneath. The cast was left without retouching and slightly pitted by cooling. A very nice warm patina adds to a quasi-pictorial effect.

Possibly the frog was a part of an ensemble involving cave or fountain deities, or the mythological story of Latona. On a journey, the goddess stopped at a pond to satisfy her thirst, but the peasants gathered there preventing her from drinking. In revenge, Latona had all of them turned into frogs.

Condition: Heavily corroded and deeply pitted with wax fills for cosmetic purposes. Reddish-brown and green patina. PV

Bibliography: Unpublished.

Comparative literature: None.

161 *Snake (?)*

Bronze, cast solid, perhaps in bivalve mold. Greek or South Italian, 4th or 3rd century BC. L. 4.4 cm.; Max. W. 2.6 cm.; Th. 0.4 cm.

This flat, wide snake forms an S-shape. Its body is a compressed oval in section. The seam produced by the two-piece mold in still visible, extending around the entire periphery of the piece. Except for the head, the upper part of the body is completely covered by plastically rendered scales, arranged in transverse rows, six to eight scales per row, becoming progressively smaller to either side. Wide transverse segment-like scales flanked by smaller scales on either side, extend the entire length of the underside. Retouched after casting, the details of the head are rendered with great delicacy and exactness: oval incised eyes with punctate pupils flank an oval area of scales, bisected by a longitudinal line, on top of the head. The mouth, along the edges of the underside of the head, is chevron-shaped: two delicate ridges enclosing a delicate channel.

Serpents occur sporadically in Greek art from the Bronze Age on, where they have cult significance; plastic snakes coiling up the handles and around the rims of Late Geometric Attic funerary *amphorae* may allude to the underworld. Archaic Boeotian workshops produced plastic vases in the form of coiled serpents. Votive bronze serpents

160

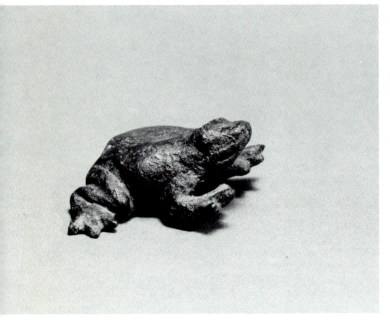

161

162

are known from the Asklepeion at Pergamum and elsewhere; these can be either coiled or extended full length. To my knowledge, the Mildenberg serpent is unparalleled among bronze serpent statuettes so far known. It is possible that the bronze caster had in mind not a serpent, but a legless lizard, the so-called "blind worm." The extreme fidelity of reproducing the creature's surface anatomy suggests a date in the late Classical or early Hellenistic Period.

Condition: Some pitting exists upon the top surface, at the curve just forward of the tip of the tail. Some wear is visible on the scales of the snake's back, as well as on the transverse scales under the chin. Dark, shiny olive-green patina. DGM

Bibliography: Unpublished.

Comparative literature: K. A. Neugebauer, *Katalog der statuarischen Bronzen im Antiquarium II: Die griechischen Bronzen der klassischen Zeit und des Hellenismus* (Berlin: Akademie-Verlag, 1951) pp. 38-40, nos. 26, 27, pl. 17; Comstock and Vermeule, *MFA Bronzes,* p. 61, no. 63 (undulating snake, ca. 400 BC); W. Hornbostel, *Kunst der Antike: Schätze aus norddeutschen Privatbesitz* (Mainz: Philipp von Zabern, 1977) p. 89, no. 59 (coiled snake, fifth century BC).

162 *Spiral Cobra Bracelet*

Gold, Roman, 1st century BC–AD 1st century. W. of band 0.8 cm.; Diam. of bracelet 7.8 cm.

A thick, flat coil of gold terminates at one end in the head of a cobra and at the other end in the snake's undulating tail. The head is a long triangle with large scales cut in deeper relief than the simple crosshatched scaling of the neck and tail. The head scales of this cobra and [163] most closely resemble those of the *Naja nigricollis* (see [48]). The eyes are deeply punched circles, the nostrils, deep holes, The tail and neck sections are divided from the plain body by a row of shallower punched circles between two plain bands followed by a triangle of twenty-one slightly larger punched circles set like pool balls in a rack.

This is an excellent example of a well-known type of bracelet described further in [163]. Close comparisons exist in the Benaki Museum, Athens.

Condition: Excellent. APK

Bibliography: Unpublished.

Comparative literature: Dieter Ahrens, "Berichte der Staatlichen Kunstsammlungen: Neuerwerbungen," *MJb* XIX (1968) 233, no. 6, fig. 8; Berta Segall, *Katalog der Goldschmiede-arbeiten* (Athens: Museum Benaki, 1938) bracelet nos. 172-176, pp. 116-117, pls. 37-38, finger-ring no. 143, p. 105, pl. 38.

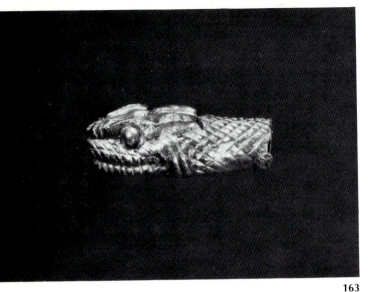

163

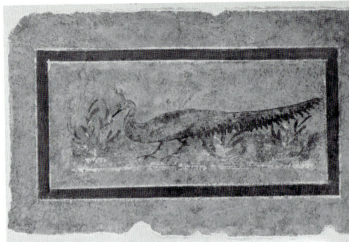

164 See also colorplate XXII

163 *Snake Head from a Bracelet*

Gold. Graeco-Roman, 1st century BC–AD 1st century.
H. 1 cm.; W. 1.3 cm.; L. 3 cm.

The cobra head was broken from a bracelet similar to [162]
except for being larger and hollow. The plates on the top of
the head are similar to those on [162] but are raised in high
relief. The eyes are bulging hemispheres; the mouth is
clearly delineated with hatchmarks for teeth. A deeply
crosshatched pattern forms the scales on the neck and
underside of the jaw. Except for fine evenly spaced
transverse incised lines, the throat is smooth.

The snake bracelet is one of the most ancient forms of
jewelry. In Egypt it was associated with the major cults of
Isis and Sarapis. The spread of these cults through the
Greek and Roman empires made the snake bracelet
especially popular in the classical world. The latest dated
examples are AD first century. Perhaps the closest example
is in the Benaki Museum, Athens. Numerous other
examples exist.

Condition: Minute cracks and dents at the left corner of
the mouth, behind the left eye, beneath the right eye, and
along the right side of the neck. APK

Bibliography: Unpublished.

Comparative literature: Berta Segall, *Katalog der Goldschmiede-
arbeiten* (Athens: Museum Benaki, 1938) p. 116, pl. 37, no. 172,
also pp. 115-118, pls. 37-38, nos. 171-179; Rodolfo Siviero, *Gli ori e
le ambre del Museo Nazionale di Napoli* (Florence: Sansoni, 1954)
p. 59, pls. 160-163.

164 *Peacock Wall Painting*

Paint on plaster. Roman, AD 1st century. H. 29.9 cm.;
L. 48.5 cm.

Set onto an ochre background and inside a red and white
frame stands an elegant, crested peacock. Posed to the
right on a white ground line, the bird is set among green
plants growing on a terrain which ranges in color from pink
to white. The body of the peacock is outlined in black, and
the same color is used for its eye, feet, and beak. The crest
and body, although not well preserved, were originally
greenish blue over brown. The long saw-toothed tail is dark
red like the frame with over-strokes of light yellow. Spots of
dark brown may indicate the "eyes" of the tail. Heavier
white is applied in dots on the peacock's face and neck and
on the plant (berries?) in front of it.

The keeping of peacocks was an aristocratic hobby in late
Republican and early Imperial times. They were imported
to Italy from India and were occasionally served at luxurious
banquets. Sacred to Juno, the peacock was appropriated by
Roman empresses as their symbol, just as their husbands
used the eagle of Jupiter. In Early Christian art it became a
symbol of immortality.

A closely related peacock, although bluer in color,
stands confronting another in a similar garden setting in a
painting found on the outside wall of a public house in
Pompeii (2195).

Condition: Broken on all sides; cracked at left; repainted
in places. JN

180

165 lamp mouth

165 See also colorplate xx

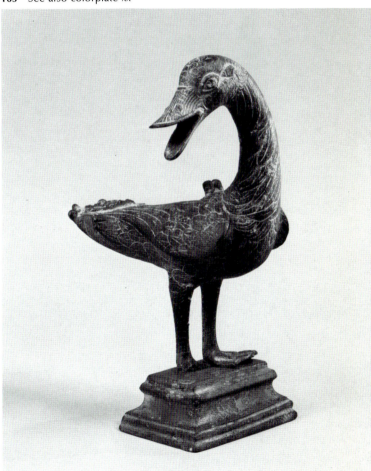

Bibliography: Unpublished.

Comparative literature: Toynbee, *Animals,* pp. 250-253; Kunsthaus Zürich; *Pompeji: Leben und Kunst in den Vesuvstädten,* exhib. (Zurich: Kunsthaus Zürich, 1974) pp. 210-211, no. 364, illus. p. 49.

165 *Duck Lamp*

Bronze, hollow cast. Roman, AD 1st century. H. 26.4 cm.; W. 14.5 cm.; L. 18.6 cm.

This magnificent duck with webbed feet firmly planted on a profiled rectangular base and befeathered body supported upon two sturdy legs functioned as a light fixture during the early Roman empire. Its body is admirably adapted to this practical purpose. An opening in the duck's back was used to fill its hollow belly with oil; an opening in its tail, to insert a wick. A comic mask—the cavernous open mouth of which serves as the wick hole—decorates the nozzle of the lamp formed within the tail of the duck, and six globular ornaments (two lost) enrich the scalloped upper edge of the nozzle. Two pierced beads with remains of a rivet near the filling hole in the middle of the back once functioned as the hinge for a leaf-shaped lid, now missing. Base and duck were cast separately and soldered together.

Practicality aside, the duck is a marvel of observation and workmanship. Having just walked onto the bank and gotten ready, so it seems, to shake dry its wings, this inquisitive and loquacious creature, momentarily distracted, halts in its footsteps, thrusts its long neck around to the right, opens its mouth wide and emits a stream of quacks. Sensitive handling—particularly of the feathers—subtle modeling, and exquisite incision overall distinguish the piece. Only an exceptional craftsman and a great lover of nature could have captured and recorded here both the beauty of the duck and the humor of a single moment in its daily routine.

Zoomorphic lamps, in terracotta as well as in bronze, were quite popular in Classical times, especially in late antiquity. Among the animals represented, the bird was clearly a favorite—perhaps because its streamlined shape could easily be adapted to lamp form. At any rate, doves, partridges, pigeons, swans, geese, roosters, and ducks were fashioned into lamps, sometimes with naturalistic feet, other times without. These bird lamps can stand on their own feet as here, rest on their bodies or on flat bases, or be suspended from chains. The majority which survive are considerably later and less realistic than this duck lamp, which should date to the first century AD, by comparison with duck lamps of that time in West Berlin and Naples. Although similar to the Mildenberg duck in technique and

general appearance, these ducks differ somewhat in stance and style.

This piece is a duck first and foremost and a lamp second, while its smaller relatives in Berlin and Naples are lamps first and ducks second. These ducks seem to glide across the water in contrast to our shore-bound one, for they do not walk upon their own two feet atop a base but instead rest directly upon their breasts with their feet tucked up beneath their bodies. Closer in conception to the Mildenberg duck is a bronze fountain figure of a raven in Naples, found at Stabiae and dating to the first century AD; this bird, which stands upon its own feet and seems about to devour an insect (in reality the pipe for the fountain), reveals a love of nature and a humor similar to that observed here.

Condition: Part of the right webbed foot, the lid for the filling hole, and two of the six globular ornaments on the nozzle are missing. Diagonal break in the neck, near which small patch has fallen out. Small hole where right leg meets body, two small gouges on right side of upper beak, rectangular patch on back of profiled base with small hole and plug above this, and small repair, presumably ancient, on upper part of tail feathers between first and second preserved globules on right side. Dull black to medium green patina. KPE

166

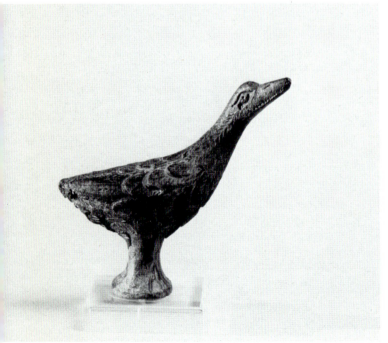

Bibliography: Unpublished.

Comparative literature: F. Schottmüller, Bronze Statuetten und Geräte, Bibliothek für Kunst- und Antiquitätensammler, XII (Berlin, 1921) 46-47, fig. 27; J.B. Ward-Perkins and A. Claridge, Pompeii A.D. 79, vol. II: The Objects Described, exhib. cat. (Boston: Museum of Fine Arts, 1978) p. 141, no. 68 (raven, inv. 4891) and p. 190, no. 211 (duck lamp, inv. 11064); S. Boucher, Bronzes romains figurés du Musée des Beaux-Arts de Lyon (Lyon, 1973) p. 158, no. 263 (cock lamp); H. Menzel, Die römischen Bronzen aus Deutschland I: Speyer (Mainz, 1960) p. 24, no. 37, pl. 35 (dove lamp); Mitten, Rhode Island Cat., pp. 196-198, no. 69; H. Menzel, Antike Lampen im Römisch-Germanischen Zentralmuseum zu Mainz (Mainz: Römisch-Germanisches Zentralmuseum, 1954) p. 112, no. 698-700, figs. 93.2-4; Toynbee, Animals, pp. 264-273.

166 Goose

Bronze, solid cast (lost wax). Roman, AD 2nd–3rd centuries. H. 7.5 cm.; W. of body 2.8 cm.; L. 8 cm.

This goose, head aggressively thrust forward, stands on a rounded base (W. 2.2 cm.; L. 1.8 cm.) with flaring foot; its legs and feet are incised on the front and sides of this stand. It has a short, stubby tail, an elongated, cylindrical neck, and a straight bill. Details are almost completely rendered by incision added after the casting; individual feathers are incised in great detail over the entire body, wings, and tail. Finer down is shown on the neck. The head has large oval eyes and an incised mouth along the base of the bill.

No geese close to this truculent bird are known to me. The extensive cold working suggests a date in the second through third centuries AD. The rendering of the feet as vestigial incised features suggests that this bronze was produced fairly late, at a time when anatomical renderings of birds and animals as well as human figures were becoming increasingly simplified. The Mildenberg goose probably served as a finial on a lid or other larger object; its shape makes it an effective handle or grip. See also [165].

Condition: Intact. Covered with a dark gray to black patina. DGM

Bibliography: Unpublished.

Comparative literature: Toynbee, Animals, pp. 261-264.

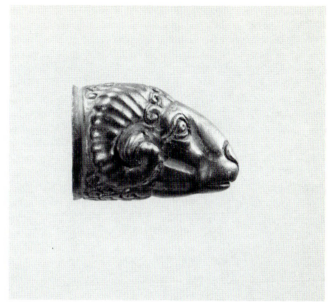

167

168

167 *Ram Head Appliqué*

Bronze relief, cast. Graeco-Roman, 1st century
BC–AD 1st century. H. 3.6 cm.; L. 4.6 cm.; Th. 1.8 cm.

Cast with a flat back, this ram's head probably once served as an applied ornament for a household item, possibly vessel, utensil, or furniture. No trace of a rivet or rivet hole is to be seen, so the head must have been soldered to whatever object it decorated. Facial features are rendered with subtlety and sensitivity, with the eye nicely rounded and set into its cavity, the pupil and brows indicated, the nose outlined by incision, and the mouth marked by a groove. Impressionistic modeling of the ram's woolly coat manages to capture the appearance and texture of fleece remarkably well. Worked in relatively high relief, the curving horn with its carinated edge encircles the pointed ear and provides a nice contrast to the smooth facial planes and the soft fleecy locks.

Skillful craftsmanship and evident feeling make a Hellenistic date possible, although the appliqué might also be an exceptionally able product of early Roman Imperial times.

Condition: Intact. Medium to dark green patina. KPE

Bibliography: Unpublished.

Comparative literature: G.M.A. Richter, *Greek, Etruscan and Roman Bronzes, The Metropolitan Museum of Art* (New York: Metropolitan Museum, 1915) p. 353, no. 1200 (ram head appliqué);

G.P. Oikonomos, "Bronzen von Pella," *AthMitt* LI (1926) 76-80, esp. pls. 8-9 ("impressionistic" mule head); J. Babelon, *Les trésors du Cabinet des Antiques, le Cabinet du Roi ou le Salon Louis XV de la Bibliothèque Nationale* (Paris, Brussels: G. Vanvest, 1927) p. 50, no. 28, pl. 16 (mule head); *The Frederick M. Watkins Collection,* The Fogg Art Museum, Harvard University (Cambridge, MA: Harvard University, 1973) pp. 81-82, no. 34 (ram head vessel handle); A. de Ridder, *Les bronzes antiques, Musée du Louvre* (Paris: G. Braun, 1913) fig. 59 (ram head cheek piece of Corinthian-style helmet).

168 *Ram Head Finial from Patera Handle*

Bronze, hollow cast. Roman, AD 1st–2nd centuries. H. 2.2 cm.; W. 3.1 cm.; L. 4 cm.; Diam. of opening 2.7 cm.

This ram's head once ornamented the end of a long, round, ribbed handle on a *patera,* a shallow round bowl or pan (often provided with a central navel or *omphalos).* These vessels were apparently used for cooking, serving, or eating food in classical antiquity, but perhaps occasionally for making ritual libations as well, as were the handleless variety of *paterae* and some considerably earlier *paterae* with different types of handles (cf. [115]). A fairly large number of *paterae,* both whole and fragmentary, including numerous handles, have survived; many of these are quite elaborate, others relatively plain. *Paterae* with ribbed cylindrical handles such as this and terminating in a head of some sort were certainly in use during the Hellenistic

Period, as securely dated remains from Pella prove; however, they continued to be manufactured into late Roman times. For the *patera* handle type just described, a ram's head appears to be the most common finial—possibly because rams figured in the ritual occasions for which some *paterae* were employed.

Well-modeled facial features and careful workmanship characterize this piece. Yet the low relief and heavy stylization here, particularly in the flat, spiral curls around the face, stand in stark contrast to the forceful and dynamic modeling of another ram's head in the Mildenberg collection [167], which is certainly closer to its Hellenistic prototype, if not indeed itself Hellenistic. Ram head finials from *patera* handles similar to the one here have been found buried in the eruption of Vesuvius in AD 79 and discovered amid Roman remains in France, Germany, Belgium, Yugoslavia, and Egypt—which suggests a date in the 1st–2nd centuries AD for this finial.

Condition: Intact. Shiny, black patina.　　　KPE

Bibliography: Unpublished.

Comparative literature: For round *patera* handles with ram head finials, G. Faider-Feytmans, *Les bronzes romains de Belgique* (Mainz: Philipp von Zabern, 1977) pp. 168-169, nos. 340, 342, pp. 176-177, 179-180, nos. 360, 363, 368, pls. 127, 138-139, 141, 146-147; S. Boucher and S. Tassinari, *Bronzes antiques du Musée de la Civilisation Gallo-Romaine à Lyon,* I (Lyon, 1976) nos. 138, 140-142 (with bibliography); M. Veličković, *Petits bronzes figurés romains au Musée National* (Belgrad: National Museum, 1972) p. 197, no. 161; Popović et al., *Bronzes in Yugoslavia,* pp. 241, 244; A. de Ridder, *Les bronzes antiques du Louvre,* vol. II: *Les instruments* (Paris, 1915) p. 138, nos. 3028-3029, pl. 106, p. 140, nos. 3049-3053, pl. 107; H.F. de Cou, *Antiquities from Boscoreale in Field Museum of National History,* Field Museum of Natural History publication 152, Anthropological series, vol. VI, no. 4 (Chicago, n.d.) pp. 187-188, no. 24410, pls. 136-138; F.B. Tarbell, *Catalogue of Bronzes, etc. in Field Museum of Natural History, Reproduced from Originals in the National Museum of Naples,* Field Museum of Natural History publication 130, Anthropological series vol. VII, no. 3 (Chicago, 1909) p. 134, no. 211; F.W. von Bissing, "Die griechisch-römischen Altertümer im Museum zu Kairo, IV: Die Bronzen," *AA* (1903) pp. 145-146, fig. 3b; E. Pernice, "Bronzen aus Boscoreale," *AA* (1900) pp. 191-192, nos. 22-27, fig. 20 (Karlsruhe, Badisches Landesmuseum, mus. neg. R 12240).

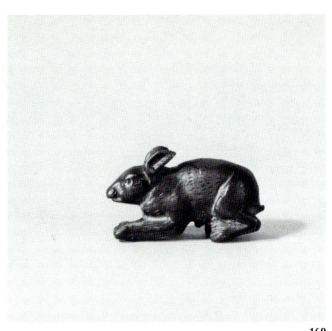

169

169　*Crouching Rabbit*

Bronze, solid cast. Roman, 1st century BC–AD 1st century. H. 2.3 cm.; W. 1.6 cm.; L. 4.2 cm.

Crouching close to the ground, ears raised attentively, eyes sighting, and nose sniffing something of interest, this plump, little rabbit seems ready to pounce—perhaps upon a fruit or nut left unattended. No generic distinction was made between hares and rabbits by the Romans, and none can be made in ancient art because the difference is not necessarily one of physical appearance but is instead one of biological makeup. Convention, however, would call the long, lean animal chased by hounds a hare (cf. [117]) and the rounder, cuter variety, often visible in domestic scenes on Roman walls, a rabbit.

Capable modeling and incised detail mark the piece. Short incisions, randomly placed and running the length of the animal, indicate the rabbit's fur. The eyes are sunken, with a ridge for the iris and a hole for the pupil. Incision on the inner ears resembles the veining of a leaf. Three incised lines appear on each forepaw and two on the hind paws.

The procreative profligacy of these furry little animals seems to have alternately astonished, bewildered, and amused the Romans. Many were the opportunities for them to observe the customs of hares in Republican and Imperial times. It is reported that the earliest game preserves dotting the Italian countryside contained only hares, from which

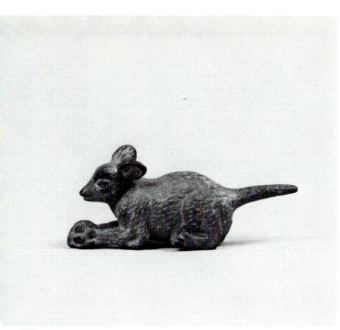

170

tradition arose the name *leporia (lepus-oris* = hare) used later for game preserves on late Republican country estates, containing animals of several or many kinds. Many, moreover, were the tales and anecdotes about Romans being unsettled and driven to desperation by the burrowing and grazing activities of rabbits and hares—particularly numerous were those about the hard-pressed provincials in the appropriately nicknamed "rabbity" Spain.

It seems that the Mildenberg rabbit, perhaps together with its snack, originally served as an ornament for a vessel or piece of furniture; certainly, the flat underside of its paws would make a good attachment surface, and a projecting knob on the belly may have been used to join it to something.

A date in late Republican to early Imperial times seems suggested by the rather numerous representations of similar rabbits in domestic contexts, often nibbling at figs or grapes, in Roman wall paintings around that time.

Condition: Intact. Shiny, dark brown patina. KPE

Bibliography: Unpublished.

Comparative literature: C.A. di Stefano, *Bronzetti figurati del Museo Nazionale di Palermo,* Studi e Materiali II (Rome, 1975) 78, no. 135, pl. 29; Reinach, *Répertoire,* IV, 518.3, 519.5; Toynbee, *Animals,* pp. 200-203, pl. 105.

170 *Crouching Mouse*

Bronze, solid cast (lost wax). Roman, AD 1st to 2nd century. H. 2.3 cm.; W. 2.1 cm.; L. 6 cm.

This wiry mouse reclines in an alert position, as if to protect the seed or small nut that it holds between its forepaws, which are stretched straight out in front. It turns its head slightly to the right. Its highly individualized head has a small pointed muzzle, incised mouth, large oval eyes marked with incised horizontal slits in the middle, and prominent oval ears projecting diagonally backward. There is an oval projection in the middle of each ear. The modeling of body and legs is strong and detailed. The body, including the underside of the belly and the front legs, is completely covered with diagonally oriented lines of short horizontal stipples. A short, pointed tail projects straight out from the top of the rump. The underside of the hind legs is flat and unstippled. The fruit or nut is modeled completely in the round.

This is the most detailed bronze mouse that I know of, seemingly representing a different animal from [171] and [172]. The extensive cold working and incision points to an early Roman date and also suggests that it was meant to stand on its own and was never attached to a base, as in [172]. Our ignorance about the purpose or purposes that such mice were intended to serve does not obscure our appreciation of these little statuettes or of the sympathy and amusement with which their Roman makers (and viewers) regarded them.

Condition: Intact. Dark gray-green patina overall. DGM

Bibliography: Unpublished.

Comparative literature: See [171].

171 *Mouse*

Roman, AD 1st to 3rd centuries. Bronze, hollow-cast (probably lost wax). H. 3.9 cm.; W. at base 2.3 cm.; L. 5 cm.

This massively modeled mouse sits upright on his hind legs, leaning forward as he nibbles something that he holds to his mouth with his forepaws. His rounded, hollow ears and protruding eyes are rendered in the casting; there is no incised surface ornament. The short triangular tail projects straight backward, enabling the mouse to stand upright. A hollow space in the underside extends upward into the body.

This statuette is more massively and finely modeled than many Roman bronze mice and could even be late

Hellenistic in date. Might it be a dormouse rather than a conventional house or field mouse? We do not know whether such bronze mice served primarily as freestanding household decorations or stood atop larger objects, perhaps metal food containers.

Condition: Intact. Covered with dark shiny blue-gray to black patina. DGM

Bibliography: Unpublished.

Comparative literature: Toynbee, *Animals,* pp. 203-204, figs. 99-101; Walters, *BM Bronzes*, p. 285, no. 1865.

172 *Mouse on Octagonal Base*

Bronze, cast. Roman, AD 1st to 3rd century. Overall H. 4 cm.; W. 1.7 cm.; L. 4.2 cm.

This plump mouse balances on its hind legs, circus-fashion, on a faceted base (H. 1.6 cm.; ca. 3 cm. square), holding a disk-shaped object (seed or cake?) to his mouth with his forepaws. The mouse and base were cast in one piece. The loop of tail, curled upward over his rump, is broken away; the tip adheres to his right haunch. This mouse has a plump oval body marked by extremely tiny, fine horizontal stipples, rendering its pelt. Its small rounded ears, hollowed inside, point upward. The base upon which it perches is octagonal in section, tapering from top to bottom; it is bounded at both top and bottom by a slender *torus* molding. The casting is unfinished beneath the base.

This mouse, standing on its elaborate base, may be an ornamental bric-a-brac, a finial for some large object like a lampstand, or even a votive offering. A mouse in the British Museum crouches on top of an Ionic base, while snacking on an elongated piece of food. A mouse very similar to this one, but without a base, is in the Landesmuseum für Kärnten, Austria. A similar mouse in Basel, crouching more horizontally, has been called Classical.

Condition: Intact, except for loop of tail, which is broken away. DGM

Bibliography: Unpublished.

Comparative literature: Reinach, *Répertoire*, II, 777, 3, 5, 8; 778, 3, 5; IV, 546, 1 ff.; V, 465, 3; Walters, *BM Bronzes*, pp. 284-285, nos. 1858-1871 (esp. no. 1860, with Ionic base); Fleischer, *Bronzen*, p. 190, no. 275, pl. 130; Schefold, *MgK*, pp. 62, 222, 224 (illus.), no. V 257.

171

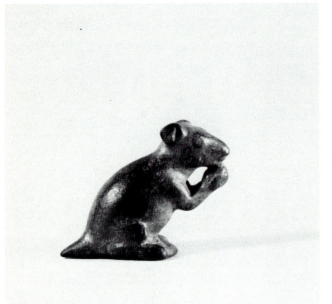

172

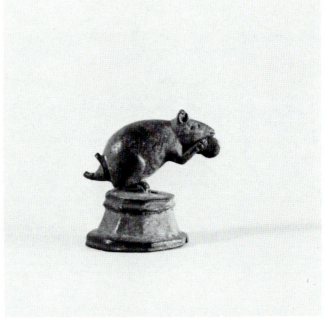

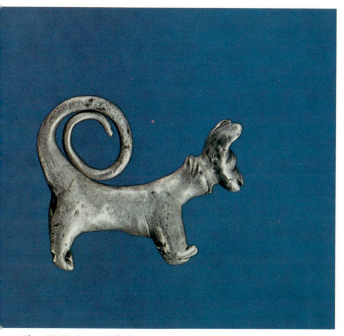

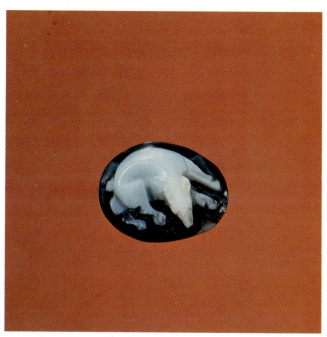

Plate XVII Long-Tailed Dog Amulet [3]

Plate XVIII Sleeping Dog [185]

Plate XIX Gold Brooch with Glass Cameo: Sleeping Dog [186]

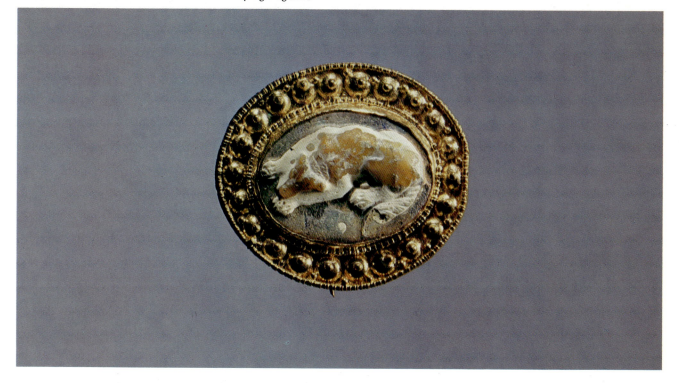

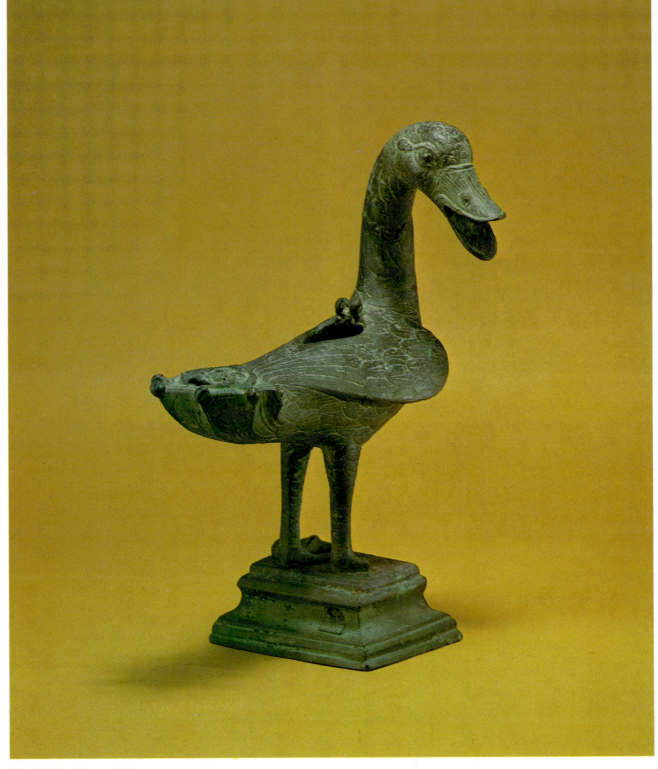

Plate XX Duck Lamp [165]

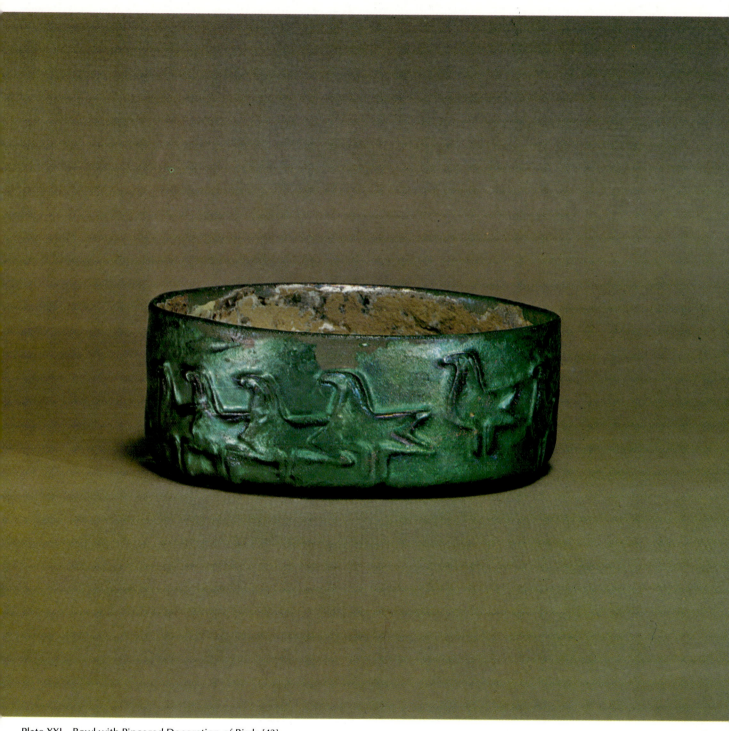

Plate XXI Bowl with Pincered Decoration of Birds [43]

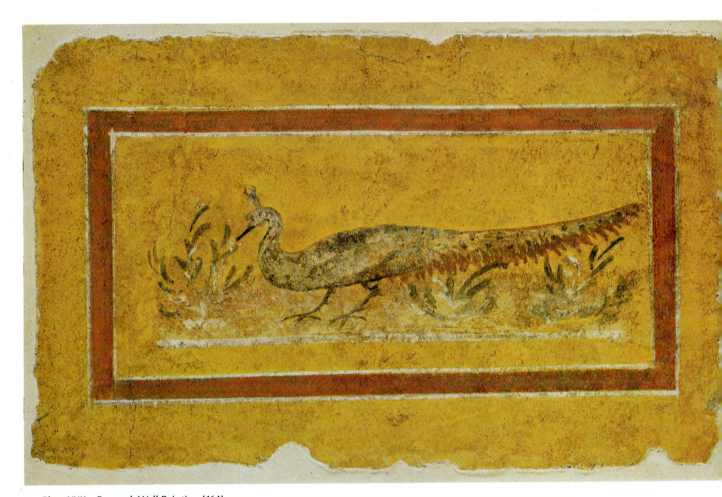

Plate XXII Peacock Wall Painting [164]

173 *Fearsome Feline*

Bronze, solid cast. Graeco-Roman, 1st century BC–AD 1st century. H. 5.2 cm.; W. 1.5 cm.; L. 6.3 cm.

Half-crouching—rather uncomfortably, it seems—upon its hind legs, this fearsome feline supports itself upon its left foreleg and raises its right. It turns its head to the right, pricks up its ears attentively, and with malice aforethought displays a mouth full of teeth and a hungry tongue. The tail is contentedly curled about the animal's right leg, which carries an unusual knob-like projection, possibly the result of incomplete chasing.

Albeit awkward in stance and aberrant in shape, this piece yet exhibits rather fine incised detail. An incised line of chevrons follows the slightly carinated and curving line of the spine from the lower neck to the mid-back, while wavy incised lines appear on the rump. Seven long, loose, wavy incisions form the animal's beard, and three grooves indicate its paws.

A strange creature is this with its tubular body, heavy legs, and awkward stance. Exactly what sort of animal it is does not seem immediately obvious. Canines and felines, of course, come very quickly to mind here as possible identifications—although clearly not the common household hold dog or cat but instead wolves, hyenas, mountain cats, and panthers. Both the half-crouching stance with one raised forepaw and the toothy snarl would be appropriate for wild canines and felines. Four facts, however, favor a feline identification above a canine one, and these are: first, that the animal most commonly represented in this stance in classical art is the feline, secondly that the canine only rarely bares his teeth in a hostile or menacing manner in classical art, that the animal here sports a fairly large, pointed beard beneath its chin, and finally that the curling tail of this quadruped is clearly more feline than canine in character. The beard, in fact, is most significant, for the only animal to be represented with this sort of beard on classical bronzes is the panther. Countless small bronzes show the wild panther or leopard, sometimes with spotted coat (cf. [33]), other times without, in just this stance and with just this sort of beard (cf. [174]). Dogs, hyenas, and wolves, on the other hand, may be represented in this crouching stance with bared teeth, and they may even have stylized or naturalistic hair patterns around their faces and necks and occasionally upon their bodies as well. Never, however, are they given beards like the one here. Thus, a feline identification for this animal seems assured, despite its unusual appearance.

Confirmation for the feline character comes from an unusual quadruped in Baltimore; shorter muzzle and facial

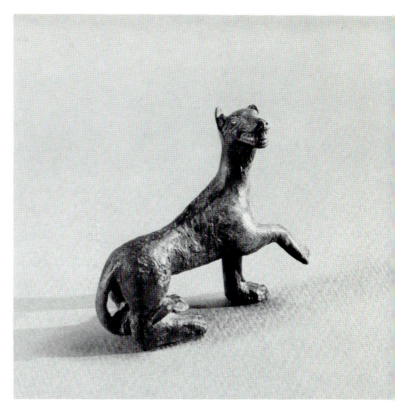

173

detail make the Baltimore quadruped more obviously feline than the animal here, but unfortunately the identification, date, and function of the Baltimore bronze remain open to speculation. At any rate, the Baltimore animal, which is tentatively suggested to be Etruscan work of the fifth century BC, is certainly earlier than the Mildenberg feline and more sophisticated in its modeling. The animal here, in fact, is probably just an unusual and rather sketchily modeled variant of the numerous small bronze crouching felines produced in the Roman Period and used as ornament for various kinds of objects—including chariots and horse trappings—but harking back to a Hellenistic prototype. In any case it could perhaps have come from a Bacchic group as the tethered panther [174].

Condition: Intact. Medium to dark green patina. KPE

Bibliography: Ars Antiqua, sale cat. (Lucerne, 1964) no. 74, there described as Roman Imperial dog.

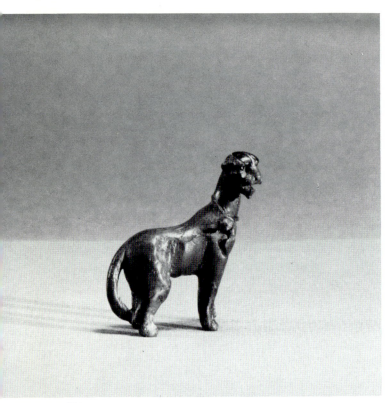

174

174 *Ivy-Tethered Pet Panther from a Bacchic Group*

Bronze, solid cast with lead-tin solder repairs. Roman, AD 1st–2nd centuries. H. 5.2 cm.; W. 1.5 cm.; L. 6.3 cm.

Heavy of limb and long of neck, this deceptively docile, ivy-tethered panther probably once stood as the solemn, but not silent, sentinel beside his master Bacchus. Attentive forequarters with legs poised and ready for action belie the seeming lassitude of the panther's powerful hindquarters and drooping tail, while alert eyes, snarling visage, and gaping mouth emitting a long, low growl make his nature clear: pet to his master but menace to others.

Numerous ivy-tethered panthers accompany Bacchus and occasionally his followers, the satyrs, throughout classical art—most notably, in life-size marble groups and in small bronze statuette groups. None, however, appears to resemble this one closely in stance or style, for their position is usually a crouching one and their proportions are normally quite different, never with such heavy and immobile hindquarters combined with such comparatively lean forequarters and so small a head. The ivy tethers worn by the panthers in these Bacchic groups take many forms. Some are very freely entwined about the animals' bodies and resemble the living vine; others like this one, with its two large leaves carefully positioned over the panther's shoulder blades, suggest plant forms translated into the metal and leather of a real harness. The customary panther beard, here rather small, appears beneath the beast's opened jaw, while its head is turned slightly to the right, presumably to threaten all who would approach the god who once stood nearby. Only one foot, that of the right hind leg, is in its original state; apparently it survived, strengthened by the tip of the thick tail joined to it, while the other feet were lost or miscast. These feet, together with a large patch on the head, probably miscast also, were repaired with a lead-tin solder presumably in antiquity. Yet, despite its damaged condition, this unusual panther with dramatic modeling and forceful expression produces an inescapable impression of immense power, momentarily checked.

A date in the first two centuries AD is suggested by numerous Roman panthers of related stance and style from that time.

Condition: Top of the head, lower forelegs, and lower left hind leg repaired as noted above; these areas are a

Comparative literature: See also [174]; D.K. Hill, *Catalogue of Classical Bronze Sculpture in the Walters Art Gallery* (Baltimore: Walters Art Gallery, 1949) p. 121, no. 278, pl. 54; S. Boucher, *Bronzes romains figurés du Musée des Beaux-Arts de Lyon* (Lyon: Editions de Boccard, 1973) p. 161, no. 269 (supposed hyena); Comstock and Vermeule, *MFA Bronzes,* pp. 181-182, no. 217; for small bronzes of crouching panthers with raised forepaw: from Bacchic contexts, Fleischer, *Bronzen,* p. 179, no. 249, see also pp. 178-179, nos. 245-248 for feline horse trappings; over prey, Reinach, *Répertoire,* III, 212.6; IV, 473.1; V, 420.6; over vessel, S. Boucher, pp. 168-169, nos. 289-291, also p. 169, no. 290 (from unknown context) pp. 161-162, 168-170, nos. 271-273, 287-291, 294 (feline horse trappings); for additional felines associated with chariot ornament or horse trappings, Pinney and Ridgway, *Aspects,* pp. 224-225, no. 109; M. Veličković, *Petits bronzes figurés romains au Musée National* (Belgrad: National Museum, 1972) 188-189, no. 139; L.B. Popovič et al., *Bronzes in Yugoslavia,* p. 197 a-b; J. Babelon, *Les trésors du Cabinet des Antiques, le Cabinet du Roi ou le Salon Louis XV de la Bibliothèque Nationale* (Paris, Brussels: G. Vanoest, 1927) p. 49, pls. 14-15, nos. 26-27. See also Reinach, *Répertoire,* I–V, for representations of panthers in diverse poses and contexts.

striking black in contrast to the green of the rest of the animal. Underparts of the body not chased. Shiny, dark olive-green patina. KPE

Bibliography: Unpublished.

Comparative literature: See also [173]; for small bronze of Bacchus riding a panther (apparently ivy-tethered) on foot of Naples candelabrum, F.B. Tarbell, *Catalogue of Bronzes, etc., in Field Museum of National History, Reproduced from Originals in the National Museum of Naples,* Field Museum of Natural History publication 130, Anthropological series 7, no. 3 (Chicago, 1909) p. 111, no. 72, pl. 59, fig. 72; for small bronzes of untethered panthers with Bacchus and/or satyrs, G. Seure, "Un char thraco-macédonien," *BCH* XXVIII (1904) 210-237, fig. 20, pl. 11; M. Veličković, *Petits bronzes figurés romains au Musée National* (Belgrad: National Museum, 1972) pp. 149-150, no. 66; for small bronzes of ivy-tethered panthers, unaccompanied in their present state, G.M.A. Richter, *Catalogue of Greek and Roman Antiquities in the Dumbarton Oaks Collection* (Cambridge, MA: Harvard University Press, 1956) pp. 38-39, no. 20, pl. 11b.

of Edmond de Rothschild. It resembles more closely an ivy-tethered example now in the Louvre (Br. 4452) but is distinguished by its erect posture and the abstract, linear rendering of details. These traits substantiate the late Roman date and may indicate a provincial source.

Condition: Dull green patina. Surface slightly pitted. Hard, gray layered matter coating interior. PV and JN

Bibliography: Unpublished.

Comparative literature: Mitten, *Rhode Island Cat.,* pp. 162-164, no. 47; Mitten and Doeringer, *Master Bronzes,* p. 303, no. 304; Annalis Leibundgut, *Die römischen Bronzen der Schweiz,* III: *Westschweiz Bern und Wallis* (Mainz: Philipp von Zabern, 1980) p. 104, no. 116, pl. 133; Salomon Reinach, "Panthère de bronze," *MonPiot* IV (1897) 105-114, pl. X; Pierre Devambez, "Antiquités grecques et romaines," *Revue du Louvre* XVIII, nos. 4-5 (1968) 326, fig. 7.

175 *Seated Panther*

Bronze, hollow cast. Late Roman. H. 8.3 cm.; W. 3.7 cm.

This erectly seated panther is facing left and holding up its right forepaw. Its tail is curled around its left stifle. Rough incision marks the lips, muzzle, eyes, pupils, hair encircling the face, paws, and tufted tail. Less distinct markings indicate the shoulders, rib cage, and abdomen, and light stippling, representing fur, covers the animal's body.

The base of the figurine is cut off aslant, with the far right rear paw missing entirely. The left forepaw has additional padding underneath to enable it to reach base level on this side. The open mouth preserves a cylindrical hole, made more pronounced by the thin skin of bronze between the panther's lips. It seems evident from the slanted base that the panther was originally seated on a curved surface, perhaps a vessel. The heraldic, upright pose suggests that it may have been one of a confronted pair with some third element, such as a handle, held between their mouths. Another possibility, given the hollow body and hole in the mouth, is that it served as a small fountain attachment, as the bronze panther in Rhode Island or the bronze dolphin in a Swiss collection. A lunging pantheress, found in Saint-Prex, Switzerland (now Lausanne 4231), shows a similar cutting on her right rear flank, but unfortunately its function is unknown.

In style the Mildenberg feline contrasts markedly with other bronze panthers of Roman date, such as the beautifully naturalistic example formerly in the collection

175

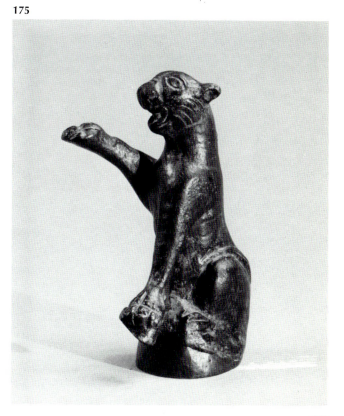

176 *Pacing Lion*

Bronze, solid cast (lost wax). Roman, AD late 1st–2nd centuries. H. 5.3 cm.; W. 2 cm.; L. 6.2 cm.

This pacing lion steps forward on his left legs. His tail hangs down in an S-curve, parallel to the right rear leg but separate from it. His head, held upright, turns to his right; his mouth is open as if in a snarl or roar. The modeling of the head and muzzle is very fine; the eyelids as well as the eyebrows are cast. Plastic ridges extending from the forehead reach to the inner corner of the eyes. Horizontal lines mark the cheeks.

The lion's mane is rendered in stiff, highly plastic locks, which have been cold worked; they cascade from the chin passing between the front legs. The cold working extends to incised grooves that separate internal subdivision within individual locks of the mane. The body is handled with extremely free, taut, powerful modeling. Horizontal depressions occur on either side of the body behind the rib cage. The two hindmost ribs on the left side are depicted. The underside of the body moves upward sharply behind the rib cage. Longitudinal channels extend down the exteriors of the legs.

176

While this lion projects a powerful impression when seen in profile, it becomes extremely attenuated and thin when seen from front or back. Hence, it was probably designed to be mounted on the rim or edge of some larger vessel or piece of furniture upon which it would appear to be walking and could be viewed effectively in silhouette. It is a smaller, leaner, and more finely modeled cousin of a group of bronze lions who walk with their heads down. Both these and the Mildenberg lion would have served equally well as ornamental adjuncts to larger vessels or pieces of furniture or as freestanding votive or ornamental statuettes. Similar lions are in the Walters Art Gallery (54.1022) and in Trier.

Condition: Intact, except for missing right rear foot and tip of tail. Lustrous, dark olive-green patina over entire surface. DGM

Bibliography: Unpublished.

Comparative literature: Toynbee, *Animals,* pp. 61-69; Mitten and Doeringer, *Master Bronzes,* p. 290, no. 284; E.K. Gazda and G.M.A. Hanfmann, in *Art and Technology: A Symposium on Classical Bronzes* (Cambridge, MA: MIT Press, 1970) p. 256, figs. 19-20, nn. 100-102; J. Petit, *Bronzes antiques de la collection Dutuit* (Paris: Musée de Petit Palais, 1980) p. 121, no. 49; D.K. Hill, *Catalogue of the Classical Bronze Sculpture in the Walters Art Gallery* (Baltimore: Walters Art Gallery, 1949) p. 116, no. 265 (inv. no. 54.1022), pl. 52; H. Menzel, *Die römischen Bronzen aus Deutschland II: Trier* (Mainz: Philipp von Zabern, 1966) pp. 118-119, no. 288, pl. 93.

177 *Lion Head Jar Stopper (?)*

Bronze, solid cast. Roman, ca. AD 2nd century. H. 2 cm.; W. 1.9 cm.; L. 3.7 cm.

A roaring lion head merges in the back with a truncated cone. An incised line circles the cone 0.5 cm. from the back of the lion's head (see discussion of related incised decoration on jewelry [29]). The lion's mouth is open as if roaring and the tongue is in relief inside. The muzzle and nose form a triangle (see [178, 179]). Tiny, beady eyes are set below a furrowed brow which gives the lion a worried look incongruous with his natural personality but consistent with second-century Roman representations. The flews (flesh at the sides of the mouth) are exaggerated and the lower jaw somewhat slack (see also [52]).

The end of the truncated cone looks as though it was broken in antiquity and filed down. Was the piece originally designed for one use then altered for another? One might suggest an original use as a key knob and later transfor-

177

178

mation to a jar stopper (see [22]), but these suggestions are purely conjectural.

Condition: See break described above. Dark green patina with patches of cuprite.

APK

Bibliography: Unpublished.

Comparative literature: See [22, 29, 52, 178, 179].

178 *Couch Attachment with Lion Head*

Bronze, probably solid cast (lost wax). Roman, AD late 2nd or 3rd century. H. 8.5 cm.; W. 8.5 cm.; L. 9 cm.

This lion head projects forward, mouth open, as it looks out and down. The teeth and gums in the upper jaw are clearly delineated; the thinly cast tongue projects from the lower jaw. The nostrils are shallowly modeled with delineating grooves. The small oval eyes are widely spaced. The small rounded ears are virtually submerged in the locks of the ruff-like mane. The locks in the lower half of the mane are separated by deep, wide, cold worked grooves. Similarly, the mane on the right side of the head is virtually a grid of lozenge-shaped incised locks. The left side is lightly modeled in the form of grooves within individual locks. Two cold worked grooves channel from the center of the mane-line to the inner corner of each eye. The left profile view of this lion is the most effective one.

Many such animal-head *fulcra* from the Roman era are known; the type seemingly began in early Hellenistic times. The favorite animals so used are horses and mules, but dogs, occasionally lions, and even ducks and elephants are recorded. As far as we now know, the type came to an end during the third century AD.

Condition: Intact; dark blue-gray surface shading to green in spots. Surface appears to be eroded or pitted. The bottom of the attachment is broken away, just below the bow-shaped feature that transverses the neck of the lion.

DGM

Bibliography: Unpublished.

Comparative literature: G.M.A. Richter, *The Furniture of the Greeks, Etruscans and Romans* (New York: Phaidon, 1966) pp. 57-58, figs. 530-547; no detailed monographic treatment of these bronze attachments exists.

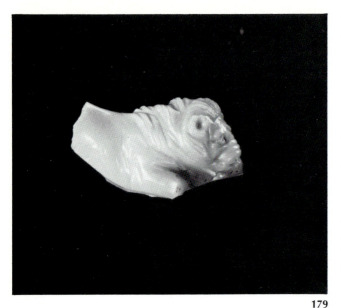

179 *Pouncing Lion*

Honey-colored agate. Probably Roman from Egypt, ca. AD 2nd–3rd centuries. H. 1.7 cm.; W. 1.9 cm.; L. 3.4 cm.

The lion turns slightly on the axis of his body as he appears to tackle his prey. The prey is not another animal, but a vessel which he grasps at the lip (see [114]). His full mane streams behind him in thick incised ropes that are somewhat more carefully arranged on the right side than on the left. A ridge of stone barely extends below his forelegs and connects under his body. The nose and upper lips form a triangle with striations marking wrinkles. The eyes are tiny, high bulges; the pupils are not drilled. The edges of the ears are tooled to indicate hair and even the insides of the ears are lightly incised. There are five rib marks on each side, and a ruff of fur along the back of each foreleg. The color of the stone is a perfect description of the lion's natural tawny hide.

The proportions, description of movement, and handling of anatomical details are clearly classical. However, the usual question arises—is it Hellenistic or Roman? The casual, asymmetrical clumps of ropy hair appear more Roman than Greek. The cutting technique is similar to that used to describe hair and drapery in semiprecious stone ware throughout the Roman Empire. The triangular form of nose and upper lips is also a Roman convention (see [177]).

The more fascinating question concerns the original use of the object. Its size suggests the easy answer of amulet,

but the ridge of stone still attached suggests something else. It is doubtful that a similar size base as on an amulet (see [52]) would have broken off in this manner. Both the type of break and the ridge suggest that the lion was part of a substantially larger object. Because the lion's mouth is closed, not clamping onto the neck or haunches of another animal, it probably does not come from a sculptural group.

Considering both the material and the shape of the figure, it is most likely that the lion was a vessel handle. Agate vessels from Greek and especially Roman times are well known. Bühler lists several vessels of honey-colored agate, the most famous of which is the Rubens Vase in the Walters Art Gallery. An animal-form handle in agate dated to the second half of the third century AD is in Cologne (V 419). Lions and other felines were common as vessel handles in a variety of materials (see [2, 33, 44, 86, 113-115]). With its haunches high in the air and its hind paws attached to the vessel, the Mildenberg lion would have formed a small, but comfortable lug. The remains create an arc which suggest a vessel diameter of about 5 cm.

Condition: Broken off at mid back. Left ear damaged; right foreleg lost. The ridge mentioned has been formed by a break which starts at the abdomen and curves convexly to the base of the neck. APK

Bibliography: Unpublished.

Comparative literature: Hans-Peter Bühler, *Antike Gefässen aus Edelsteinen* (Mainz: Philipp von Zabern, 1973) pl. 4, no. 13, color pl. I, no. 18, pl. 25, no. 79; A. Lucas, *Ancient Egyptian Materials and Industries*, 4th ed. rev. by J.R. Harris (London: Edward Arnold, 1962) pp. 386-387.

180 *Rampant Lion Support or Lion Bracket*

Bronze, hollow cast. Gallo-Roman, AD first half of 2nd century. H. 14.1 cm.; W. of base 5.6 cm.; L. 13.5 cm.

This large lion with long curling tail rears on its hindquarters on top of a rectangular profiled base. Springing upward, with mouth gaping and head raised and slightly turned to the left, this mighty beast extends its forepaws toward a flat vertical sheet of bronze. A tripod now in Lyon (E155) with "feet" in lion form almost exactly like the Mildenberg lion shows precisely how this piece was used. In that example three lions hold a circular support for a large round basin. The profiled base of each lion rests directly on the ground (or table) and the vertical bronze sheet fits into a socket in the circular element.

Three bronze lion statuettes from Switzerland reveal a very similar style with broad, loose forms and together suggest that the Mildenberg lion is a product of Gallo-Roman art north of the Alps, presumably from Switzerland like the others. A statuette of Herakles wrestling the Nemean lion, dated to the second century AD, from Avenches (Aventicum) and now in the Swiss National Museum, provides a good comparison for the modeling of the body and the flat striated rib cage in the lion here. Two smaller statuettes of standing lions carrying young boys (perhaps the child Bacchus)—which come from Venthône in the Rhone Valley and are now in the museum of Sion (Valais)—also present excellent comparisons for the Mildenberg piece, particularly for the head and the large, round locks of the mane; these statuettes seem to have served as antithetic appliqués, perhaps for a Bacchus monument.

Condition: Break in left flank at rib cage. Green patina, somewhat incrusted. KPE

Bibliography: Unpublished.

Comparative literature: Stephanie Boucher, Bronzes romains figurés du Musée des Beaux-Arts de Lyon (Lyon: Editions de Boccard, 1973) p. 166, no. 283; A. Leibundgut, Die römischen Bronzen der Schweiz II: Avenches (Mainz: Philipp von Zabern, 1976) 33-36, no. 18, pl. 17; A. Leibundgut, Die römischen Bronzen der Schweiz III: Westschweiz, Bern und Wallis (Mainz: Philipp von Zabern, 1976) 89-90, nos. 90-91, pl. 117.

180

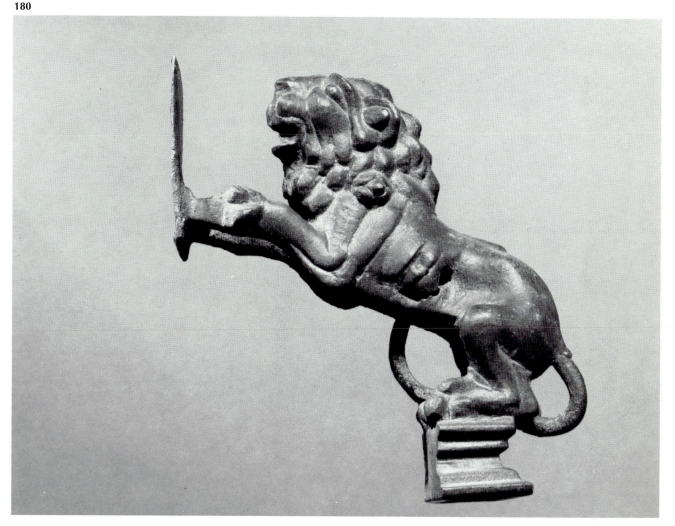

181 See also colorplate VI

181 Lion Textile Panel

Polychrome, looped-knot pile, wool on undyed linen. Egypt, Byzantine, AD 5th–6th centuries. H. 30 cm.; W. 37 cm.

The lion rears and attacks toward the left, his tail curled high. His mouth is open; his red tongue emerges in a horizontal line. Most of his body is colored in gold and greens, ranging from forest green through olive to lime. The mane, eyebrow, and decorative spots on the body are red. The spots are probably an attempt at texturing the animal's hide rather than suggesting the exotic coloration. A gold and red bucket shaped element in the lower left corner is a decorative device, probably floral.

Numerous looped-knot pile textile fragments exist, but relatively few are published. Since very few have been found in carefully stratified excavations, their dating is insecure. Dated on the basis of style, the polychromed examples generally fall into the sixth century or later. However, some with very classically styled figures such as a group from Akhmim and now in the Victoria and Albert are dated fourth to fifth century. Two of the finer sixth-century examples are the figure of an acolyte in the Museum of Fine

Arts Boston (49.313) and a flutist in The Cleveland Museum of Art (68.74). Fine seventh-century examples exist in Washington (Textile Museum, 71.46), Detroit (Institute of Arts, 46.75), and the E. Bloch-Diener collection (Bern).

The pose of the lion recalls numerous late classical mosaics with hunt scenes in which lions and bears attack hunters on foot. The same theme appears in other media, for example, on a late fourth-century bronze pitcher in Berlin (Antikenabteilung, 30244) and on a third- to sixth-century papyrus presumably from Egypt and now in London (The British Library Board, pap. 3053). On a fourth- to fifth-century Coptic wool tapestry in the Dumbarton Oaks collection (37.4), there is a fragmentary lion (upper left quadrant) in a pose similar to the Mildenberg lion attacking a hunter on foot (upper right quadrant).

Although the Mildenberg lion recalls classical types (see [180]), the rigidity of his pose and heavy outlining of parts of his body give him a more Byzantine appearance. The careful classicizing shading of his body contrasted with the spotted pattern of his hide (generally a later device) suggests a dating of fifth to sixth century.

Condition: Some staining throughout. Horizontal gash and loss in upper right quadrant; another smaller in upper left. Some tears below horizontal mid-line. Loss from bottom right edge. APK

Bibliography: Unpublished.

Comparative literature: A. F. Kendrick, Catalogue of the Textiles from Burying Grounds in Egypt, vol. I: Graeco-Roman Period (London: His Majesty's Stationery Service, 1920) 48, 49, nos. 23, 26. 27 ET AL., PLS. X, XI; Etienne Coche de la Ferté et al., L'art Copte, exhib. cat. (Paris: Ministère d'État Affaires Culturelles, 1964) nos. 165, 172, 175; Bloesch et al., Das Tier, p. 22, no. 138, pl. 23; Stephen R. Zwirn in Age of Spirituality, ed. Kurt Weitzmann, exhib. cat. (New York: Metropolitan Museum of Art, 1979) pp. 86-87, no. 76, pp. 95-96, no. 86; John D. Cooney, Pagan and Christian Egypt, exhib. cat. (Brooklyn: Brooklyn Museum, 1941) pp. 59-60, nos. 175, 176.

182 Begging Dog

Bronze, solid cast (lost wax) with minute traces of gold leaf. Late Hellenistic or early Roman, 2nd to 1st century BC. H. 7 cm.; W. 1.5 cm.; L. 9.5 cm.

This dog is slender and graceful with short neck, small pointed head, long body, wiry legs with big feet, and a slender tail that curves to the dog's left. The modeling is sensitive, although generalized. Just in front of the left rear leg there is a pronounced oval depression; a corresponding depression, somewhat shallower, exists on the left rear leg.

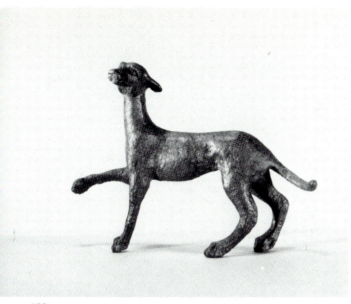

182

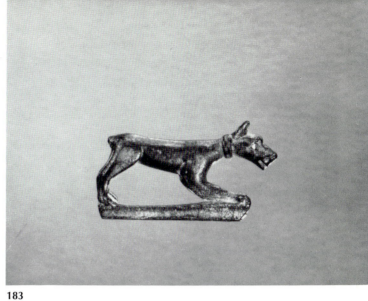

183

The muscles in the right rear leg are stretched taut along the haunch as the leg is pulled backward.

The dog raises its right front leg horizontally, in that familiar attention-demanding "petitioning" gesture. The four digits of the upraised paw are plastically rendered; the underside is flat. The dog's left rear leg is advanced, the right drawn back. The tail gives the impression of wagging, an important gesture to accompany the "petition" of the upraised paw. In added emphasis to this begging mood, the dog's head turns upward to the left. The ears slant down- ward and back; the left ear is concave beneath. The eyes, recessed beneath projecting brows, have incised dot pupils and are surrounded by a groove. Nostrils and mouth are incised, too. The dog's fur is textured over its entire extent by minute stipples.

The dog's pose is one of naturalistic, amiable inquiry. The raised forepaw—later to become a stylized, choreographic gesture in Roman panthers and lions (see [175]), especially those produced as ornamental chariot fittings—is here a spontaneous, momentary gesture. The skill of modeling, casting, and the exquisite detailing of the fur, as well as the superb characterization of the dog's personality and age (an adolescent, with feet still too large for his body) suggest a Hellenistic date for this eloquently and eagerly begging dog. The pose is reminiscent of that in a very fine Etruscan bronze dog of the fourth century BC or later. Whether the Mildenberg dog stood by itself or formed part of a group is presently uncertain.

Condition: Intact. Right front leg appears to have been crushed (broken and mended?) halfway to paw; it is bent inward slightly. There are a few pits in the surface, at base of neck. The surface, somewhat shiny, is covered by a brownish to red patina. DGM

Bibliography: Unpublished.

Comparative literature: Toynbee, *Animals,* pp. 102-106, figs. 46-47; Comstock and Vermeule, *MFA Bronzes,* pp. 181-182, no. 217.

183 *Running Dog with Silver Eyes*

Bronze, solid cast; eyes inlaid with silver. Roman, AD 1st to 2nd century. H. 1.9 cm.; W. 0.5 cm.; L. 3.7 cm.

This wiry, alert dog—captured as if straining at the end of a leash—is cast with his front and hind legs as single solid members on a narrow plinth (L. 3.15 cm.). Both sides of his front and hind legs are incised with grooves; the digits of the paws are incised, as are grooves at the rear of the front legs and at the front of the back legs. He wears a plastically rendered collar around his neck. His ears, cocked forward, are separated. Nostrils and open mouth are rendered by incision. His small beady eyes, inlaid with silver, look out from under furrowed brows; there is an incised pupil at the front of the right eye.

The dog's tail has been broken off almost flush with the body. The sides of the plinth are concave; the ends appear

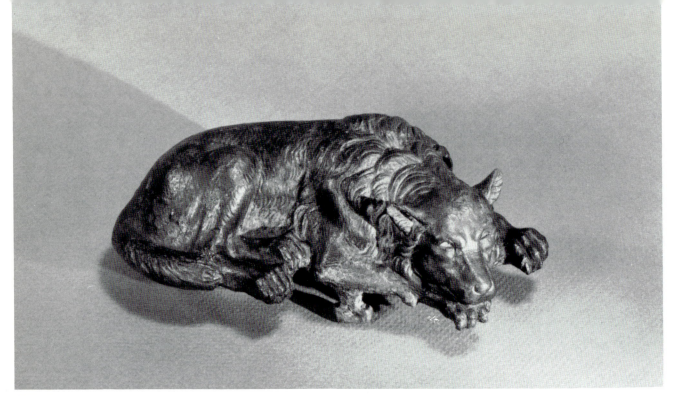

184

to be beveled and smoothed as if having been refinished after being broken from a larger object. While no trace of a longitudinal seam remains, it is possible that this extremely flat dog was cast in a bi-valve mold.

The function of this lively little dog—silhouette-modeled, yet carefully executed and provided with inlaid silver eyes—is not clear. Its strong emphasis upon silhouette and its plinth are reminiscent of the small bronze foxes that chase hares around the disks of Classical Greek caryatid mirrors (see [117]), yet the bottom of the plinth is not curved. The presence of extensive cold working and the silver eyes suggest a Roman date, somewhere in the first or second century AD. Could it have ornamented the handle of a knife or other instrument, then have been refinished as a statuette when it was broken from its original setting? A somewhat similar small bronze dog in Augst was perhaps the finial for a pin.

Condition: Intact; evidence of refinishing ends of plinth. Dark, shiny olive-green patina. DGM

Bibliography: Unpublished.

Comparative literature: A. Kaufmann-Heinimann, *Die römischen Bronzen der Schweiz I: Augst* (Mainz: Philipp von Zabern, 1977) 140, no. 241, pl. 149.

184 *Molossian Hound*

Bronze, hollow cast (lost wax). Roman, AD 2nd to 3rd century. Max. H. 4.5 cm.; W. 8 cm.; L. 16 cm. Ex Ernest Brummer and Durighiello collection; said to have been found in Syria.

This massive dog lies flat, resting his chin on his right forepaw; his head and body are turned toward his right. Both of his hind legs are on his right side; his tail is curved around his right haunch. His left front paw projects straight forward. His body, modeled in broad rounded volumes, is textured throughout by highly differentiated incised lines for different areas of his hide: fine short curving lines over the back and haunches and deeper diagonal curving lines on the tail which ends in a tuft of parallel incisions. More plastically rendered tuft-like masses behind the front legs and shoulders connect with the neck fur. While these are also present in the deep concavity formed between the right front leg and the rear paws, they are especially well rendered on the left side of the body. The mass of crescentic locks forming the neck fur falls symmetrically on either side of the neck. Small cascades of three-dimensional curls descend from each ear to front sideburns.

The ears point diagonally away from the head and open upward; inside, they are textured with fur. The eyes are

deeply excavated, perhaps originally to hold silver inlays. The left eye has a slight perforation that extends completely through the bronze to the hollow interior of the piece. The eyes are outlined by fine raised ridges; the eyebrow folds are heavy, parted in the middle by a furrow. The nostrils are formed by fine crescentic grooves; a vertical depression connects the end of the nose with the mouth. The mouth itself is a long, deep furrow, widening and deepening at the corners to render the flaps of skin forming the lips. The large paws are painstakingly depicted, with each joint and claw accurately shown. The bronze is cast thin; the edges upon which the dog rests are rounded and curved inward.

This highly realistic dog is captured in a pose at once relaxed and alert, an impression heightened by the deeply scooped eyes and the shadowed mouth. While it was clearly intended to be seen from all sides, its most important view would have been from the right. The pair of hammer-shaped tangs (H. 1.4 and 1.5 cm.) projecting from the bottom edges of the casting were meant to be inserted in the flat surface of a larger object. This might have been the railing of a chariot, the top of a chest or other piece of furniture, or indeed anything for which a resting but still vigilant Molossian hound might have served as a decorative, yet protective, adjunct.

The cold working on the pelt suggests that this hound might be late second or early third century AD in date. In an earlier publication of this piece, Herrmann adjudges it the finest of a series of such hound attachments which adorned varying settings like wagons, fountains, and a strong-box. A close parallel, now in the Metropolitan Museum of Art (62.10), reclines but raises his head alertly, turning it to the left. A third, fragmentary reclining Molossian is in Speyer, Germany. In all three, the bronzecasters have emphasized this famous breed's bulky, powerful anatomy and almost leonine appearance. Heads of Molossian hounds also surmount *fulcra,* the endrests for *klinai* (banqueting couches). In all of these, a working dog both powerful and intelligent appears to us, a worthy ancestor for at least some of the formidable Balkan and Anatolian sheepdogs of today.

Condition: Nearly intact except for two triangular gaps broken out of the rear (left) edge, which have some fiberglass infills. Surface shiny dark brown to dark green. DGM

Bibliography: A. Herrmann, in *The Ernest Brummer Collection,* vol. II: *Ancient Art,* sale cat. (Zurich: Galerie Koller/Spink & Son, 16–19 October 1979) 148-149, no. 578.

Comparative literature: Toynbee, *Animals,* pp. 102-108; *Kunstwerke der Antike, Auktion XXII,* sale cat. (Basel: Münzen und Medaillen, 13 May 1961) pp. 47-48, no. 93, pl. 27 (MMA

hound); H. Menzel, *Die römischen Bronzen aus Deutschland I: Speyer* (Mainz: Philipp von Zabern, 1960) 21, no. 29, pl. 32; Mitten and Doeringer, *Master Bronzes,* p. 302, no. 302 (Musée d'art et d'histoire, Geneva, C 1166), the *fulcrum* attachment with dog no. 303, pp. 302-303 may also represent a Molossian.

185 *Sleeping Dog*

Layered sardonyx; dog carved in white stone against blue background. Roman AD 1st or 2nd century. W. 1 cm.; Th. 0.5 cm.; L. 1.4 cm.

A dog with pointed muzzle curls up with his head over his right shoulder. His front feet stretch forward and parallel, with both paws turning outward. Both hind legs are on the right side of his body. His left hind leg, underneath, is more sketchily and shallowly cut than the right. Body and legs are a milky blue color; the head—carved in higher relief, the muzzle actually undercut and rendered in the round—is more nearly pure white. While delicate and accomplished, the modeling is still somewhat angular and summary, especially in the hind legs. A stub of a tail is carved behind the hind legs.

The dark blue background layer of stone has inclusions of lighter blue concentric layers on underside and edge, below and to right of right front foot and rear foot. The stone itself is a slightly irregular oval in shape, slightly narrower at the end with the dog's front feet.

The subject of this cameo occurs in plastic vases and lamps as well. The circular top of a bronze lamp in the Museum of Fine Arts, Boston (60.1451), has a mother greyhound curled around her puppy. Other cameo versions include a highly lifelike dog in the Cabinet des Médailles, Paris, and a possibly medieval sardonyx cameo in the Juritzky collection, Paris. It is also related to the reclining bronze Molossian hounds, like [184]. Could such cameos have symbolic value, implying something of the fidelity of the dogs they depict, as well as their bravery and dependability as guardians?

Condition: Intact except for tiny chip off tip of nose and right ear. DGM

Bibliography: Unpublished.

Comparative literature: Comstock and Vermeule, *MFA Bronzes,* p. 347, no. 487; R. Higgins, "Magenta Ware," *The Classical Tradition: The British Museum Yearbook* I, 1974 (London: British Museum Publications, 1976) p. 13, nos. 45-47, pp. 23-24, figs. 29-30; G.M.A. Richter, *The Engraved Gems of the Greeks, Etruscans and Romans 2: Engraved Gems of the Romans* (London: Phaidon Press, 1971) p. 77, no. 373; H. Wentzel, " 'Staatskameen' im Mittelalter," *Jahrbuch der Berliner Museen,* N.F., IV (1962) 53-54, fig. 10.

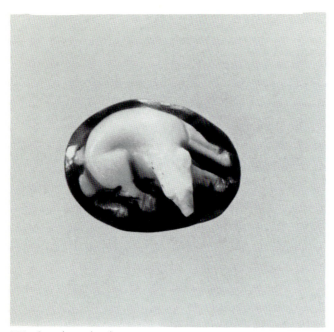

185 See also colorplate XVIII

186 See also colorplate XIX

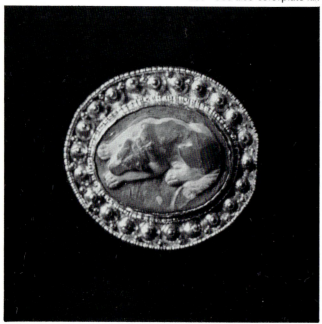

186 *Gold Brooch with Glass Cameo: Sleeping Dog.*

Molded blue, white, and yellow layered glass in gold mount. Roman, AD 2nd to 3rd century. Brooch: W. 2.9 cm.; L. 3.3 cm.; Cameo: W. 1.7 cm.; L. 2.3 cm.

The gold mount consists of a frame with edges of very fine bead and reel on outside and inside, just at the base of the raised edge that holds the cameo in place. These bound a frame of twenty-two flattened gold bosses, on each of which rests a large gold granule. There are also gold granules between the bosses next to the outer frame. The back side of the brooch shows impressions of two of these bosses just below the hook for the end of the pin.

The glass cameo has a blue background, with the dog in white (paws, tail, edge of body) and dark yellow (head and top of body). The tip of the tail has been broken away. Toes and the hair on tail and neck are indicated by very fine incisions. The way in which the tip of the tail has broken away suggests that the dog may have been molded separately, joined to the blue background as an appliqué, then painted with the white substance, which ran beneath the appliqué. Was the yellow color on the dog's head and the top of his body deliberate, or is it simply the result of the white surface wearing away? The white surface might also be the usual dehydration layer that forms on the surface of ancient glass. The dog reclines, turned toward his left; his rear legs and tail are disposed toward the left, while his chin rests on his left front leg.

This cameo is an inexpensive equivalent in glass to the sardonyx versions like [185]. Questions about it, such as whether or not the cameo is of the same age as the gold setting or whether the two-color scheme of the dog is intentional or merely the result of disintegration, cannot be easily answered. The dog's modeling, while effective, is noticeably flattened and unrealistic, perhaps in order to produce an effective, readable, silhouette. The similarity of this glass cameo to [185] implies that less expensive glass was used to imitate expensive carved gems and cameos in the Roman world.

Condition: Intact, with the notes mentioned above. DGM

Bibliography: Unpublished.

Comparative literature: See [185].

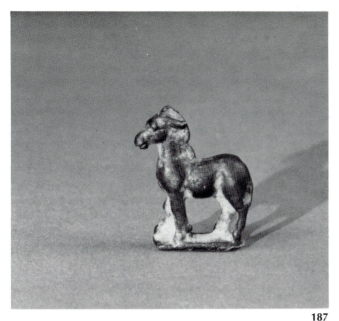

187

188

187 *Miniature Mule*

Bronze, solid cast (lost wax). Roman, western provincial, AD 1st century. H. 2.7 cm.; W. 0.7 cm.; L. 2.3 cm.

This diminutive mule, identified as such by its clearly elongated ears, appears to stride forward on its right feet. The impression of animation, actual and potential, is heightened by the mule's turn of its head slightly to the left. The ears are laid back; the eyes project as rounded bumps; the swelling of the jaw is rounded; and the mouth is grooved open. The tail hangs down as far as the hocks. The mane is hogged; there is a notch in the edge just above the withers.

The broad, sure modeling of the basic volumes of the body and legs lends a vigorous monumental air to this tiny statuette. This and the animated pose suggest a date somewhere in the first century AD, perhaps looking back to late classical models. The function of this statuette, votive or decorative adjunct to a vessel or piece of furniture, remains uncertain. Roman bronze animal statuettes of such minute size are rare, although miniature gold and silver animals of this size and even tinier are well known.

Condition: Intact; surface is a shiny, almost silvery-tinged bronze color. DGM

Bibliography: Unpublished.

Comparative literature: Toynbee, *Animals,* pp. 185-192; A.N. Zadoks-Josephus Jitta, W.J.T. Peters, and W.A. van Es, *Roman Bronze Statuettes from the Netherlands* I (Groningen: J.B. Wolfers, 1967) no. 50; Fleischer, *Bronzen,* p. 181, no. 253, pl. 126 (miniature horse from Carnuntum).

188 *Miniature Ram*

Bronze. Gallo-Roman, said to be from Carnuntum, AD 2nd century. H. 3.1 cm.; W. 1.7 cm.; L. 3.3 cm.

This solid bronze ram stands with his feet firmly planted on the ground and his head raised and cocked slightly to his right. The small, oval head barely protrudes from the animal's thick, woolly neck. Reticulated horns surround the face, and near their roots are set the tiny beady eyes. The thickly tufted neck and body contrast with the shorn legs. The feet are splayed like a camel's. A long woolly tail hangs down to the rear legs, and a pair of hatched pouches resembling wine skins straddles the ram's back.

Because of the ram's association with Mercury, the god of flocks, the object on the animal's back is often called the purse of the god, in this case as also on a similar miniature bronze in the Bibliothèque Nationale, a double purse. However, a small bronze goat found in Belgium bears a similar burden. Although neither the ram nor the goat is a traditional pack animal, the size and the shape of these pouches suggest wine skins rather than coin purses.

Condition: Intact. Dark, blackish-green patina. JN

199

189

190

Bibliography: Unpublished.

Comparative literature: Ernest Babelon and J.-Adrien Blanchet, *Catalogue des bronzes antiques de la Bibliothèque Nationale* (Paris: Ernest Leroux, 1895) p. 484, no. 1185; G. Faider-Feytmans, *Les bronzes romains de Belgique* (Mainz: Philipp von Zabern, 1979) p. 96, no. 113, pl. 60.

189 *Billy-Goat*

Bronze, solid cast (lost wax). Roman, western European provinces, AD 2nd to 3rd century. H. 5.5 cm.; Max. W. 2.1 cm.; L. 5 cm.

This perky goat, poised on his rectangular plinth, stands with his legs braced and turned inward. His head, turned slightly to his proper right, is large in proportion to his stubby body. His sturdy, stubborn, alert nature is effectively conveyed by the pose.

The goat's fleece is organized in longitudinal rows of vertical crescent-shaped incisions. These rows lie parallel to a central incised line running from the base of the neck to the tail. The incised crescents face in opposite directions in alternate rows; the rows on either side of the spine open toward the head. Irregular crescentic incisions adorn the neck and chest, as well as the beard beneath the chin. A whorl of incisions lies on top of the head, just below the horns. Shorter, finer incisions cover the stubby tail, legs, muzzle (in parallel vertical rows), ears, and eyebrows.

Deeper diagonal grooves score both sides of the horns. Nostrils and mouth are incised. The eyes are large, oval, and bounded by upper and lower grooves and an eyebrow groove; the pupils are incised dots. A small round pit (bored ?) between the base of the hind legs indicates the anus. The hooves display summary vertical median incisions; at their tops, they are separated from the legs by deep grooves.

Similar goats are numerous from the western provinces of the Roman Empire, where they are found in isolation as well as occasionally in circumstances suggesting that they may have accompanied statuettes of Mercury, as is likely for a statuette of Mercury from Augst. The heavily cold worked and incised surface treatment is a characteristic Roman provincial imitation of the fine texturing of fleece rendered plastically in finer bronze statuettes cast in lost wax in late Hellenistic and early Roman times. The Mildenberg goat appears to be a freestanding figure, perhaps intended to be a votive offering in a shrine of Mercury in Gaul or the Rhine watershed area during the second or third century.

Condition: Tips of horns missing. Dark green patina.

DGM

Bibliography: Unpublished.

Comparative literature: A.N. Zadoks-Josephus Jitta, W.J.T. Peters, W.A. van Es, *Roman Bronze Statuettes from the Netherlands I* (Groningen: J.B. Wolfers, 1967) p. 108, no. 44, (Leeuwarden, Fries Museum 51-1), without comment or date; Fleischer, *Bronzen,* p. 186, no. 264, pl. 128; G. Faider-Feytmans, *Les bronzes romains*

de Belgique (Mainz: Philipp von Zabern, 1979) pp. 95-96, nos. 108-113, pl. 60; G. Faider-Feytmans, Recueil des bronzes de Bavai (Paris: Centre National de la Recherche Scientifique, 1957) pp. 83-84, nos. 155-155 bis, pl. xxxi; A. Kaufmann-Heinimann, Die römischen Bronzen der Schweiz I: Augst (Mainz: Philipp von Zabern, 1977) pp. 88-89, nos. 93-97, pl. 94. This list could be elaborated almost indefinitely.

190 Ram Figure from a Vessel (?)

Bronze, solid cast. Late Antique–early Byzantine, AD 3rd–4th centuries. H. with base 7.4 cm.; W. without base 2.5 cm.; L. 8.2 cm.

A ram with inconspicuous horns stands with head half turned over right shoulder, left foreleg slightly advanced, and all four legs braced forward. The bronze is extremely heavy, indicating a high lead content. The pupils of the eyes (especially the left) are drilled in such a way as to give the ram an air of omniscience and self-importance. His unnaturally long nose and high nostrils add haughtiness and even pomposity to the whole impression. His fleece was formed in large clumps in the mold and then crudely cold worked with gouges afterward. Leg fleece is stippled with narrower gouges. The beast's legs are as heavy as the rest of him. The front pair like the hind pair are joined by a thick unworked web of bronze. The cloven hooves are exaggerated like crab claws. The ram was cast in one piece with a thin (2 mm.) sheet of bronze, apparently torn from the vessel it once decorated. Everything about this beast is ponderous.

Rams with many of the same features—clumpy fleece, large hooves, and small horns—appear in third- and fourth-century AD representations in a variety of media. The closest comparison in bronze is a slightly smaller sheep (H. 5.35 cm.) in the Burton Y. Berry collection said to be Early Byzantine from the eastern Mediterranean. The heaviness of the sheep is similar to the Mildenberg ram, as are the exaggerated hooves. The Berry bronze's legs also seem to be joined in the same manner. The tip of its tail corkscrews outward suggesting a similar formation for the original state of our ram's tail. The Berry bronze is stiffer in pose than this one and its fleece is indicated by incised crescents like the Mildenberg billy-goat [189].

The remaining piece of metal under the feet looks as though it once belonged to the bowl of a vessel such as a patera. Metal bowls with three-dimensional fish figures inside are known from Sutton Hoo, but nothing of the sort is known in classical vessels. A red earthenware relief bowl in Mainz has on its interior Orpheus, Jonah, and two rams, one in a position similar to our ram. Could the earthenware bowl be a copy of a prototype in bronze with three-dimensional figures?

Condition: Left horn tip missing; also right? Loss at tip of tail. Dark green to black patina. APK

Bibliography: Unpublished.

Comparative literature: Kurt Weitzmann, ed., Age of Spirituality, exhib. cat. (New York: Metropolitan Museum of Art, 1979) pp. 519-521, nos. 463-465; Wolf W. Rudolph, Highlights of the Burton Y. Berry Collection (Bloomington: Indiana University Art Museum, 1979) p. 35, no. 36; Rupert Bruce-Mitford, The Sutton Hoo Ship-Burial (London: The Trustees of the British Museum, 1972) pl. 8.

191 Lid with Recumbent Ram

Bronze, solid cast (lost wax). Late Roman or early Byzantine, AD 3rd–6th centuries. H. 8 cm.; W. 9.5 cm.; L. 15 cm.; L. of tang 5 cm.

A chubby ram reclines on top of a lid with both hind legs tucked under his body, the right front foot extended straight forward. The hoof of this leg is cloven. The animal raises his head, turning it to his right. Stubby horns spiral around his ears. The eyes appear only as bumps; no other surface features are shown either by modeling or cold working. The short massive body is modeled in a compact, generalized way. The short tail curves upward.

The lid, hollow beneath, must have fitted like a cap over whatever it was intended to cover. The hole in the tang that projects backwards from the edge of the lid has ridges

191

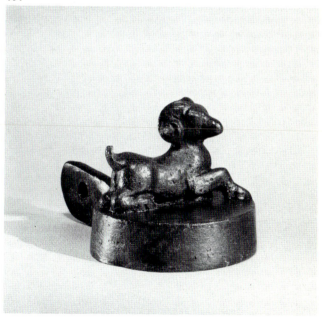

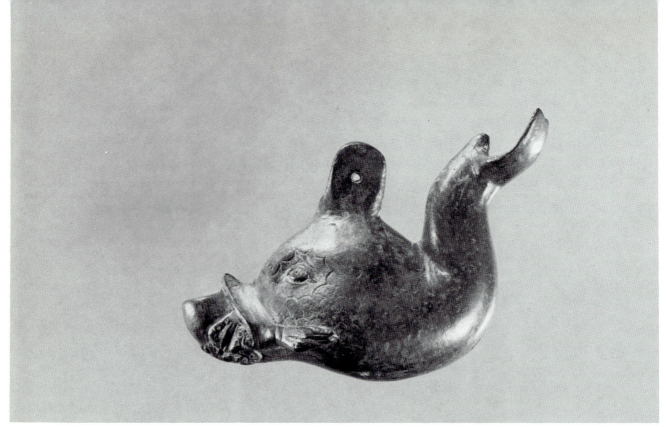

192

running around it on both sides. The object appears to have belonged to a large vessel or to have covered the filling hole for the oil reservoir of a very large bronze lamp. Its massive, simplified casting suggests a late Roman Imperial or even a late antique date. Rams and lambs as sacrificial animals extend beyond their classical symbolic values into Early Christian symbolism of the prodigal, the lost sheep gone astray. Carrying these values and allusions, a ram could have been a highly suitable choice of animal adornment for the lid of a massive lamp or even a censer. In the absence of close parallels, these considerations make a date somewhere in the third through the sixth centuries AD more than likely.

Condition: Intact. The lid formerly had a dull gray-black surface, with abundant bronze disease. It was cleaned by reduction in the Conservation Department's laboratory of The Cleveland Museum of Art, in 1980–1981, then it was boiled to darken it. The surface has extensive pitting. DGM

Bibliography: Unpublished.

Comparative literature: Toynbee, *Animals,* pp. 163-164; Kurt Weitzmann, ed., *The Age of Spirituality* (New York: Metropolitan Museum of Art, 1979) pp. 518-522, nos. 462-466.

192 *Dolphin Lamp*

Bronze, hollow-cast; plaster-like filling added later. Late Roman--Early Byzantine, probably cast in Mediterranean, ca. 400–500 AD. H. 9.2 cm.; W. at fins 4.5 cm.; L. 11 cm.; H. of tang 2.7 cm.

The dolphin's body is decorated with incised scales, running in a single line back up to the tail. There are at least five rows of these on each side of the body; on the right side, these incisions are almost obliterated by wear. The large oval eyes have incised pupils with punctate dots in the center; the lids, the upper overlapping the lower, are plastically rendered. Each eye is formed by a border of scalloped incisions, points radiating outward. A plastically modeled fin projects backward along the body from each corner of the mouth. The right fin, wider than the left, has a central longitudinal groove flanked by two more lightly incised grooves, one on either side; two short transverse grooves are incised across the base of the fin.

The tail is concave, with modeled ridges on either side of the central spine. A hole into the interior of the vessel enters the recess between the cupped tail fins.

The rim of the lamp nozzle is horizontal. Projecting beyond the dolphin's lower lip along the underside of the spout are several raised curling ridges marked by tiny incised circles with central dots. The nature of these ridges, while resembling octopus tentacles, is not readily apparent.

The spout has been filled with some hard substance, identified in the Conservation Department, Cleveland Museum of Art, by Frederick Hollendonner (24 January 1981) as a cement containing particles of crushed brick; this also fills the hole in the tail. The presence of this cement may suggest that the lamp had been immured in mortar, perhaps in a wall or pavement, or someone had added the cement to make the lamp into a steelyard weight.

This lamp resembles a series of hanging dolphin lamps made throughout the eastern Mediterranean region from the third at least into the seventh century AD. A comparable lamp is in the Musée des Beaux-Arts, Lyon; another is in the British Museum. The possibility that this lamp was converted into a weight is in keeping with the practice during late Roman and early Byzantine times of transforming bronze figural vessels such as satyr-bust *balsamaria* or even heads of small hollow-cast bronze statues into such weights. Dolphins, with their rich accumulated tradition of benevolent iconographic associations throughout classical, then Early Christian, centuries also serve as handles for *paterae* and waterspouts for fountains.

Condition: Intact. Shiny dark green patina. DGM

Bibliography: Unpublished.

Comparative literature: M. Wellmann, "Delphin," *RE VIII* (Stuttgart: Alfred Druckenmüller, 1901) cols. 2504-2509; Toynbee, *Animals,* pp. 206-208; S. Boucher, *Bronzes romains figurés du Musée des Beaux-Arts de Lyon* (Lyon: Editions de Boccard, 1973) p. 159, inv. E 305, no. 266; Walters, *BM Bronzes,* p. 289, no. 1924; Mitten, *Rhode Island Cat.,* pp. 194-195, no. 68; H. Rolland, *Bronzes antiques de Haute Provence* (Paris: Editions de CNRS, 1965) pp. 168-169, nos. 386-387.

193 *Eagle*

Silver. Roman, AD 2nd or 4th century. H. 2.5 cm.; W. 1.2 cm.; L. 2.2 cm.

The eagle stands still, scanning afar with eyes like gleaming balls. The feathers are chased like an imbrication of leaves with striations starting from the spine of each feather. The primaries and coverts on the back and the tail feathers are rendered as overlapping, shingled elements. The wings cross over each other at the tips. The talons grip a triangular ledge which curves upward to the tail.

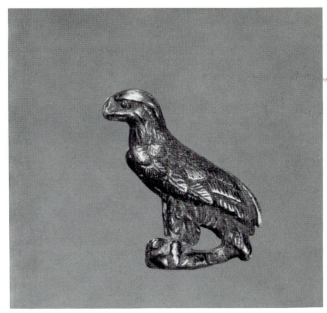

193

Since in Imperial Rome the eagle symbolized both the victorious state and the emperor embodied in Jupiter, it is possible that the Mildenberg eagle was held in the hand of a silver statuette of an emperor made for his private chapel or *lararium*. Such a supposition has been made for a famous bronze statuette of an eagle found at Silchester in England. On the other hand, the eagle as bird of Jupiter topped the short scepters held in their triumph by victorious commanders-in-chief which remained an attribute of the consuls until the reign of Justinian (527–565), as evidenced on the ivory consular diptychs. Twenty-nine such scepters, some in silver, kept in Constantinople, are mentioned by Constantine VII Porphyrogenitus (in his *De Ceremoniis*) around the middle of the tenth century. By a happy coincidence, two objects recently on the market suggest two interpretations—one, a bronze statuette of Jupiter, from Asia Minor, second century AD, which has at his feet an eagle 3.7 cm. high, and the other, a bronze eagle with the same dimensions and attitude as the Mildenberg silver eagle, on top of a triumphal column.

Condition: Some wear on the head and back. PV

Bibliography: Unpublished.

Comparative literature: Th. Schneider and E. Stemplinger, "Adler" in *Reallexikon für Antike und Christentum,* I (Stuttgart: Hiersemann, 1950) cols. 87-89; Dorothy Miner and Emma J. Edelstein, "A Carving in Lapis Lazuli," *Journal of the Walters Art Gallery,* VII–VIII (1944–1945) 92-103; J.M.C. Toynbee, *Art in Roman*

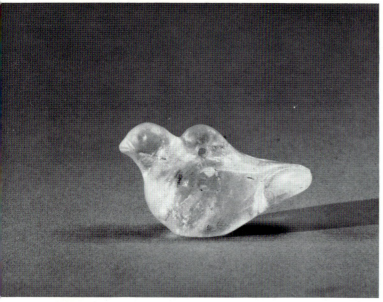

194

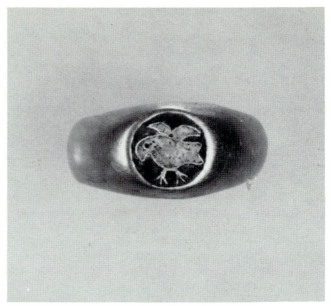

195

Britain (London: Phaidon Press, 1962) p. 150, no. 60, pl. 61; Toynbee, *Animals*, p. 241, pl. 121; Erica Cruikshank Dodd, *Byzantine Silver Stamps* (Washington, D.C.: The Dumbarton Oaks Research Library and Collection, 1961) pp. 260-261, no. 95; *Antike Bronzen*, Liste 14, commercial exhib. cat. (Zürich: Arete Galerie für Antike Kunst, n.d.) nos. 45, 50.

194 *Dove Amulet*

Rock crystal. Egypt, or North Africa, late Roman, ca. AD 300. H. 2.5 cm.; W. 1.7 cm.; L. 4.7 cm.

Like rock crystal objects of late antiquity, this one was formed more by grinding and polishing than by actual cutting. That method produced a depression between the two wings and the tail, which is slightly indented by blunt notches. The eyes were drilled, and shallow incised lines delineate the bill. In modern times a small area was cut off under the breast to allow it to sit firmly. A loop bored in a hump of material reserved behind the neck indicates that the dove was used as a pendant or amulet.

Very few small sculptures in rock crystal date to Roman times, although a handful of statuettes or portraits have survived. Except for two lion heads in the Cluny Museum in Paris, most of the rock crystal animals of late antiquity are *ex-voto* objects or amulets—a shell, a duck, a turtle, and two fishes in the Benaki Museum, Athens, and more fishes in a private collection in New York, in the Kunsthistorisches

Museum in Vienna, the Cabinet des Médailles in Paris, and in the Naples Museum. A lion carving, the forepart of a horse, and a dolphin, the latter in the Metropolitan Museum, New York (55.139), are also known. The *ex-voto* in the Benaki Museum were related to the cult of a Syrian goddess of animals. The Metropolitan Museum rock crystal supposedly comes from a well in Carthage. It may be posited that the Mildenberg rock crystal originated in Egypt. The dove belongs to the cult of Isis who was in Graeco-Roman times equated with Aphrodite, as it has been established by the discovery in Antinoë of a number of steles of boys consecrated to Isis and holding a bunch of grapes and a dove.

Condition: Intact except for slice from breast. PV

Bibliography: Unpublished.

Comparative literature: M.L. Vollenweider and H. Wentzel, "Gems and Glyptics," in *Encyclopedia of World Art*, VI (New York, Toronto, London: McGraw-Hill Book Co., 1962) cols. 56-62; H. Wentzel, "Bergkristall," in *Reallexikon zur Deutschen Kunstgeschichte*, II (Stuttgart-Waldsee: Alfred Druckenmüller, 1948) col. 275, fig. 1, cf. 275-278; Walter Dennison and Charles R. Morey, *Studies in East Christian and Roman Art*, University of Michigan Studies, Humanistic Series, XII (New York: Macmillan, 1918) 164-166; Berta Segall, *Katalog der Goldschmiede-Arbeiten* (Athens: Benaki Museum, Prysos, 1938) pp. 82-83, no. 94, pl. 26; Fritz Eichler and Ernst Kris, *Die Kameen im Kunsthistorischen Museum* (Vienna: von Anton Schroll, 1927) p. 93, no. 123; *Early Christian and Byzantine Art*, exhib cat. (Baltimore: The Walters Art Gallery, 1947) p. 111, nos. 537, 538, 541, pls. LXXIV, LXXV.

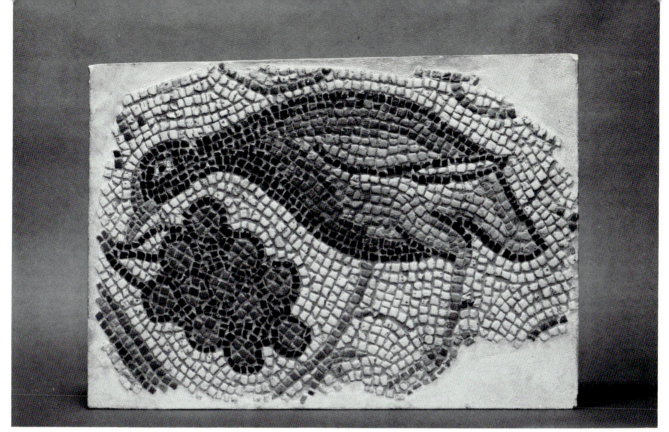

196 See also colorplate XII

195 Gold Ring with Displayed Bird
in Cloisonné Enamel

Late Roman or Byzantine. Diam. 2.2 cm.; Diam. of cloisonné design 0.8 cm.

The shape of the hollow ring with its swelling shoulders, its flattened oval bezel, and tape-thin shank is Near Eastern Roman. The bezel, set flush with the upper part of the ring, is decorated with a fluttering dove with cloisonné enamel on gold. The color of the bird is white; the background is green. The cloisons delineating the bird's body, wings, feet, and eyes were soldered on the gold ground and then filled with enamel pastes and fired.

The Mildenberg bird belongs to a series of birds which played an important part in the development of cloisonné enamel on gold. First the bird was cut in gold and applied on a ground of colored soft glass. Fixing was obtained by heating. In a second stage the bird was cut out on the soft glass ground. The dove of this ring represents the final process which led directly to enamel cloisonné on gold in which the cloisons build up the design and enameling is unified.

Condition: Numerous dents on band. PV

Bibliography: Unpublished.

Comparative literature: Marc Rosenberg, *Zellenschmelz: I Entstehung* (Frankfurt: Joseph Baer, 1921) 39-43, III *Die Frühdenkmäler,* 7-10.

196 Pavement Fragment with Bird

Stone mosaic. Near Eastern Mediterranean, AD 6th century. W. 35.5. cm.; L. 52.2 cm.; Th. 3.4 cm.

A guinea fowl, or partridge, is about to pick at a bunch of grapes in a now almost entirely lost trellis scroll. It has become difficult to determine whether the bird was enframed within the tendrils of a vine medallion or used as a filler in the interval of a net of medallions. The *tesserae* off-white for the ground, a pale and warmer brick color, and two shades of green for the design, and a manganese black for the main outlines. The modeling of the fowl's body was obtained by graduating the green *tesserae* from light to dark.

205

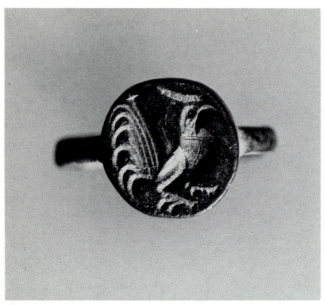

197

The Mildenberg bird is only a fragment of a floor mosaic patterned as an animated scroll or a more complex trellis design. Both types were created in late Roman art, particularly in northern Africa, and spread while acquiring more colorful effects to Palestine, Lebanon, northern Syria, and Cilicia. The best examples date in the sixth century AD.

Condition: The *tesserae* are worn. No losses from within the fragment. PV

Bibliography: Unpublished.

Comparative literature: M. Avi-Yonah, "Mosaic Pavements in Palestine: Supplement," *QDAP*, III, no. 2 (1933) 62-63, 65; "Mosaic Pavements at El Hammām, Beisān," *QDAP*, V, nos. 1 and 2 (1935) 14ff., cf. 19-20; G.M. Fitzgerald, *A Sixth Century Monastery at Beth-Shan (Scythopolis),* IV (Philadelphia: The University of Pennsylvania Press, 1939) 9, pls. XVI, XVII; Ludwig Budde, *Antike Mosaiken in Kilikien* I (Recklinghausen: Aurel Bongers, 1969) 50-51, fig. 24, color fig. 126, pp. 89ff., II (1972) 162-163, figs. 175-184, 263-271, 273-274; François Baratte, *Catalogue des mosaïques romaines et paléochrétiennes du musée du Louvre* (Paris: Éditions de la Réunion des musées nationaux, 1978) nos. 48, 55.

197 *Signet Ring with Gamecock*

Cast bronze, engraved. Late Roman or Byzantine, AD 5th–6th centuries. Diam. of band 2.4 cm.; Diam. of bezel 1.3 cm.

This ring is a shape used frequently in the late antique and early medieval periods for signet rings. The band of the hoop has been slightly angled, and the bezel is a flat solid disk sitting on top of the hoop. The ring is large enough to suggest that it was worn by a man.

The bezel is decorated by a deeply engraved fighting gamecock (see also [16]). Lucilius, at the end of the second century BC, described Roman fighting cocks in a manner which suits this representation. The victor cock proudly struts and rises on its toes as it goes forward, an apt description of this bird. Its comb swept back, its chest out, and tail up, it struts forward, eyes and spurs ready for another challenger. Although gamecocks were not a popular subject for signet rings, they do appear in a style similar to the one here in late Roman bronzes, such as those in the Musée des Beaux-Arts, Lyon.

A simple hoop with an applied engraved bezel appears as early as the third century and continues to the eighth century in gold and silver, as well as bronze. The depth, sharp angles, and straight lines of the engraving are characteristic of fifth-century work. Early Christian rings tend to have the same simple shape as this one, but their decoration is limited to animals and symbols relating to Christianity. Clement of Alexandria suggested that Christians wear only one ring and that it be simply decorated with items such as a dove, fish, fisherman, cross, or monogram. Subjects such as emperors, Mercury, Eros, or even a gamecock would have been most unsuitable for a Christian ring. This ring must, therefore, be for pagan use. Its construction dates it to the fifth or sixth century, with the design on the bezel being a holdover from late antiquity.

Condition: Intact, shape of hoop bent slightly out of true. It has a blackish patina. SJP

Bibliography: Unpublished.

Comparative literature: Stephanie Boucher, *Bronzes romains figurés du Musée des Beaux-Arts de Lyon* (Lyon: Boccard, 1973) figs. 259–263; Henri Leclercq, *Dictionnaire d'archéologie chrétienne et de liturgie* (Paris: Librairie Letouzey et Ané, 1924) I, 2, cols. 2174–2223; Gerald Taylor and Diana Scarisbrick, *Finger Rings from Ancient Egypt to the Present Day* (London: Lund Humphries for the Ashmolean Museum and the Worshipful Company of Goldsmiths, 1978) nos. 107–212.

Abbreviations

In addition to the following, the abbreviations used in this catalog follow those established in the *American Journal of Archaeology* LXXXII (1978) 5-10.

Bloesch et al., *Das Tier*　Hansjörg Bloesch et al., *Das Tier in der Antike: 400 Werke ägyptischer, griechischer, etruskischer und römischer Kunst aus privatem und öffentlichem Besitz,* exhibition catalog. Zurich: Archäologisches Institut der Universität Zürich, 1974.

Bouzek, *Bronzes*　Jan Bouzek, *Graeco-Macedonian Bronzes.* Prague: Universita Karlova, 1973.

Brendel, *Etruscan Art*　Otto J. Brendel, *Etruscan Art.* Harmondsworth, Middlesex: Penguin Books, 1978.

Brown, *Etruscan Lion*　W. Llewellyn Brown, *The Etruscan Lion,* Oxford: Oxford University Press, 1960.

Comstock and Vermeule, *MFA Bronzes*　Mary Comstock and Cornelius Vermeule, *Greek, Etruscan and Roman Bronzes in the Museum of Fine Arts, Boston.* Boston: Museum of Fine Arts, 1971.

de Ridder, *Acro. Cat.*　A. de Ridder, *Catalogue des bronzes trouvés sur l'Acropole d'Athènes.* Bibliothèque des Écoles Françaises d'Athènes et de Rome, fasc. LXIV. Paris: Fondation Piot, 1896.

Farkas, Piotrovsky, et al., *Scythians: Treasures*　Ann Farkas, Boris Piotrovsky, et al., *From the Lands of the Scythians: Ancient Treasures from the Museums of the USSR 3000 BC—100 BC,* exhibition catalog. New York: The Metropolitan Museum of Art, 1975.

Fleischer, *Bronzen*　Robert Fleischer, *Die römischen Bronzen aus Österreich.* Mainz: Philipp von Zabern with Römisch-Germanisches Zentralmuseum zu Mainz, 1967.

Kilian, *Fibeln*　Klaus Kilian, *Fibeln in Thessalien von der mykenischen bis zur archaischen Zeit.* Munich: Beck, 1975.

Mitten, *Rhode Island Cat.*　David Gordon Mitten, *Classical Bronzes.* Providence: Museum of Art, Rhode Island School of Design, 1975.

Mitten and Doeringer, *Master Bronzes*　David Gordon Mitten and Suzannah F. Doeringer, *Master Bronzes from the Classical World,* exhibition catalog. Cambridge, MA: Fogg Art Museum, 1967.

Moorey, *Adam Coll.*　P. R. S. Moorey, *Ancient Persian Bronzes in the Adam Collection.* London: Faber and Faber, 1974.

Payne, *Necrocorinthia*　Humfry Payne, *Necrocorinthia: A Study of Corinthian Art in the Archaic Period.* Oxford: Clarendon Press, 1931.

Pinney and Ridgway, *Aspects*　Gloria Ferrari Pinney and Brunilde Sismondo Ridgway, editors, *Aspects of Ancient Greece,* exhibition catalog. Allentown, PA: Allentown Art Museum, 1979.

Popovič et al., *Bronzes in Yugoslavia*　L. B. Popovič, D. Mano-Zisi, M. Veličković and B. Jeličič, *Greek, Roman and Early-Christian Bronzes in Yugoslavia.* Belgrade: National Museum, 1969.

Reinach, *Répertoire*　Salomon Reinach, *Répertoire de la statuaire grecque et romaine,* 6 vols. Paris: Ernest Leroux, 1897–1930.

Richter, *Animals*　Gisela M. A. Richter, *Animals in Greek Sculpture: A Survey.* New York: Oxford University Press with the Metropolitan Museum of Art, 1930.

Roeder, *Bronzefiguren*　Günther Roeder, *Ägyptische Bronzefiguren, Mitteilungen aus der Ägyptischen Sammlung* VI. Berlin: Staatliche Museen zu Berlin, 1956.

Schefold, *MgK*　Karl Schefold, *Meisterwerke griechischer Kunst.* Basel: Benno Schwabe and Co., 1960.

Schimmel Catalog (1974)　Oscar White Muscarella, editor. *Ancient Art: The Norbert Schimmel Collection,* exhibition catalog. Mainz: Philipp von Zabern, 1974.

Schimmel Catalog (1978)　Jürgen Settgast, editor. *Von Troja bis Amarna: The Norbert Schimmel Collection, New York.* Mainz: Philipp von Zabern, 1978.

Tarbell, *Bronzes*　F. B. Tarbell, *Catalogue of Bronzes, etc., in Field Museum of Natural History, Reproduced from Originals in the National Museum of Naples.* Field Museum of Natural History Publication 130, Anthropological Series VII No. 3. Chicago, 1909.

Toynbee, *Animals*　J. M. C. Toynbee, *Animals in Roman Life and Art.* Ithaca: Cornell University Press, 1973.

Walters, *BM Bronzes*　H. B. Walters, *Catalogue of the Bronzes, Greek, Roman, and Etruscan, in the Department of Greek and Roman Antiquities, British Museum.* London: The Trustees of the British Museum, 1899.

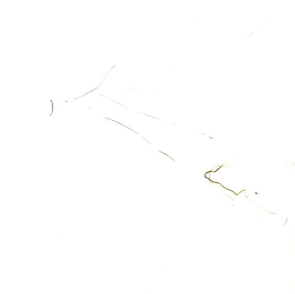